P9-DDK-016

Graphic Design USA: 14

The Annual of the American Institute of Graphic Arts

Written by Steven Heller, R. Roger Remington, Leslie Sherr

Designed by Beth A. Crowell, Cheung/Crowell Design

Computer composition by Mark F. Cheung, Cheung/Crowell Design

Philip F. Clark, Managing Editor

Copyright 1993 by The American Institute of Graphic Arts.
First published in 1993 in New York by The American Institute
of Graphic Arts, 1059 Third Avenue, New York, NY 10021 and
Watson-Guptill Publications, a division of BPI Communications,
Inc., 1515 Broadway, New York, NY 10036.

Distributed to the trade by Watson-Guptill Publications,
1515 Broadway, New York, NY 10036.

ISBN: 0-8230-6297-X

All rights reserved. No part of this publication may be reproduced
or used in any form or by any means without written permission of
the publishers.

Printed in Japan by Toppan Printing Co., Ltd.
Typeset by Cheung/Crowell Design, Rowayton, CT.
First printing, 1993.

Distributed outside the U.S. and Canada by
Hearst Books International, 1350 Avenue of the Americas,
New York, NY 10019.

CONTENTS

Board of Directors 1993-1994

Anthony Russell, *President*
Caroline Hightower, *Director*
Joe Duffy, *Secretary/Treasurer*

Directors
Samuel N. Antupit
Michael Cronan
Paul Davis
Pat Hansen
Richard Koshalek
Ellen Lupton
Fred Murrell
Wendy Richmond
Gordon Salchow
Judy Skalsky
Robert O. Swinehart
Lucille Tenazas
Alina Wheeler
Doug Wolfe
Massimo Vignelli

Staff

Caroline Hightower, *Director*
Irene Bareis, *Associate Director*
Chris Jenkins, *Associate Director for
 Membership and Chapters*
Natalia Ilyin, *Director of Education and
 Professional Development*
Greg Hendren, *Development Director*
Philip F. Clark, *Managing Editor*
Pam Roetzer, *Business Manager*
Nathan Gluck, *Archivist*
Michelle Kalvert, *Assistant to the Director*
Libby Croteau, *Chapters Coordinator*
Kay Bergl, *Public Relations/Traveling
 Show Coordinator*
Luis DeJesus, *Competitions Coordinator*
Steven D. Martin, *Facility Assistant*
Evelyn Andino, *Membership Assistant*
Frances Velasquez, *Office Assistant*

AIGA Chapters and Chapter

Presidents as of June 1, 1993

Anchorage — Dan Miller
Atlanta — Bob Wages
Baltimore — Craig Ziegler
Birmingham — Matthew Dorning
Boston — Marc English
Chicago — Steven Liska
Cinncinati — P. Mike Zender
Cleveland — Kim Zarney
Denver — Deborah Williams
Detroit — Joann Kallio
Honolulu — Daphne Chu
Indianapolis — David Stahl
Jacksonville — Tom Schifanella
Kansas City — Debbie Robinson
Knoxville — Ron Koontz
Los Angeles — Sean Adams
Miami — Terry Stone
Minnesota — John DuFresne
Nebraska — Sandi Jewett
New York — Joseph Feigenbaum
Philadelphia — Steven Yarnall
Phoenix — Al Sanft
Pittsburgh — Denise Hatton
Portland — Jeff Smith
Raleigh — Dana Bartelt
Richmond — Will Flynn
Rochester — Henry Brent
St. Louis — Gretchen Schisla (co-pres.)
 Edward Madden (co-pres.)
Salt Lake City — Rob Ronald
San Diego — Ann von Gal
San Francisco — Mark Coleman
Seattle — Janet Dedonato
Texas — Craig Minor
Washington — Michael Fitzgerald
Wichita — Jon Kowing

Contributors

*Advancing excellence in graphic design is
a collaborative effort. For their generous sup-
port of the Institute during the past year we
would like to thank the following for their
in-kind contributions:*

Alexander Isley
Andresen Graphic Services
April Greiman
Champion International Corporation
Cross Pointe Paper Corporation
Digital Composition Inc.
Fleetwood Fine Arts
George Rice & Sons
Heritage Press
Intergraphic
James River Corporation
John Parnell Photography
Kent Hunter
Masterpiece Printers
Mohawk Paper Mill, Inc.
Neenah Paper Company
Pikes Peak Lithographing Company
R/Greenberg Associates
RPI
Samuel N. Antupit
Sarabande Press
Simpson Paper Company
Strathmore Paper Company
Trilon Color Lithographers
Walbern Press

**The American Institute
of Graphic Arts**

The American Institute of Graphic Arts is the national non-profit organization which promotes excellence in graphic design. Founded in 1914, the AIGA advances graphic design through competitions, exhibitions, publications, professional seminars, educational activities, and projects in the public interest.

Members of the Institute are involved in the design and production of books, magazines, and periodicals as well as corporate, environmental, and promotional graphics. Their contributions of specialized skills and expertise provide the foundation for the Institute's programs. Through the Institute, members form an effective, informal network of professional assistance that is a resource to the profession and the public.

Separately incorporated, the 35 AIGA chapters enable designers to represent their profession collectively on a local level. Drawing upon the resources of the national organization, chapters sponsor a wide variety of programs dealing with all areas of graphic design.

By being a part of a national network, bringing in speakers and exhibitions from other parts of the country and abroad, focusing on new ideas and technical advances, and discussing business practice issues, the chapters place the profession of graphic design in an integrated and national context.

The competitive exhibition schedule at the Institute's national gallery in New York includes the annual Book Show and Communication Graphics. Other exhibitions include Illustration, Photography, Covers (book jackets, record albums and compact discs, magazines, and periodicals), Posters, Signage and Packaging. The exhibitions travel nationally and are reproduced in *Graphic Design USA*. Acquisitions have been made from AIGA exhibitions by the Popular and Applied Arts Division of the Library of Congress. Each year The Book Show is donated to the Rare Book and Manuscript Library of Columbia University, which houses the AIGA collection of award-winning books dating back to the 1920s. For the past 10 years, The Book Show has also been exhibited at the Frankfurt Book Fair.

The AIGA sponsors a biennial national conference covering topics including professional practice, education, technology, the creative process, and design history. The 1993 conference will be held in Miami, Florida.

The AIGA also sponsors an active and comprehensive publications program. Publications include *Graphic Design USA*, the annual of the Institute; the *AIGA Journal of Graphic Design*, published quarterly; the *AIGA Salary and Benefits Survey*, *Graphic Design For Non-Profit Organizations, 2nd Edition*; *Symbol Signs, 2nd Edition* and the *Symbol Signs Repro Kit*, the book and accompanying portfolio containing 50 passenger/pedestrian symbols originally designed for the U.S. Department of Transportation and guidelines for their use; the *AIGA Membership Directory*; the AIGA Standard Form of Agreement (Contract); a Graphic Design Education Statement; and a voluntary Code of Ethics and Professional Conduct for AIGA Members.

Founding Patrons

Under the leadership of Ivan Chermayeff, Milton Glaser, and Massimo Vignelli, a Founding Patrons Program was established. Contributions from 29 individuals created an endowment — the AIGA's first — to be used for pro-active and educational programs, and programs that respond to contemporary issues.

Primo Angeli
Saul Bass
Bruce Blackburn
Kenneth Carbone
Roger Cook
Ivan Chermayeff
Bart Crosby
James Cross
Richard Danne
Paul Davis
Michael P. Donovan
Lou Dorfsman
Thomas Geismar
Milton Glaser
Nancye Green
Robert M. Greenberg
Cheryl Heller
Jerry Herring
Kit Hinrichs
Miho
Clement Mok
Paul Rand
Stan Richards
Robert Miles Runyan
Anthony Russell
Paula Scher
Deborah Sussman
Michael Vanderbyl
Massimo Vignelli

1991 Patrons

We wish to thank the following individuals for becoming Patrons this year:

Charles Spencer Anderson
Michael Cronan
Peter Good
Leo Lionni
Robert B. Ott, Jr.
Arthur Paul
David Rhodes
Silas Rhodes
Arnold Saks
James Sebastian
Dugald Stermer
Bradbury Thompson
Henry Wolf
Richard Saul Wurman
Lois Ehlert

1992-93 Patrons

We wish to thank the following for becoming Patrons this year:

Art Center College of Design
Joe Duffy
Richard Koshalek
Jennifer Morla
John D. Muller

1992-93 Patrons

This is the first year that we have created the Corporate Patrons Program, an invaluable source of annual report. The funds raised will be completely expended each year to sponsor a high-profile project to be selected by the Corporate Patrons Committee from a list of programs developed by our Programs Committee. Participation in this program required a contribution of $7,500, $5,000, or $2,500.

Champion International
Fine Arts Engraving Company
Fox River Paper Company
French Paper Company
Weyerhaeuser Paper Company

Past AIGA Presidents

1914-1915	William B. Howland
1915-1916	John Clyde Oswald
1917-1919	Arthur S. Allen
1920-1921	Walter Gilliss
1921-1922	Frederic W. Goudy
1922-1923	J. Thompson Willing
1924-1925	Burton Emmett
1926-1927	W. Arthur Cole
1927-1928	Frederic G. Melcher
1928-1929	Frank Altshul
1930-1931	Henry A. Groesbeck, Jr.
1932-1934	Harry L. Gage
1935-1936	Charles Chester Lane
1936-1938	Henry Watson Kent
1939-1940	Melbert B. Carey, Jr.
1941-1942	Arthur R. Thompson
1943-1944	George T. Bailey
1945-1946	Walter Frese
1947-1948	Joseph A. Brandt
1948-1950	Donald S. Klopfer
1951-1952	Merle Armitage
1952-1953	Walter Dorwin Teague
1953-1955	Dr. M.F. Agha
1955-1957	Leo Lionni
1957-1958	Sidney R. Jacobs
1958-1960	Edna Beilenson
1960-1963	Alvin Eisenman
1963-1966	Ivan Chermayeff
1966-1968	George Tscherny
1968-1970	Allen Hurlburt
1970-1972	Henry Wolf
1972-1974	Robert O. Bach
1974-1976	Karl Fink
1976-1977	Massimo Vignelli
1977-1979	Richard Danne
1979-1981	James Fogleman
1981-1984	David R. Brown
1984-1986	Colin Forbes
1986-1988	Bruce Blackburn
1988-1991	Nancye Green

The 1993 Annual is going to press at a truly momentous time in the history of the AIGA: we have just purchased a permanent home on lower Fifth Avenue. It will make a strong statement about what we have accomplished and can become. It puts us in a position to make graphic design more visible as a cultural force not only through a public street level gallery and the already surfacing opportunities for cooperative programs with other institutions but also through the development of a computer access library, AV center and accessible archives. The building will also become a national and highly visible center for the AIGA's programs.

We held four competitions and exhibitions this year, one of which, Entertainment Graphics, *opened at Lincoln Center to a large audience of the general public and travelled to London. We sponsored the* Vive les Graphistes *exhibition from Paris which opened at the French Cultural Services in New York. In addition to these non-design venues, AIGA exhibitions opened in 43 places this year including Seoul, Sydney, Melbourne, London, Frankfurt, Leipzig, London and Quebec as part of our initiative on internationalism.*

In addition to the Annual and the Journal, we published or co-produced six significant publications: an extensive 228 page bibliography of graphic design, sponsored by the American Library Association, which makes an important statement about the depth and breadth of the field; the proceedings of a symposium on intellectual property, Bit by Bit: Infringement on the Arts, *which we co-sponsored at the Smithsonian; second editions of* Graphic Design for Non-Profit Organizations *and the* DOT Symbol Signs; *and, this fall,* Graphic Design: A Guide to Education and Practice, *including a directory of schools and* A Guide to the Environmentally Responsible Office. *We also published* The Ethics Game: "Where Do You Draw the Line?"

Other programs include awarding conference scholarships, videotaping the New York City Board of Education/ AIGA Mentor program, sponsoring a panel on designers of color at the GDEA conference and last but not least, we are knee deep in Living Contradictions, *our national conference in Miami this October. The keynote speaker will be Neil Postman author of* Amusing Ourselves to Death; *who will provide insight on the cultural implications of the information age.*

Our membership has grown to 7,800 in tight times, our programs have increased and our budgets are strained. We have initiated a Patrons and Corporate Patrons program, and secured major funding for the conference. The National Capital Campaign Committee will convene tomorrow, for an historic meeting, the first in the new building. These are exiting times. We have many people to thank and much to be grateful for.

Caroline Hightower

June 9, 1993

1992 Awards Committee

Kit Hinrichs, Chairman
Partner, Pentagram, San Francisco

Meredith Davis
*Head of Graphic Design,
North Carolina State University
School of Design*

Caroline Hightower
Director, American Institute of Graphic Arts

Katherine McCoy
*Design Department Co-chair,
Cranbrook Academy of Art*

Martin Pedersen
Publisher and Editor of Graphis

George Tscherny
Principal, George Tscherny Inc.

The AIGA Medal

*For 73 years, the medal of the AIGA has been
awarded to individuals in recognition of their
distinguished achievement, services, or other
contributions within the field of the graphic arts.
Medalists are chosen by a committee, subject to
approval by the Board of Directors.*

Past Recipients
Norman T. A. Munder, 1920
Daniel Berkeley Updike, 1922
John C. Agar, 1924
Stephen H. Horgan, 1924
Bruce Rogers, 1925
Burton Emmett, 1926
Timothy Cole, 1927
Frederic W. Goudy, 1927
William A. Dwiggins, 1929
Henry Watson Kent, 1930
Dard Hunter, 1931
Porter Garnett, 1932
Henry Lewis Bullen, 1934
J. Thompson Willing, 1935
Rudolph Ruzicka, 1936

William A. Kittredge, 1939
Thomas M. Cleland, 1940
Carl Purington Rollins, 1941
Edwin and Robert Grabhorn, 1942
Edward Epstean, 1944
Frederic G. Melcher, 1945
Stanley Morison, 1946
Elmer Adler, 1947
Lawrence C. Wroth, 1948
Earnest Elmo Calkins, 1950
Alfred A. Knopf, 1950
Harry L. Gage, 1951
Joseph Blumenthal, 1952
George Macy, 1953
Will Bradley, 1954
Jan Tschichold, 1954
P. J. Conkwright, 1955
Ray Nash, 1956
Dr. M. F. Agha, 1957
Ben Shahn, 1958
May Massee, 1959
Walter Paepcke, 1960
Paul A. Bennett, 1962
William Sandberg, 1963
Saul Steinberg, 1963
Josef Albers, 1964
Leonard Baskin, 1965
Paul Rand, 1966
Romana Javitz, 1967
Dr. Giovanni Mardersteig, 1968
Dr. Robert R. Leslie, 1969
Herbert Bayer, 1970
Will Burtin, 1971
Milton Glaser, 1972
Richard Avedon, 1973
Allen Hurlburt, 1973
Philip Johnson, 1973
Robert Rauschenberg, 1974
Bradbury Thompson, 1975
Henry Wolf, 1976
Jerome Snyder, 1976
Charles and Ray Eames, 1977
Lou Dorfsman, 1978
Ivan Chermayeff and
Thomas Geismar, 1979
Herb Lubalin, 1980
Saul Bass, 1981
Massimo and Lella Vignelli, 1982
Herbert Matter, 1983
Leo Lionni, 1984
Seymour Chwast, 1985
Walter Herdeg, 1986
Alexey Brodovitch, 1987
Gene Federico, 1987
William Golden, 1988
George Tscherny, 1988
Paul Davis, 1989
Bea Feitler, 1989
Alvin Eisenman, 1990
Frank Zachary, 1990
Colin Forbes, 1991

The Design Leadership Award

*The Design Leadership Award has been estab-
lished to recognize the role of the perceptive and
forward-thinking organization which has been
instrumental in the advancement of design by
application of the highest standards, as a matter
of policy. Recipients are chosen by the awards
committee, subject to approval by the Board
of Directors.*

Past Recipients
IBM Corporation, 1980
Massachusetts Institute of
 Technology, 1981
Container Corporation of America, 1982
Cummins Engine Company, Inc., 1983
Herman Miller, Inc., 1984
WGBH Educational Foundation, 1985
Esprit, 1986
Walker Art Center, 1987
The New York Times, 1988
Apple and Adobe Systems, 1989
The National Park Service, 1990
MTV, 1991
Olivetti, 1991

The Lifetime Achievement Award

*The Lifetime Achievement Award, presented
this year for the first time, is posthumously
awarded to individuals in recognition of their
distinguished achievements, services or other
contributions within the field of graphic arts.
This award is conclusive and is for special and
historical recognition. This award has been
created to ensure that history, past and present,
is integral to the awards process, is part of the
awards presentation and is documented in the
Annual. Recipients are chosen by the awards
committee, subject to approval by the Board
of Directors.*

Past Recipients
E. McKnight Kauffer, 1991
George Nelson, 1991

**The AIGA Awards 1992-93:
A Continuum of Excellence**

The AIGA Medal, received by fewer than 100 individuals and institutions over our 75 year history, is the highest award achievable in our field. Perhaps of no less importance is the design continuum it chronicles.

Implicit in our recognition of an individual designer is the broader acknowledgement of the importance of design within our culture. Passed from generation to generation, the cadence and tools of design, through inevitably changing, seamlessly link our past with our future.

This influence is boldly apparent among this year's honorees. Lester Beall, the recipient of the 1993 Lifetime Achievement Award, significantly influenced the direction of industrial, typographic and graphic design during the 1940's and 1950's. His work for the *Chicago Tribune*, Upjohn Pharmaceutical and *Time Magazine* was the forerunner for much of corporate design today.

The influence of Rudy de Harak, the year's AIGA Medalist, was pervasive in the mid 1960's, when I first arrived in New York from my native Los Angeles. His design was everywhere — on book jackets for McGraw-Hill, exhibits at Expo '67, the New York Public Library, the Ford Foundation, shopping bags for the Met, and environmental graphics for the UN Plaza Hotel, to name a few venues. The clarity of his vision continues to shape today's professionals.

Children's Television Workshop's *Sesame Street*, our third honoree, taught graphic excellance to future generations of Americans at a very tender age. Like the *Dick and Jane* readers of my generation, the letters and numbers presented in *Sesame Street* by Bert, Ernie, Kermit, Big Bird, the Count and the Cookie Monster have left an indelible impression on anyone born after the 1970's.

My colleagues, Meredith Davis, head of Graphic Design at North Carolina State University School of Design; Katherine McCoy, co-chair of the Design Department at Cranbrook Academy of Art; Martin Pedersen, publisher and editor of *Graphis*; George Tscherny, recipient of AIGA Medal; Fred Woodward, Art Director, *Rolling Stone Magazine*, Caroline Hightower, director of the American Institute of Graphic Arts and I are honored to have had the opportunity to award this year's Medals and to add three filaments to the continuing tapestry of American design.

Kit Hinrichs
Chairman, Medalist Committee

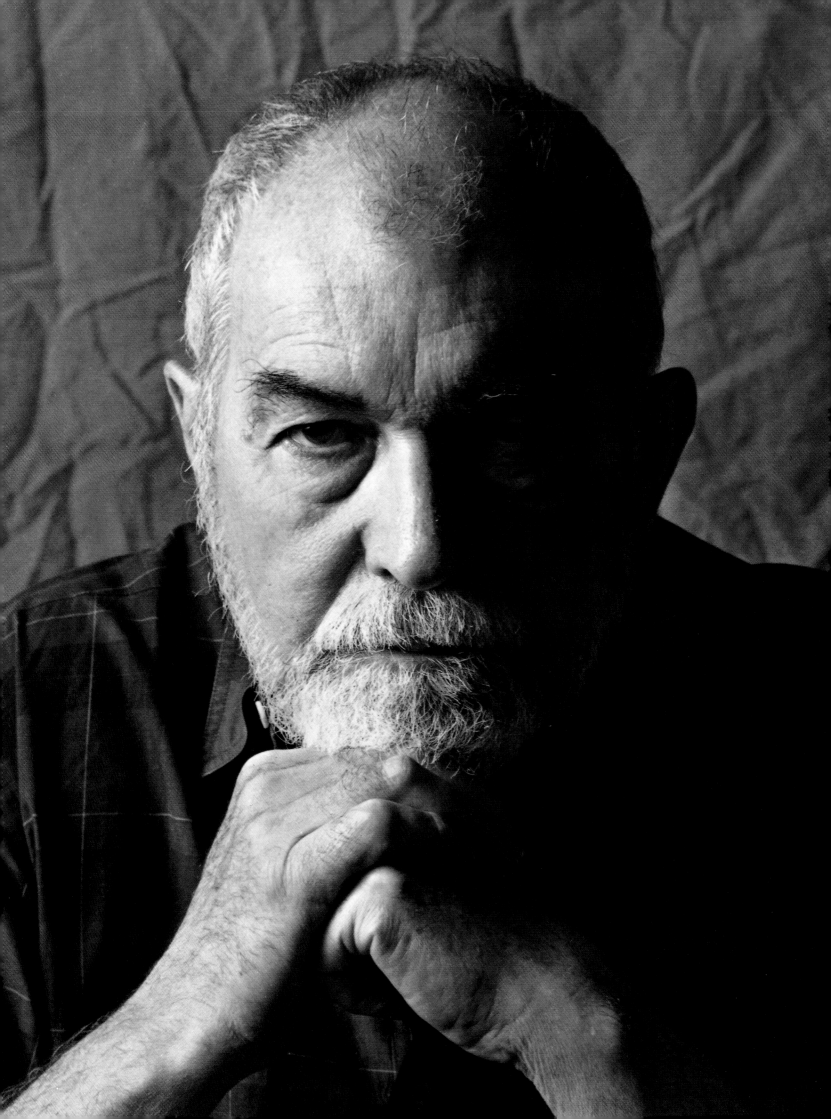

Rudolph de Harak

A Humanist's Modernist

BY STEVEN HELLER

If Modernism imposes coldness and sterility, as some critics have argued, then Rudolph de Harak must be doing something wrong. A devout Modernist, his work for public and private institutions is uncompromisingly human. For proof, take 127 John Street, a typically Modern skyscraper in New York City's financial district. Before de Harak designed its entrance-level facade it exuded all the warmth of glass and steel on a winter's day. But with the installation of his three-storey-high digital clock (comprised of 72 square modules with numerals that light according to date, hour, minute and second); the mysterious neon-illuminated tunnel leading to the building's entrance; and the bright, canvas-covered, permanent scaffolds that serve as both protection and sundecks, 127 John Street was transformed from a Modern edifice into a veritable playground.

De Harak's innovative addition to the John Street building enlivened a faceless street, and likewise his inspired exhibition designs for museums and expositions have transformed didactic displays into engaging environments. Dedicated to the efficient communication of information, de Harak uses detail the way a composer scores musicals notes, creating melodies of sensation to underscore meaning. His exhibits are indeed symphonies that both enlighten and entertain. His exploded diesel engine, the centerpiece of the Cummins Engine Museum in Columbus, Indiana, in which almost every nut and bolt is deconstructed in midair, is evidence of the designer's keen ability for extracting accessible information from even the most minute detail. And yet while his exhibition design explores the rational world, his graphic design uncovers the subconscious.

Although de Harak deliberately uses neutral typography to anchor his design, the hundreds of book jackets, record covers, and posters he has created since opening a design office in 1952, is evidence that he also expresses *emotion* through type and image. While not the raw expressionism of today's most fashionable designers, de Harak employs abstract form ever so subtly to unlock alternative levels of perception. He relates this practice to Abstract Expressionism, which in the early Fifties he wholeheartedly embraced; and while this may be difficult to see amid his orthodox, systematic design, the nearly 350 covers he

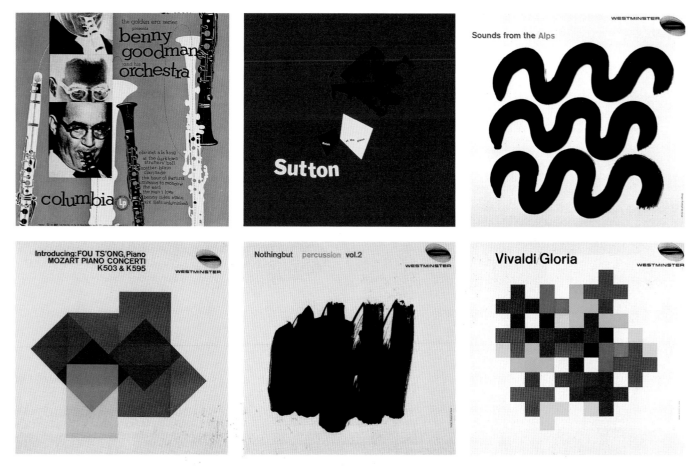

Record covers: Benny Goodman,
1950; Ralph Sutton, 1954;
Westminister covers, 1960.

designed for McGraw-Hill Paperbacks in the early Sixties brings this relationship into sharp focus. De Harak's rigid grid is, in fact, a *tabula rasa* on which rational and eccentric imagery together evoke inner feelings. The conceptual themes of these books — philosophy, anthropology, psychology, and sociology, among them — offered de Harak a proving ground to test the limits of conceptual art and photography. At the same time, he experimented with a variety of approaches inspired by Dada. Abstract Expressionism, and ultimately Op-Art movements.

His on-the-job research helped push the design practice towards an art-based theory. First as a teacher and later as the Frank Stanton Professor of Design, for a quarter century at the Cooper Union, and visiting professor at Yale, Alfred University, Parsons, Pratt Institute, and other schools, de Harak influenced scores

of young designers to build upon the Modernist canon. But attaining his own eminence did not come easily. Waving the Modernist banner, even in the early Fifties when the International Style was embraced by key corporations, did not insure that he would receive lucrative commissions. Consumed by Modern principles that were devised in pre- and post-war Europe, de Harak became an iconoclast with an uncompromising belief in both the rightness of form and his own methodology, which did not earn him many clients in those early days. In fact, the paucity of steady work during the formative years caused him to switch from design to photography to earn a living. The illustrious multi-disciplinary career that is celebrated with this year's AIGA Medal developed painstakingly over time.

Born in Culver City, California on April 10, 1924, Rudolph de Harak had a

peripatetic early childhood and adolescence. During his pre-teens, his family moved to New York City where he later attended the New York School of Industrial Arts and learned some basic commercial art practices. He attended this trade school because he was interested in drawing and was less at ease with academic studies. Graduation coincided with World War II, and he was drafted into the infantry. But upon being discharged he returned to Los Angeles, where, out of work and uncertain about his future, he was encouraged by an employment counselor to take advantage of his artistic leanings and accept an apprenticeship at a small art service/ advertising agency. There he began honing his craft first as a mechanical artist, and then making layouts and illustrations. One of his ads was entered into the Los Angeles Art Directors Club

Print America'sGraphicDesignMagazine May/June1961

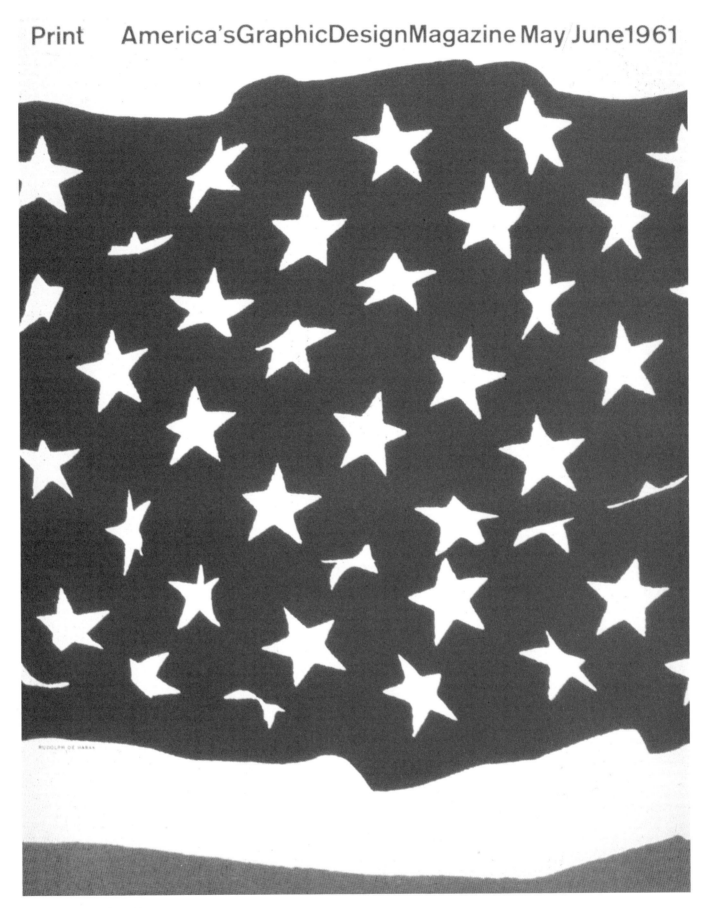

Cover of *Print* magazine, 1961.

Rudolph de Harak, 1952.

Trade marks, top to bottom:
Kurt Versen Lighting Company,
1957; United Nations Plaza
Hotel, 1976; Alan Guttmacher
Institute, 1971.

competition and won an award. This was a defining moment: De Harak was so amazed that he could get acclaim for something that also earned him a living that he decided to seriously pursue graphic design in a manner that would ultimately consume his life.

De Harak's future course was also profoundly influenced by two lectures at the Art Center School given in the late Forties by Will Burtin, the German master of information and exhibition design, and Gyorgy Kepes, the Hungarian designer and author of *Language of Vision.* "These experiences had a profound effect on my life. The first was a lecture by Will Burtin — 'Integration: The New Discipline in Design.' Burtin not only spoke about design and communications, but he presented an exhibition of his work, which moved the viewer through a series of experiences which were described as *the four principal realities of visual communication:* The reality of man, as measure and measurer; the reality of light, color, texture; the reality of space, motion, time; the reality of science. He was the first person I had heard use the term 'visual communications.' A short time later, I also had the opportunity of hearing Gyorgy Kepes. At the time I didn't fully understand everything he had to say; yet, I knew that his words were very important to me, and I recall my excitement, as I was able to draw parallels between what he was saying about the *plastic arts* and what Will Burtin had said concerning *the realities of visual communications.*"

Shortly after Kepes's lecture, de Harak and six other designers, including Saul Bass, Alvin Lustig, and Lou Danziger, founded the Los Angeles Society for Contemporary Designers. De Harak explained that the reasons for forming it was a matter of survival: "We were a young, very enthusiastic group trying to function in a desert, which is what Los Angeles was at that time." In

fact, with the notable exceptions of charter members Bass, who was making inroads in motion picture advertising, and Lustig, who was doing innovative book and book jacket designs, Los Angeles was not known for its progressivism. Since de Harak did not believe that the future would be any brighter he moved back East in 1950.

His first job in New York was as promotion art director for *Seventeen* magazine, then located at 11 West 42nd Street, where coincidentally Will Burtin also had an office. "I didn't get to meet him until 13 years later when we became good friends," de Harak says. *Seventeen* soon moved to 488 Madison Avenue — the Look Building — which was a hotbed of publishing and advertising activity. Not only were *Look,* where Alan Hurlburt was art director, and *Coronet* headquartered in the modernistic, step-backed structure, but so was the Weintraub Agency where Paul Rand was art director, *Esquire,* where Henry Wolf was art director, and *Seventeen* itself, where Art Kane was art director. De Harak, Wolf, and Kane were all friends and deeply interested in photography. On weekends they would take photographs and discuss design together.

De Harak's ideas about design were still being formulated, and the uneven quality of his *Seventeen* promotions revealed certain growing pains. And yet because he was intent on formulating a direction, a personality was beginning to emerge. De Harak has a vivid memory of this early stage: "Around 1950, I was particularly influenced by Alvin Lustig and Saul Bass, who were poles apart. Bass, who was a very content-conscious designer, would get a strong idea and put together a beautiful design based on that idea. Lustig, on the other hand, was a strong formalist, much less concerned with content, but deeply interested in developing forms and relating the type to them. I too went off in that direction and

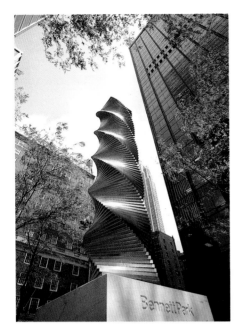

Left, stainless steel and marble sculpture, 1972, 77 Water Street, New York City. Below, *New York Times* truck typography, 1975.

[became] dedicated to the concept of form. I was always looking for the *hidden order,* trying to somehow either develop new forms or manipulate existing form. Therefore, I think my work was more obscure, and certainly very abstract. Sometimes it was hard for me to understand why [my solutions] fell short. But one thing I did, was to sharpen my design sensibilities to the point that my work generally fell into a purist category."

Purism was not, however, an extremely marketable methodology in the crassly commercial post-war culture. Frustrated by the limitations that business had placed on him, de Harak stayed at *Seventeen* for only 18 months, and then did a stint at an advertising agency for about four months, the last full-time job he would ever take. "I think it was too hard for me to work for somebody. It's not that I didn't want to, but I was very strong in my convictions and the way I wanted to work is antithetical to the way most advertising agencies think. Actually, I didn't take direction too well. Therefore, going out on my own was a choice of necessity, not so much something I wanted to do."

A few commissions came de Harak's way. Eventually, the most long-term was a 20-year relationship with the Kurt Versen Lighting Company designing the trademark, house style, packaging, and catalogs. Yet de Harak's most public work in the early 1950's were the monthly illustrations that Henry Wolf assigned him to do for *Esquire.* These little "design illustrations, a kind of 1950's Dada," as de Harak refers to them, married conceptual and formal thinking; they were collages comprised of photographs, drawings, and found materials which he juxtaposed in rebus-like compositions and then rendered as composite photographs. These gems of abstract illlustration were like jazz improvisations. At the same time de Harak was improvising with various photographic methods, such as photograms and reticulating processes, that were ultimately used, not coincidentally, in his work for Columbia, Oxford, Circle, and Westminster record covers, all of which were also his labs for typographic experimentation.

With one eye on the International Style, the other was focused on pushing the boundaries of letterform composition. Following in the tradition of 1920's poetic typography, de Harak imposed his own levels of legibility through experimentation with various forms of letter and word spacing.

For all his efforts, de Harak was finding it increasingly hard to make ends meet from design alone. In 1952 he began a long tenure at Cooper Union teaching what in those days was called "advertising" design. "I hadn't been a designer long, but what I lacked in experience I made up for in enthusiasm and commitment," he says. And many former students agree that he brought intelligence and excitement, free of dogma, to teaching both the process and ethic of design. And yet by 1955 business was so bad that he decided to put together a photographic portfolio which did earn him more work shooting many fashion, still life, and set-up assignments for *Esquire, Apparel Arts* and various ad agencies. But he was never really satisfied with the direction of this interim career. So around 1958, throwing caution to the wind, he moved into an office on Lexington Avenue, hired a couple of students from Cooper Union, and began seriously selling design under the name Rudolph de Harak Incorporated.

"This was a very exciting and crucial point in my life," de Harak explains. "It was when I was introduced to specimens of Berthold's Akzidenz Grotesk from Berlin." This bold European typeface effectively anchored de Harak's design approach and afforded him a neutral

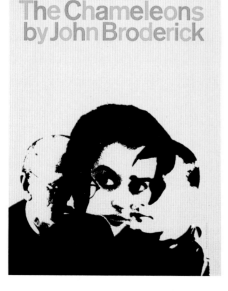

Book Jackets, left to right: *The Chameleons,* 1960; *Varieties of Mystic Experience,* 1974.

Right, cover for Italian graphic
design magazine *Linea Grapfica*,
1974. Below, two posters
Functional Graphics, 1985,
Images: Illusional, 1959.

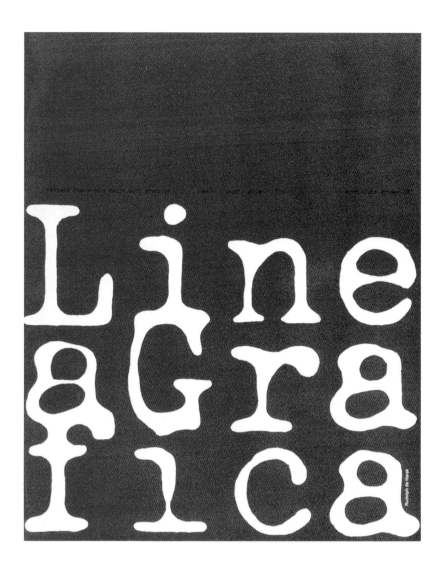

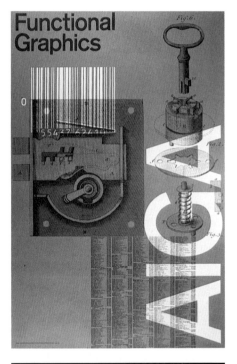

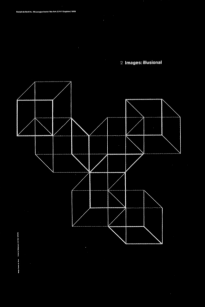

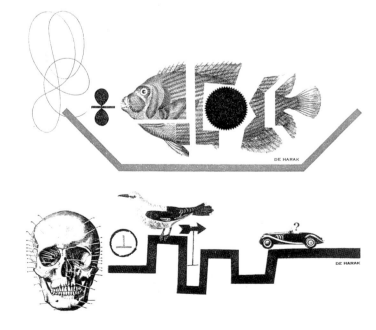

Two illustrations for *Esquire*
magazine, 1954.

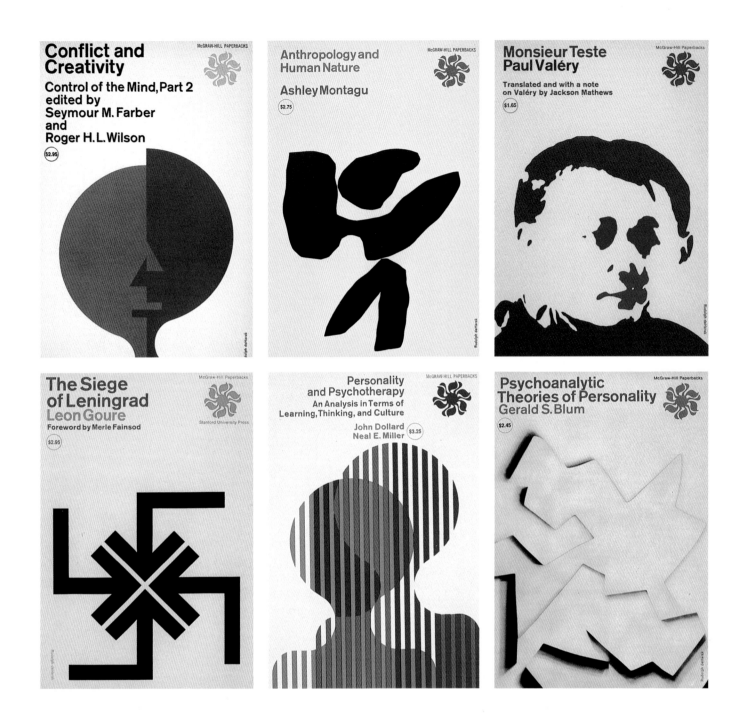

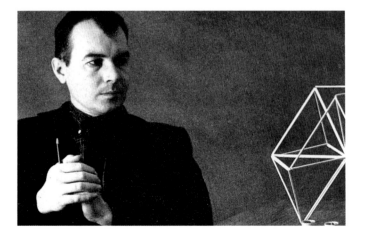

Above, book covers for
McGraw-Hill paperbacks, 1963-65.
Right, Rudolph de Harak, 1955.

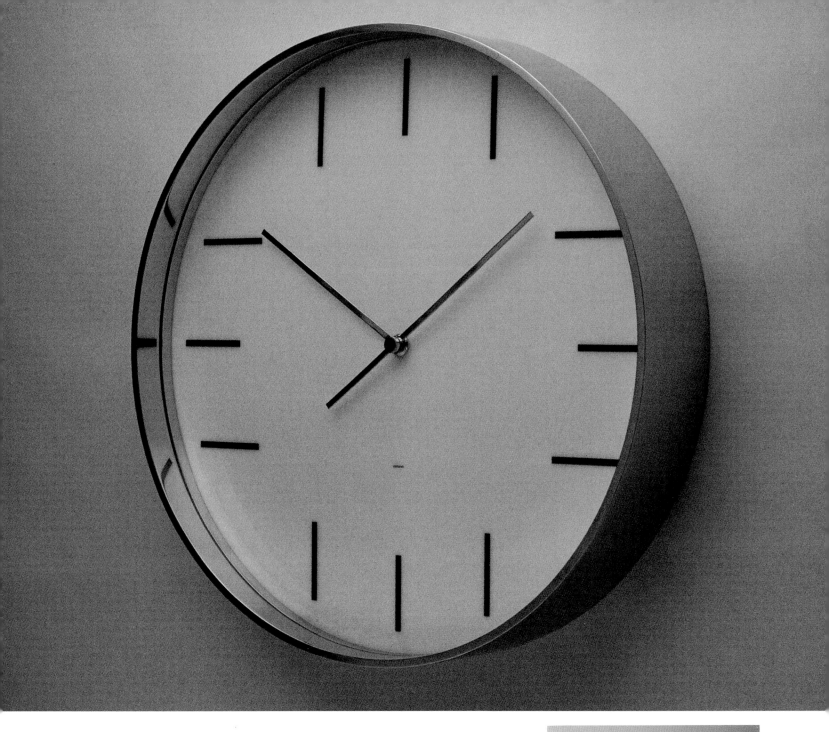

Above, wall clock, 18" diameter,
chromium case, 1963, collection
of the Museum of Modern Art,
New York City. Right, wall clock,
18" diameter, plastic with saw
cuts, 1963.

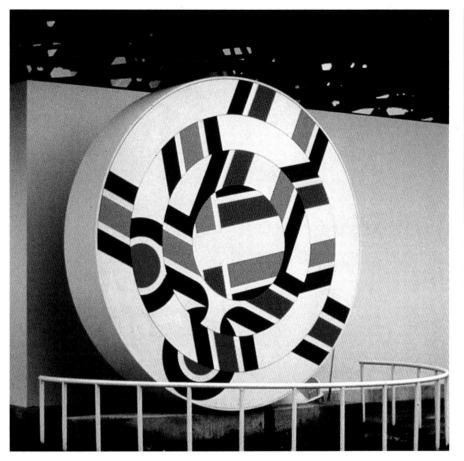

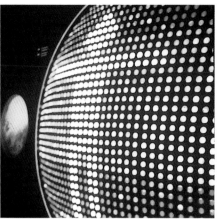

Canadian Pavilion, Expo '67, Montreal. Left and below, animated symbol for pavilion entrance. Above, detail of illuminated display.

element against which to play with a growing repetoire of images. His early experiments, including 50 covers done for Westminster Records, were the basis for the decidedly Modern book jackets that he designed for Meridian Press, New Directions, Holt Rhinehart and Winston, and Doubleday. And all the approaches that he developed during the late Fifties led to his opus — the McGraw-Hill paperback covers which became laboratories for his experiments with color, type, optical illusion, photography, and other techniques. More important, these covers would define his design for years to follow.

To understand de Harak's influence on graphic design during the Sixties it is necessary to know that the McGraw-Hill paperbacks were emblematic of that period. They were based on the most contemporary design systems, and were unique compared to other covers and

jackets in the marketplace. At this time the International Style and American Eclecticism were the two primary design methodologies at play in the United States. The former represented Bauhaus rationalism, the latter Sixties exuberance. De Harak was profoundly influenced by the exquisite simplicity of the great Swiss Modernist, Max Bill, but as an American he wanted to find a vehicle for somehow reconciling these two conflicting sensibilities. Although, just as he resisted the hard sell approach in advertising, he also rejected the eclectic trend to make typography too blatantly symbolic. "I never saw the need to put snowcaps on a letterform to suggest the cold," he offers as an example of the extreme case. Instead he worked with a limited number of typefaces, at first Franklin Gothic and News Gothic (preferring it over Futura), and then Akzidenz Grotesk, and ultimately Helvetica. De Harak still believes

that the last gave him all the color, weight, and nuance he needed to express a variety of themes and ideas.

The McGraw-Hill covers were paradigms of purist visual communication. Each element was fundamental since de Harak did not allow for the extraneous. Yet, as economical as they were, each was also a marriage of expressionistic or illusionistic imagery and systematic typography, the same repertoire of elements that he would later use in other graphic work. De Harak became known for simplifying the complex without lessening meaning.

In the mid-Sixties, as de Harak was building a solid reputation as a teacher and practitioner, a new facet to his career, exhibition design, began almost by accident. In 1965 a friend, Nicholas Chaparos who taught at Canada's University of Waterloo, recommended de Harak to design the "Man, His Planet,

and Space" pavilion at Montreal's EXPO '67. At the time, de Harak notes, there were simply not enough Canadian designers to handle the volume of work that went into making this milestone exposition. He spent two intensive years researching and developing information modules comprised of light, sound, and text that presented complex information. It would become the cornerstone of his expanding practice which eventually included signage, exposition, and exhibition design.

For the design of the U.S. Pavilion in Japan, Osaka's EXPO '70, de Harak teamed up with Ivan Chermayeff and Tom Geismar creating a tour de force of information communications. Subsequently, he earned commissions from U.S. government agencies, among them the Atomic Energy Commission, National Parks Service, National Endowment for the Arts, and the U.S. Postal Service. He was also in demand for large commercial assignments, such as the United Nations Plaza Hotel, for which he created graphic programs and wayfinding systems. Although pleased with these commissions, even more satisfying than developing livable environments such as this, presenting histories and stories became de Harak's prime talent and greatest pleasure. The Cummins Engine Com-

127 John Street, New York City, 1970. Below, illuminated digital clock, 40 feet high. Right, neon-illuminated entrance tunnel.

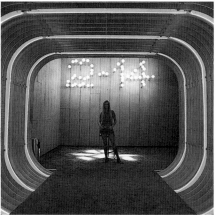

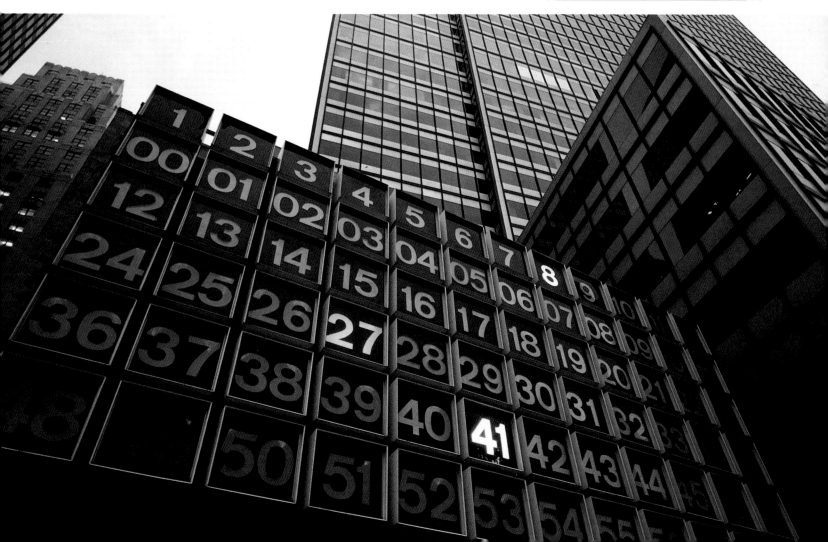

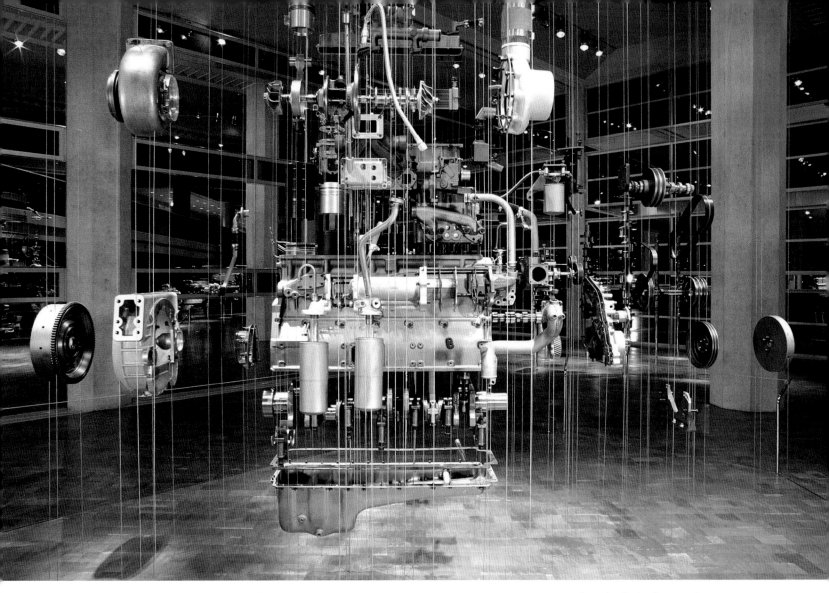

Cummins Engine Company Corporate Museum, 1985. Disassembled diesel engine suspended on wires between floor and ceiling. Below, first conceptual drawing.

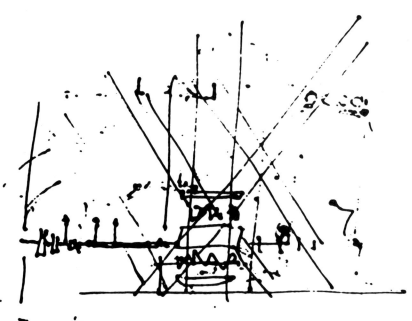

pany museum is not only a masterpiece of corporate culture, but of retelling — what de Harak refers to as "real people's stories." He interviewed scores of Cummins workers to develop the museum's content. With its 1000-plus-pieces exploded engine as a dynamic focal point, de Harak created a living testament to the company's commitment to progress through artful displays that pulls in history and contemporary practice without a hint of nostalgia. The combination of de Harak's modernism and eclecticism are fully realized through his museum designs.

The commission to participate in the design of the Egyptian Wing of New York's Metropolitan Museum of Modern Art is another key example. When the Met's architect, Kevin Roche, invited de Harak to work on the new wing he wanted someone who would conform to the modern scheme of the new wing and its master plan, and yet be sympathetic to the Met's traditions. The project took 10 years to complete — years that were devoted to exhaustive research of every nuance of the magnificent collection before the design process began. Deciding what and how to show the panorama of ancient history with enough entry-points to engage even the casual viewer was as difficult a challenge as de Harak had ever faced. How to identify the invaluable materials required a variety of inventive formats. Transparency was one of the keys. De Harak discretely printed captions on glass, which gave the viewer the option to learn about and/or see the treasured objects at the same time. A photographic timeline, which was also available as an accordian-fold booklet, provided another level of access for the viewer. Over a decade after its opening, the Egyptian Wing is still a popular attraction, perhaps as much for de Harak's design purity as for the stunning artifacts in the collection itself.

Despite his passion for purism, de Harak has also embraced the virtues of randomness. "I love the ambivalence," he says about the essence of art and design, "of what happens visually when you see something that you're not sure of, then all of a sudden you get a handle on it. What's really important is getting the viewer to participate. If that person can look at an image and say 'Wow!' in some way, that is a key function of design." And so that in a nutshell is what he has taught and how he has practiced.

As the 1980's came to a close, de Harak turned from the rigors of multidisciplinary, systematic design to abstract art. Then in his sixties, the thought of stepping away from his business to pursue other interests — once unthinkable to this veteran — became an appealling prospect. It would allow him to pursue and investigate more fully other passions he harbored since entering the field. Of course, even in the work-a-day world he continued to seriously practice painting, photography, and collage. But leaving New York with his wife Carol to the home they designed and built in Maine allowed him more freedom for his interests in the visual arts and music. Like the other milestones of design that defined de Harak's long career, his last "official" graphic design while still the head of his design office was the jacket design for the AIGA Annual, *Graphic Design USA: 9.* It is fitting since moving to Maine, he has been elected into the Art Directors Hall of Fame, received a Honorary Doctorate of Fine Arts Degree from the Corcoran Museum School of Art and now AIGA's highest award, their Gold Medal. For decades de Harak used his art to fulfill clients' needs. He stands poised to make art for himself. It is a meaningful conclusion to one career and the beginning of a new life of a man who has imbued graphic design with both a vocabulary and an ethic.

Dust jacket for *Graphic Design USA: 9,* 1987.

Two collages, 12" x 12"; "Crash", 1990 and "Oohps", 1987.

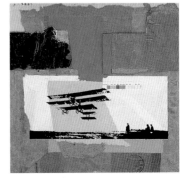

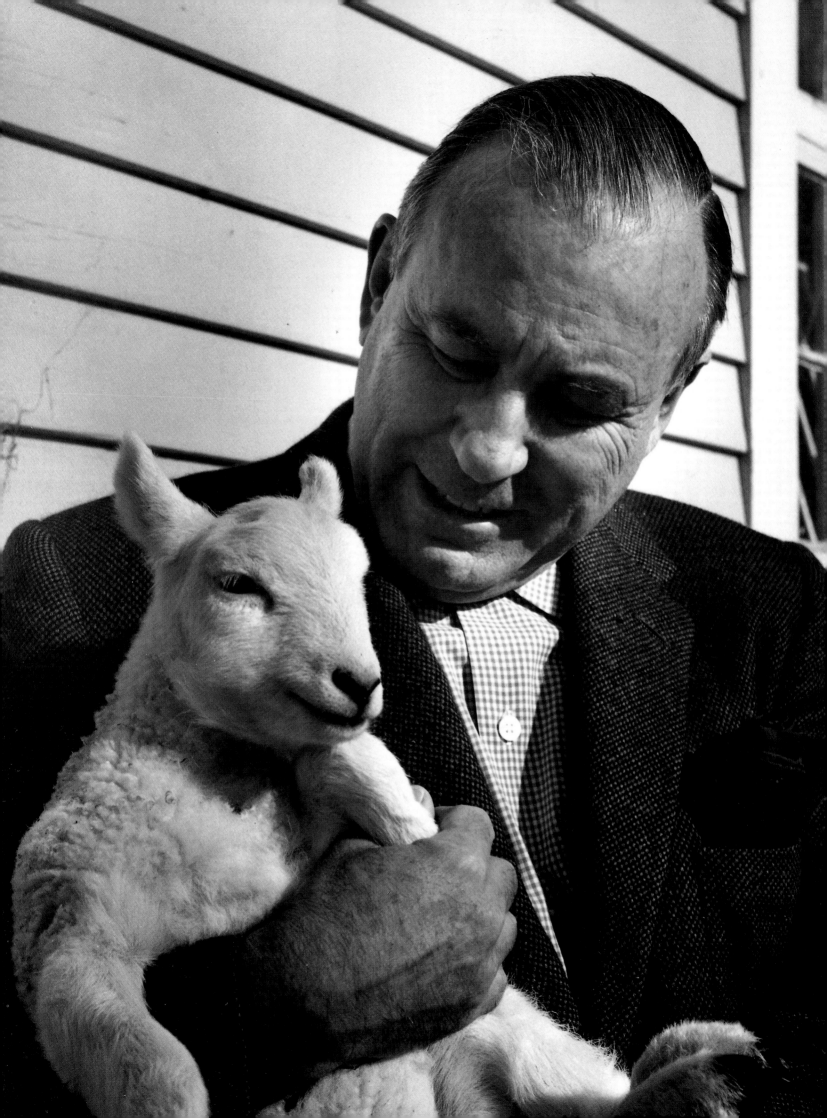

Lester Beall

A Creative Genius of the Simple Truth

BY R. ROGER REMINGTON

Opposite page, Lester Beall with a Cheviot sheep at Dumbarton Farm, 1960's. This page, female figures from a sketchbook, 1946.

Creativity speaks to the heart of the process of graphic design. What were the creative forces that allowed Lester Beall to produce consistently great art and design over the span of a 44-year career? Over this span of time, Beall produced solutions to design problems that were fresh and innovative. He studied the dynamic visual form of the European avant-garde, synthesized parts into his own aesthetic and formed graphic design applications for business and industry that were appropriate, bold, and imaginative. In his mature years he led the way with creative and comprehensive packaging and corporate identity programs that met the needs of his clients. Along the way in his work, manner and style, Beall proved to American business that the graphic designer was a professional

that could creatively solve problems and at the same time deal with pragmatic issues of marketing and budget. The qualities and values that led to Beall's effectiveness are timeless and provide contemporary practitioners with an historical reference base upon which to evaluate present standards.

Beall felt that the designer "must work with one goal in mind — to integrate the elements in such a manner that they will combine to produce a result that will convey not merely a static commercial message, but an emotional reaction as well. If we can produce the kind of art which harnesses the power of the human instinct for that harmony of form, beauty, and cleanness that seems inevitable when you see it . . . then I think we may be doing a job for our clients."

For Beall that creativity was present at every stage of the design process. He said, "The designer's role in the development, application and protection of the trademark may be described as pre-creative, creative, and post-creative."

Born in Kansas City, Missouri in 1903, Beall's early childhood years were spent in St. Louis and Chicago. He was educated at Chicago's Lane Technical School and graduated from the University of Chicago. He began his design career in 1927. By 1935 Beall had decided to move to New York and in late September of that year had opened a studio/office in his apartment in Tudor City on Manhattan's east side. In 1936, while maintaining the office in New York, he moved to Wilton, Connecticut where he established his home and studio in a

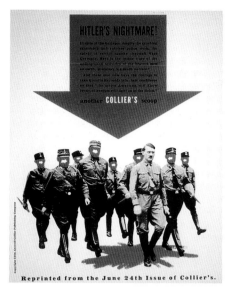

"Hitler's Nightmare" for Crowell
Publishing Company, 1939.

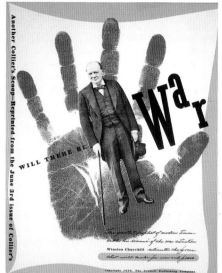

Cover for "What's New,"
from 1939-40.

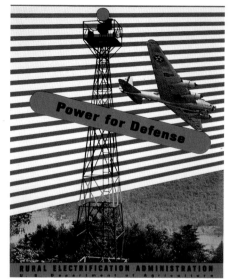

"Power for Defense" from the third
series of Beall's U.S. Rural Electrification
Administration posters, 1941.

rural setting. He was to remain in Wilton until 1950. Many of the significant works from this period were done in this location. Through the 1930's and 1940's Beall produced innovative and highly regarded work for clients including the *Chicago Tribune,* Sterling Engraving, The Art Directors Club of New York, Hiram Walker, Abbott Laboratories, and *Time* magazine. Of particular interest was his work for the Crowell Publishing Company which produced *Colliers* magazine. The promotional covers "Will There Be War?" and "Hitler's Nightmare" are powerful designs which distill messages of the time. In these works he utilizes angled elements, iconic arrows, silhouetted photographs and dynamic shapes, all of which captures the essence of his personal style of the late 1930's. Also of interest in this period are the remarkable poster series for the United States Government's Rural Electrification Administration. In all Beall designed three series of posters between 1937 and 1941 with the simple goals of increasing the number of rural Americans who would electrify their homes and increasing public awareness of the benefits of electricity. His poster for the ill-fated "Freedom Pavilion" at the 1939 World's Fair was another dynamic

example of this time in which he used what he called "thrust and counter-thrust" of design elements.

Beall had moved his office to 580 Fifth Avenue around 1940. He worked there as well as from his home in Wilton, Connecticut. In 1949 he purchased Dumbarton Farm in Brookfield and, in 1950, he moved to consolidate all his operations there. He had developed some of the farm's out buildings into a professionally-praised office and studio space. During the 1950's and '60's Beall's design office expanded both in its staff and scope, adding associate designers and mounting full-scale corporate identification campaigns for large companies such as Caterpillar Tractor, Connecticut General Life Insurance Company, The New York Hilton, and Merrill Lynch, Fenner Pierce and Smith, Inc. His identity program for International Paper Company from 1960 was his most extensive identity program and is noteworthy for the graphics standards manual, one of the first to be so fully articulated.

Beall maintained, throughout his life, a core of sources which stimulated his perception, creativity, and methods of making art and design. He was a highly visual person with a great need to express

himself. Always first and at the center of his ways of working were his form experimentation in the drawing and painting of the human figure. He was always at work in his studio, whether it was creating design, art, or photography. His wife, Dorothy Miller Beall characterized her husband as "first of all an artist, not only because of a vital and important talent, but because of an emotional spiritual quality, a very special attitude." His daughter Joanna remembers this fine art expression as "a major part of his thinking." Beall, in his memoirs, confirms this by recalling that "all through my life as a designer, I have spent considerable time developing myself as an artist. I am constantly drawing, with particular emphasis on the figure, which I find fascinating though difficult in terms of evolving something that is not completely abstract but certainly not literal or realistic."

Photography also was a lifelong interest to Beall and an important part of his creative process. He experimented with photography and photographic processes almost from the beginning of his career in design in Chicago. Cameras, a photographic studio, and a darkroom were always necessary for his visual ex-

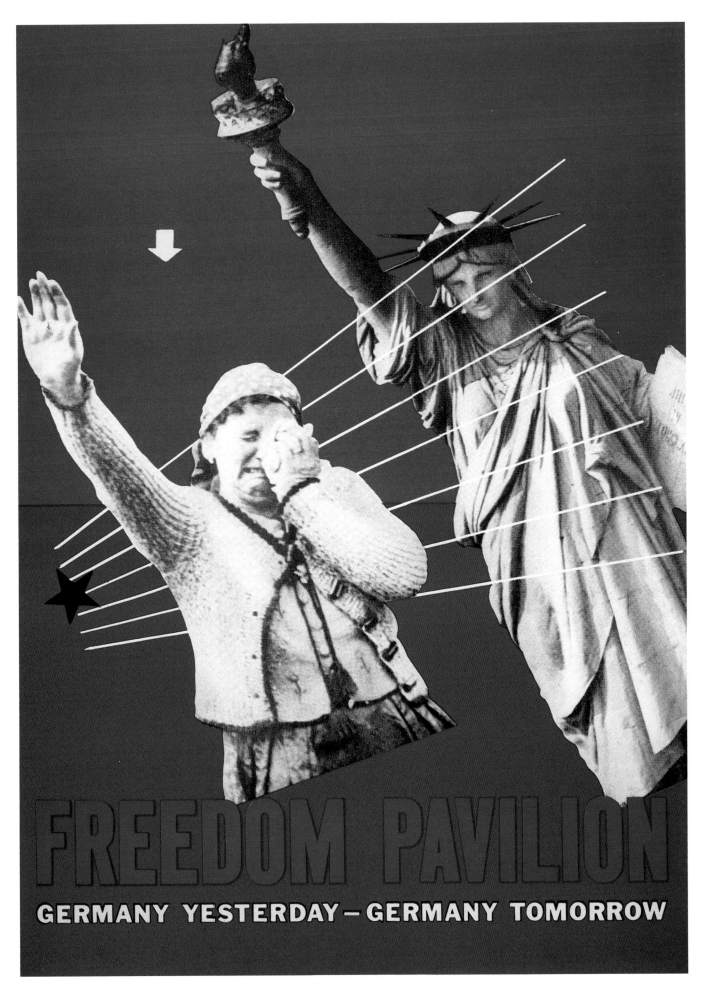

Poster for "Freedom Pavilion" at
1939 World's Fair in New York.

Dorothy Miller Beall, photographed by Lester Beall.

periments. In the '30's he had seen the experimental photographic work of the European avant-garde designers such as Herbert Bayer, El Lissitzky, and Lazlo Moholy-Nagy. Beall would experiment regularly with photograms, and with straight photography both in and out of the studio. Even today, many of Beall's photographic images remain unusual and innovative visual experiments. Beall carried his camera with him on all his travels. These images formed an image bank from which he drew inspiration for his lectures. Others found their way into direct graphic design application for his clients such as in the cover for *ORS,* a journal for health services professionals. A more complex photographic technique is used on the cover of *What's New,* a house organ of Abbott Laboratories. This image from 1939 shows a complex intergration of photographic and graphic elements, set in a scale which juxtaposes the size relationships of foreground and background.

The psychologist Erich Fromm said, "Education for creativity is nothing short of education for living." Beall's creative activities were powerfully influenced, enhanced and supported by the working environments that he established to support them. Whether he was working from his office near the Loop in Chicago, an office in a New York skyscraper or from the pastoral setting in Connecticut, Beall was sensitive to the importance of the space around him and how this could influence his creavity. In 1968 he wrote: "By living and working in the country I felt I could enjoy a more integrated life, and although I still need the periodic stimulation of New York City, the opportunity and creative activity in an area of both beauty and tranquility seemed to me to far exceed anything that a studio and residence in New York might offer — the way a man lives is essential to the work he produces. The two cannot be separated. If I could condense into a single idea the thinking we are trying to do here at

Below, cover for "What's New," from 1939-40. Below right, experimental photographic image, 1940's.

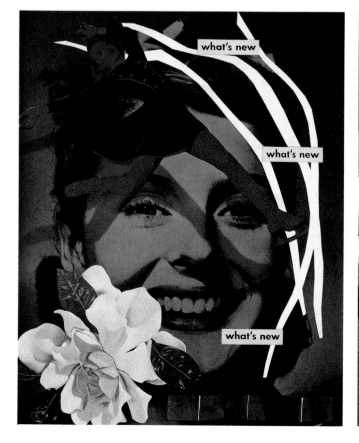

Dumbarton Farm, it would be to achieve, through organic and integrated design, that power of inevitability. . . .This has for a long time been an effort to work out a way of living for me and my family — and for the people who work with me. It gives me more time at home. It surrounds me with atmosphere I feel is pretty essential to good creativity." With Beall it was not so much that he had his studio in the country, but that he had a way of life built around the country, part of which involved having his studio there at his elbow.

As with other pioneers of his era, Beall believed that the designer cannot work in a vacuum. He remarked, "all experience in fields directly or indirectly related to design must be absorbed and stored up, to provide the inspirational source that guides, nourishes and enriches the idea-flow of the designer." Beall's own interests in other art forms provided further stimulus to his immense curiosity and creativity. Dorothy Beall wrote that Lester "believed that any one interested in design must necessarily be interested in other fields of expression — the theater, ballet, photography, painting, literature, as well as music, for from any of these the alert designer can at times obtain not only ideas related to his advertising problem, but genuine inspiration." His books and periodicals were another great source of inspiration for Beall. He collected books and periodicals seriously from the beginning of his design career in Chicago. By the Sixties, Beall had accumulated a major personal collection of publications on creative forms such as art, design, photography, and architecture. He also collected seminal magazines such as *Cahiers d'Art* and rare volumes such as the famous *Bauhausbucher.* Music was another important ingredient of Beall's creative environment. He was very familiar with jazz, having grown up with it in Chicago. While working in his

studio there in the mid-'20's, he would often listen to live broadcasts on radio. Throughout his life, he would surround himself with music, be it jazz, or the classical compositions of Europeans such as Stravinksy, Prokofiev, and Shostakovich.

Beall, in 1963, when writing about what he saw as the qualifications for a designer, listed "an understanding wife." Throughout their life together, from the earliest days of struggle in Chicago to the golden years at Dumbarton Farm, Dorothy Miller Beall was by his side, relating to his friends and clients. She participated as she could to realize her husband's work, career, and life. She said, "I have always felt very close to my husband's career, having been a part of it from the very beginning." Together Dorothy and Lester built living environments for themselves and their family which were rich with collected folk art, antiques, Americana, as well as contemporary works. Beall said, "A lot of wives take a dim view of their husbands coming home for lunch. Dorothy actually looks forward to my coming home; perhaps even too much so. I enjoy getting over to the house, being surrounded by the things in my home." In remembering the beginning of Beall's career, Dorothy recalled "It was a time of discovering the interdependence of painting, sculpture, and the technique of modern industry and of the underlying unity of all creative work." For many years after Beall's death, Dorothy preserved the artifacts of his career, sustained his name in the design press with articles and was continually supportive to inquiring students or researchers.

Beall was a major synthesizer of the ideas of European avant-garde artists and designers into the mainstream of design for American business. An associate Fred Hauck, with whom he had shared office space in Chicago, was probably the major

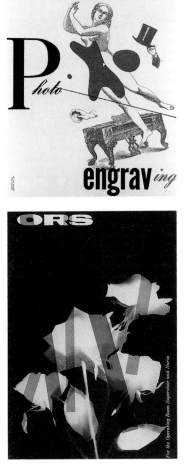

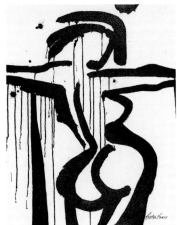

Top to bottom: Cover from "Photoengraving No.5," designed for Sterling Engraving Company in New York, 1938; *ORS* cover with photogram by Lester Beall; Figure drawing by Lester Beall.

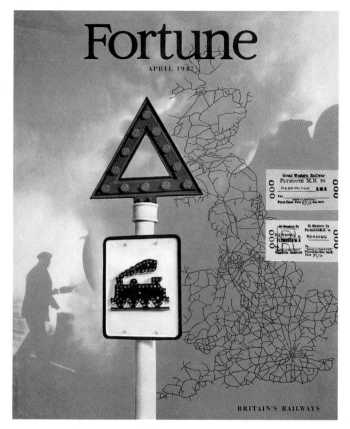

Cover for *Fortune* magazine, 1947.

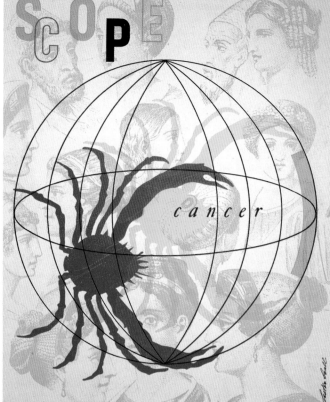

Cover for *Scope* magazine,
Upjohn Company.

vehicle through which Beall received those exciting ideas from Europe. Hauck, who had lived and painted in Paris and had gone to Hans Hofman's school in Munich, returned to Chicago and shared with Beall an enthusiasm for the European artists and designers, especially the Bauhaus. Hauck showed Beall valued copies of the Bauhaus books and publications of the avant-garde which he had brought back with him. This interest as well as such publications as *Arts et Metier Graphiques,* and *Gebrauschgraphik* helped Beall consolidate his own thinking away from a limiting vision of design as ordinary middle-American commercial illustration and towards a new dynamic, progressive form of graphic communication.

Beall earned great respect from his clients and staff. Bob Pliskin recalled that Beall "was a good man to work for. He had the gift of enthusiasm and he knew how to communicate it. He gave us free-dom and guidance too. His studio was a happy, stimulating place where work was fun and clocks did not exist. And Beall could teach. He taught us to spurn symmetry, which he called an easy out . . . a static response to a dynamic world. He taught us that the solution to a design problem must come from the problem. That form must follow function." About Beall's graphic design imagery of the 1940's Plisken wrote, "You couldn't miss Beall's work. It riveted you . . . held your attention . . . and planted an idea in your head. He was a skillful typographic designer and he liked working with type and typographic symbols. He loved arrows. Loved them and used them in nearly everything he did. It was a natural symbolism for him because the arrow was and is the simplest, most direct way to move the eye from one spot to another."

The recognition of Lester Beall's pioneering efforts has been slow in coming. It is fitting that his importance to design is now to be acknowledged again by The American Institute of Graphic Arts. Looking back, however, he was consistently commended for the excellence of this work. As early as 1937 Beall was given the first one-man exhibit of graphic design at the Museum of Modern Art in New York. Then, in 1942, Beall's greatness was acknowledged as he accompanied a distinguished group of colleagues, namely Dr. Agha, Alexey Brodovitch, A.M. Cassandre, Bob Gage, William Golden and Paul Rand in an ADG exhibit, "A Half Century on the Greatest Artists of the Modern Media." August Freundlich remarked in the brochure, "These are men who have bridged the gap between art and commerce. Although we fully recognize their success within their commercial regions, it is their success as creative artists, as creative thinkers, as innovators, as inventors that

All photographs are courtesy and property of the Lester Beall Collection, Archives and Special Collections, Wallace Library, Rochester Institute of Technology.

concerns us." It took the New York Art Directors Club until 4 years after Beall's death in 1969, to vote him into their prestigious Hall of Fame in 1973. At that time Bob Plisken, who worked for Beall in the early 1940's, spoke on his behalf, "In my opinion, Beall did more than anyone to make graphic design in America a distinct and respected profession." Lorraine Wild, in her writing on American design history, has characterized Beall as a leader of those designers from the Thirties to the Fifties whose work has a "quality of openness and accessibility. It is evidence of all the energy spent trying to make a real contribution to the common good and the environment. The stakes were clear — a new profession was formed." Another distinguished design historian, Ann Ferebee, knew Beall personally and is steadfast in referring to his formative work as "the conscience of American design." Philip Meggs in his *A History of Graphic Design,* credits Beall with "almost single-handedly launching the Modern movement in American design." The

excellence of Beall's life and work has made him into a near mythic figure who, even a quarter of a century after his death, still dazzles the imagination of many students and professionals alike.

"The quality of any man's life has got to be a full measure of that man's personal commitment to excellence, . . ." Beall would have felt good about these words spoken by Vince Lombardi, because competition and commitment were the ways in which he was able to achieve brilliance in his professional career in design. Beall said, "When a designer designs a beautiful product he has unveiled a simple truth. In short, this product of his creativeness communicates a simple message — a message that will outlast the product's function or salability. The designer, furthermore, can then be said to have contributed something of value to his culture." So it is entirely appropriate that Lester Beall's legacy to the profession of graphic design is now honored; his was surely a "lifetime achievement."

Top to bottom: Corporate identity marks for Caterpillar Tractor, 1967, International Paper Company, 1960, Merrill Lynch, Fenner, Pierce and Smith, Inc., 1968.

Two-page spread from style book for Connecticut General Life Insurance Company, 1959.

31

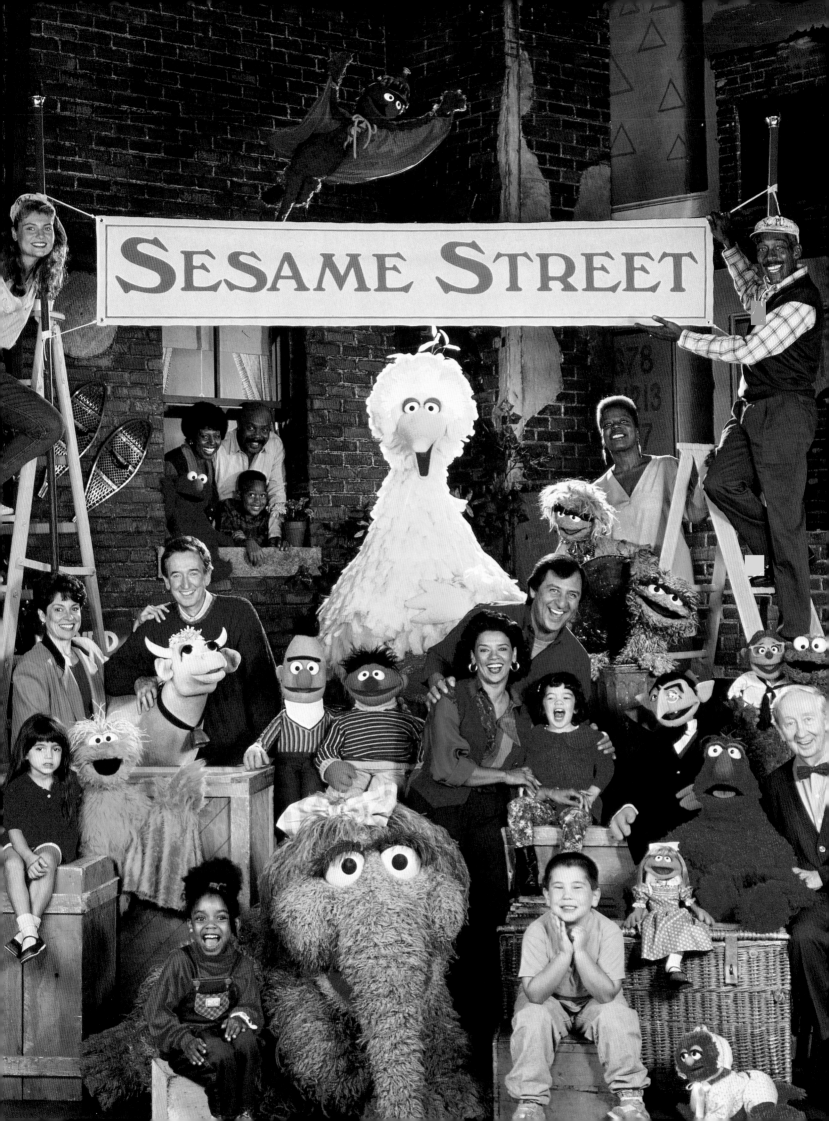

Sesame Street

The ABCs of Learning

BY LESLIE SHERR

Opposite page, photograph of Sesame Street cast by John E. Barrett.

The task of children's television is to hook kids on learning for life. No show fits that job description better than Sesame Street. At twenty-five, Sesame Street is the oldest television show for two-to-six-year olds in America. Since 1968, when it first aired on public television, it has attracted and retained the steady attention of preschoolers — no small achievement in a period increasingly obsessed with sensationalism. Recipient of a record fifty Emmy awards, Sesame Street's English-language version, and its international co-productions, are seen in ninety-eight countries worldwide. Last year, its guest stars included Mel Gibson, Danny Glover, Tito Puente, Harry Connick, Jr., and Queen Latifah. Film segments using William Wegman's dogs and animated characters based on the

work of the late pop artist Keith Haring were also part of an irresistible line-up. Small wonder then that to those of us weaned on Sesame Street, Jim Henson's Muppet characters — Big Bird and Kermit; Bert and Ernie; the purple, fanged Count von Count, who loves to add; Cookie Monster, who loves you-know-what, and Oscar, the green grouch who lives in a garbage can — are still as clever and engaging as when we were young. Such a legacy can only be credited with earning it this year's American Institute of Graphic Arts "Design Leadership Award," for demonstrating a committment to outstanding graphics during the past quarter-century.

Sesame Street is a potent combination of the simple and the sophisticated. The brainchild of Joan Ganz Cooney,

an Emmy Award-winning public affairs producer, and Lloyd Morrisett, an executive at the Carnegie Corporation, it began as a laboratory to stimulate the educational development of children through television. To 11 million parents across America, it is the acceptable face of a baby-sitter in a box: shaped as much by the minds of Ph.D.'s as by the needs of preschoolers. The show's collaborative spirit and free thinking come across powerfully on TV. Sesame Street offers a sense of hope, without hype. "We try to help children develop self-esteem. If you feel good about yourself and you feel that you can learn, then you're half way there, aren't you?" emphasizes Dulcy Singer, executive producer. "The basic message is that life holds all kinds of possibilities for you. I hope we open doors for

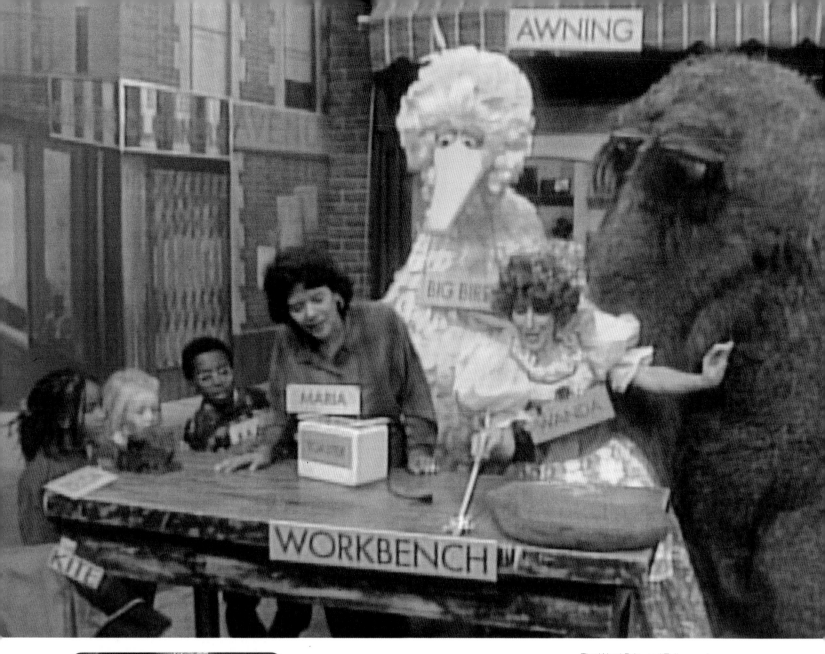

The Word Fairy and Telly, regulars who call attention to words and letterforms. Simple recognition is a goal, aided by plot, character and animation. By the end of the show when "Sesame Street has been brought to you by the letters O, P, and the number 2" is announced, children recognize them.

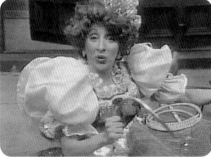

children rather than closing them. I hope the message is that the world holds all kinds of opportunities, and that you can succeed."

Sesame Street's sincerity is also what gets the parody behind much of the writing such a wry chuckle from adults. "We have double-level jokes on the show consciously," admits Singer. How else to explain a pink, tuxedo-clad bird named Placido Flamingo? Or the stage-struck bovine blond Meryl Sheep? Or How Now Brown & the Moo Wave, a group of rock-and-roll cows, singing 'Danger, It's No Stranger'?" Singer explains, "We want to do anything we can to encourage parents to watch with their children. Studies have shown that kids who watch with parents actually get more out of the show. We also want to attract older brothers and sisters — they control the television dial. We want a firm grip on the remote."

The show's unparalleled success has as much to do with the creative minds behind it as it does with the research that goes into each segment. Research is, in fact, where it all begins. Scripts are then developed to meet the season and the producers,' priorities. Each season, each show, each segment is dominated by at least one of a reputedly daunting list of curriculum goals. Scripts are then distributed to every member of the production staff. Once the scripts have been read, a production meeting is called, where everything from scale to masking muppets to special effects is discussed. Next, schedules are reworked, based on what has to be finished when. "It's often a very confusing process but, miraculously, it works," says Pantuso, with utmost confidence.

The art department on Sesame Street is a long, narrow windowless room, a corridor, really, with just enough space for a row of drafting tables set end to end, three art directors and three chairs. There is one computer. A fair amount of work is still done by hand. The office is shared by Mike Pantuso, graphic designer; Victor DiNapoli, production designer; and Bob Phillips, art director, all of whom won Emmys this year in addition to this award. The residue of creative thinking hangs heavily in the air. "We produce 120 shows over five months. That's the equivalent of two shows a day or ten shows a week for five months," declares DiNapoli. "A fine artist can spend three months on one painting. But our work comes at you like the IRT subway line. You have to be able to jump on and go with it, to do the best you can in the time allotted. You can't work on one show and have a vision of it. You're working on bits, thirty-second to one minute segments from a show. But that's part of what we do best: we fend off a never-ending data stream in a creative way. " Phillips adds, "When I got here, it struck me that nothing is off-limits. You can say whatever comes into your head. That's not the end in itself, but it sparks a reaction, and the idea bounces around the room like a billiard ball and finally lands in the pocket and you say, 'That's it!' It works that way. Even in this room. Especially in this room!"

A collaborative spirit permeates attitudes from the producers on down. The close proximity of working quarters helps to stir creative juices. "We're about to move our offices, and we're trying to make sure we stay together. Otherwise, we'll get separated and the magic might not happen." states Phillips . "There's so much information we have to produce, get out, get done. It's good to do this *with* people," says Pantuso. DiNapoli agrees, "If we all had separate offices, we'd have major problems."

"We share things. We sit around in the mornings and ask, 'Did you see that new ad on the subway? Did you see that commercial? What did you think of that show opening the other night?'

Above, three book cover props, designed by Mike Pantuso. Below, the Count counting.

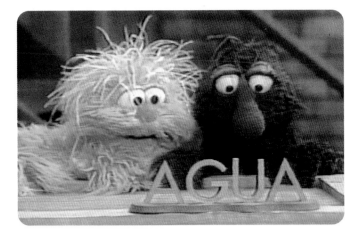

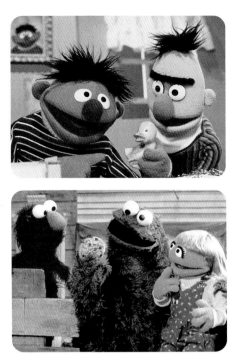

There are many things happening on the set. The graphics have to be bold, obvious. "Our design problem is that when we are teaching a specific curriculum letter, number or word, we are locked into one typeface: Futura."

We'll pick out the parts that worked, and somewhere along the way, we'll use it. Not as a direct lift: it's the sensibility that will somehow find its way in later on." Influences come from all over, and the pressure to be as progressive as any other channel gives the average day its own urgency.

Sesame Street once concerned itself only with teaching children the basics — to count to ten, to recognize letters and forms, to reason and solve problems. Over the years, it has broadened its mandate to include the sensitive exploration of such emotionally-charged issues as love, marriage, adoption, birth, sibling rivalry and even death. Each curriculum goal is addressed repeatedly, using a range of different mediums — animation, live-action and puppet segments. Yet, for all its conceptual latitude, there are some stylistic constraints. "The goal is simple recognition. The child must be able to

recognize and remember the letter and number forms. In the course of a single show the kids get bombarded by the same letter. By the end of the program when 'Sesame Street has been brought to you by the letters, say, Q, P, and the number 2,' appears on the screen, they know those images," explains DiNapoli. "When we are teaching a specific curriculum letter, number or word, we are locked into one typeface: Futura. That's our design problem. Futura is the most clean cut, the most recognizable of letterforms. The trick is to keep it interesting. Pantuso elaborates, "Our Futura is modified. It has little quirks in it for the sake of clarity. Our 4, for example, has a break at the top so that it doesn't re-semble the uppercase A. The two sides of the capital letter M are splayed so that it doesn't look remotely like an N. Unlike all the other letters, the capital letter I has a serif so it isn't floating and doesn't look like a

lowercase L or the number 1. The zero and the O are also different. The O is fully round and the zero is compressed. They took the hook off the q because the child was probably confusing it with the g. Now it's just a descender. It's basically the Futura font, but it's tweaked here and there. Nothing looks exactly like anything else. "

"Visually, our goal is always simplicity. You can't give it so much that it is confusing because there are always many other things happening on the set — there are always Muppets and props and sets around. The graphics have to make a point. They have to be bold, obvious. You are dealing with four-year-olds. The work has to be right out there. But you also need a real sensitivity to work at Sesame Street. You don't want to create something frightening, and you don't want to design something so complicated that it gets lost." says Pantuso.

Left, sample characters of alphabet created by Mike Pantuso for "Ethel Mermaid." Below, video sequence of Polly Darton in "Save Your Energy for Me."

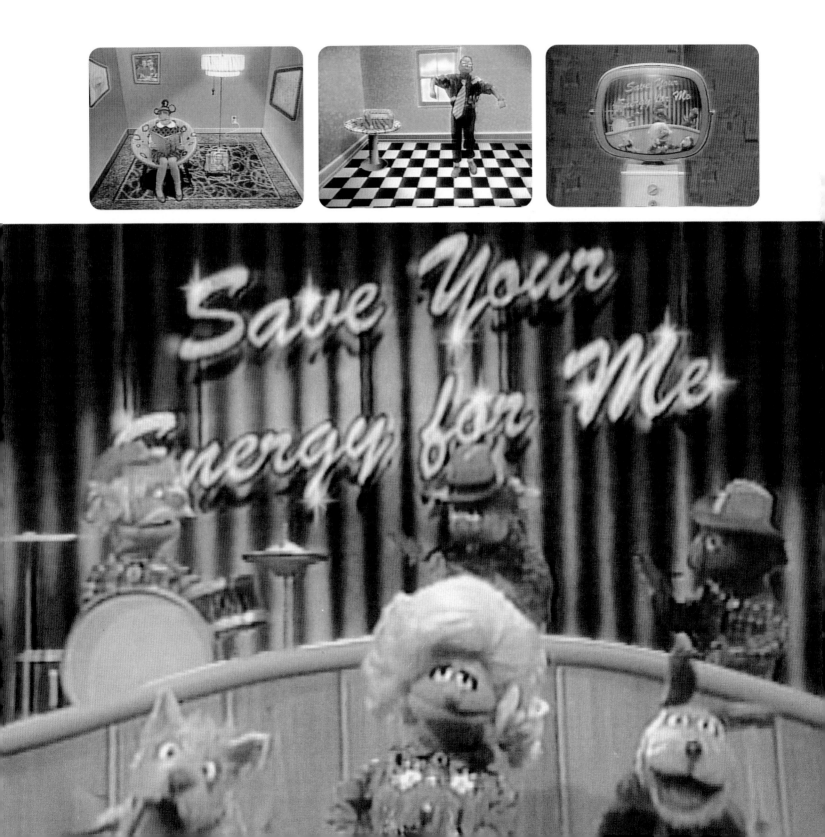

Perhaps the most significant change in the look of the show's graphics has come as a result of the computer. "The computer has been a major tool for the past couple of seasons. Victor has been exploring computer animation. Suddenly there's a new door-way that allows Mike's creativity to take off in ways that he probably wouldn't have thought of without the computer. It saves a lot of time on the drudgery so we can focus on the details," says Phillips. "The computer is probably the most extraordinary breakthrough we've had here," admits Pantuso. "I haven't used press-type in two years."

An effective balance of curriculum goals is only one aspect of teaching preschoolers skills that will facilitate a successful transition from home to school. The format of the show is paced according to Sesame Street's mandate. To keep the child's attention from wandering, each hour-long show is a stream of thirty, two-minute commercials. "In the original study, they found that children responded mostly to commercials. Within the span of thirty seconds to a minute, each has a beginning and an end. Their attention spans are short," says DiNapoli. "Sesame Street's repetitive punch of 'boom, boom, boom, and thirty seconds later it's off' is remembered the same way that jingles are remembered, " adds Phillips.

Were it not for Pantuso's phenomenal visual empathy with children, his graphics might have been either dry-as-dust or forced into primitive scrawls. As it is, he has given to each Muppet character a graphic style in keeping with its personality and age. A tall, tawny, inquisitive canary, fashioned of boa-like plumes, Big Bird draws like a typical six-year old, making the sky purple or orange, and ignoring the details. A "Scram!" sign for Oscar the Grouch is legible, but deliciously sloppy. "Kids draw from their emotions. They aren't concerned with how the picture is going to come out. It's my job to translate graphics into something a four-year-old can recognize."

Children, and artists, like to play by their own rules. To some extent, Pantuso, DiNapoli and Phillips are no different. Having been involved for so many years in entertaining and educating children, it is gratifying to discover that they remain genuinely excited about their subject. "This is the best job in the world. We love our work!" they exclaim. "You can not do better than this job in the television industry." It has to be that way, for a show to survive this amount of time and to be as progressive and entertaining and enlightening and still be here. Their delight is not forced or invoked. It is a testament to their enchantment with things that belong to the world of children. "When I arrived here I realized that the staff has the open-ended vision and wonderment of children. That's the reason the show works the way it does," recalls Phillips, his expression inviting agreement. "We're really forty or fifty-year-old people with the spirits of four- year-olds," DiNapoli adds with pride. Perhaps the key to Sesame Street's longevity is its refusal, like Peter Pan, to ever grow up.

Big Bird, Telly and the Sesame Street cast in masks for the video sequence on the letter M.

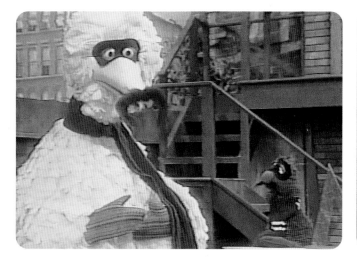 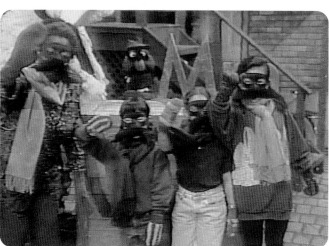

All photographs © Children's Television Workshop. Sesame Street Muppets © Jim Hensen Productions, Inc.

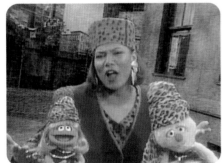
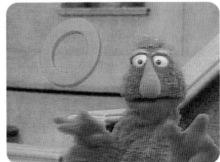
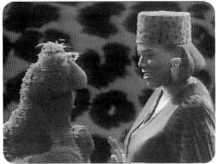

Queen Latifah is one of many
celebrities who join the Sesame
Street regulars to entertain and
educate.

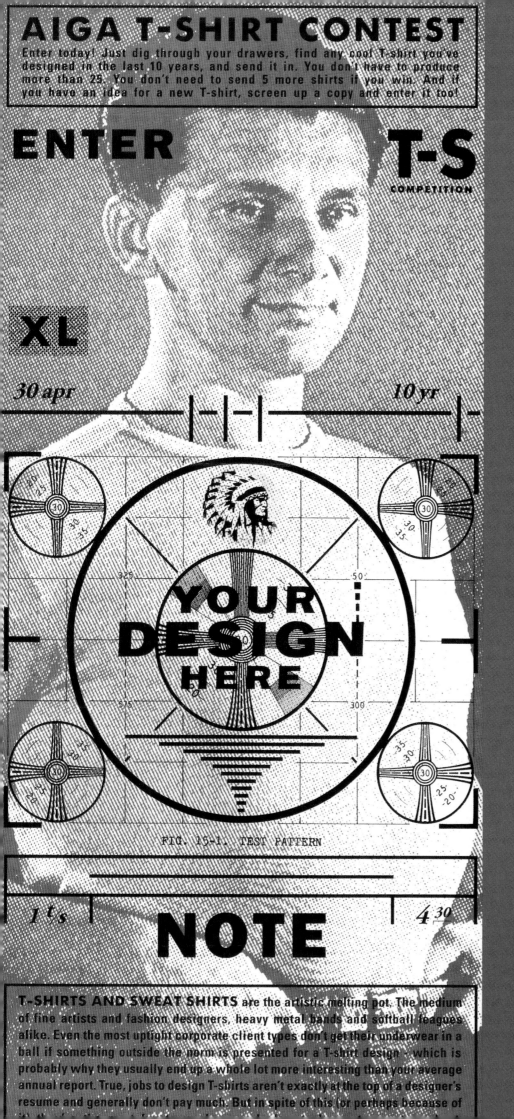

AIGA T-SHIRT CONTEST

Enter today! Just dig through your drawers, find any cool T-shirt you've designed in the last 10 years, and send it in. You don't have to produce more than 25. You don't need to send 5 more shirts if you win. And if you have an idea for a new T-shirt, screen up a copy and enter it too!

ENTER

T-S
COMPETITION

XL

30 apr

10 yr

YOUR
DESIGN
HERE

FIG. 15-1. TEST PATTERN

1 t's

4 30

NOTE

T-SHIRTS AND SWEAT SHIRTS are the artistic melting pot. The medium of fine artists and fashion designers, heavy metal bands and softball leagues alike. Even the most uptight corporate client types don't get their underwear in a ball if something outside the norm is presented for a T-shirt design – which is probably why they usually end up a whole lot more interesting than your average annual report. True, jobs to design T-shirts aren't exactly at the top of a designer's resume and generally don't pay much. But in spite of this (or perhaps because of

Tshirts and sweat shirts are the artistic melting pot. The medium of fine artists and fashion designers, heavy metal bands and softball leagues alike. Even the most uptight corporate client types don't get their underwear in a ball if something outside the norm is presented for a T-shirt design — which is probably why they usually end up a whole lot more interesting than your average annual report. True, jobs to design T-shirts aren't exactly at the top of a designer's resume and generally don't pay much. But in spite of this (or perhaps because of it) they're the most fun to work on and almost always turn out the best.

Charles Spencer Anderson, *Chairman*

The Tee Shirt Show

Jury

Charles S. Anderson (Chair)
Principal
Charles S. Anderson Design
Minneapolis, MN

Mark Fox
Principal
Blackdog Design
San Francisco, CA

Valerie Richardson
Partner/Designer
Richardson or Richardson
Phoenix, AZ

Janis Koy Porter
Owner/Designer
Koy Design, Inc.
Houston, TX

Jesse Reyes
Design Director
Harris Publications Guitar World
New York, NY

Matt Dorning
Designer
Matt Dorning Design
Birmingham, AL.

Call for Entries

Design Charles S. Anderson Design Co.
Paper French Parchtone, 65 lb. Cover, White
Printer Print Craft, Inc.

Title Buster's Bowl 1990
Designer/Illustrator Van Hayes
Design Firm Van Hayes Design, Dallas, TX
Client Buster Moore

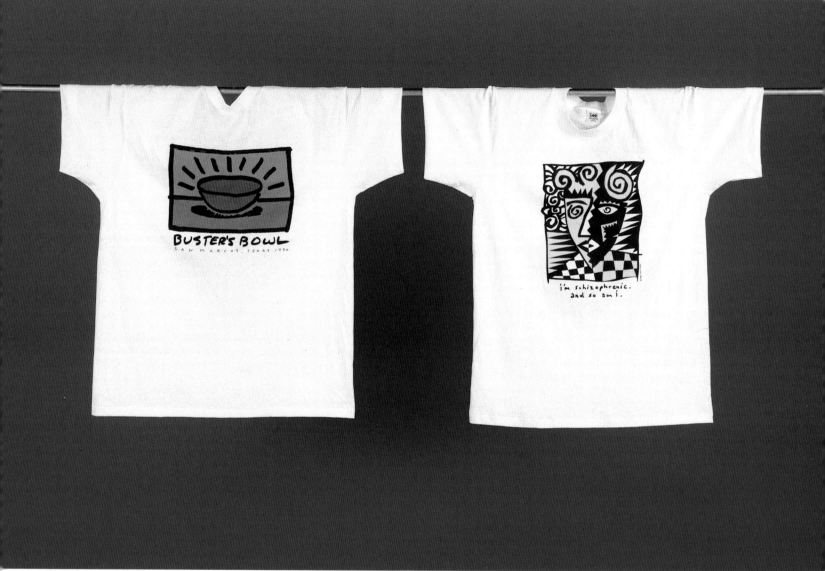

Title I'm Schizophrenic . . . And So Am I
Art Director/Designer/Illustrator John Evans
Design Firm John Evans Design, Dallas, TX

Title Michigan Humane Society
Art Director Amy Swita
Designers Stephen Schudlich, Jeannine Caesar
Illustrator Stephen Schudlich
Design Firm Stephen Schudlich Illustration + Design, Troy, MI
Agency W.B. Doner, Southfield, MI
Client The Michigan Humane Society

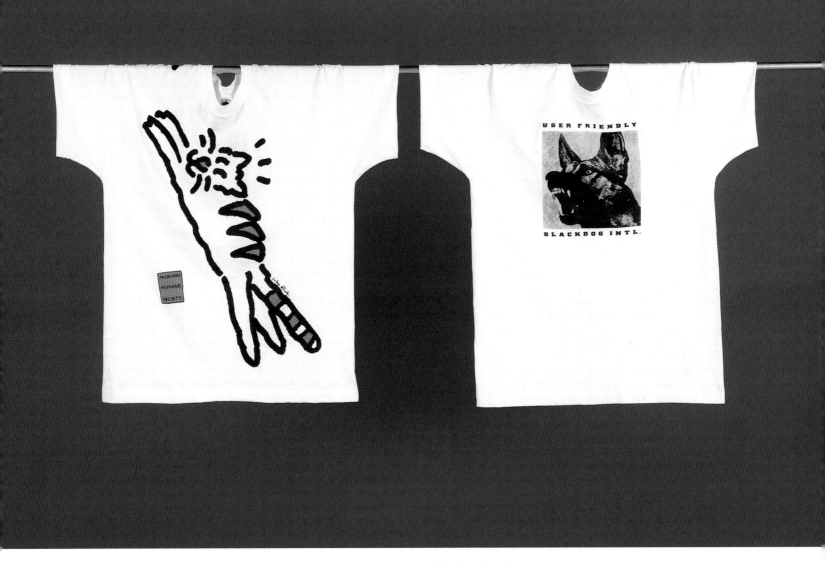

Title User Friendly
Designer Mark Fox
Design Firm/Client BlackDog, San Rafael, CA

Title "To Hell With Illustration"
Art Director Pam Sommers
Designer/Illustrator Steven Guarnaccia
Design Firm Studio Guarnaccia, New York, NY
Client The Illustration Gallery

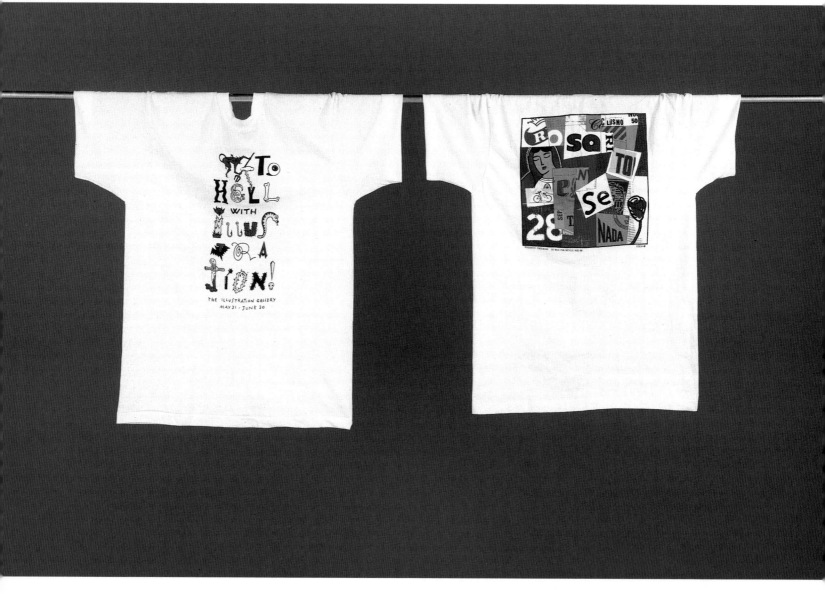

Title Rosarito to Ensenada, September 28
Designer/Illustrator Gerald Bustamante
Design Firm Studio Bustamante, San Diego, CA
Client Bicycling West, Inc.

Title "Some of My Best Friends Are Artists"
Designer Joe Miller
Design Firm Joe Miller's Company, San Jose, CA
Client Works Gallery

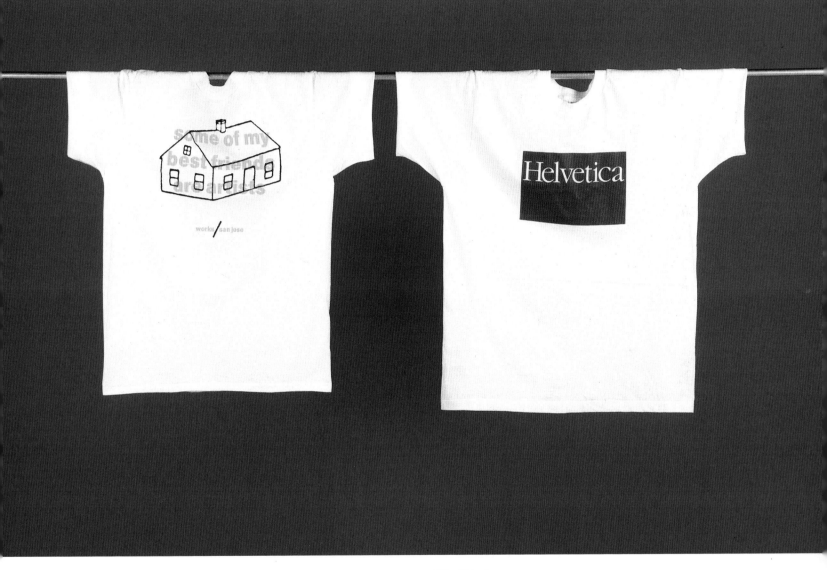

Title Helvetica
Art Director/Designer Jack Summerford
Design Firm Summerford Design, Inc., Dallas, TX
Client AIGA/Dallas

Title Glad-Nost
Art Director/Designer/Illustrator Samuel Kuo
Design Firm Kuo Design Group
Client Island Trading Co.

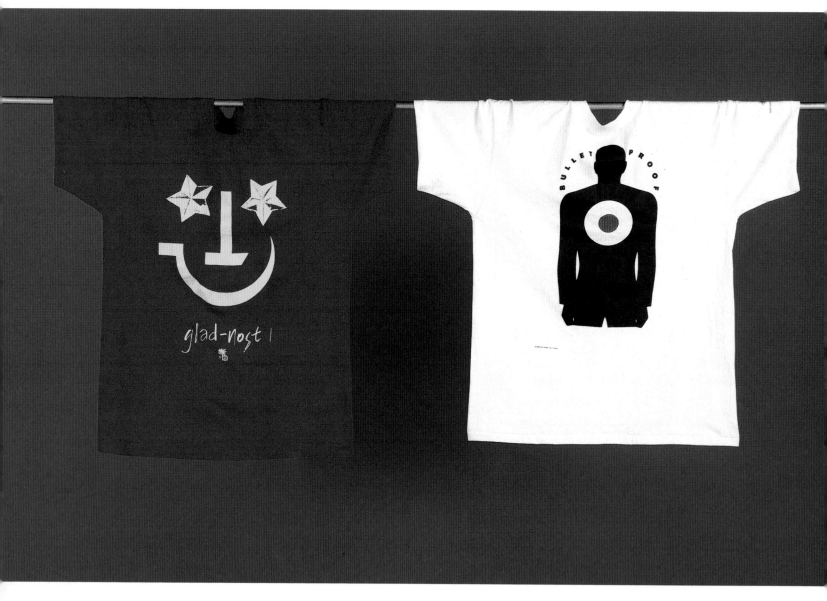

Title Target Man
Designer/Illustrator Tim Scott
Design Firm Bullet Communications, Inc., Chicago, IL
Client Bullet Brigade Dangerwear

Title No War
Art Director/Designer Mark Van S., Seattle, WA
Publisher Mark Van S.

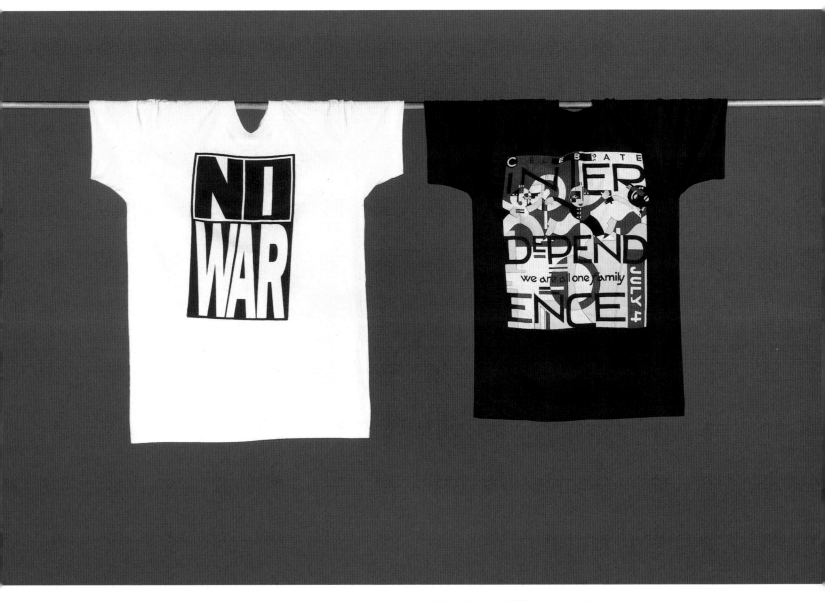

Title Celebrate INTERdependence July 4
Designer/Illustrator Mary Lynn Sheetz, Colorado Springs, CO
Client Alterni-T's
Printer Tayco Screen Printing

Title America3
Art Director Jeff Wertz
Designer John Dixon
Photographer Daniel Forster
Design Firm Winterland Productions, San Francisco, CA
Client America3 Foundation

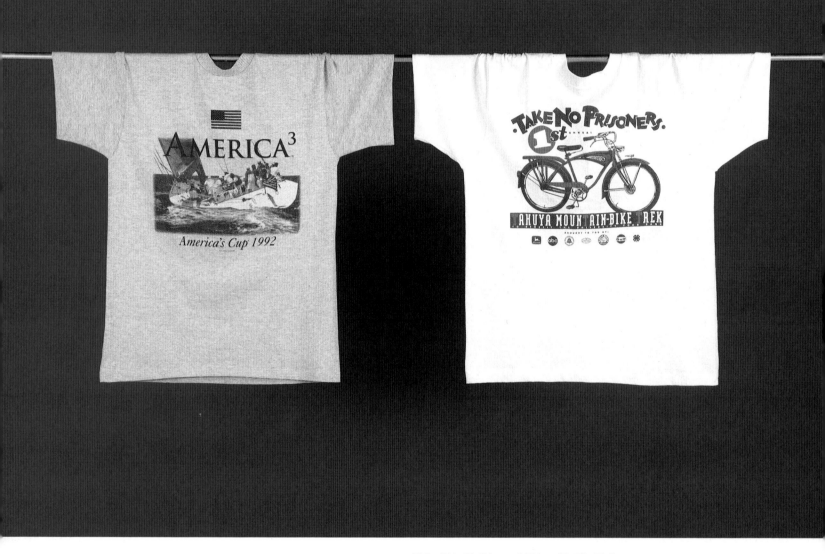

Title "Take No Prisoners"/Tahuya Mt. Bike Trek
Art Director/Designer Kory Davidson
Design Firm Ampersand And, Tacoma, WA
Client Tahuya Mt. Bike Trek

Title The Cult: Ceremonial Stomp
Art Director Sandra Horvat Vallely
Designer Troy Alders
Design Firm Winterland Productions, San Francisco, CA
Client The Cult

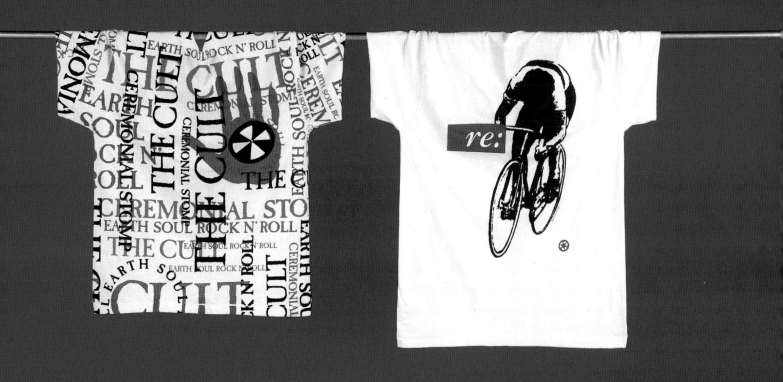

Title RE:Cycle
Designers Gail Rigelhaupt, Harris Silver
Design Firm Rigelhaupt Design, New York, NY
Publisher/Client Conscious Messages
Typography Macintosh
Printer Showplace

Title Armani 10014 Jeans Soho
Art Director/Designer Joe Duffy
Illustrator Neil Powell
Design Firm The Duffy Design Group, Minneapolis, MN
Client Giorgio Armani

Title Rupert's Atlanta
Art Director Haley Johnson
Illustrators Haley Johnson, Lynn Schulte
Design Firm The Duffy Design Group, Minneapolis, MN
Client Rupert's Nightclub

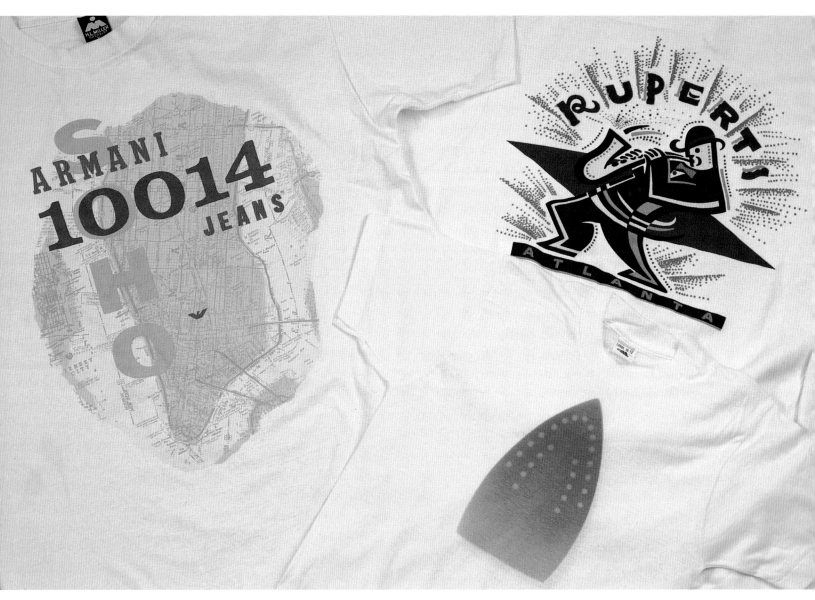

Title Scorch
Designers Liz Throop, Joy Wasson
Design Firm Liz Throop Graphic Design, Atlanta, GA
Client Art Papers

Title Armani 10014 Jeans
Art Directors Sharon Werner, Todd Waterbury
Designers Todd Waterbury, Sharon Werner
Illustrator Todd Waterbury
Design Firm The Duffy Design Group, Minneapolis, MN
Client Giorgio Armani

Title Schaffer's
Art Director/Designer John Sayles
Design Firm Sayles Graphic Design, Des Moines, IA
Client Schaffer's

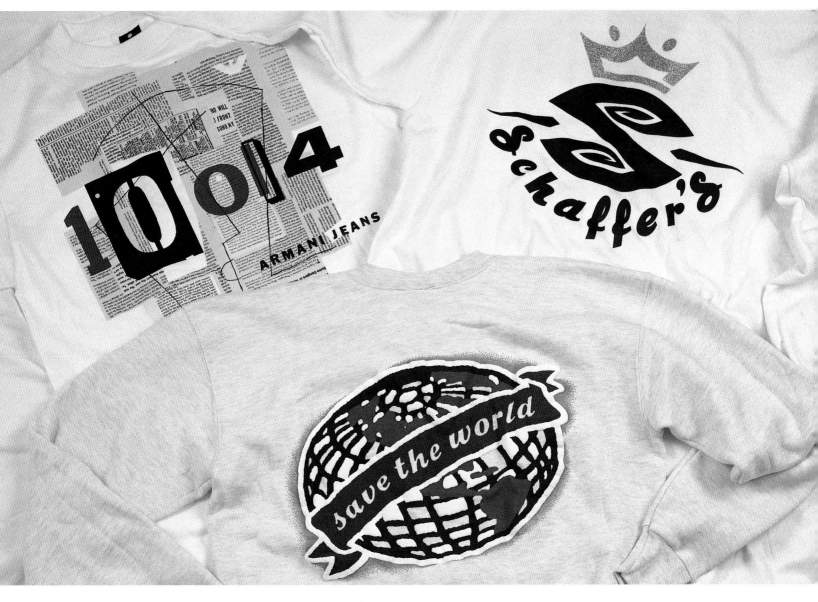

Title Save the World
Art Directors Daniel Olson, Charles S. Anderson
Designers Charles S. Anderson, Daniel Olson
Design Firm Charles S. Anderson Design Co., Minneapolis, MN
Client Cabell Harris, Spy Magazine

Title Pure Fresh Milk
Art Director Kory Davidson
Designers Kory Davidson, Dorik Downing
Design Firm Ampersand And, Tacoma, WA

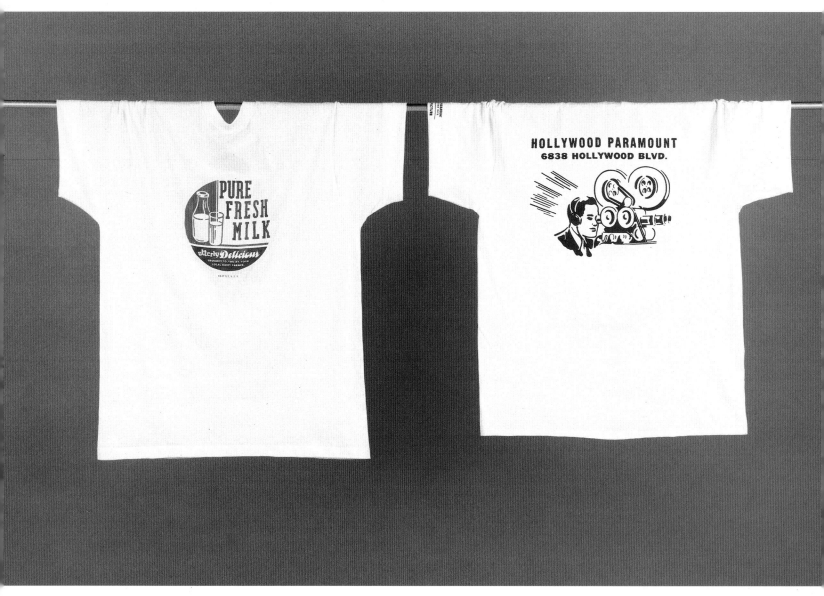

Title Hollywood Paramount
Art Directors Charles S. Anderson, Daniel Olson
Designers Daniel Olson, Charles S. Anderson
Design Firm Charles S. Anderson Design Co., Minneapolis, MN
Client Hollywood Paramount Products

Title Universal Grill
Art Director Tana Kamine
Designer Scott Frommer
Design Firm Tana & Co., New York, NY
Client Universal Grill Restaurant

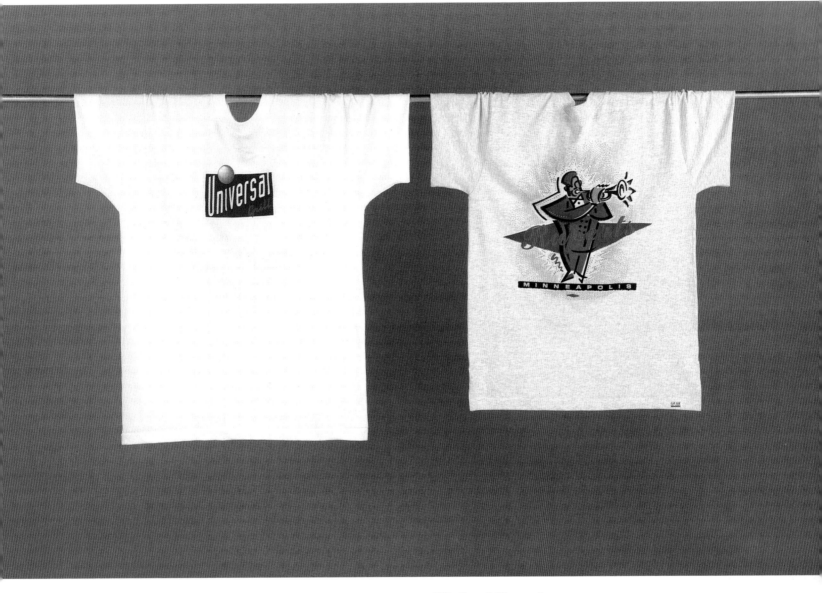

Title Rupert's Minneapolis
Art Director/Designer Haley Johnson
Illustrators Haley Johnson, Lynn Schulte
Design Firm The Duffy Design Group, Minneapolis, MN
Client Rupert's Nightclub

Title Italia
Art Directors/Designers Jack Anderson, Julia LaPine
Illustrators Julia LaPine, David Bates
Design Firm Hornall Anderson Design Works, Seattle, WA
Client Italia

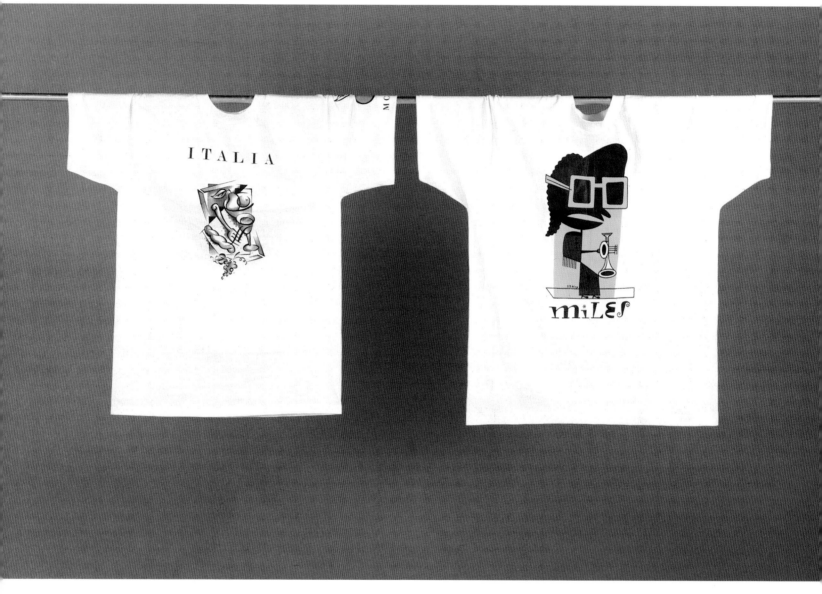

Title Miles
Designer/Illustrator J.D. King, Brooklyn, NY
Client Downtown Music Gallery

Title The Art Directors Club of Denver
Designer/Illustrator Seymour Chwast
Design Firm The Pushpin Group, Inc., New York, NY
Client The Art Directors Club of Denver

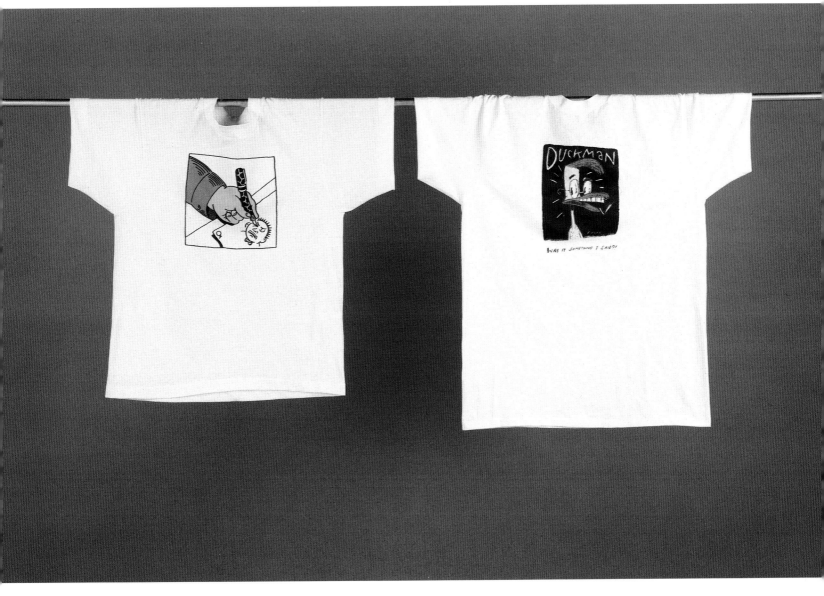

Title Duckman: "Was It Something I Said?"
Designer/Illustrator Everett Peck, San Francisco, CA
Client Dark Horse Comics, Inc.
Publisher Mike Richardson

Title Elvis
Art Director Sandra Horvat Vallely
Designer Bryan Berry
Design Firm Winterland Productions, San Francisco, CA
Client Graceland

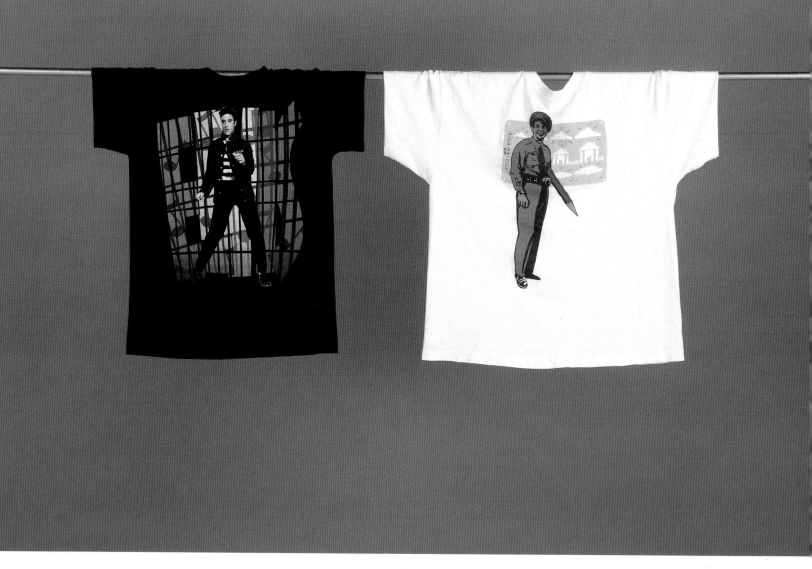

Title AIGA/Raleigh
Art Directors Todd Coats, Douglass Grimmett, Pat Short
Designers/Illustrators Todd Coats, Patrick Short
Design Firm Space Time Design, Chapel Hill, NC
Client AIGA/Raleigh

Title Z-Rock/"If You're Not Crankin' It, You Must Be Yankin' It!"
Art Director/Designer Art Chantry
Design Firm Art Chantry Design, Seattle, WA
Client Z-Rock

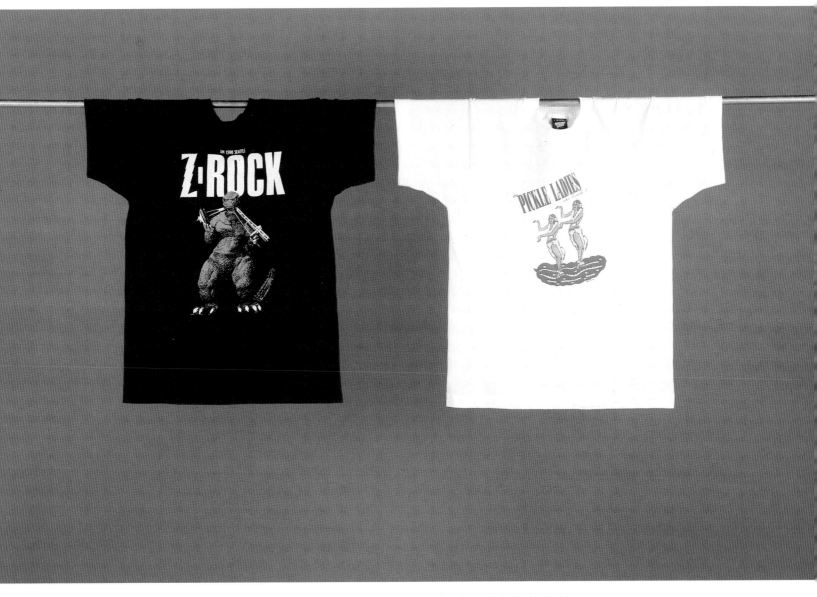

Title The Pickle Ladies Are Back!
Art Director/Designer Judy Seckler
Design Firm SEC Design and Illustration, Studio City, CA
Client Women's Community Service Organization

Title Levi's
Art Director/Designer Sandra Horvat Vallely
Photographer Mindy Manville
Design Firm Winterland Productions, San Francisco, CA
Client Levi Strauss & Co.

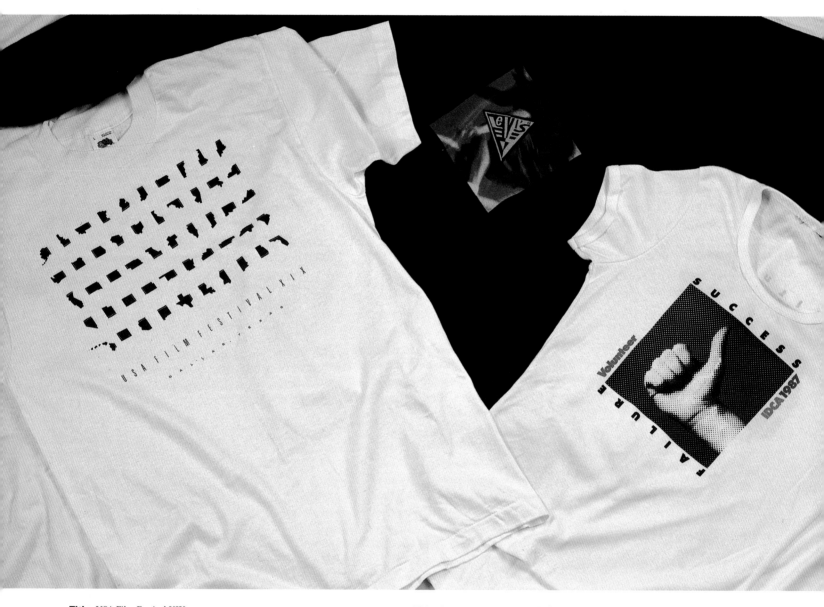

Title USA Film Festival XIX
Art Director/Designer Kenny Garrison
Design Firm RBMM/The Richards Group, Dallas, TX
Client USA Film Festival/Dallas

Title Success/Failure/IDCA 1987
Designer Michael Bierut
Photographer Reven T. C. Wurman
Design Firm Pentagram, New York, NY
Client The International Design Conference at Aspen

Title Roughing It/Design Camp 1991
Art Director Thea Tulloss
Illustrator Lynn Tanaka
Design Firm Tulloss Design, Minneapolis, MN
Client AIGA/Minneapolis

Title Levi's "No Sweat"
Art Director Dennis Crowe
Designer/Illustrator John Pappas
Design Firm Zimmerman Crowe Design, San Francisco, CA
Client Levi Strauss & Co.

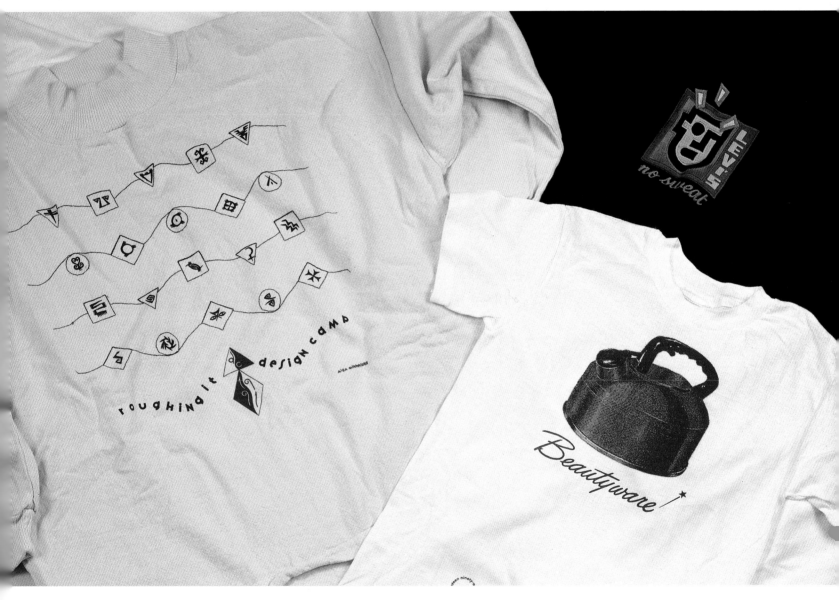

Title Beautyware
Art Director Jane Tilka
Designers Jane Tilka, Ann Elliot Artz Hadland, Bruce Macindoe
Design Firm/Client Tilka Design, Minneapolis, MN

Title No Evil
Illustrator Carl Smool, Seattle, WA

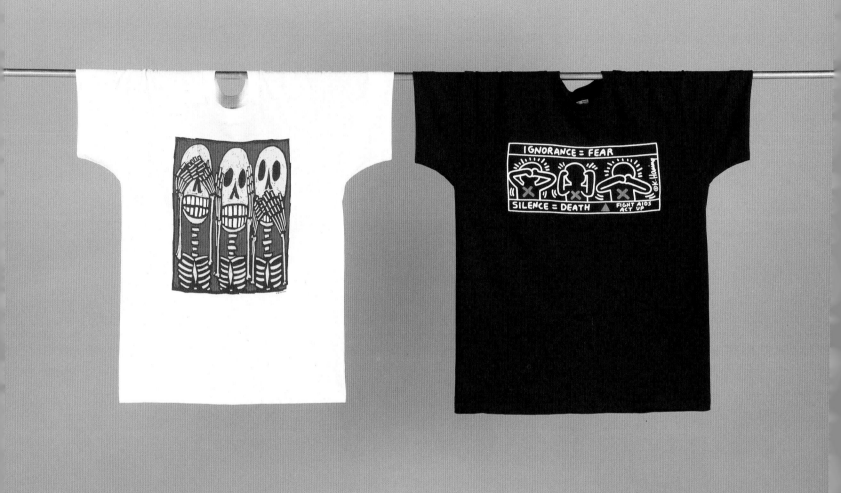

Title Ignorance = Fear
Illustrator Keith Haring
Client ACT UP

Title Quicksand
Art Director/Illustrator Melinda Beck, Brooklyn, NY

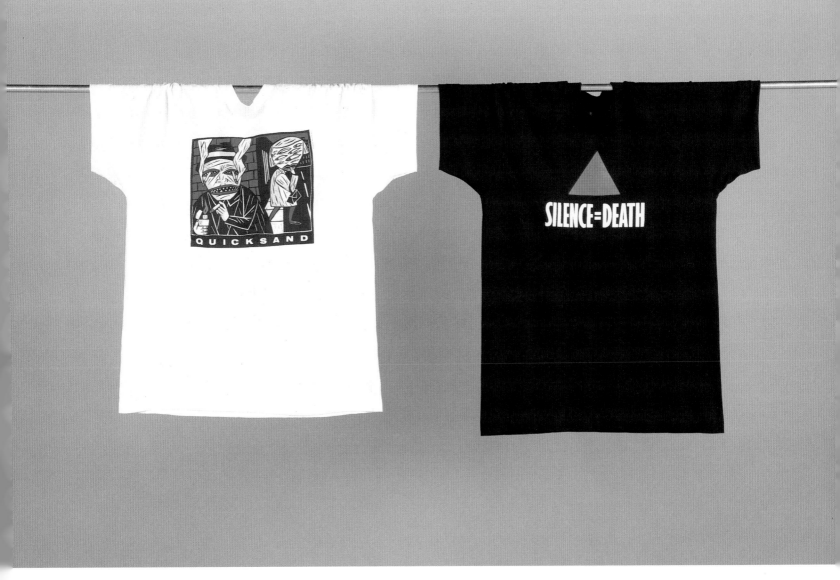

Title Silence = Death
Designers Silence = Death Project
Client ACT UP

Title The Dead Can't Surf
Art Director/Designer Art Chantry
Design Firm Art Chantry Design, Seattle, WA
Client Post Industrial Stress + Design

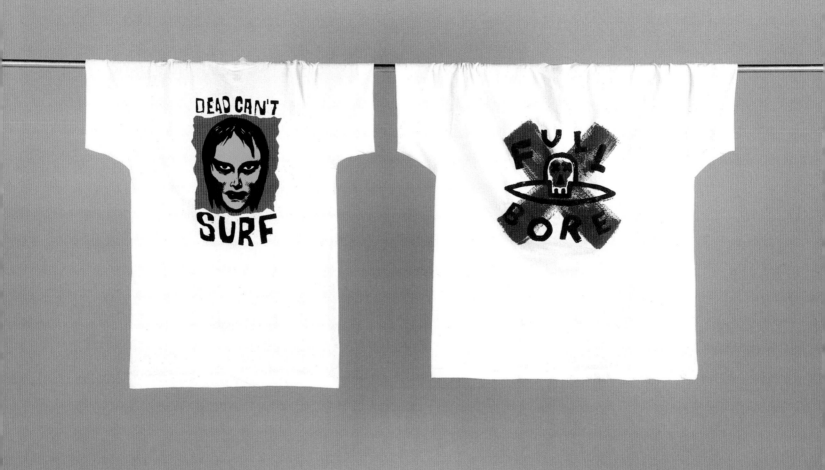

Title Full Bore
Art Director Scott Mires
Designers Scott Mires, Gerald Bustamente
Illustrator Gerald Bustamente
Design Firm Mires Design, Inc., San Diego, CA
Client Full Bore Surf Shop

Title "10-S Anyone?"
Art Director/Designer/Illustrator Steven Guarnaccia
Design Firm Studio Guarnaccia, New York, NY
Client 10-S

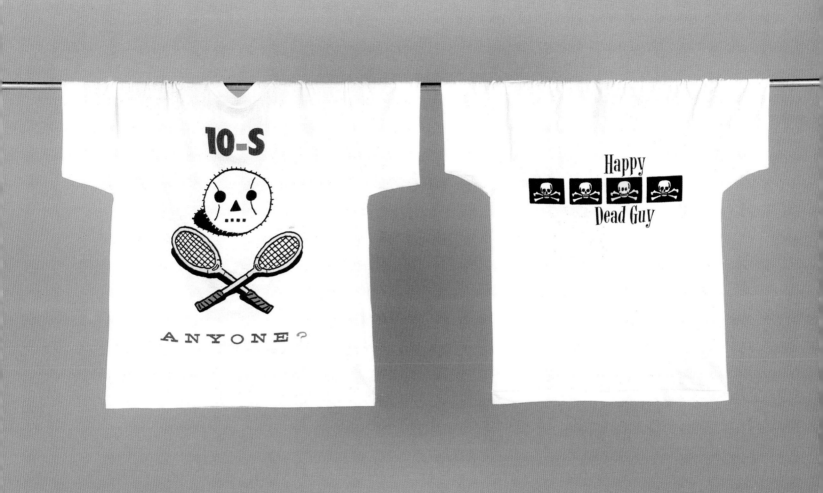

Title Happy Dead Guy
Art Director/Designer Art Chantry
Design Firm Art Chantry Design, Seattle, WA
Client Post Industrial Stress + Design

Title Fifth Annual Boy's Weekend
Art Director/Designer John Pappas
Design Firm Zimmerman Crowe Design, San Francisco, CA
Client The Kit Foundation

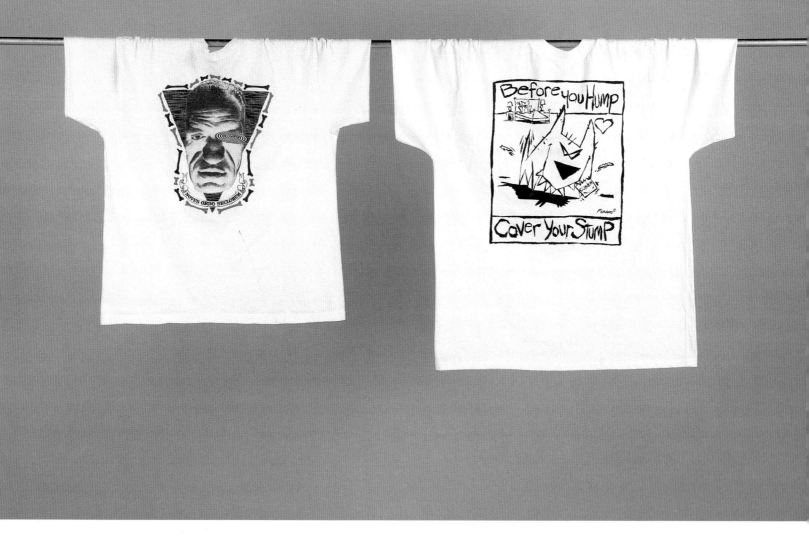

Title Before You Hump, Cover Your Stump
Illustrator Darrell Fusaro, Little Falls, NJ

Title Hired Gun
Art Director Dan Lloyd Taylor
Illustrator Mark Falls
Design Firm Tonal Values, Miami Beach, FL
Client Leisure America Productions

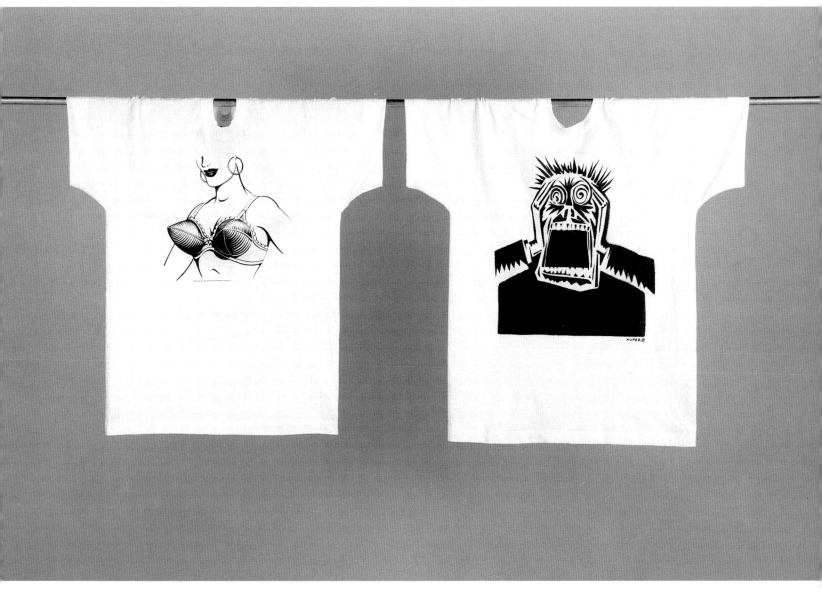

Title ACT UP/AIDS
Art Director/Designer/Illustrator Peter Kuper, New York, NY

Title Richard Reens
Art Director/Designer/Illustrator Luis D. Acevedo
Design Firm RBMM/The Richards Group, Dallas, TX
Client Richard Reens Photography

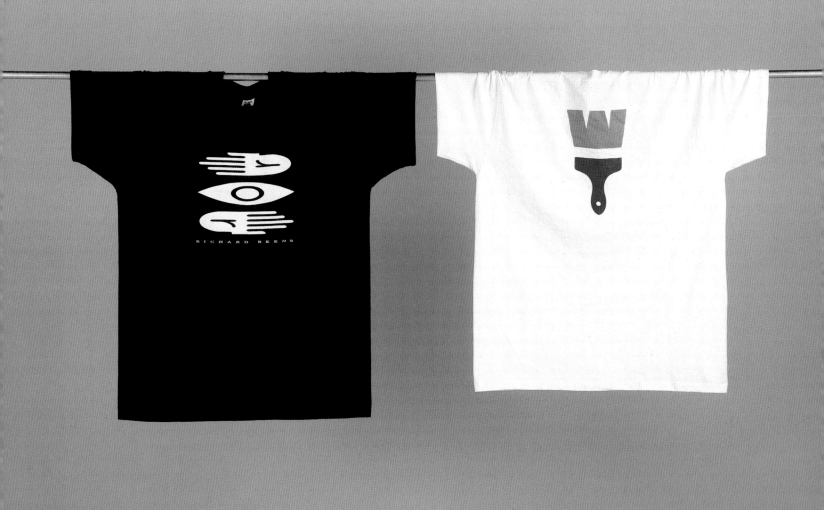

Title Willis Painting
Art Director/Designer D.C. Stipp
Design Firm RBMM/The Richards Group, Dallas, TX
Client Willis Painting Contractors

Title "Copy? We Don't Need No Stinkin' Copy!"
Art Director/Designer/Illustrator William Homan
Design Firm/Client John Ryan Co., Minneapolis, MN

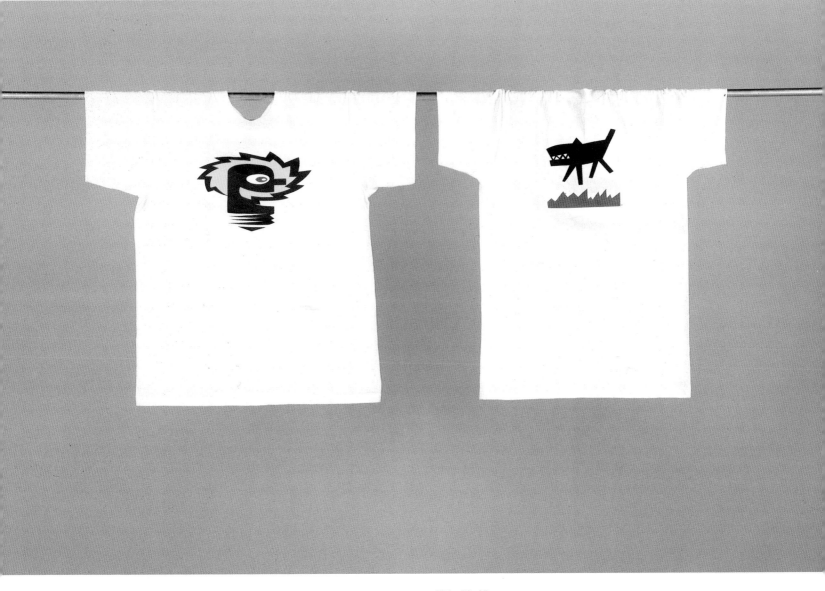

Title BlackDog
Designer/Illustrator Mark Fox
Design Firm/Client BlackDog, San Rafael, CA

Title Jingle Bell
Art Director Doug Wolfe
Designers John Howze, Bob Prow, Dave Holt
Design Firm Hawthorne/Wolfe Inc., St. Louis, MO
Client Southwestern Bell Corp.

Title Asian, Black, Hispanic...and Any Mix of These
Art Director/Designer Mene Santana
Design Firm Manville Bakacs Santana, New York, NY

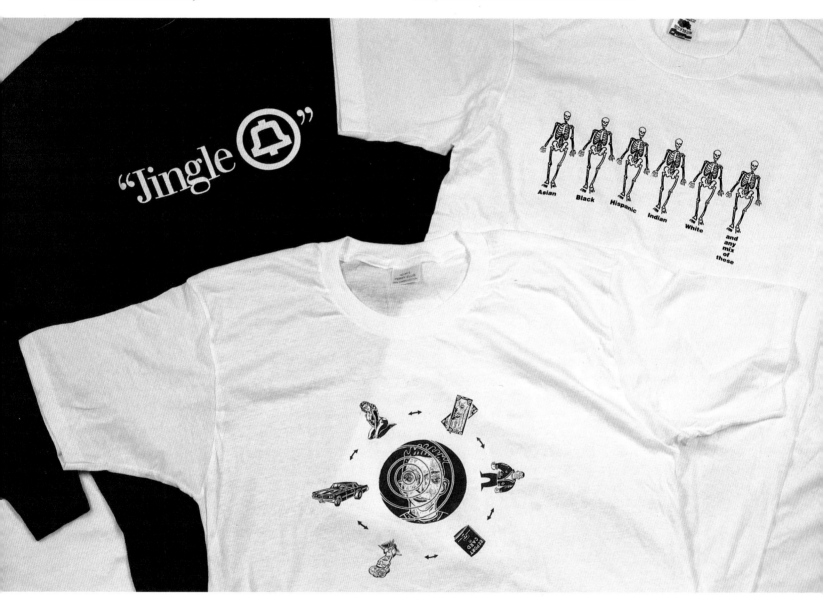

Title Pressure
Art Director/Designer/Illustrator Geoffrey Grahn, Culver City, CA
Client Geoffrey Grahn

Title 2nd Annual Summer Design Conference, Los Gaviatos, Mexico
Art Directors Sergio Bravo, Dwight Smith
Illustrator K.J. Bowen
Design Firm Smith Smith & Smith, Hermosa Beach, CA

Title Bush
Art Director/Designer Charles A. Hamilton
Design Firm Charles A. Hamilton Design, New York, NY

Title T.G.I.Friday's Bartender Olympics '86
Art Director/Designer Kenny Garrison
Design Firm RBMM/The Richards Group, Dallas, TX
Client T.G.I. Friday's

Title Mambo Truck Engines
Art Director Dare Jennings
Designer Wayne Golding
Illustrator Reg Mombassa
Design Firm Tonal Values, Miami Beach, FL

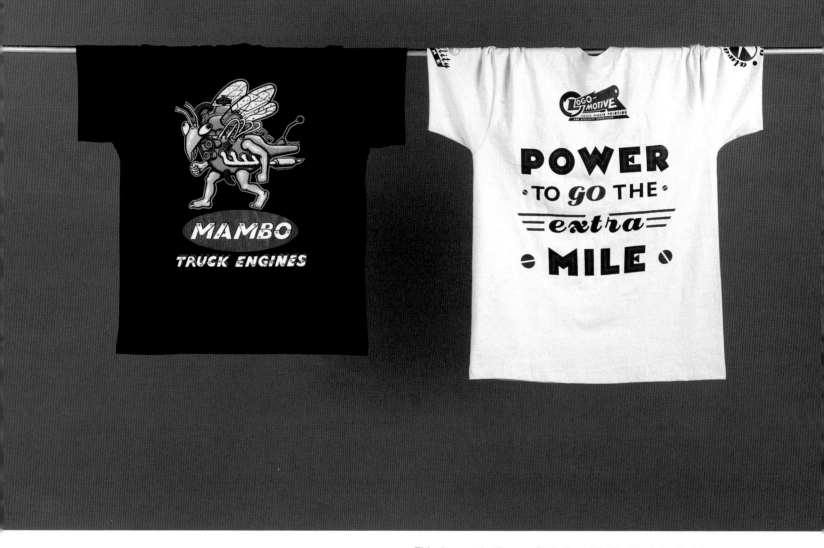

Title Logo-motive: Power to Go the Extra Mile/You Won't Pay the Caboose
Art Director/Designer John Sayles
Design Firm Sayles Graphic Design, Des Moines, IA
Client Logo-motive

Title Beaverdale
Art Director/Designer John Sayles
Design Firm Sayles Graphic Design, Des Moines, IA
Client Art to Wear

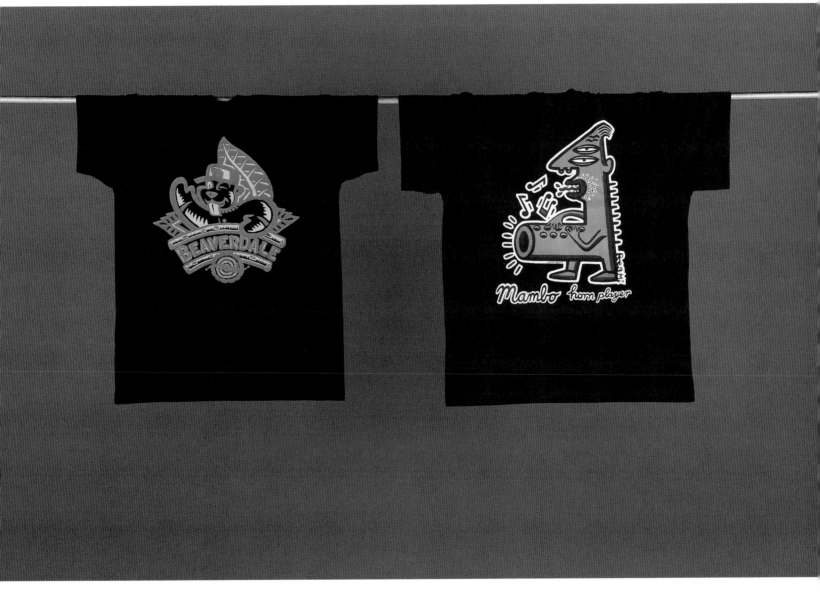

Title Mambo Horn Player
Art Director Dare Jennings
Designer Wayne Golding
Illustrator Reg Mombassa
Design Firm Tonal Values, Miami Beach, FL
Client 100% Mambo

Title International Consultants of the Environment
Designer/Illustrator Renee Nyahay
Design Firm R. Bird & Co., White Plains, NY
Client International Consultants of the Environment

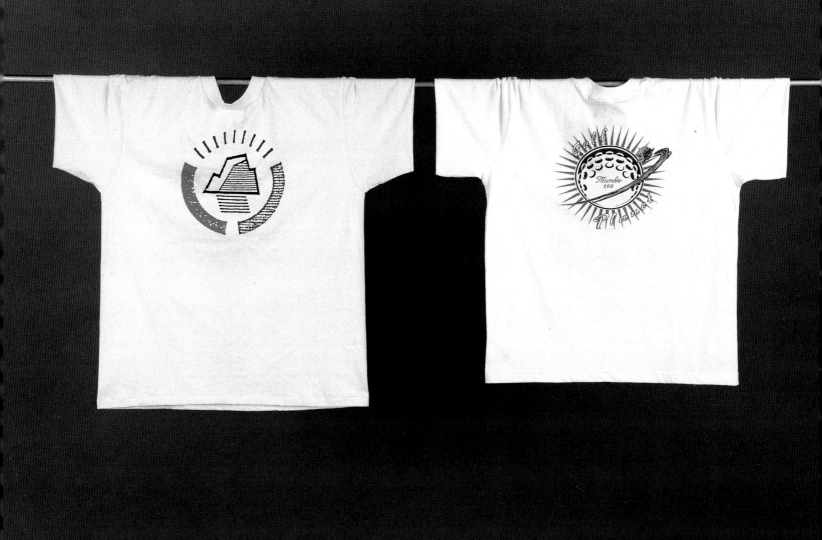

Title Golf Planet/Mambo 100
Art Director Dare Jennings
Designer Wayne Golding
Illustrator Mark Falls
Design Firm Tonal Values, Miami Beach, FL
Client 100% Mambo

Title Habitat Urban Conference
Art Director Joe Rattan
Designers Joe Rattan, Greg Morgan
Illustrator Greg Moran
Design Firm Joseph Rattan Design, Dallas, TX
Client Habitat For Humanity

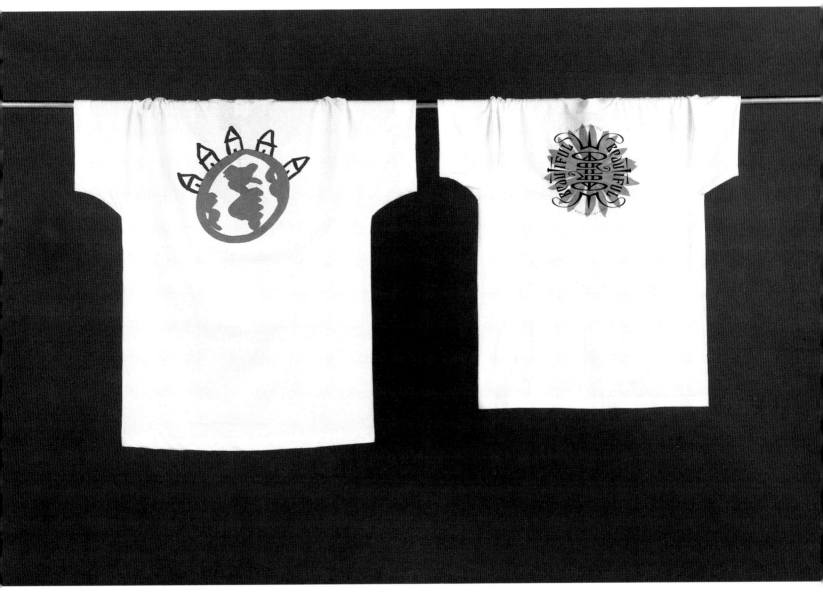

Title Beautiful World
Art Director Margo Chase
Design Firm/Client Margo Chase Design, Los Angeles, CA

Title "Cool Cats"
Art Director/Designer/Illustrator Gary Baseman, Brooklyn, NY
Client The Illustration Gallery

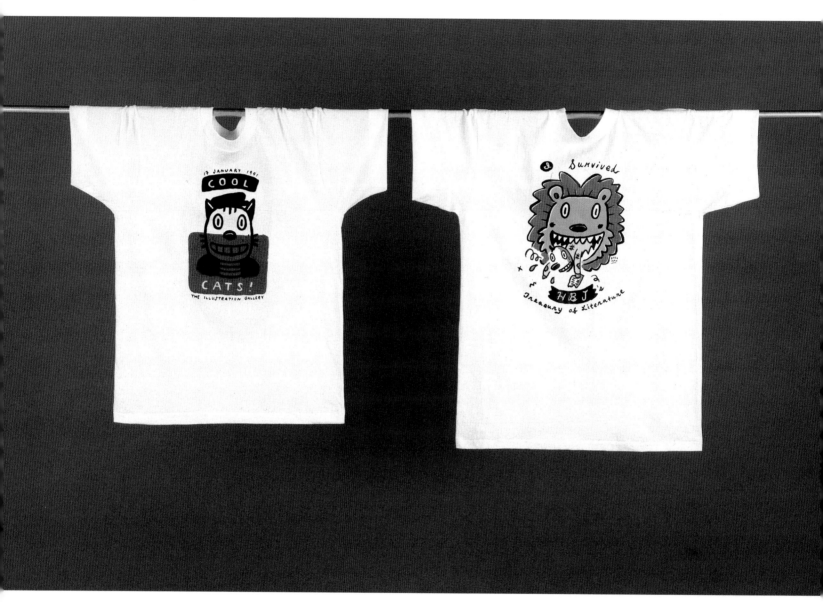

Title I Survived HBJ's Treasury of Literature
Art Director Scott Mires
Designers Scott Mires, Gary Baseman
Illustrator Gary Baseman
Design Firm/Client Mires Design, Inc., San Diego, CA

Title The Illustrated Dog X
Art Director/Designer/Illustrator Gary Baseman, Brooklyn, NY
Client The Illustration Gallery

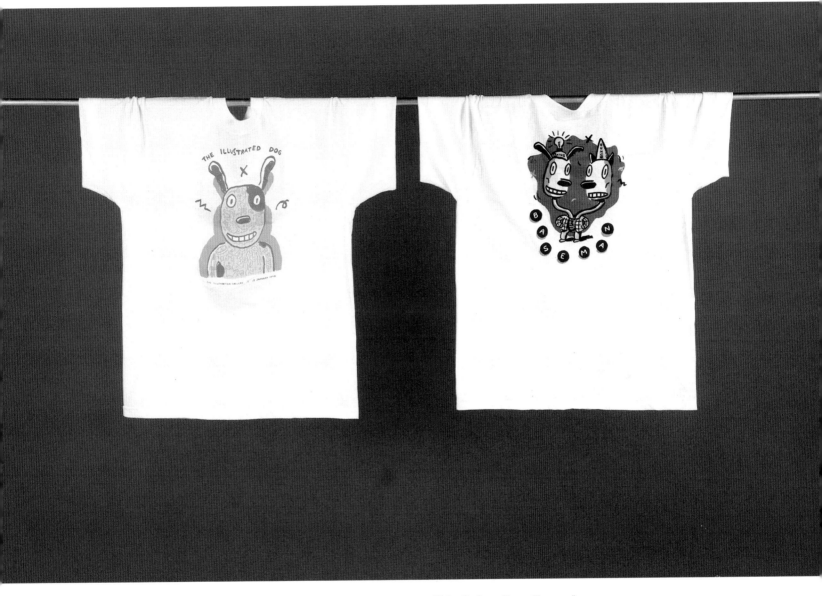

Title Genius — Dunce "Baseman"
Art Director/Designer/Illustrator Gary Baseman, Brooklyn, NY
Client Gary Baseman

Title Chaps/Ralph Lauren
Art Director/Designer Joe Duffy
Illustrators Joe Duffy, Lynn Schulte
Design Firm The Duffy Design Group, Minneapolis, MN
Client Chaps/Ralph Lauren

Title "Don't Panic"/ESPRIT
Art Director/Designer/Illustrator Gary Baseman, Brooklyn, NY
Client Esprit de Corp

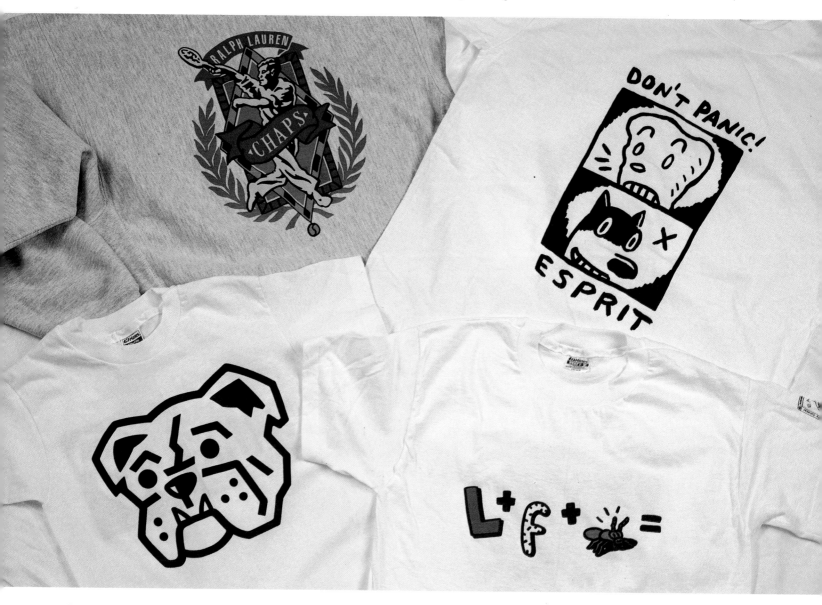

Title Ballard Pride
Art Directors Daniel Olson, Charles S. Anderson
Designers Charles S. Anderson, Daniel Olson
Illustrator Randall Dahlk
Design Firm Charles S. Anderson Design Co., Minneapolis, MN
Client Jerry French

Title L+F+Ant=Elephant
Art Directors Mary Bush, Karen Wiand
Designer/Illustrator Stephen Schudlich
Design Firm Stephen Schudlich Illustration + Design, Troy, MI
Client Earthkids: Earth Friendly Funwear

Title Buckeye Roadhouse
Art Director Bill Higgins
Designer/Illustrator Mark Fox
Design Firm BlackDog, San Rafael, CA
Client Real Restaurants

Title Kamp Po-Ka-Wa-Tha
Art Director/Designer Steve Liska
Illustrator B.J. Johnson
Design Firm Liska and Associates, Inc., Chicago, IL
Client Kamp Po-Ka-Wa-Tha

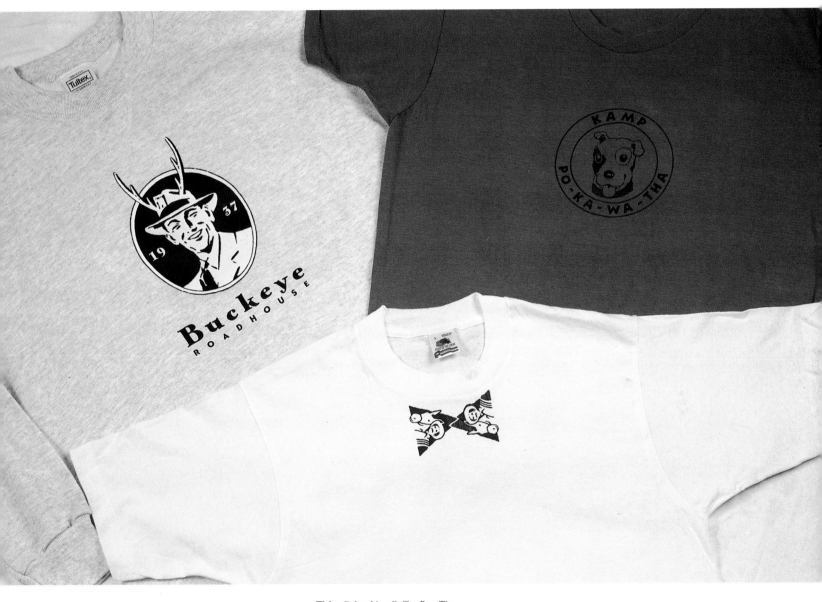

Title Columbian Coffee Bow-Tie
Art Director/Designer Sharon Occhipinti, New York, NY
Design Firm DDB Needham, New York, NY
Client Columbian Coffee

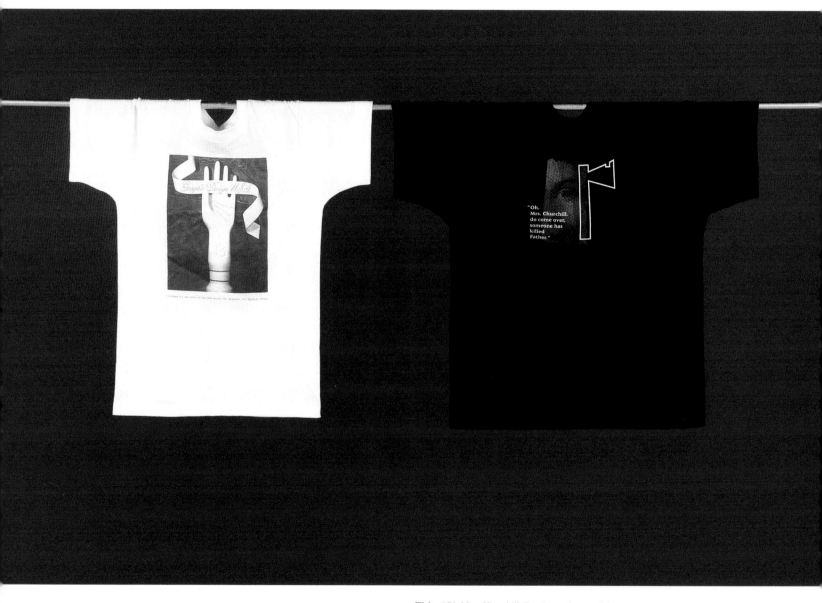

Title Graphic Design USA:13
Art Director/Designer Louise Fili
Photographer David Barry
Design Firm Louise Fili Ltd., New York, NY

Title "Oh Mrs. Churchill, Do Come Over . . ."/
John Giffin's Fall River Follies Coming March '92
Art Director/Designer Oscar Fernández
Design Firm Wexner Center Design Department
Client Wexner Center for the Arts/Fall River Follies

Title UV03/Ozone
Art Director Julie Koch-Beinke
Designers Julie Koch-Beinke, Barbara Kimball-Walker
Design Firm/Client Alternatives, New York, NY

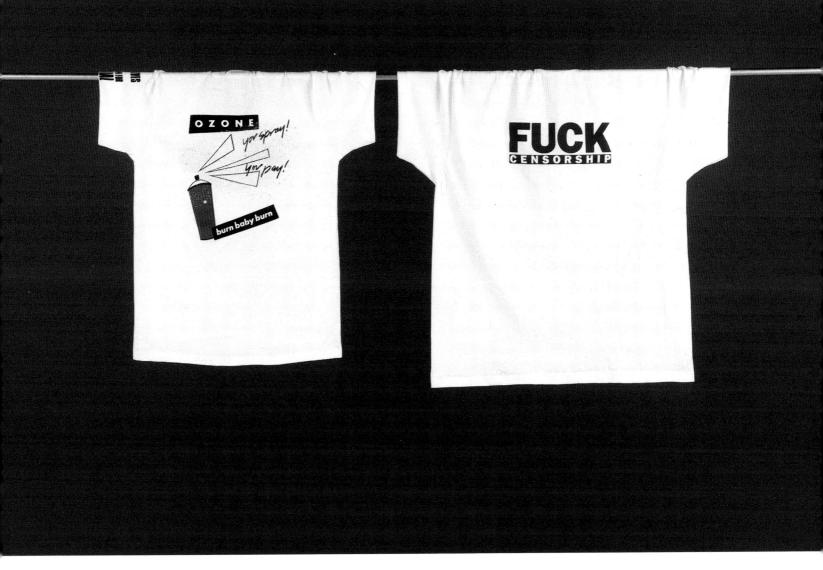

Title Fuck Censorship
Art Director/Designer Gunnar Swanson
Design Firm/Client Gunnar Swanson Design Office, Venice, CA

20
Title Mudhoney
Art Director/Designer Art Chantry
Design Firm Art Chantry Design, Seattle, WA
Client Art Institute of Seattle

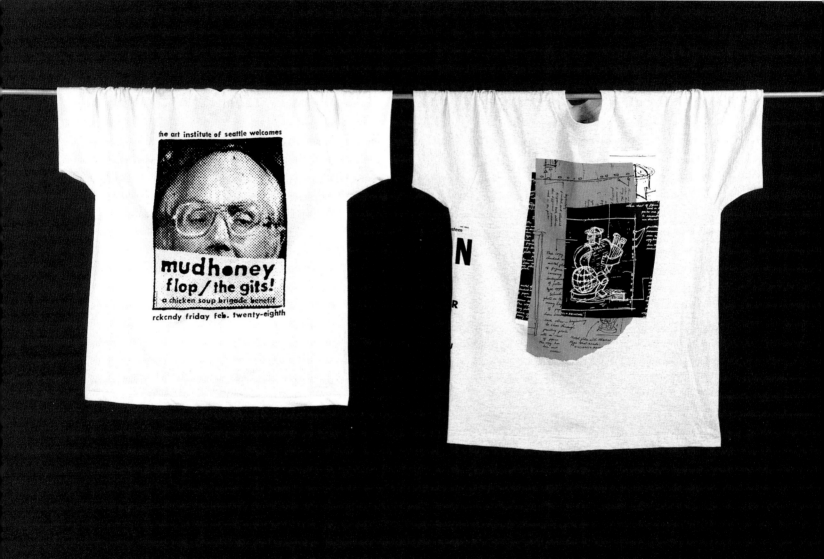

Title Williamson Printing Corp.
Art Directors Sharon Werner, Todd Waterbury
Designers Toddy Waterbury, Sharon Werner
Photographer Geof Kern
Design Firm The Duffy Design Group, Minneapolis, MN
Client Williamson Printing Corp.

Title FPG: Exceptional Stock Photography
Art Directors Jessica Brackman, Eric Savage
Illustration Anonymous
Design Firm Eric Savage Design, New York, NY
Client FPG International

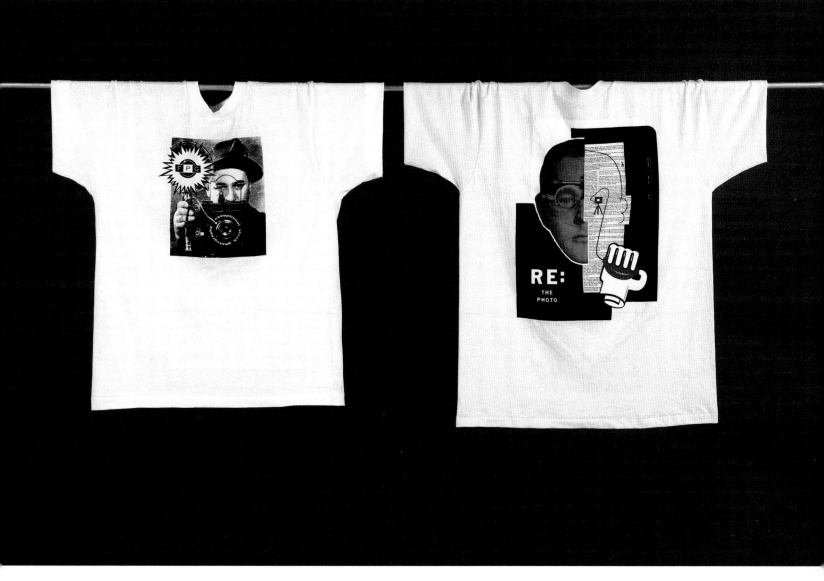

Title RE: The Photo
Art Director Todd Waterbury
Designers Toddy Waterbury, Sharon Werner
Design Firm The Duffy Design Group, Minneapolis, MN
Client Fox River Paper Company

Title The Peter Joseph Gallery Presents the Fifth Annual Second Stage
All-Star Bowling Classic/Hamlet Contemplating a 7-10 Split
Designer Michael Bierut
Illustrator Milton Glaser
Design Firm Pentagram, New York, NY
Client Second Stage Theatre

Title Charivari: Never Coming to a Mall Near You
Design/Client Charivari, New York, NY

Title Pez On Earth, Good Will Toward Men
Art Director/Designer/Illustrator Michael R. Hilker
Design Firm/Client Iconographic Communications, Falls Church, VA

Title Prana . . .
Art Director/Designer/Illustrator Lael Robertson
Design Firm DBA Homefries, San Francisco, CA
Client Prana Investments

THE AIGA

Call for Entries

ONE-COLOR & TWO-COLOR

Deadline: August 14, 1992

COMPETITION

Having a small budget is no excuse for not creating an effective design. When the budget's tight, you've got to try a little harder; you have to rely more on having a good idea.

In judging this competition, we were looking for smart, innovative, and resourceful design that succeeded in spite of — and perhaps because of — budgetary and production limitations. We looked for thoughtfulness, not flashiness.

This work shows how good design can succeed in the face of even the most gruesome of budgetary deficiencies. And how true it is that simpler is often better anyway.

Alexander Isley, *Chairman*

Jurors

Alexander Isley (Chair)
Principal
Alexander Isley Design
New York, NY

Margo Chase
Principal
Margo Chase Design
Los Angeles, CA

Thomas Ryan
Principal
Thomas Ryan Design
Nashville, TN

Lori Siebert
Principal
Siebert Design Associates, Inc.
Cincinnati, OH

Michael Vanderbyl
Principal
Vanderbyl Design
San Francisco, CA

Call for Entries

Design Alexander Isley Design
Illustration Nathan Gluck
Paper Mohawk P/C (10% postconsumer waste content), Colonial White

1

Poster 29th Annual Bird Calling Contest
Art Director David Bartels
Designer Brian Barclay
Photographer Tom Ryan
Design Firm Bartels & Company, Inc., St. Louis, MO
Client Leonard J. Waxdeck, Piedmont H.S.
Hand Lettering Brian Barclay
Printer Ultra Color

2

Brochure Conservationists for Educational Television
Art Director Ron Sullivan
Designer/Illustrator Dan Richards
Design Firm Sullivan Perkins, Dallas, TX
Client Conservationists for Educational Television
Typography Sullivan Perkins
Printer Monarch Press, Inc.

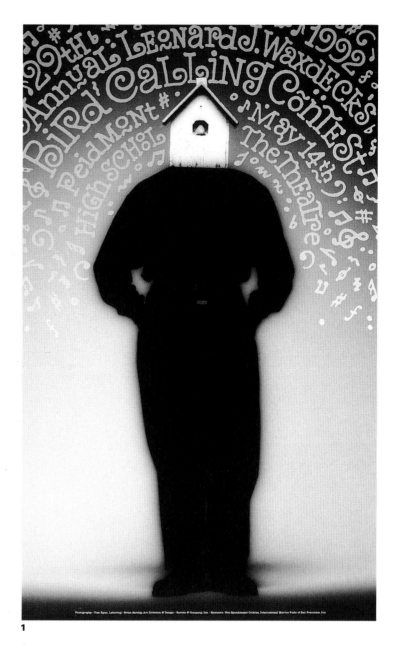

1

2

3

4

3
Brochure Tape Critters Series
Art Director/Designer Craig Frazier
Illustrator Craig Frazier
Design Firm Frazier Design, San Francisco, CA
Client Watermark Press
Typography Typewriter
Printer Watermark Press
Paper Manufacturer French Paper Company

4
Poster For the Birds
Art Director Steve Pattee
Designers Steve Pattee, Kelly Stiles
Design Firm Pattee Design, Des Moines, IA
Client Orchard Place
Typography Macintosh
Paper Manufacturer Gilbert Paper Company

1

1

Shirt Box Schaffer's Tuxedo Express
Art Director John Sayles
Illustrator John Sayles
Design Firm Sayles Graphic Design, Des Moines, IA
Typographer John Sayles
Printer Image Maker
Paper Manufacturer James River Paper Corporation

2

Desk Calendar Simpson 1992/On Time
Art Director/Designer Michael Bierut
Illustrator Michael Bierut
Design Firm Pentagram Design, New York, NY
Typographer Typogram
Printer Diversified Graphics
Paper Manufacturer Simpson Paper Company

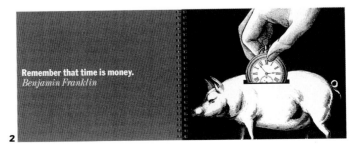

Remember that time is money.
Benjamin Franklin

2

3
Self Promotion Guarnacchino
Art Director/Designer Steven Guarnaccia
Illustrator Steven Guarnaccia
Design Firm Steven Guarnaccia, New York, NY
Printer Kader Lithographers

4
Stationery Polite Design
Designer Kerry Polite
Design Firm Polite Design, Philadelphia, PA
Printer Kalnin Graphics
Paper Manufacturer Cartier Fedrigoni

3

Guarnacchino

4

Polite Design

Polite Design

Cristina Minervini

Graphic Design

Twenty One Sixteen
Locust Street

Philadelphia,
Pennsylvania 19103

Telephone
(215) 985.4818

Facsimile
(215) 985.9402

Twenty One Sixteen
Locust Street

Philadelphia,
Pennsylvania 19103

Telephone
(215) 985.4818

Polite Design Graphic Design

Polite Design Graphic Design

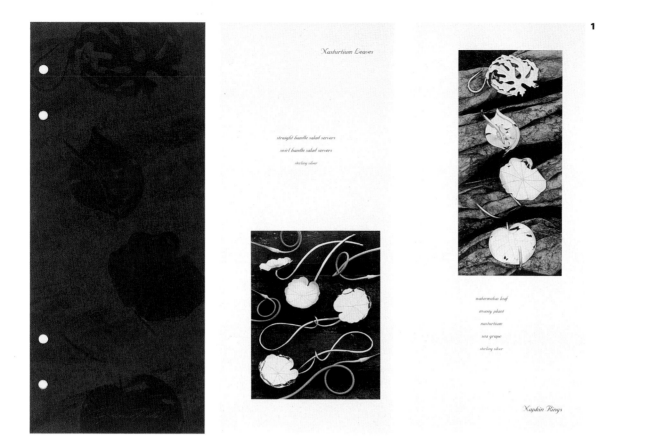

Nasturtium Leaves

straight handle salad servers

swirl handle salad servers

sterling silver

watermelon leaf

money plant

nasturtium

sea grape

sterling silver

Napkin Rings

1

1

Brochure Robyn Nichols

Art Directors/Designers Ann Willoughby, Phyllis Pease

Photographers Hollis Officer

Design Firm Willoughby, Robinson, Knauss; Kansas City, MO

Client Robyn Nichols

Typographer Cicero

Printer The Lowell Press

Paper Manufacturer S.D. Warren

2

Poster The Next Generation: Student Work from the United States

Art Director/Designer Lucille Tenazas

Photographer Richard Barnes

Design Firm Tenazas Design, San Francisco, CA

Client Art & Architecture Exhibition Space

Typographer Ken Rackow/Eurotype

Printer Forman/Leibrock

Paper Manufacturer Simpson Paper Company

2

3
Poster Architecture Represented, Furniture Realized
Art Director/Designer Lucille Tenazas
Photographer Richard Barnes
Design Firm Tenazas Design, San Francisco, CA
Client Art & Architecture Exhibition Space
Typographer Eurotype
Printer Alans Printing
Paper Manufacturer Simpson Paper Company

4
Brochure Garbage or Art?
Art Director/Designer Paula Scher
Photographer Margaret Casella
Design Firm Pentagram Design, New York, NY
Typographer JCH
Printer Rapaport Printing

3

4

Dinner-size paper napkins

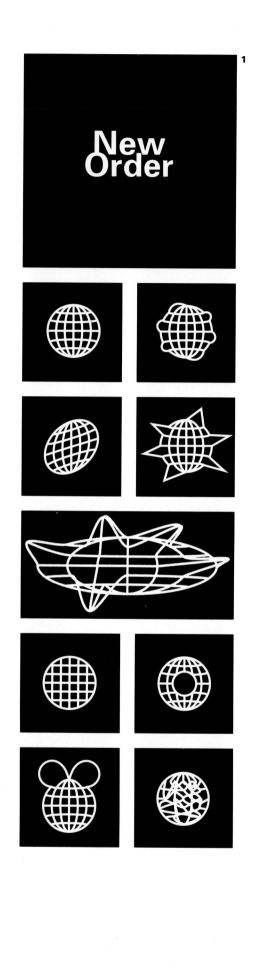

1

Brochure 91 Ways to Destroy the New World Order
Art Director/Designer Takaaki Matsumoto
Illustrator Takaaki Matsumoto
Design Firm/Client M Plus M Incorporated, New York, NY
Typography M Plus M Incorporated
Printer Strine Printing Inc.

2

Poster 91 Ways to Destroy the World
Art Director/Designer Takaaki Matsumoto
Illustrator Takaaki Matsumoto
Design Firm M Plus M Incorporated, New York, NY
Client Gallery 91
Typography M Plus M Incorporated
Printer Strine Printing Inc.

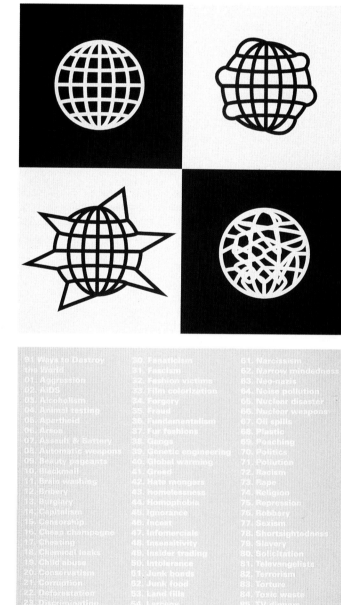

91 Ways to Destroy the World
01. Aggression
02. AIDS
03. Alcoholism
04. Animal testing
05. Apartheid
06. Arson
07. Assault & Battery
08. Automatic weapons
09. Beauty pageants
10. Blackmail
11. Brain washing
12. Bribery
13. Burglary
14. Capitalism
15. Censorship
16. Cheap champagne
17. Cheating
18. Chemical leaks
19. Child abuse
20. Conservatism
21. Corruption
22. Deforestation
23. Discrimination
24. Dishonesty
25. Drug addiction
26. Drug cartels
27. Embezzlement
28. Extortion
29. Famine
30. Fanaticism
31. Fascism
32. Fashion victims
33. Film colorization
34. Forgery
35. Fraud
36. Fundamentalism
37. Fur fashions
38. Gangs
39. Genetic engineering
40. Global warming
41. Greed
42. Hate mongers
43. Homelessness
44. Homophobia
45. Ignorance
46. Incest
47. Infomercials
48. Insensitivity
49. Insider trading
50. Intolerance
51. Junk bonds
52. Junk food
53. Land fills
54. Larceny
55. Loitering
56. Loss of laughter
57. Money laundering
58. Monopolies
59. Mugging
60. Murder
61. Narcissism
62. Narrow mindedness
63. Neo-nazis
64. Noise pollution
65. Nuclear disaster
66. Nuclear weapons
67. Oil spills
68. Plastic
69. Poaching
70. Politics
71. Pollution
72. Racism
73. Rape
74. Religion
75. Repression
76. Robbery
77. Sexism
78. Shortsightedness
79. Slavery
80. Solicitation
81. Televangelists
82. Terrorism
83. Torture
84. Toxic waste
85. TV dinners
86. Tyranny
87. Vagrancy
88. Vandalism
89. Vegetarians
90. War
91. Xenophobia

3

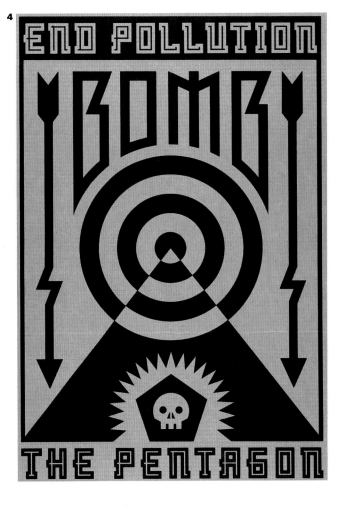

4

3
Poster Bierutah
Art Director/Designer Michael Bierut
Illustator Michael Bierut
Design Firm Pentagram Design, New York, NY
Client Art Directors Club of Salt Lake City, Utah
Typographer Trufont
Printer Lorraine Press

4
Poster Bomb the Pentagon
Designer/Illustrator Mark Fox
Design Firm/Client BlackDog, San Rafael, CA
Typographer Mark Fox
Printer Acme Silk Screen

1
Poster Issues of Self Esteem
Art Director Jeff Larson
Designer Scott Johnson
Design Firm Larson Design Associates, Rockford, IL
Client Stamford Hospital
Typography Starr Typography
Printer Advertising Creations
Paper Manufacturer Zanders

2
Poster Vision
Art Directors Jackson Boelts, Eric Boelts
Designers Jackson Boelts, Eric Boelts, Kerry Stratford
Typographer Kerry Stratford
Design Firm/Client Boelts Bros. Design, Tucson, AZ
Printer Fabe Litho

3

6

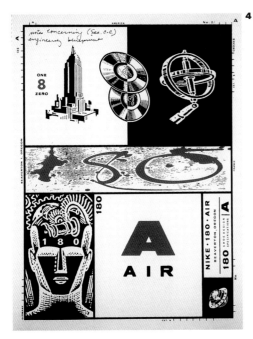

4

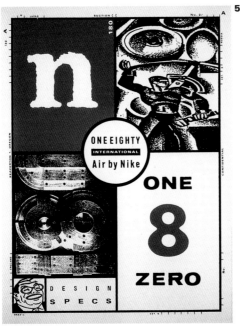

5

3

Hang Tag Full Bore
Art Director/Designer Scott Mires
Illustrator Gerald Bustamante
Design Firm Mires Design, Inc., San Diego, CA
Client Full Bore
Typographer Gerald Bustamante
Printer Gordon Silkscreening
Paper Manufacturer Simpson Paper Company

4

Poster Nike (A)
Art Director Charles S. Anderson
Designers Daniel Olson, Charles S. Anderson
Illustration/Photography Takenobu Igarashi, Japan;
Alfons Holtgreve, Germany; Ralph Steadman, England;
André Francois, France; Philipe Taborda, Brazil
Design Firm Charles S. Anderson Design, Minneapolis, MN
Printer Print Craft, Inc.
Paper Manufacturer French Paper Company

5

Poster Nike (180)
Art Director Charles S. Anderson
Designers Daniel Olson, Charles S. Anderson
Illustration/Photography Takenobu Igarashi, Japan;
Alfons Holtgreve, Germany; Ralph Steadman, England;
André Francois, France; Philipe Taborda, Brazil
Design Firm Charles S. Anderson Design, Minneapolis, MN
Printer Print Craft, Inc.
Paper Manufacturer French Paper Company

6

Poster Cover Your Head . . . Wear A Condom
Designer/Illustrator Mark Fox
Design Firm BlackDog, San Rafael, CA

Marks/Bielenberg believes that graphic design is a thoughtful and creative process.

A process that includes working with the client to discover and develop strategic objectives.

These objectives then drive the design, resulting in a solution that doesn't depend on preconceived notions of style or technique and compellingly conveys an idea.

An idea that remains long after the item itself is gone. Because...

You can't throw away an idea.

1
Brochure You Can't Throw Anything Away
Art Director John Bielenberg
Designers John Bielenberg, Allen Ashton, Brian Boram
Design Firm/Client Bielenberg Design, San Francisco, CA
Printer Warren's Waller Press
Paper Manufacturer Simpson Paper Company

2
Packaging Deleo Clay Tiles
Art Director/Designer Jose Serrano
Illustrator Tracy Sabin
Design Firm Mires Design, Inc., San Diego, CA
Client Deleo Clay Tile
Typographer Miguel Perez
Printer Rush Press

1
Self Promotion Watch Faces Watch
Art Director Charles S. Anderson
Designers Charles S. Anderson, Daniel Olson
Illustration/Photography Randall Dahlk
Design Firm Charles S. Anderson Design, Minneapolis, MN
Typography In-house

2
Stationery Form Furniture and Interiors
Art Directors/Designers Fiona Scrymgour, David High
Illustrator David High
Design Firm/Client IT Design, Inc., New York, NY
Typographers Fiona Scrymgour, David High
Printer Scrymgour and Sons Pty., Ltd.
Paper Manufacturer Conservation

Poster Modern Site
Art Director/Designer Jennifer Morla
Design Firm Morla Design Inc., San Francisco, CA
Client San Francisco Museum of Modern Art
Typographer Spartan Typographers, Inc.
Printer Mastercraft Press Inc.
Paper Manufacturer Potlatch Corporation

Poster Futura
Art Director/Designer Jennifer Morla
Illustrator Jennifer Morla
Design Firm Morla Design, Inc., San Francisco, CA
Client/Typographer Mercury Typography
Printer Hero Presentation Printing
Paper Manufacturer Zanders

1

Poster AIGA: Environmental Awareness
Art Director Jennifer Morla
Designers Jennifer Morla, Jeanette Aramburu
Design Firm Morla Design, Inc., San Francisco, CA
Client AIGA/San Francisco
Printer Ford Graphics
Paper Manufacturer Xerox

2

Annual Report This Annual Report is Trash
Art Director Steve Pattee
Designers Steve Pattee, Kelly Stiles
Illustration Pattee Design, Andy Lyons
Design Firm Pattee Design, Des Moines, IA
Client Des Moines Metro Solid Waste Agency
Typographer Macintosh
Paper Manufacturers Jerusalem Paperwork,
Simpson Paper Company

Sunflowers, Tuscany, Italy, 1989

OFTEN I SEE the materials of photography as being a type of terrain. Emulsions, liquid developers, silver salts, and fixers interact and make up a landscape which I need to explore in my mind's eye if I am to manifest an artful image in silver. Light strikes silvered emulsions, and lenses reshape the forms riding on the rays which affect film. This world of transformation etches and shapes a landscape in the surface of the emulsion. Herein can be a place of conceiving, where mind and imagination might combine with the world of feeling to bring a new object into being. It is here also that overtones from the symbolic language of the medieval alchemist might be apprehended. ➤ While photographing, I do not necessarily visualize complete images before returning to my darkroom to print. Rather, my intent is to sense an emotional shape or grasp some visitation to carry forth into that dimly lit space of hopes and discoveries. ➤ In the same way that I come to see my exposed and developed negatives as a shaped terrain, I also see the land which I photograph as a form of sculpture created on a larger scale by a greater force. Deep ravines, thrusting mountains, curved hills, and winding rivers impress their physical aspects on the eye and camera, but there is also a deeper cutting and impressing within the psychological landscape. Inner correspondences to the outer shapes and physical events provide me with a magical bridge to link the seemingly separated places and spaces of man and earth. A living and fluid ecology ensues. At the root of creativity is the impulse to understand. This inner pulse links me to the greater creativity. Having achieved this communion, I patiently wait and work for a state of continued openness... the voice of the print wishes entrance to the migrations of ideas and materials. ➤ PHOTOGRAPHY FOR ME is a juncture of time, space, light and emotional stance. One needs to be still enough, observant enough, and aware enough to acknowledge the life of the materials; shift the stance far enough back from expectations and try to "hear through the eyes." Associative thinking, preconceiving, and categorizing hamper clear perception. Clarity of process and simplicity of being will melt under the heat of the intellect's excesses. ➤ Try to see the live tonalities as being entities in themselves rather than losing them to the forms of the objects photographed. The subjects in the photographs are not necessarily the tones reflecting from the paper print; they simply occupy the same space within the emulsion. Try to separate and accept print tone for its own sake and embark on an adventure of listening for the voice of the print. ➤ Learning to separate and feel the mood of tonality is not an easy exercise, but one which is very instructive and rewarding. Color in the black and white print combines with tonality and further heightens the emotional impact. Scale gives added shape, and if sensitively combined, tones can impart that silent evidence of emotional intent. To photograph panoramas or details which might become pulsing tones within the print, I must achieve a communion with both my subjects and my materials. I encourage the viewer to allow the art to flow and take on a meaning needing no explanatory notes.

3

3
Poster Lux One
Designer Glenn Johnson
Photographers Paul Caponigro, Huntington Witherill
Design Firm Jerry Takigawa Design, Pacific Grove, CA
Client Center for Photographic Art
Typographer Glenn Johnson
Printer Phelps Schaefer Lithographics
Paper Manufacturers Consolidated Paper, Neenah Paper, Seaman-Patrick Paper Co.

4
Poster New Dutch Graphics
Art Director/Designer Cheryl Brzezinski
Design Firm Minor Design Group, Houston, TX
Client Design Center, WMU

4

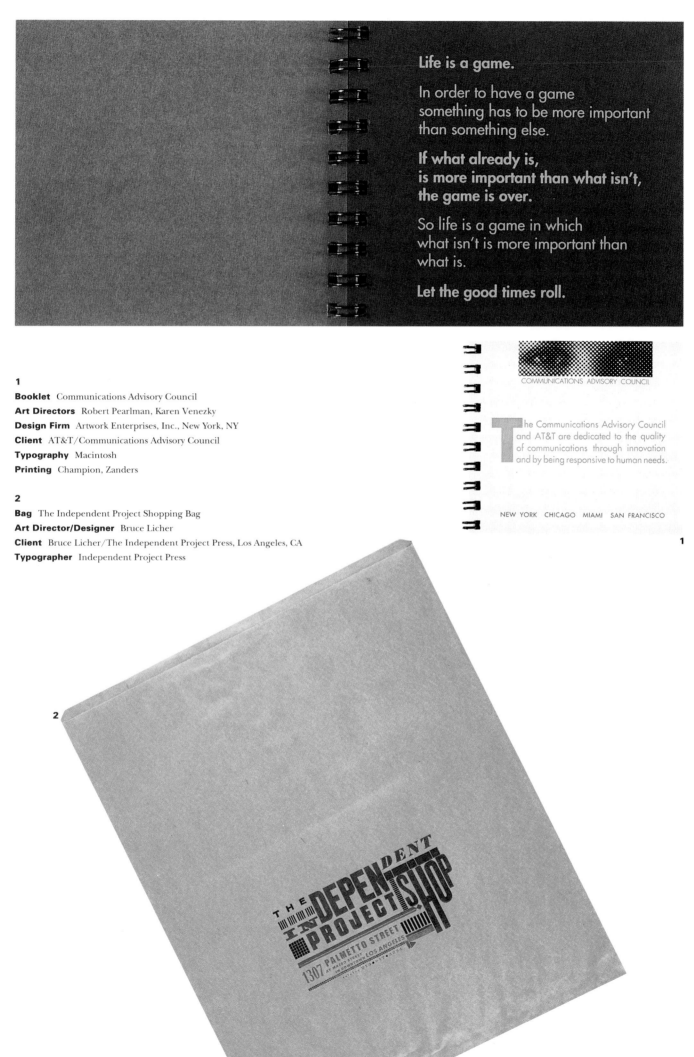

Life is a game.

In order to have a game
something has to be more important
than something else.

**If what already is,
is more important than what isn't,
the game is over.**

So life is a game in which
what isn't is more important than
what is.

Let the good times roll.

COMMUNICATIONS ADVISORY COUNCIL

The Communications Advisory Council
and AT&T are dedicated to the quality
of communications through innovation
and by being responsive to human needs.

NEW YORK CHICAGO MIAMI SAN FRANCISCO

1

1

Booklet Communications Advisory Council
Art Directors Robert Pearlman, Karen Venezky
Design Firm Artwork Enterprises, Inc., New York, NY
Client AT&T/Communications Advisory Council
Typography Macintosh
Printing Champion, Zanders

2

Bag The Independent Project Shopping Bag
Art Director/Designer Bruce Licher
Client Bruce Licher/The Independent Project Press, Los Angeles, CA
Typographer Independent Project Press

2

3
Poster The Big A
Art Director/Designer Paula Scher
Illustrator Paula Scher
Design Firm Pentagram Design, New York, NY
Client Ambassador Arts
Typographer Paula Scher
Printer Ambassador Arts

4
Brochure advertisign
Art Director Kent Hunter
Design Firm Frankfurt Gips Balkind, New York, NY
Client AIGA/New York
Typography In-house
Printer Quality House of Graphics
Paper Manufacturer Strathmore Paper Company

3

4

1

1
Brochure ARK/Architectural Response Kollection
Art Director/Designer John Clark
Design Firm Looking, Los Angeles, CA
Client Architectural Response Kollection
Printer Gardner Lithograph

2
Self Promotion Looking
Art Director/Designer John Clark
Photographers Chris Morgan, Marshal Safron
Design Firm/Client Looking, Los Angeles, CA
Typography Looking
Printers Looking, Platinum Press (Duotones), Marina Graphics (Text)
Paper Manufacturer Simpson Paper Company

3
Newsletter In the Spirit of Modernism
Art Director/Designer Linda Hinrichs
Illustrators Various
Design Firm Powell Street Studio, San Francisco, CA
Client San Francisco Museum of Modern Art Journal
Typographer Design + Type
Printer Colorgraphics
Paper Manufacturer Simpson Paper Company

4
Box Packaging NCD/Network Computing Devices
Art Director Marty Neumeier
Designer Christopher Chu
Design Firm Neumeier Design Team, Atherton, CA
Client Network Computing Devices
Typographer Christopher Chu

2

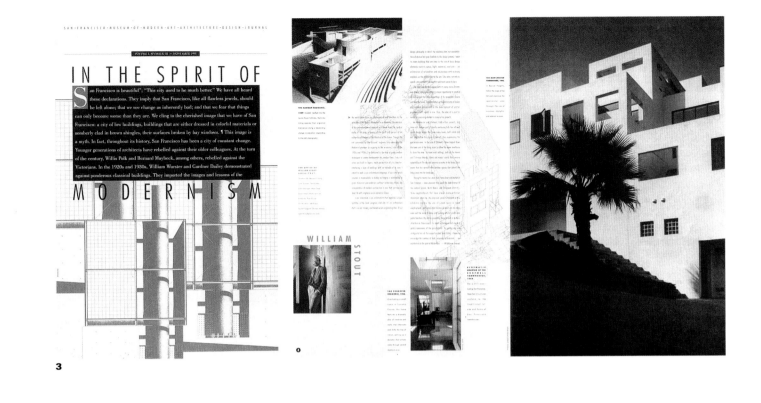

1

Poster Fix It Now or Later
Art Director/Illustrator Trudy Cole-Zielanski
Design Firm/Client Trudy Cole-Zielanski Design, Frostburg, MD
Printer Trudy Cole-Zielanski

2

T-Shirt Packaging HBJ
Art Director Scott Mires
Designers Catherine Sachs, Scott Mires
Design Firm/Client Mires Design, Inc., San Diego, CA
Typographers Various
Printer Rush Press
Paper Manufacturer Gilbert Paper Company

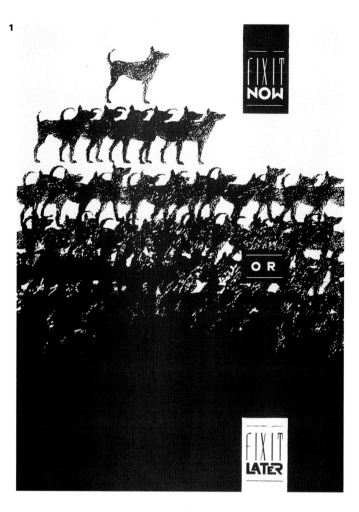

3
Logo DogBoy
Designer/Illustrator Mark Fox
Design Firm/Client BlackDog, San Rafael, CA

4
Stationery George for Dogs
Art Director/Designer Mike Hicks
Illustrator Mike Hicks
Design Firm Hixo, Inc., Austin, TX
Client George for Dogs
Printer Macintosh
Printer Press Corps
Paper Manufacturer French Paper Company

1
Invitation Croatia Fundraiser
Art Director Scott Mires
Designers Scott Mires, Gerald Bustamante
Illustrator Gerald Bustamante
Design Firm Mires Design, Inc., San Diego, CA
Client Anuska Smith
Typography Smith Corona
Printer Rush Press

2
Brochure DIFFA/Designers Garage Sale
Art Director Dana Arnett
Designer Curt Schreiber
Cover Photographer Chris Froeder
Design Firm VSA Partners, Inc., Chicago, IL
Client DIFFA/Chicago

1

2

WARSAW NEW YORK

Andrzej Dudzinski came to America from Poland in 1977 at the invitation of the International Design Conference in Aspen, Colorado. He didn't return home. "I just kept extending my visa until I became an American citizen," he explains. In Poland, Dudzinski was a well-known satirical cartoonist. His work appeared in the weekly paper Szpilki and in many underground newspapers, including Olz, tf, Ink and Time Out.

In America, Dudzinski became a very successful illustrator, working for the international market. Among his many clients are The New York Times, The Boston Globe, Newsday, and in France, IBM and Fortune magazine. He and his family live in New York and he teaches at Parsons School of Design. Here, Dudzinski talks about life in Poland before freedom and the difference between working in Poland and in America.

BY MARY YEUNG

ILLUSTRATIONS BY ANDRZEJ DUDZINSKI

3

3

Brochure ADC 3
Art Director Paula Scher
Designers Paula Scher, Ron Louie
Illustrators Various
Design Firm Pentagram Design, New York, NY
Client Art Directors Club
Typographer JCH
Printer Queens Litho
Paper Manufacturer Mohawk Paper Company

4

Self Promotion Patent Pending: Al U. Minum
Art Director/Designer Steven Guarnaccia
Illustrator Steven Guarnaccia
Design Firm Steven Guarnaccia, New York, NY
Client Purgatory Pie Press
Printer Purgatory Pie Press

1

1
Moving Announcement Ventura
Art Director Joe Wilcox
Designer Keith Puccinelli
Design Firm Puccinelli Design, Santa Barbara, CA
Client Kruger Berman Ziemer Architects
Typography Macintosh
Printer Ron Petersen/Printers Inc.

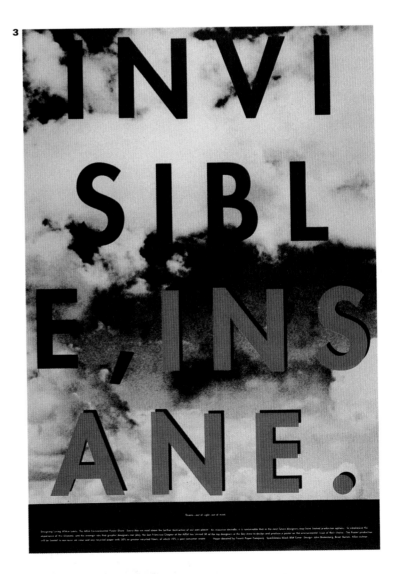

2

3

2
Logo Lino Boy
Designer/Illustrator Mark Fox
Design Firm/Client BlackDog, San Rafael, CA
Typography Andresen Graphic Services
Printing BlackDog

3
Poster Invisible, Insane
Art Director John Bielenberg
Designers John Bielenberg, Allen Ashton, Brian Boram
Illustrator Allen Ashton
Design Firm Bielenberg Design, San Francisco, CA
Client AIGA/San Francisco

4
Poster AIGA/San Francisco Events
Art Director/Designer Paul Woods
Illustrator Paul Woods
Photographers Bernard Marque, Jayme Odgers
Design Firm Woods + Woods, San Francisco, CA
Typographer Eurotype
Printer Graphic Impressions
Paper Manufacturer Westvaco

5
Poster Art Exhibitions '90
Art Director/Designer Doug Kisor
Design Firm Siren, Ypsilanti, MI
Client Eastern Michigan University
Typography Siren
Printer Great Lakes Printing
Paper Manufacturer Vintage

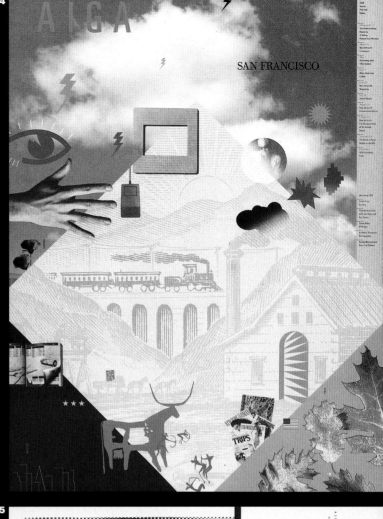

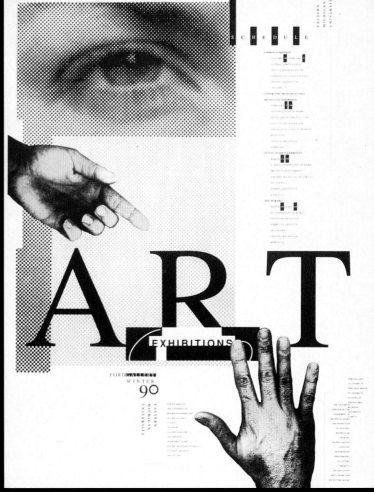

AMERICAN INSTITUTE OF
GRAPHIC ARTS
NEW YORK CHAPTER

• • • •

BOOK ARTS
RESOURCE
GUIDE

ooks have the power to capture and project ideas, to preserve and convey inspiration. For graphic designers, books were the beginning, for their history closely parallels the history of communication. However, as the modern need for communications stretches into new areas of commerce and new layers of technology, books sometimes seem archaic.

This Small Talk starts from the premise that Book Arts, in all their forms, are still a varied terrain of inspiration for graphic designers. It is where we often turn for ideas which distinguish even non-book commercial design projects, and we are especially interested in books which, in one way or another, have been touched by a hand process, whether it be letterpress printing, unique papers, special bindings, or creative applications of small-run commercial printing.

We thank our panelists for their contributions: Peter Bishop of PETRARCH PRESS, Esther K. Smith and Dikko Faust of PURGATORY PIE PRESS, Michael Josefowicz of RED INK PRODUCTIONS, and Jerry Kelly of the STINEHOUR PRESS.

We hope this resource guide is helpful, if only as a brief introduction to the rich world of the Book Arts.

1

2

Aesthetics come first. Mundane things are ignored. However, once you've caught the eye, you need to engage the mind. And in this regard, writing can be incomparably useful—in my unbiased opinion. **Dan Wallace** Copywriter **112 N. Third Street Minneapolis, MN 55401 (612) 339-7848**

Each day we're exposed to hundreds of commercial messages. There's direct mail, newspaper and magazine ads, TV & radio spots, posters, brochures, billboards... the list goes on. Billions are spent on these efforts. Yet most people ignore 90% of the messages, I specialize in the other 10%. **Dan Wallace** Copywriter **The Amsterdam, 112 N. Third Street, Suite 206, Minneapolis, Minnesota 55401**

Writing can inform, entertain, persuade, sadden, gladden, anger, and enlighten. Used properly, words can also move products off shelves, market services, and turn ideas into reality. **Dan Wallace** Copywriter **The Amsterdam Building, 112 North Third Street, Suite 206, Minneapolis, Minnesota 55401-1650, Telephone 612-339-7848**

All this from ink on paper.

1
Brochure Book Arts Resource Guide
Art Director/Designer Eric Baker
Design Firm Eric Baker Design Associates, New York, NY
Client AIGA/New York
Printer Eric Baker
Paper Manufacturer Red Ink

2
Stationery Dan Wallace
Art Director/Designer Michael Skjei
Design Firm Michael Skjei Design Company, Minneapolis, MN
Client Dan Wallace
Typographer Michael Tarachow
Printer Pentagram Press
Paper Manufacturer Cranes Fine Papers

PERFORMING ARTS LIVE SERIES

5

3

HARMONIOUS VALENTINE'S DAY

MICHAEL OSBORNE DESIGN

4

3
Card Valentine's Day
Art Director/Designer Michael Osborne
Design Firm Michael Osborne Design, San Francisco, CA

4
Poster Yale Symphony Orchestra, Holst: The Planets
Art Director/Designer Robin Lynch
Design Firm Negerkunst
Client Yale University
Paper Manufacturer Mohawk Paper

5
Poster Performing Arts Live Series
Art Directors Russ Ramage, Bill Grant
Designer Russ Ramage
Illustrator Jerry Burns
Design Firm DESIGN!
Client Creative Arts Guild
Typography In-house
Printer Colonial Printing
Paper Manufacturer S.D. Warren

1

Poster Concrete Productions Christmas
Art Director/Designer Bryan L. Peterson
Illustrator Robb Debenport
Design Firm Peterson & Company, Dallas, TX
Printer Printing by Buck

2

Poster Halloween Dance
Art Director/Designer Randall Sexton
Illustrator Randall Sexton
Design Firm Sexton Design, San Francisco, CA
Client IBM Club/IBM San Jose Design Center
Typographer Randall Sexton
Printer ScreenTronix
Paper Manufacturer Potlatch

3

Self Promotion Snowball
Art Directors Cheryl Brzezinski, Craig Minor
Designer Cheryl Brzezinski
Design Firm Minor Design Group, Houston, TX
Typography Characters
Printer Superb and Stafik

Seasons Greetings

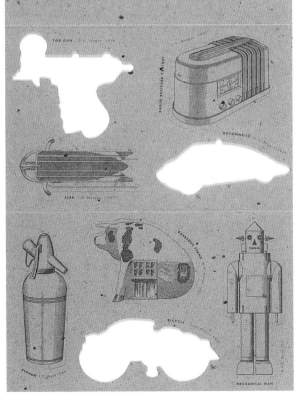

4
Poster Downtown
Art Director/Designer Craig Bissell
Illustrator Craig Bissell
Design Firm/Client Gregg & Associates, Kansas City, MO
Typography In-house
Printer J2 Printing, Inc.
Paper Manufacturer Simpson Paper Company

5
Self Promotion Season's Greetings
Art Director/Designer Eric Baker
Design Firm Eric Baker Design Associates, New York, NY
Printer Eric Baker

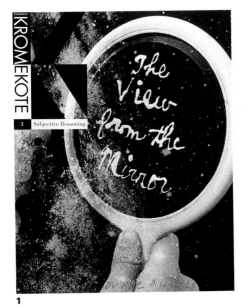

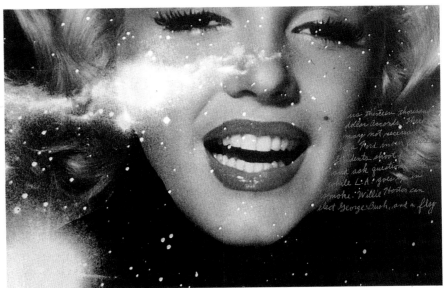

1
Publication The View From the Mirror
Art Directors Paula Scher, William Drenttel
Designer/Photographer Duane Michals
Design Firm Pentagram Design, New York, NY
Client/Publisher Champion International Corporation
Printer Van Dyke/Columbia Printing Company
Paper Manufacturer Champion International

2
Shopping Bags Z Gallerie
Art Director John Bricker
Illustrator Wendy Wells
Design Firm Gensler and Associates/Graphics, San Francisco, CA
Typography Z Gallerie
Printer Andresen Typographics
Paper Manufacturer Armor Packaging

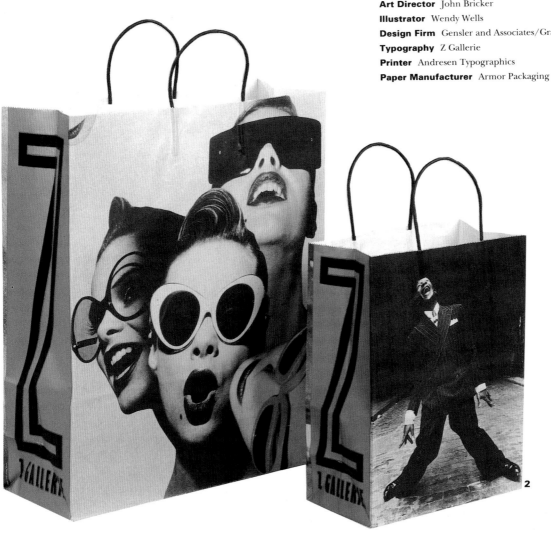

3

Brochure Yunker '92-'93 Fall-Winter Collection
Art Director/Designer Del Terrolonge
Photographer Shin Sugino
Design Firm Terrelonge Design Inc., Toronto, CAN
Client James Yunker

4

Brochure New York's Most Entertaining Secret
Art Director Alane Gahagan
Designer Lori Littlehales
Illustrator Lee Friedman
Design Firm/Agency Ziff Marketing, New York, NY
Client Tisch Center for the Arts
Typography In-house
Printer Zarrett Graphics
Paper Manufacturer Consolidated Paper Company

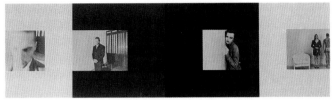

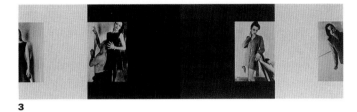

3

4

1

2

3

1

Poster Peace, Christmas 1991
Art Director Lorraine Guttormsen
Designer Lorraine Guttormsen
Calligraphy Yasuko Shimizu
Design Firm/Client Granados Associates, Inc., Bensalem, PA
Silkscreening Ray Granados
Paper Manufacturer Handmade Recycled Paper by Ray Granados

2

Poster Great Ideas
Art Director/Designer Daniel J. Walsh
Design Firm/Client Granados Associates, Inc., Bensalem, PA
Typography/Silkscreen Printing Ray Granados
Paper Manufacturer Handmade Recycled Paper by Ray Granados

3

Poster Creativity
Art Director/Designer Lorraine Guttormsen
Illustrator Lorraine Guttormsen
Design Firm/Client Granados Associates, Inc., Bensalem, PA
Typography/Silkscreen Printing Ray Granados
Paper Manufacturer Handmade Recycled Paper by Ray Granados

4

Self Promotion Charles S. Anderson Metal File
Art Director Charles S. Anderson
Designers Charles S. Anderson, Daniel Olson
Design Firm/Client Charles S. Anderson Design, Minneapolis, MN

5

Logo Exos
Art Director/Designer Karen Dendy
Illustrator Karen Dendy
Design Firm Barrett Design, Cambridge, MA
Client Exos

6

Stationery Archetype Press
Art Director/Designer Vance Studley
Design Firm Archetype Press, Pasadena, CA
Client Art Center College of Design
Typographer Vance Studley
Printer Nugent Printing
Paper Manufacturer Strathmore Paper Company

EXOS

6

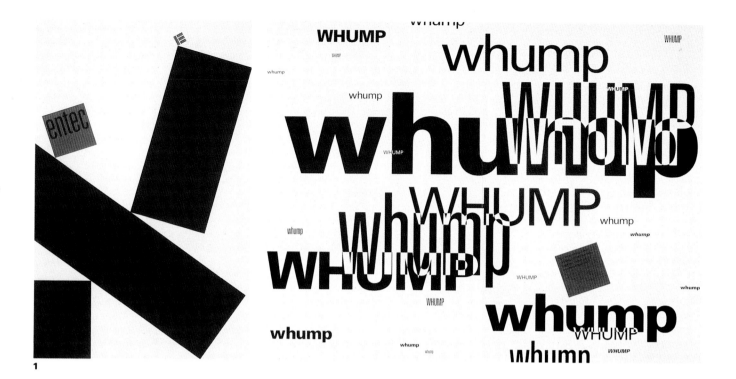

1

Brochure Entec
Art Director/Designer Mitchell Mauk
Design Firm Mauk Design, San Francisco, CA
Client Entertainment Technologies
Typographer Z Typography
Printer AR Lithography

2

Packaging UVU/Thompson Consumer Electronics/RCA
Art Director Paula Scher
Designers Paula Scher, Ron Louie
Design Firm Pentagram Design, New York, NY
Client Thompson Consumer Electronics/RCA
Typographer Paula Scher

3
Poster AIGA T-Shirt Show
Art Director Charles S. Anderson
Designers Charles S. Anderson, Todd Hauswirth
Design Firm Charles S. Anderson Design, Minneapolis, MN
Client AIGA
Printer Print Craft, Inc.
Paper Manufacturer French Paper Company

4
Poster What is Good Design?
Art Director/Designer Michael Bierut
Illustrator Elizabeth Bierut
Design Firm Pentagram Design, New York, NY
Client American Center for Design
Printer Meehan Tooker
Paper Manufacturer Cross Pointe Paper Corporation

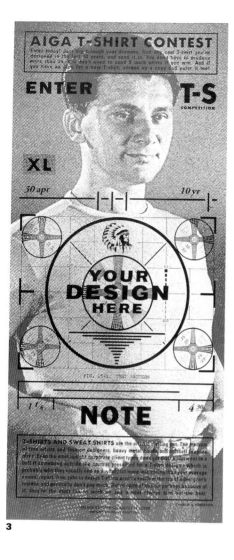

3

4

1
Promotion "Bodeans: Black-and-White" Postcard Set
Art Director/Designer Kim Champagne
Photographer Michael Wilson
Design Firm/Agency Warner Brothers Records, Burbank, CA
Client Reprise/Slash Records
Printer Westland Graphics
Paper Manufacturers International, Simpson Paper Company

2
Drink Coaster Buckeye Bar
Designer/Illustrator Mark Fox
Design Firm BlackDog, San Rafael, CA
Client Bill Higgins/Real Restaurants

3

Advertising Levi's Silver Tab Collection
Art Director/Designer Jennifer Morla
Photographer David Martinez
Design Firm Morla Design, Inc., San Francisco, CA
Client Levi Strauss & Co.
Typographer Andresen Typographics
Printer The James H. Barry Co.
Paper Manufacturers Seaman Patrick, Simpson Paper Company

4

Brochure L.S. & Co. Ranch
Art Director Neal Zimmermann
Designers Husted/Glasson, Neal Zimmermann
Design Firm Zimmermann Crowe Design, San Francisco, CA
Client Levi Strauss & Co.

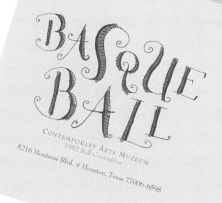

1
Program and Stationery Basque Ball
Art Director Herman Dyal
Designer Susan McIntyre
Illustrator Herman Dyal
Design Firm Fuller Dyal & Stamper, Austin, TX
Client Contemporary Arts Museum
Typographer Susan McIntyre

Poster Marie and Bruce
Art Director/Designer Michael Bierut
Illustrator Michael Bierut
Design Firm Pentagram Design, New York, NY
Client Parallax Theatre Company
Typographer Typogram
Printer Ambassador Arts

3

Restaurant Menu MacArthur Park
Art Director Jennifer Morla
Designers Jennifer Morla, Jeanette Aramburu
Photographer Jeanette Aramburu
Design Firm Morla Design, Inc., San Francisco, CA
Client Spectrum Foods, Inc.
Typographer Spartan Typographers, Inc.
Printer Apex Die, Inc.
Paper Manufacturer French Paper Company

1
Poster Best Part of Our Wedding
Art Director John Sayles
Illustrator John Sayles
Design Firm Sayles Graphic Design, Des Moines, IA
Client Schaffer's Bridal and Formal Wear
Typographer Printing Station
Printer 24-Hour Sign and Display
Paper Manufacturer James River Paper Corporation

2
Packaging Cocolat
Art Director/Designer Jennifer Morla
Illustrator Jennifer Morla
Design Firm Jennifer Morla Design, Inc., San Francisco, CA
Client Cocolat
Typographer Spartan Typographers
Printer Conifer Paper Products, Inc.
Paper Manufacturer French Paper Company

3

Poster En Vino Veritas

Art Director/Designer Kerry Polite

Photographer Kim Puliti

Design Firm Polite Design, Philadelphia, PA

Client AIGA/Philadelphia

Typographer The Type Connection

Printer Waldman Graphics

Paper Manufacturer Mohawk Paper Company

4

Promotion One By One

Art Director John Sayles

Illustrator John Sayles

Design Firm Sayles Graphic Design, Des Moines, IA

Client Gilbert Paper

Typographer Printing Station

Printer Artcraft, Inc.

Paper Manufacturer Gilbert Paper

1
Packaging Barber Ellis
Art Director Charles S. Anderson
Designers Charles S. Anderson, Daniel Olson
Design Firm Charles S. Anderson Design, Minneapolis, MN
Client Barber Ellis Fine Papers

2
Brochure Hat Life 1992
Art Director Alex Bonziglia
Photographer Scott Wipperman
Design Firm David Morris Design Associates, Jersey City, NJ
Client Hat Life
Typography David Morris Design Associates
Printer Thompson Printing
Paper Manufacturer Appleton Papers, Inc.

3
Brochure Taki's Haircare
Designer/Illustrator A. Ma
Design Firm Tanagram, Chicago, IL
Client Taki's of America
Typographer A. Ma
Printer L + C Ficks
Paper Manufacturer S.D. Warren

4
Stationery Joanie Bernstein
Art Director Sharon Werner
Designers Sharon Werner, Lynn Schulte
Design Firm Werner Design Werks, Inc., Minneapolis, MN
Typographer Great Faces
Printers Print Craft, Togerson

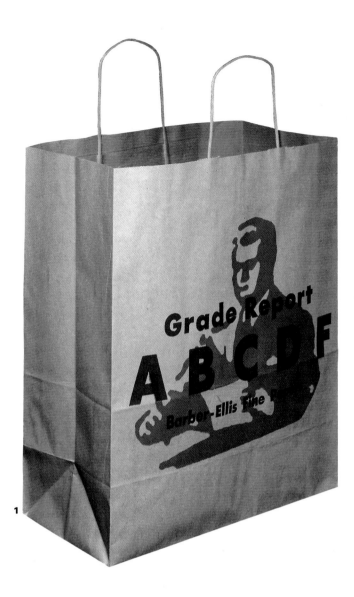

1

2

1

Poster I Don't Need No Toxic Colors

Art Director Marty Neumeier

Designers Marty Neumeier, Christopher Chu

Design Firm Neumeier Design Team, Atherton, CA

Client AIGA/San Francisco

Typographer Christopher Chu

Paper Manufacturer French Paper Company

2

Poster Save Our City

Art Director/Designer Michael Bierut

Illustrator Michael Bierut

Design Firm Pentagram Design

Client Designing New York Committee

Typographer Typogram

Printer Ambassador Arts

3

Announcement SIT

Art Director/Designer Jack Summerford

Design Firm Summerford Design, Inc., Dallas, TX

Client American Institute of Graphic Arts

Typographer Typographics

Printer Monarch Press

Paper Manufacturer Simpson Paper Company

4

Book Jacket Joe

Designer Molly Renda

Design Firm Molly Renda Graphic Design, Durham, NC

Client Algonquin Books of Chapel Hill

Typographer Molly Renda

Printers Lehigh Printing, Arcata Press

Paper Manufacturers Mohawk, S.D. Warren

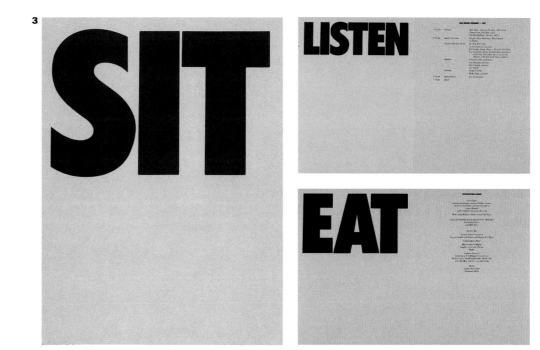

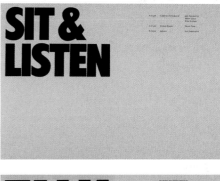

SEEKING HIGHER GROUND?

SIMPSON PAPER HAS A SOLUTION.

YOU ARE INVITED TO SHARE AN EVENING WITH

KIT HINRICHS OF PENTAGRAM

ABOARD THE LUXURY YACHT, ANITA DEE II.

OUR EVENING CRUISE ON LAKE MICHIGAN

INCLUDES DINNER, COCKTAILS

AND LIVE CALYPSO MUSIC. YOUR BOARDING

CALL IS 5:45PM, JUNE 2ND

FROM THE SOUTH SIDE OF NAVY PIER WITH

A RETURN TO PORT AT 9:00PM.

1

2

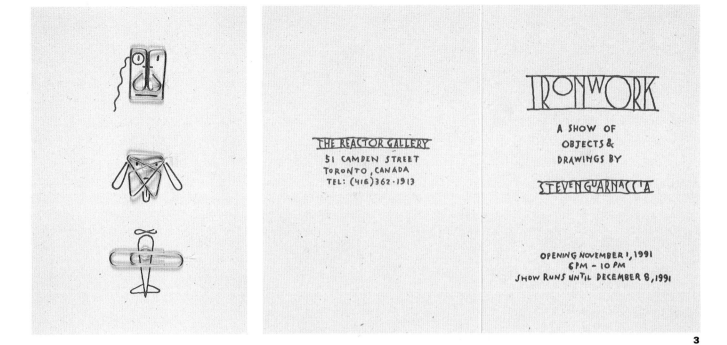

1

Invitation Simpson Paper Company Dinner
Art Director Dana Arnett
Designer Curt Schreiber
Illustrator Francois Robert
Design Firm VSA Partners, Inc., Chicago, IL
Client Simpson Paper Company
Printer Active Graphics
Paper Manufacturer Simpson Paper Company

2

Stationery Joan Ostrin
Art Director/Designer Sue T. Crolick
Design Firm Sue T. Crolick Advertising + Design, Minneapolis, MN
Client Joan Ostrin
Typography Great Faces

3

Self Promotion Ironwork
Art Director/Designer Steven Guarnaccia
Illustrator Steven Guarnaccia
Design Firm Steven Guarnaccia, New York, NY
Client Reactor Art & Design
Printer Letterpress

4

Self Promotion DDD Logo Book
Art Director/Designer Diana DeLucia
Design Firm Diana DeLucia Design, Ltd., New York, NY
Printer Soho Services

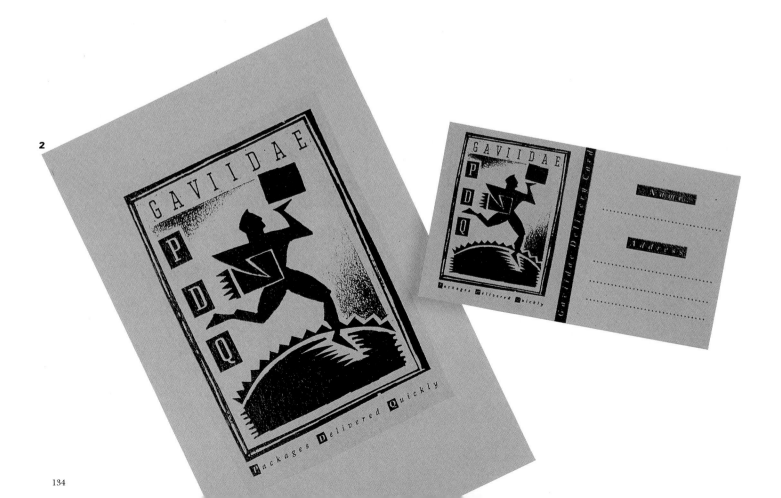

IF YOUR CAR LOOKS LIKE THIS YOU SHOULD CALL O'NEILL'S AUTO BODY WORKS
4808 STINE RD., BAKERSFIELD, CA 93313 (805) 397-4500 PATRICK J. O'NEILL, PRES.

1

2

1
Direct Mail O'Neill's Auto Body Works
Art Director/Illustrator Stavros Cosmopulos
Design Firm/Agency Stavros Cosmopulos, Inc., Boston, MA
Client O'Neill's Auto Body Works
Typographer Arrow Comp
Printer Dynagraph

2
Announcement Gavidae PDQ
Art Director/Designer Ross Adcock
Design Firm Hahn Advertising & Design, San Diego, CA
Client Gavidae Common Shopping Center
Printer Commercial Printers

3
Poster Woody Pirtle Performing Live
Art Director/Designer Woody Pirtle
Illustrator Woody Pirtle
Design Firm Pentagram Design, New York, NY
Client Ringling School of Art and Design
Typographer Monogram
Printer L.P. Thebault
Paper Manufacturer Champion International

4
Self Promotion I Spy Postcards, Nos. 1-4
Art Director/Designer/Illustrator Steven Guarnaccia
Design Firm/Client Steven Guarnacaccia, New York, NY

4

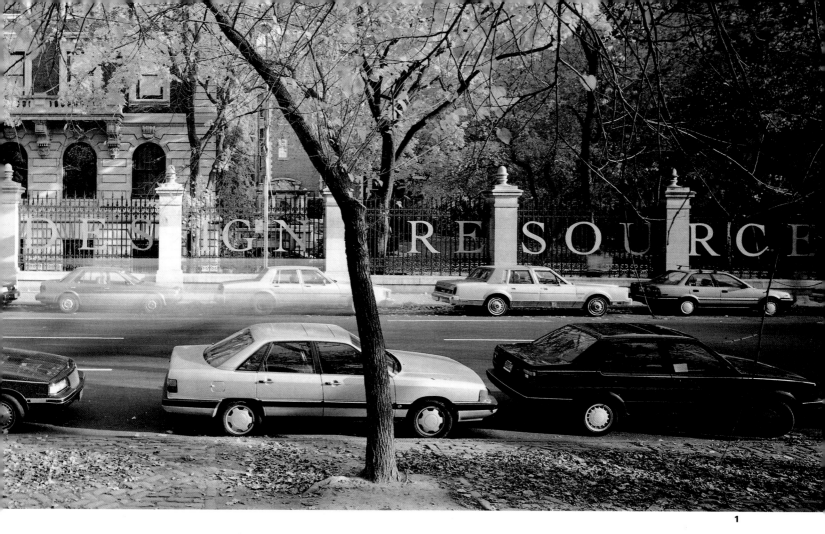

1

1
Environmental Graphics A Design Resource
Art Director Stephen Doyle
Designer Andrew Gray
Project Manager William Drenttel
Design Firm Drenttel Doyle Partners, New York, NY
Client The Cooper-Hewitt Museum

2
Packaging Shirley Goodman Resource Center
Art Directors Takaaki Matsumoto, Michael McGinn
Designers Mikio Sakai, Takaaki Matsumoto
Design Firm M Plus M Incorporated, New York, NY
Client The Fashion Institute of Technology
Typography M Plus M Incorporated
Printers Various

2

3

Stationery and Graphics Standards Guidelines

The Museums Council of New York City

Art Director/Designer Weston Bingham

Typographer Weston Bingham

Design Firm Weston Bingham, Brooklyn, NY

Client The Museums Council of New York City

Printing Artanis Offset, Apple LaserWriter

Paper Manufacturer Strathmore Paper Company

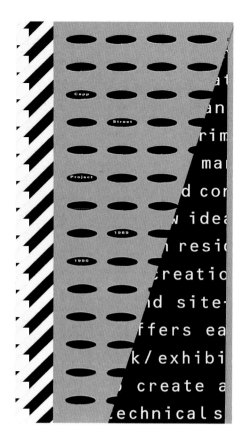
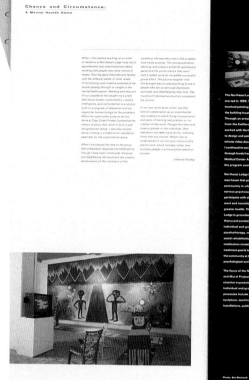

1

Catalog Capp Street Project
Art Director Jennifer Morla
Designers Jennifer Morla, Sharrie Brooks
Design Firm Morla Design, Inc., San Francisco, CA
Client Capp Street Project
Typographer Display Lettering + Copy
Printer Sung-In Printing America
Paper Manufacturer Korean Paper

2

Invitation BACIO Remodeling Sale
Art Director Jane Tilka
Designer Jerry Stenback
Design Firm Tilka Design, Minneapolis, MN
Client BACIO
Typographer Jerry Stenback
Printer Associated Lithographers
Paper Manufacturers Champion International, Fox River

3

Announcements Capp Street Project
Art Director Jennifer Morla
Designers Jennifer Morla, Sharrie Brooks
Photographer Holly Stewart
Design Firm Morla Design, Inc., San Francisco, CA
Client Capp Street Project
Typographer Copy It
Printer Venture Graphics
Paper Manufacturer Simpson Paper Company

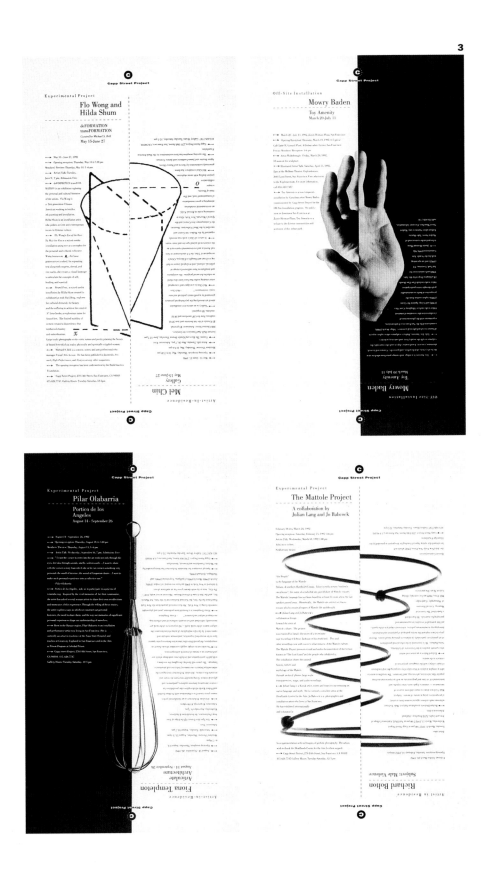

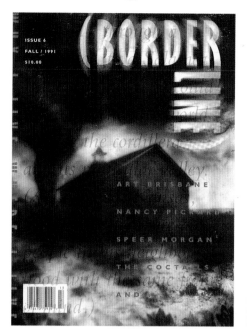
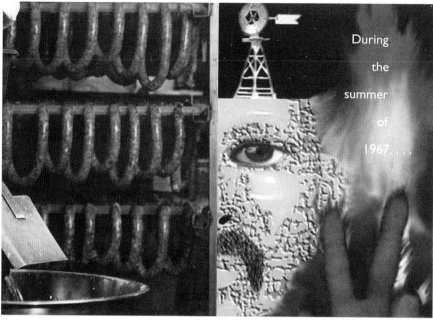

1

Editorial Design Borderline Magazine
Art Director/Designer Mike Fink
Photography Michael Regnier
Design Firm Fink x Height, Kansas City, MO
Client Borderline Magazine
Typographer Mike Fink
Printer Rosse Litho

2

Catalog SCI-ARC 1990-91
Art Director Lorraine Wild
Designers Lorraine Wild, Susan Parr
Photographers Charlie Daniels, Ana Daniels
Design Firm ReVerb, Los Angeles, CA
Client/Publisher Southern California Institute of Architecture
Typographer Pre-Press
Printer Donahue Printing Co.
Paper Manufacturers Simpson Paper Company, Rowlux

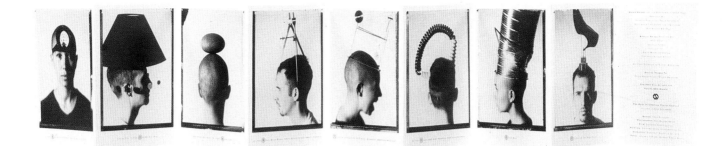

3

3
Invitation The Society of Graphic Designers of Canada Dada Hat Ball
Art Director Todd Richards
Photographer Ron Baxter Smith
Client Society of Graphic Designers of Canada/Ontario
Printer Arthurs Jones Lithographing Inc.
Paper Manufacturer S.D. Warren Paper Company

4
Brochure MODO
Art Director Marco De Plano
Designer Julia Roederer
Photographer Albano Guatti
Design Firm De Plano Design, Inc., New York, NY
Client MODO
Typography In-house
Printer Rapoport Metropolitan
Paper Manufacturer Zandor

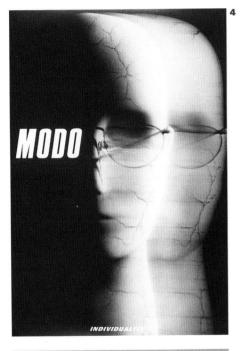

4

MODO

INDIVIDUALITY

MODO

ANONYMITY

個人的性格

INDIV**ID**UALITY

1

1
Promotion Mailer Mentors: Women in Design
Art Director Debra Nichols
Designer Catherine Montalbo
Design Firm Catherine Montalbo, San Francisco, CA
Client AIGA/San Francisco
Typography Rapidtype
Printer Venture Graphics
Paper Manufacturer Simpson Paper Company

2
Stationery Litigation Video
Art Directors Todd Hauswirth, Daniel Olson
Designer Todd Hauswirth
Design Firm Charles S. Anderson Design, Minneapolis, MN
Client Litigation Video
Typography Macintosh
Printer Print Craft, Inc.

2

LITIGATION VIDEO

LITIGATION VIDEO
2503 W. FRANKLIN AVE.
MPLS. MN. 55405-2323

LITIGATION VIDEO
NORM LARSEN · PRESIDENT
2503 W. FRANKLIN AVE.
MPLS. MN. 55405-2323
PHONE · 612-374-5649
TELEFAX · 612-374-5049

Poster De Program
Art Director/Designer Doug Kisor
Design Firm Siren, Ypsilanti, MI
Client Eastern Michigan University
Typography Siren
Printer Hamblin
Paper Manufacturer S.D. Warren

Brochure Blue Star Seven (Plus) 7
Art Director Jill Giles
Design Firm Giles Design, San Antonio, TX
Client Blue Star Art Space
Printer English Printers
Paper Manufacturers Simpson Paper Company,
Gilbert Paper Company

nick vaughn

1

1
Brochure Personal Inventory: Nick Vaughn
Art Director Garland Kirkpatrick
Designers Ellen Birren, Nick Vaughn
Design Firm Garland Kirkpatrick, Hermosa Beach, CA
Client Muckenthaler Cultural Center
Typographer Garland Kirkpatrick
Printer Dual Graphics
Paper Manufacturer Matrix

2
Newsletter Wexner Center for the Arts
Designer Gary Sankey
Design Firm/Client Wexner Center for the Arts/
Design Department
Typographer Harlan Type
Printer Fineline Graphics
Paper Manufacturer Hammermill

2

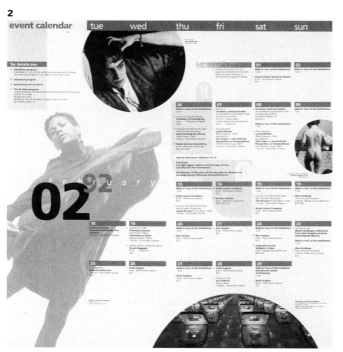

3

Publication Poster Society Journal, Spring 1987
Art Director Keith Godard
Photography Keith Godard, Various
Design Firm Studioworks, New York, NY
Publisher Bob Brown, Editor
Printer George Dembo
Paper Manufacturer 16-sheet Poster Wastesheets

4

Publication Poster Society Journal, Summer 1987
Art Director Keith Godard
Photography Keith Godard, Various
Design Firm Studioworks, New York, NY
Publisher Bob Brown, Editor
Printer George Dembo
Paper Manufacturer 16-sheet Poster Wastesheets

1

Self Promotion DESIGN! 3rd Anniversary Gift Wrap
Art Directors Russ Ramage, Bill Grant
Photographer Jerry Burns
Design Firm/Client DESIGN!, Dalton, GA
Typography In-house
Printer Colonial Printing
Paper Manufacturer Neenah Paper Company

2

Moving Announcement Mires Design
Art Directors/Designers Scott Mires, Jose Serrano
Photographer Chris Wimpey
Design Firm/Client Mires Design, Inc., San Diego, CA
Typography Mires Design, Inc.
Printer Bordeaux Printers
Paper Manufacturer Potlatch Paper Corporation

3

Promotional Calendar Morla Design 1992
Art Director/Designer Jennifer Morla
Photographer Holly Stewart
Design Firm Morla Design, Inc., San Francisco, CA
Typographer Copy It
Printers Paragraphics, Binderology
Paper Manufacturer Simpson Paper Company

4

Stationery Siebert Design
Art Director Lori Siebert
Designer Lisa Ballard
Photographer Brad Smith
Design Firm/Client Siebert Design Associates
Typography Siebert Design Associates
Printer Arnold Printing
Paper Manufacturer Simpson Paper Company

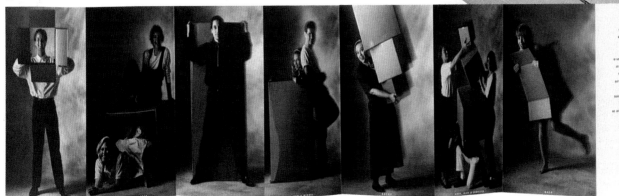

4

1

Poster Philip Burton: Defining Swiss Typography
Designer John Bowers
Design Firm John Bowers Design, Wausau, WI
Client Stanford University Department of Art
Typography/Printing John Bowers
Paper Manufacturer Strathmore Paper Company

2

Brochure Louis Dreyfus Energy
Art Director Tom Wood
Design Firm Patterson Wood Partners
Client Louis Dreyfus Energy
Paper Manufacturer Mohawk Paper Company

1992

18 May 3:15

University

of Illinois

Philip Burton

at Chicago

204
Stanford Art Building

"Defining Swiss Typography"

1

2

MUNICIPAL GOVERNMENTS AND AGENCIES. A RANGE OF ENERGY
PRODUCTS, INCLUDING CRUDE OIL, DIESEL FUEL, HEATING OIL,
GASOLINE AND NAPHTHA, IS MERCHANDISED TO INTERNATIONAL
AND DOMESTIC CUSTOMERS. WITH AN AGGRESSIVE COMMITMENT TO
THE PURCHASE OF ADDITIONAL RESERVES AS WELL AS CONTINUED
DRILLING, LOUIS DREYFUS CAN ASSURE SUPPLY CONTRACTS WITH
GUARANTEED PRICES AND DELIVERY SCHEDULES. ¶ ONE OF THE
BASIC REASONS FOR OUR SUCCESS IN THE PETROLEUM INDUSTRY IS
THE RELATIONSHIP WE HAVE WITH OUR CUSTOMERS. WE HAVE
DESIGNED A SERIES OF MARKETING PROGRAMS WHICH DIRECTLY
ADDRESS THEIR NEEDS. THROUGH THESE PROGRAMS, WE CAN
PROVIDE INNOVATIVE TOOLS WHICH ENABLE THEM TO CAPTURE NEW
MARKETS WHILE PROTECTING AND ENHANCING MARGINS IN THEIR
RETAIL BUSINESS. EACH CUSTOMER IS TREATED INDIVIDUALLY, AND
PROGRAMS ARE DESIGNED TO MEET HIS SPECIFIC REQUIREMENTS.
¶ LOUIS DREYFUS' COMMITMENT IN THE ENERGY FIELD IS DUE IN

Louis Dreyfus Energy is an innovative supplier who can put together long-term fuel supply packages that guarantee both price and delivery for the independent power producer. Louis Dreyfus Energy is able to combine traditional marketing techniques with new opportunities in an evolving deregulated market. To meet the increasing demand for electric power, Louis Dreyfus Energy is committed to providing fuel to cogeneration facilities at fixed prices for a set term. This is possible through the ownership and operation of gas reserves, effective management of production and transportation costs and global experience in merchandising and hedging activities.

3

3
Publication Louis Dreyfus Energy/E Book
Art Director Tom Wood
Photographer Jeff Corwin
Design Firm Patterson Wood Partners, New York, NY
Client Louis Dreyfus Energy
Printer Red Ink Productions
Paper Manufacturers Iknofix, PSI

4
Poster Swiss Posters 1952-1986
Art Director/Designer John Kane
Design Firm Sametz Blackstone Associates, Boston, MA
Client/Publisher AIGA/Boston, Art Institute of Boston
Typography In-house
Printer Arlington Lithograph
Paper Manufacturer Mead

4

1

Poster Beyond Buildings
Art Director Sean Adams
Designers Sean Adams, April Greiman
Design Firm Sean Adams, Los Angeles, CA
Client Los Angeles Forum for Architecture and Urban Design
Typographer RPI
Printer Glendale Rotary

2

Brochure OUTPUT
Art Director Mary Conrad Castagna
Designers Jill Wittnebel, Jana Wilson, Carey Smith,
David Erwin, David Villarreal, David Owens, Susie Hiskey,
Matt Mason, Steve Brown, Derek Pearcy
Project Supervisor Professor Diane Gromala
Design Firm University of Texas at Austin Design Department
Typographers David Erwin, Carey Smith
Printer Press Corps
Paper Manufacturer Simpson Paper Company

1

2

3

3

Poster Area

Art Directors John Pylypczak, Diti Katona

Designers John Pylypczak, Scott Christie

Photography Karen Levy, Diti Katona

Design Firm Concrete Design Communications Inc., Toronto, CAN.

Client Area

Typography Concrete, Macintosh

Printer Baker Gurney & McLaren

4

Announcement Alcan Architecture 1992

Art Director Anita Meyer

Designers Anita Meyer, Jan Baker, Matthew Monk

Design Firm plus design inc., Boston, MA

Client Alcan Aluminum Ltd.

Typographers Anita Meyer, Nicole Juen, Matthew Monk

Printers Arabesque Studio Ltd., Alpha Press

Paper Recycled Corrugated Cardboard

1

Book Jacket All the Pretty Horses
Art Director Carol Devine Carson
Designer Chip Kidd
Illustrator David Katzenstein
Client/Publisher Alfred A. Knopf, Inc., New York, NY
Typography Photolettering
Printer Coral Graphics
Paper Manufacturer Silver Co.

2

Stationery Bill Phelps
Art Director/Designer Haley Johnson
Design Firm Charles S. Anderson Design, Minneapolis, MN
Client Bill Phelps
Printer Litho, Inc.

2

3

3
Catalog In Lak'Esh
Art Director Wendy Ginther
Photographer Hedi Desuyo
Design Firm Pickmere Design, Fairfield, CA
Client In Lak' Esh
Typographer Macintosh
Printer Signature Press
Paper Manufacturer Nationwide Papers

4
Brochure Seven Kids/Six Chairs
Art Director Lise Metzger
Designer Michael Konetzka
Photographer Lise Metzger
Design Firm Konetzka Design Group, Washington, D.C.
Client Lise Metzger Photography
Printer Virginia Lithography
Paper Manufacturer Potlatch Corporation

4

1

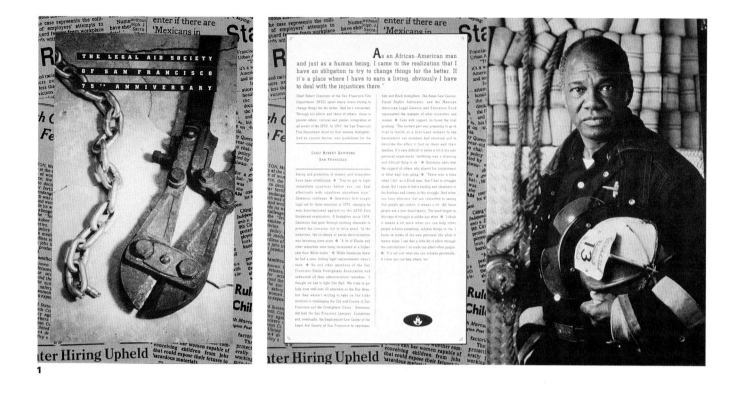

2

3
Brochure Visiting Battlefields: The Civil War
Designer Nan Dearborn, Bruce Geyman
Photography Archival
Design Firm Geyman Design Office, Reston, VA
Client National Parks and Conservation Association
Typography In-house
Printer French Bray, Inc.
Paper Manufacturer Champion International

4
Book Jacket Wuthering Heights/Everyman's Library Series
Art Director Carol Devine Carson
Designers Barbara de Wilde, Carol Devine Carson
Client/Publisher Alfred A. Knopf, Inc., New York, NY
Typography Photolettering

3

4

EMILY
BRONTE

WUTHERING

HEIGHTS

EVERYMAN'S LIBRARY

1

Poster Men of Letters, "T"
Art Directors Craig Frazier, John Casado
Designer Craig Frazier
Photographer John Casado
Design Firm Frazier Design, San Francisco, CA
Client/Typography Display Lettering + Copy
Printer Watermark Press
Paper Manufacturer S.D. Warren

2

Poster Men of Letters, "K"
Art Directors Craig Frazier, John Casado
Designer Craig Frazier
Photographer John Casado
Design Firm Frazier Design, San Francisco, CA
Client/Typography Display Lettering + Copy
Printer Watermark Press
Paper Manufacturer S.D. Warren

3

Poster Men of Letters, "Q"
Art Directors Craig Frazier, John Casado
Designer Craig Frazier
Photographer John Casado
Design Firm Frazier Design, San Francisco, CA
Client/Typography Display Lettering + Copy
Printer Watermark Press
Paper Manufacturer S.D. Warren

4

Promotion Paul Drescher Ensemble
Art Director Brian Boram
Designers Thomi Wroblewski, Marion Gray, Allen Nomura, Allen Ashton
Design Firm Boram Design, Seattle, WA
Client Paul Drescher Ensemble
Typography Eurotype, Macintosh
Printing Logos Graphics, Honeywell & Todd
Paper Manufacturer Simpson Paper Company, Gilbert Paper

5

Stationery Shin Sugino Photography
Art Director Del Terrelonge
Designer Jennifer Louie
Photographer Shin Sugino
Design Firm Terrelonge Design Inc., Toronto, CAN
Client Shin Sugino
Printer Angel Reproductions
Paper Manufacturer Whyte Hooke Papers

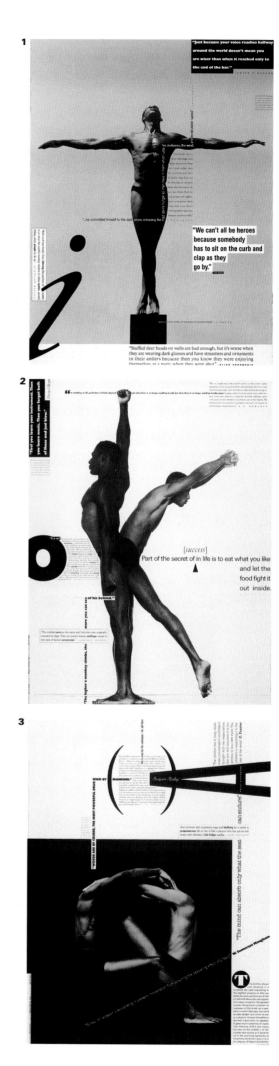

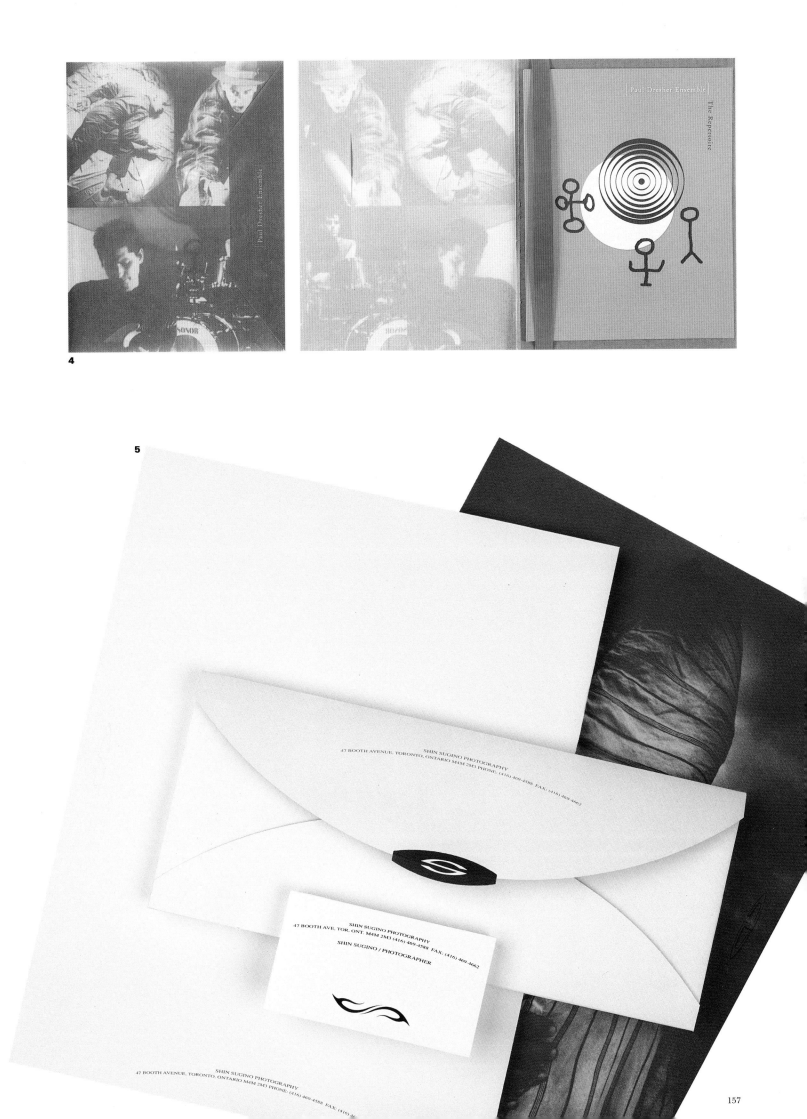

4

5

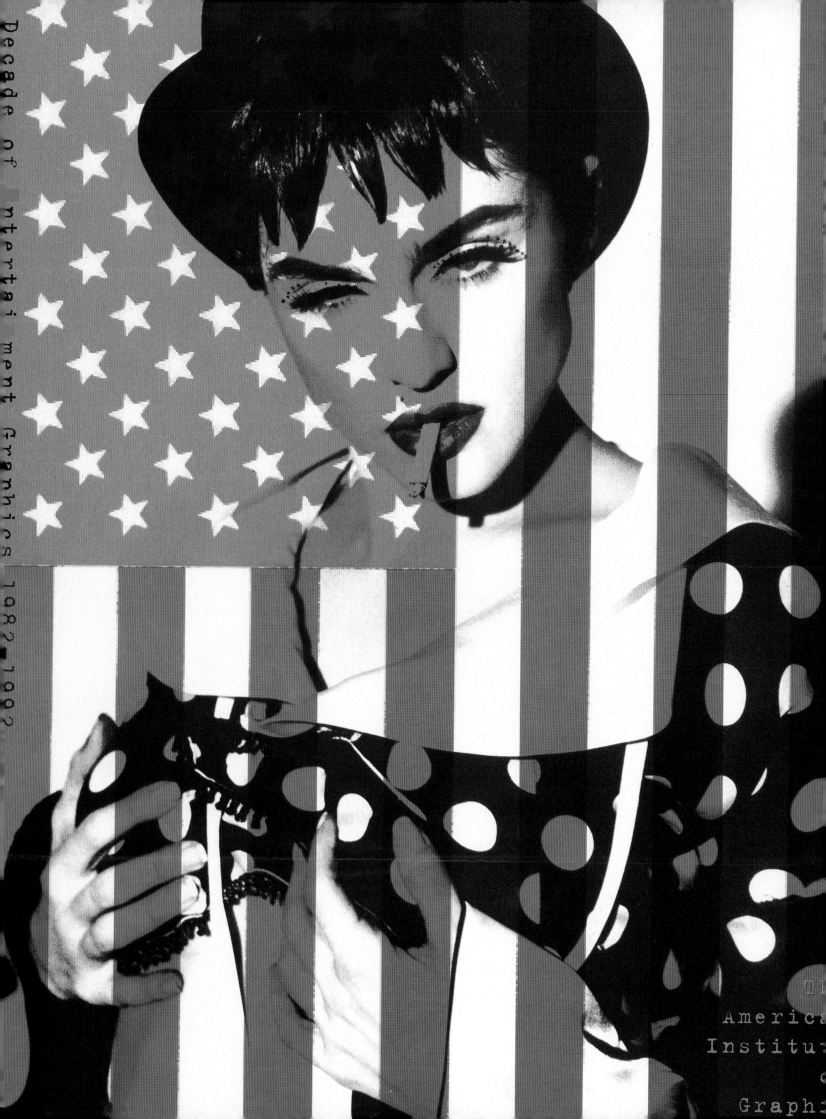

American
Institute
of
Graphics

ow can just 380 pieces represent a decades' worth of movie posters, album covers, CD packages, video and broadcast graphics, film titles, theater posters, tour books, T-shirts, and everything else designed under the broad banner of "Entertainment Graphics"? It can't. But a "sampler" can be compiled from the images you will see on the following pages — icons that take us back to the events and emotions spanning the years ween 1982-1992.

While judging this show, we lamented the evident demise of the album cover, an art form inspired more than a few of us to become graphic designers. But we saw new life in the n of the specialty CD package — a designer's dream — and one that did not shrink creativity g with the format size. As expected, a major portion of the show is on video — a medium ch has impacted design immeasurably.

Why a show of entertainment graphics? Because entertainment is America's second largest ort. In a way it's the universal language of pop culture. And graphic design is an essential nent of that language: it distills the global perceptions of our culture. The world sees us not through a movie lens or music video, but through the persuasion and entertainment of hic design. With this exhibition, the AIGA has ambitiously tried to record the view.

My thanks to the diverse and interesting group of judges who agreed to help compile our pler. It may not be comprehensive, but it's got a great beat and you can almost dance to it.

t Hunter, *Chairman*

Hunter (Chair)
ive Director
kfurt Gips Balkind
York, NY

rt Greenberg
dent/CEO
reenberg Associates
York, NY

Heiden
Creative Services
ner Bros. Records
York, NY

Koepke
ner
York, NY

es McMullan
rator
York, NY

y Oberman
ner
York, NY

Terkuhle
Creative Director
, New York, NY

Call for Entries

Design Frankfurt Gips Balkind
Photography Herb Ritts
Paper Mohawk Poseidon
Perfect White, High Finish, 80 lb. Text
Printer Heritage Press
Special thanks to Warner Bros.
Records, Jeri Heiden, Valerie Herzberg,
Liz Rosenberg, Christine Wolff and
Madonna

1

Record Album Cover Prince and the Revolution "Parade"
Art Director Laura LiPuma-Nash
Photographer Jeff Katz
Design Firm/Client Warner Bros. Records, Nashville, TN

2

Record Album Cover Cyndi Lauper "What's Going On"
Art Directors Gary Drummond, Cyndi Lauper
Designer Gary Drummond
Photographer Annie Liebovitz
Design Firm CBS Records, New York, NY
Client Epic Records

3

Record Album Cover The Doors "Classics"
Art Director Carol Friedman
Designer Carin Goldeberg
Photographer Joel Brodsky
Client Elektra Records

4

Record Album Cover Steve Winwood "Back In The Highlife"
Art Directors Jeffrey Kent Ayeroff, Jeri Heiden
Designer Jeri Heiden
Photographer Arthur Elgort
Design Firm Warner Bros. Records, Burbank, CA
Client Island Records
Printer Ivy Hill

5

Record Album Cover The Police "Synchronicity"
Art Director Jeff Ayeroff
Designer Norman Moore
Photographer Duane Michals
Design Firm Design/Art, Inc., Los Angeles, CA
Client A & M Records

6

Record Album Cover k.d. lang "Absolute Torch and Twang"
Art Directors Jeri Heiden, k.d. lang
Photographer Victoria Pearson
Prairie Photographs Westlight L.A.
Design Firm Warner Bros. Records, Burbank, CA
Client Sire Records
Typographer Aldus Type Studio, LA
Printer Ivy Hill

7

Record Album Cover "Fishbone"
Art Director/Designer Gary Drummond
Photographer Max Aquilera-Hellweg
Design Firm Sony Music, New York, NY
Client/Publisher Columbia Records

8

Laser Disc Packaging Nigel Kennedy
Art Director Scott Mednick
Designer Loid Der
Photographer Various
Agency The Mednick Group
Publisher Pioneer LDCA, Inc.

63RD ANNUAL ACADEMY AWARDS. MARCH 25 abc

1
Movie Poster Oscar
Art Directors Saul Bass, Art Goodman
Design Firm Bass/Yager and Associates, Los Angeles, CA
Client Academy of Motion Picture Arts & Sciences

2
Logo NBC
Design Director Ivan Chermayeff, Thomas Geismar
Design Firm Chermayeff & Geismar Inc., New York, NY
Client National Broadcast Company

3
Promotional T-Shirt "Channel No. 2"
Art Director Chris Pullman
Designers Tom Sumida, Chris Pullman
Photographer Tom Sumida
Design WGBH Design, Boston, MA
Client WGBH, Boston

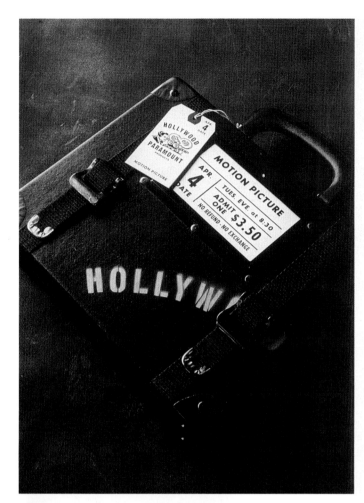

Zero Hour!

Good Timing and a Touch of Movie Magic Turn the Classic
Wristwatch into a Big Production. And Best of All, the Stars
Are Out No Matter What Time of Day It Is.

4

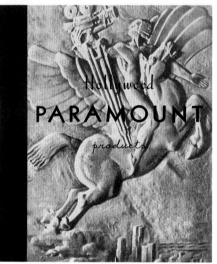

4
Brochure Paramount Products
Art Directors Charles S. Anderson, Daniel Olson, Halen Johnson
Designers Charles S. Anderson, Daniel Olson, Haley Johnson
Photographer Dave Bausman
Design Firm Charles S. Anderson Design Co., Minneapolis, MN
Client Hollywood Paramount Products

5
Sale/Promotional Apparel Paramount Hats
Art Director Charles S. Anderson
Designers Daniel Olson, Charles S. Anderson
Design Firm Charles S. Anderson Design Co., Minneapolis, MN
Client Hollywood Paramount Products

5

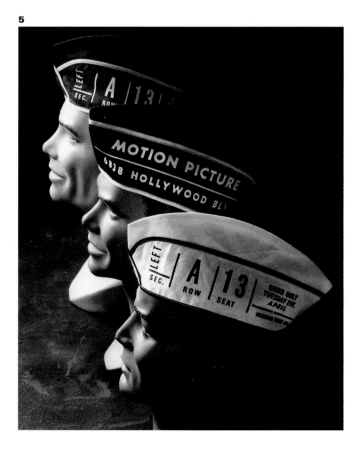

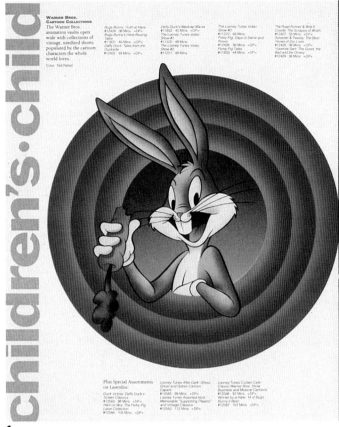
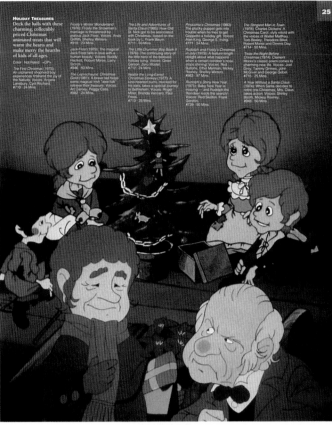

1

1

Catalog W H V '92/'93
Art Director/Designer Michael Brock
Photographer Robert Peak
Design Firm Michael Brock Design, Los Angeles, CA
Client/Publisher Warner Home Video
Typographer Characters & Color
Printer Alan Lithograph

2

Music Packaging "The Carl Stalling Project:
Music from Warner Bros. Cartoons"
Art Director Tom Recchion
Photography Warner Bros. Animation Archives and
Steve Schneider Archives
Design Firm Warner Bros. Records, Burbank, CA
Client Warner Bros. Records
Printer Ivy Hill

2

3

3
Catalog W H V '90/'91
Art Director Michael Brock
Designers Michael Brock, Daina Howard-Kemp
Design Firm Michael Brock Design, Los Angeles, CA
Client/Publisher Warner Home Video
Typographer Characters & Color
Printer Pro Color

4
Logo Time Warner
Design Director Steff Geissbuhler
Design Firm Chermayeff & Geismar Inc., New York, NY
Client Time Warner

5
Environmental Signage Time Warner
Design Director Steff Geissbuhler
Design Firm Chermayeff & Geismar Inc., New York, NY
Client Time Warner Production Company Network

1
Movie Poster "Barton Fink"
Art Directors Lucinda Cowell, Ron Michaelson
Designer Evan Wright
Design Firm Concept Arts, Hollywood, CA
Client 20th Century Fox
Typographer Bruce Peterson

2
Movie Poster "Edward Scissorhands"
Art Directors Chris Pula, David Gross
Designers Shari Chapman, John O'Brien
Photographer Zade Rosenthal
Design Firm Cimarron/Bacon/O'Brien, Hollywood, CA
Client/Publisher David Gross, Jim Darbinian, 20th Century Fox
Typographer (Logo) John O'Brien

3

1

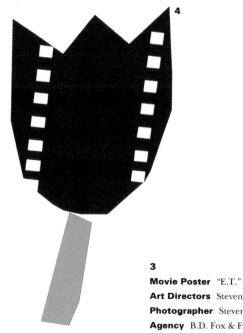

2

4

3
Movie Poster "E.T."
Art Directors Steven Spielberg, Brian D. Fox
Photographer Steven Spielberg
Agency B.D. Fox & Friends, Inc. Advertising
Client Universal Pictures, David Weitzner

4
Logo Tulip Films
Design Director Ivan Chermayeff
Design Firm Chermayeff & Geismar Inc., New York, NY
Client Tulip Films

5

Poster Filmex '85

Art Directors Saul Bass, Art Goodman

Design Firm Bass/Yager and Associates, Los Angeles, CA

Client Los Angeles International Film Exposition

6

Movie Poster "Prizzi's Honor"

Art Director Robert Biro

Writer Brenda Mutchnick

Illustrator Gemma Lamana Wills

Photographer Mike Bryan

Agency B.D. Fox & Friends, Inc. Advertising

Client Twentieth Century Fox, Tim Deegan

Typographer Tom Nikosey

7

Movie Poster "Sid & Nancy"

Art Directors Kathie Broyles, Tracy Weston

Design Firm Broyles & Associates, Los Angeles, CA

Client The Samuel Goldwyn Company

6

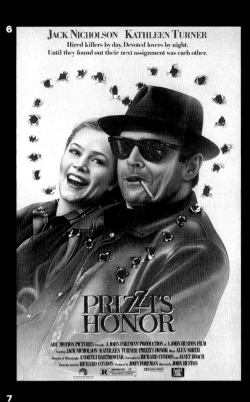

7

5

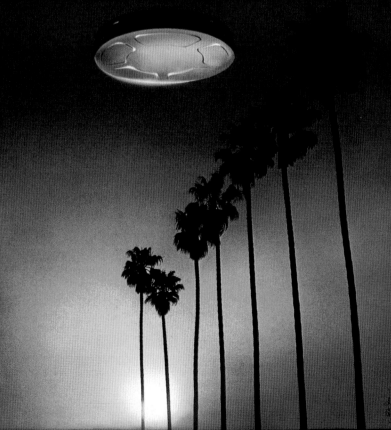

1

1

Editorial "Robert Altman — The Rolling Stone Interview"
Art Director/Designer Fred Woodward
Director of Photography Laurie Kratochvil
Photographer Albert Watson
Client Rolling Stone Magazine
Publisher Straight Arrow Publishers

2

Music Packaging k.d. lang "ingenue"
Art Director Jeri Heiden
Designers Jeri Heiden, Greg Ross
Photographer Glen Erler
Design Firm Warner Bros. Records, Burbank, CA
Client Warner Bros./Sire Records
Typographer Donald Young
Printers Westland Graphics, Ivy Hill

2

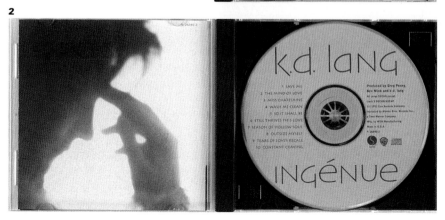

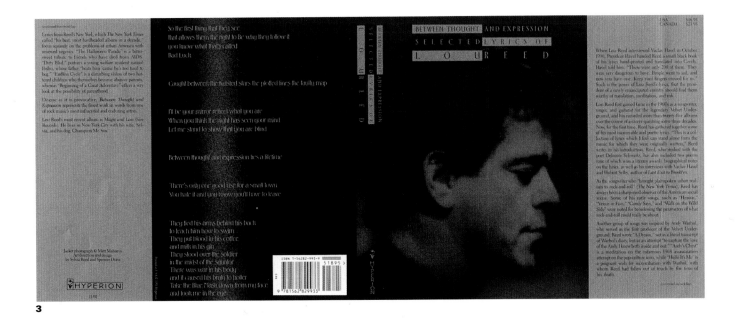

3

Book Jacket "Between Thought and Expression:
Selected Lyrics of Lou Reed"
Art Directors Sylvia Reed, Spencer Drate
Designers Sylvia Reed, Spencer Drate
Photographer Matt Mahurin
Design Firm Just Design, New York, NY
Client Hyperion Publishing
Typographer JCH Group

4

Editorial David J
Art Director David Carson
Design Firm David Carson Design, Del Mar, CA
Client Ray Gun Magazine
Typographer David Carson

5

Music Packaging Lou Reed/John Cale "Songs for Drella"
Art Directors Tom Recchion, Sylvia Reed
Booklet Photographs Billy Name, Nat Finkelstein, Stephen Shore,
Ise Valeris, Gerard Malanga, Ebel Roberts
Photograph of Andy Warhol Billy Name
Photograph of Lou Reed & John Cale James Hamilton
Design Firm Warner Bros. Records, Burbank, CA
Client Warner Bros./Sire Records
Printer AGI

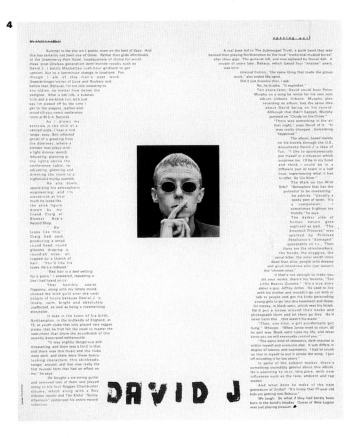

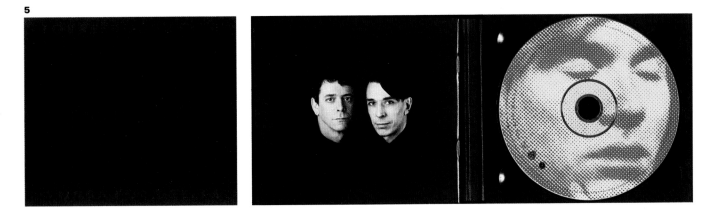

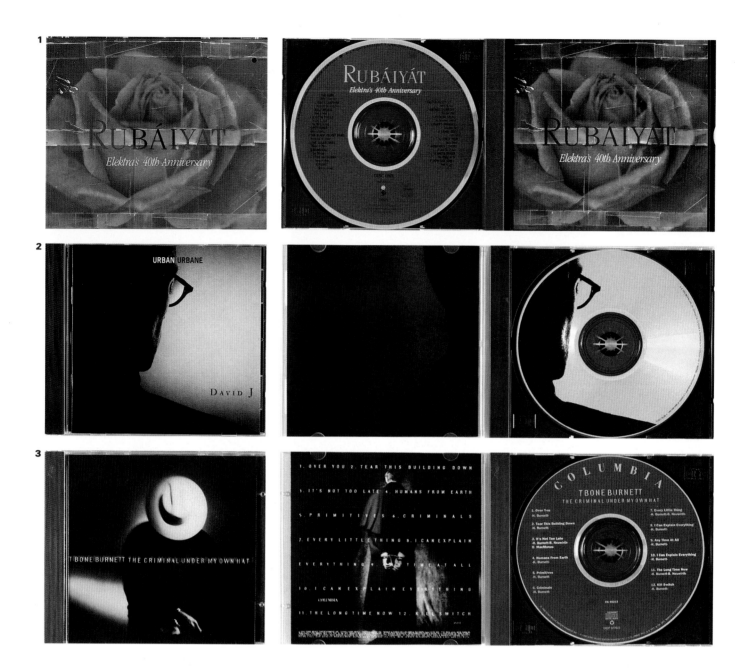

1

Music Packaging "Rubaiyat"

Art Directors Bob Krasnow, David Bither

Designers Pat Gorman & Frank Olinsky/
Manhattan Design, New York, NY

Cover Art Doug & Mike Starn

Client/Publisher Elektra Entertainment

2

Music Packaging David J "Urban Urbane"

Art Director Tim Stedman

Designers Mitch Jenkins, David J,
Tim Stedman, Todd Gallopo

Photographer Mitch Jenkins

Client MCA Records

Typographer Tim Stedman

3

Music Packaging T-Bone Burnett
"The Criminal Under My Own Hat"

Art Director Mary Maurer

Photographer Steve Nilsson

Design Firm Sony Music, Santa Monica, CA

Client/Publisher Columbia Records

4

Editorial "Elvis Costello/The Rolling Stone Interview"
Art Director Fred Woodward
Designer Jolene Cuyler
Director of Photography Laurie Kratochvil
Photographer Matt Mahurin
Client Rolling Stone Magazine
Publisher Straight Arrow Publishers

5

Music Packaging Elvis Costello "Mighty Like A Rose"
Art Directors Steven Baker, Dirk Walter
Digipak Design Dirk Walter
Booklet Design Mike Krage, Eammon Singer
Photography and Handtinting Amelia Stein
Design Firm Warner Bros. Records, Burbank, CA
Client Warner Bros. Records
Printer AGI, Chicago

6

Logo Epic Records
Art Director Mark Burdett
Design Firm Sony Music, New York, NY
Client Epic Records

1

1

Booking Packet Paul Dresher Ensemble
Art Director Brian Boram
Illustrators/Photographers Thomi Wroblewski,
Marion Gray, Allen Ashton, Allen Nomura
Design Firm Boram Design, Seattle, WA
Client Paul Dresher Ensemble
Typographer Brian Boram, Macintosh
Printers Logos Graphics, Honeywell & Todd
Paper Manufacturers Simpson, Gilbert

2

Book Jacket Barry Gifford "Night People"
Designers Fiona Scrymgour, David High
Photographers FPG International (top) Doris Kloster (bottom)
Client/Publisher Grove Press
Typographers Fiona Scrymgour, David High
Printer New England Book Components
Paper Manufacturer Standard

2

3

4

3

Movie Poster "Swoon"
Art Directors Marlene McCarty, Donald Moffett
Designers Marlene McCarty, Donald Moffett
Photographers James White & Valda Drabla
Design Firm BUREAU, New York, NY
Typography Trufont, Miller & Debel, BUREAU
Client Fine Line Features
Printer Fleetwood

4

Poster "Hydrogen Jukebox"
Art Director Gil Shuler
Design Firm Gil Schuler Graphic Design, Inc., Charleston, SC
Client Huell Adams

5

Environmental/Stage Graphics "New Music America
Projection Graphics"
Art Director Stephen Doyle
Designer Andrew Gray
Design Firm Drenttel Doyle Partners, New York, NY
Client Brooklyn Academy of Music

5

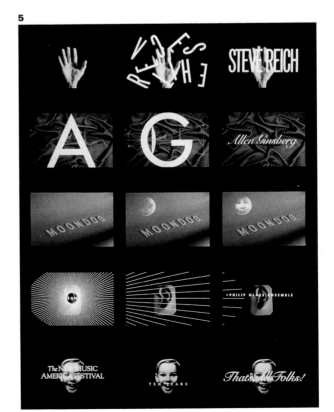

1
Music Packaging Peter Gabriel "Us"
Designer Malcom Garrett
Illustrators Various
Photographer David Scheinmann
Design Firm/Client Geffen Records, Los Angeles, CA

2
Poster "Roger Water's Radio K.A.O.S."
Art Directors Chris Austopchuk
Designer Chris Austopchuk
Design Firm Sony Music, New York, NY
Client Sony Music

3
Logo E! Entertainment Television
Art Director Holly Chasin
Designer Holly Chasin
Design Firm/Client E! Entertainment Television,
Los Angeles, CA

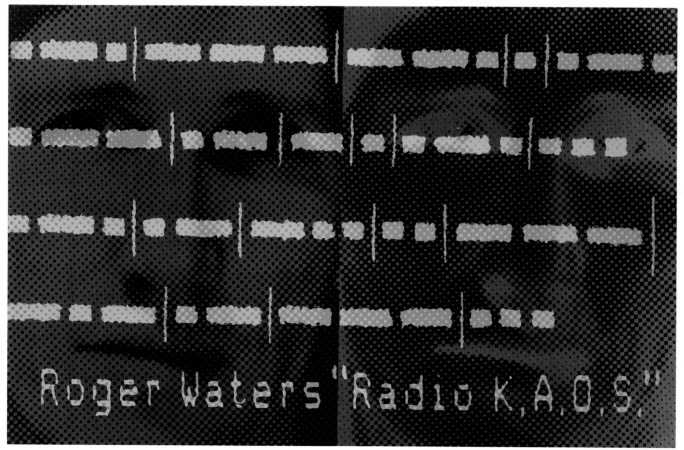

4

Music Packaging/Promotional Book "Lilliput"
Art Directors Vaughan Oliver and Chris Bigg at v23
Design Assistance Paul McMenamin
Text Designer Martin Ashton
Photographers Beverly Carruthers, Tamar Cohen, Dominic Davies, Jim Friedman, Nigel Grierson, Simon Larbalestier, Shinro Ohtake, Sarah Tucker, Kevin Westenberg
Design Firm v23/4AD Records, London, U.K.
Client 4AD Records
Printer Tinsley Robor Group PLC

5

Editorial "Robbie Robertson — The Rolling Stone Interview"
Art Director/Designer Fred Woodward
Director of Photography Laurie Kratochvil
Writer Robert Palmer
Photographer Diego Uchitel
Client Rolling Stone Magazine
Publisher Straight Arrow Publishers

IS ANYONE THERE?

THANKSGIVING

NOVEMBER 6

1
Movie Teaser Poster "Dracula"
Art Director John Kane
Designer Margo Chase
Photographer Sydney Cooper
Design Firm Margo Chase Design, Los Angeles, CA
Client Columbia Pictures

2
Movie Poster "Jennifer 8"
Art Directors Lucinda Cowell, Ron Michaelson
Designers Lucinda Cowell, Jennifer MaHarry
Photographer Sheila Metzner
Design Firm Concept Arts, Hollywood, CA
Client Paramount Pictures
Typographer Evan Wright

3
Movie Poster "Exposed"
Art Director Jeffrey Bacon, John O'Brien
Photographer Unit Photography
Design Firm Cimarron/Bacon/O'Brien, Hollywood, CA
Client/Publisher Gregory Morrison, MGM/UA
Typographer (Logo) Tim Girven

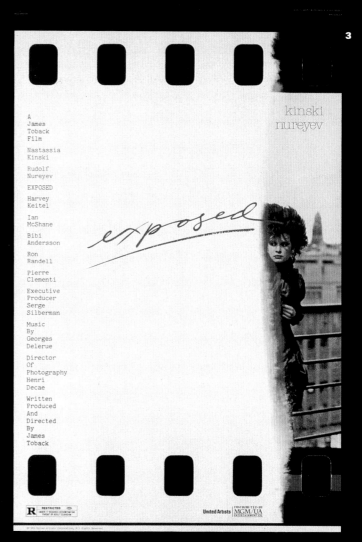

4
Movie Poster "Dead of Winter"
Art Director/Designer Mike Salisbury
Design Firm Mike Salisbury Communications Inc., Torrance, CA
Typographer Cel
Printer National Screen

5
Poster "Heart of a Dog"
Designers Paul Sahre, Gregg Heard
Client Fells Point Corner Theatre
Typographer Paul Sahre
Printer Mumbo-Jumbo
Paper Manufacturer Mohawk

6
Poster Halloween Concert
Art Director Allen Moore
Design Firm Allen Moore & Associates, New York, NY
Client Yale Symphony Orchestra
Typographer/Printer Sirocco
Paper Manufacturer Mohawk

1

2

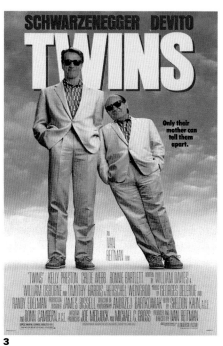

3

1

Movie Poster "Twins" (DeVito Teaser)
Art Director/Designer Tom Martin
Copywriter Tom Martin
Photographer Annie Leibovitz
Design Firm/Client MCA/Universal Pictures, Universal City, CA

2

Movie Poster "Twins" (Schwarzenegger Teaser)
Art Director/Designer Tom Martin
Copywriter Tom Martin
Photographer Annie Leibovitz
Design Firm/Client MCA/Universal Pictures, Universal City, CA

3

Movie Poster "Twins"
Art Director Tom Martin
Designers Tom Martin, Michael Gross
Copywriter Tom Martin
Photographer Annie Leibovitz
Design Firm/Client MCA/Universal Pictures, Universal City, CA

4

Movie Poster "Slaves of New York"
Art Directors Lucinda Cowell, Ron Michelson
Designer Jennifer MaHarry
Illustrator Lucinda Cowell
Design Firm Concept Arts, Hollywood, CA
Client Tri Star Pictures
Typographer Lucinda Cowell

4

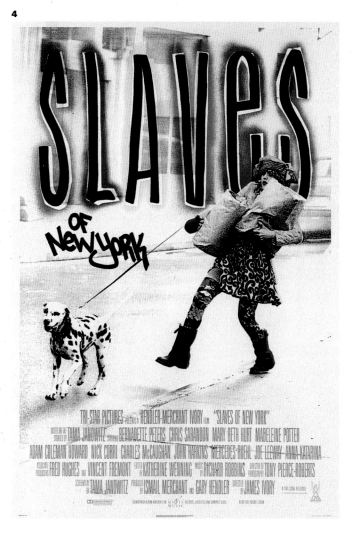

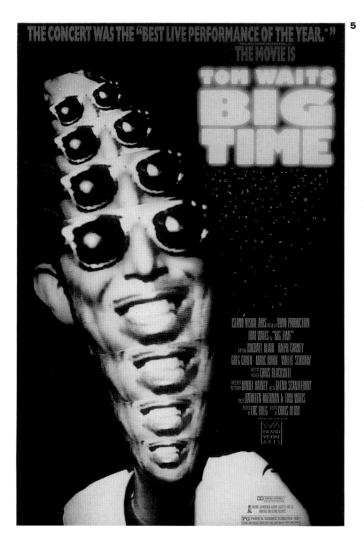

THE CONCERT WAS THE "BEST LIVE PERFORMANCE OF THE YEAR."
THE MOVIE IS
TOM WAITS
BIG
TIME

5

5
Movie Poster "Big Time"
Art Directors Lucinda Cowell, Ron Michaelson
Designer Bruce Peterson
Design Firm Concept Arts, Hollywood, CA
Client Island Pictures
Typographer Ron Michaelson

6
Band Logo Beer Whores
Art Director/Illustrator Karen Koziatek
Design Firm KMKdesign, Chicago, IL
Client Beer Whores
Typographer Macintosh

7
Editorial "Big Shot"
Art Director Fred Woodward
Designer Debra Bishop
Director of Photography Laurie Kratochvil
Photographer Herb Ritts
Client Rolling Stone Magazine
Publisher Straight Arrow Publishers

6

7

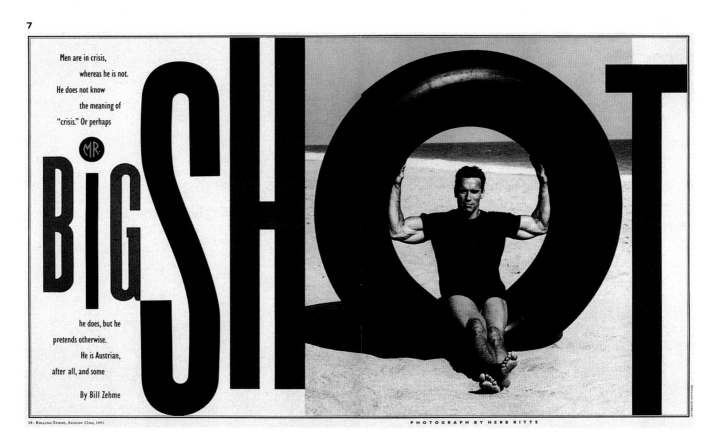

Men are in crisis,
whereas he is not.
He does not know
the meaning of
"crisis." Or perhaps

he does, but he
pretends otherwise.
He is Austrian,
after all, and some

By Bill Zehme

Mr. BIG SHOT

PHOTOGRAPH BY HERB RITTS

179

1

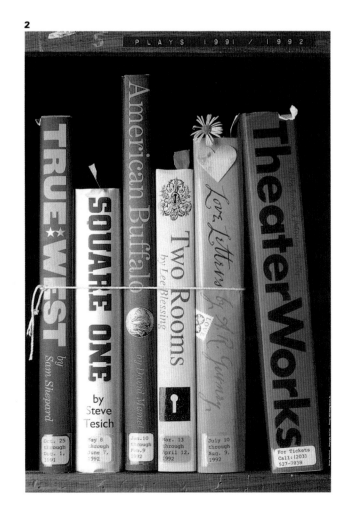

2

1
Poster Series "Les Fourberies de Scapin"
Art Director Danielle Roy
Designer Paulo Correia
Photographer Normand Gregoire
Client/Publisher Groupe Juste Pour Rire, Montreal, CAN
Typographer Paulo Correia
Printer Hit Graphiques
Paper Manufacturer Magnomatt

2
Poster TheaterWorks 91-92 Plays
Art Director/Designer/Illustrator Peter Good
Photographer Jim Coon
Design Firm Peter Good Graphic Design, Chester, CT
Client TheaterWorks
Typographer Typehouse

3
Poster "T-Bone 'n Weasel"
Art Director/Illustrator Paul Sahre
Designers Paul Sahre, Chris Panzer
Client Fells Point Corner Theatre
Typographer Paul Sahre
Printer Mumbo-Jumbo
Paper Manufacturer Mohawk

4
Poster "Boris Godunov"
Art Director Julia Saylor
Designer/Illustrator Michael Schwab
Design Firm Michael Schwab Design, Sausalito, CA
Client San Francisco Opera
Typographer Andresen Typographics

5

3

6

4

5
Poster AICP/MoMa: The Art and Technique
of the American Television Commercial
Art Director Richard Poulin
Designer J. Graham Hanson
Design Firm Richard Poulin Design Group Inc., New York, NY
Client Association of Independent Commercial Producers
Typographer Quark XPress
Printer Colahan-Saunders Corporation
Paper Manufacturer S.D. Warren

6
Logo "Alice B. Theatre"
Art Directors Rick Rankin, Susan Finque, Christopher Malarkey
Designer Michael Strassburger
Design Firm Modern Dog, Seattle, WA
Client Alice B. Theatre
Typographer Michael Strassburger

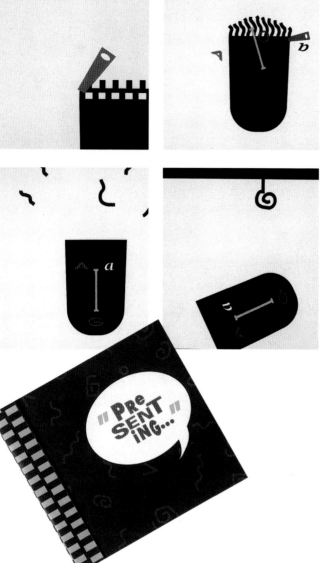

1

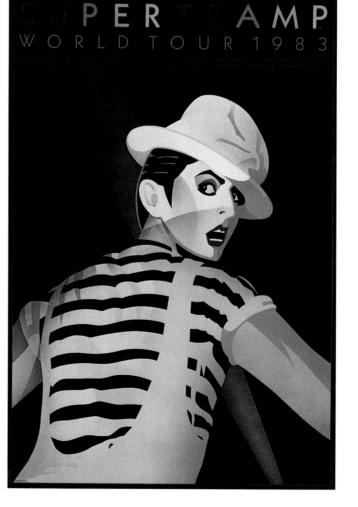

1
Flip Book AIGA Film Night
Designers Melanie Bass, Julie Sebastianelli, Richard Hamilton,
Andres Tremols, Jim Jackson, Pam Johnson, Neil Kopping
Writer Jake Pollard
Illustrators Melanie Bass, Julie Sebastianelli
Client/Publisher AIGA, Washington
Printer Peake Printers, Specialties Bindery, Inc.
Paper Manufacturer Champion Paper

2
Poster Supertramp — "World Tour 1983"
Art Director/Illustrator Norman Moore
Design Firm Design/Art, Inc., Los Angeles, CA
Client Supertramp

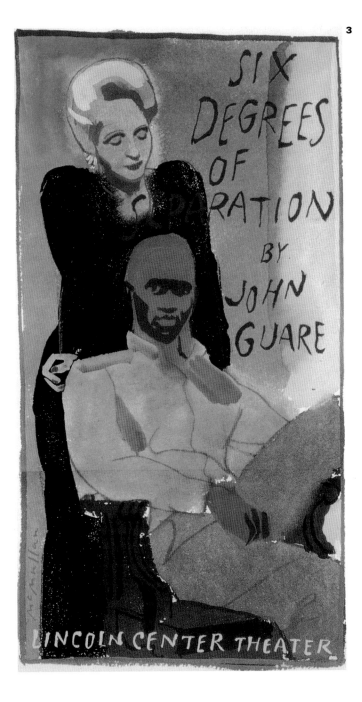

3

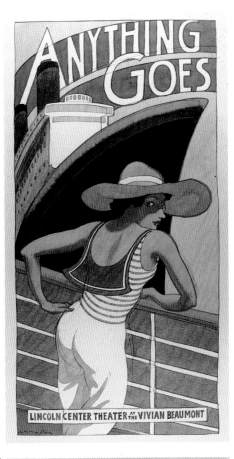

4

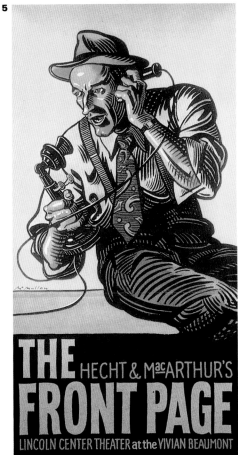

5

3

Environmental Graphics/Poster Six Degrees of Separation
Art Director Jim Russek
Illustrator James McMullan
Design Firm Russek Advertising, New York, NY
Client Lincoln Center Theater

4

Environmental Graphics/Poster Anything Goes
Art Director Jim Russek
Illustrator James McMullan
Design Firm Russek Advertising, New York, NY
Client Lincoln Center Theater

5

Environmental Graphics/Poster The Front Page
Art Director Jim Russek
Illustrator James McMullan
Design Firm Russek Advertising, New York, NY
Client Lincoln Center Theater

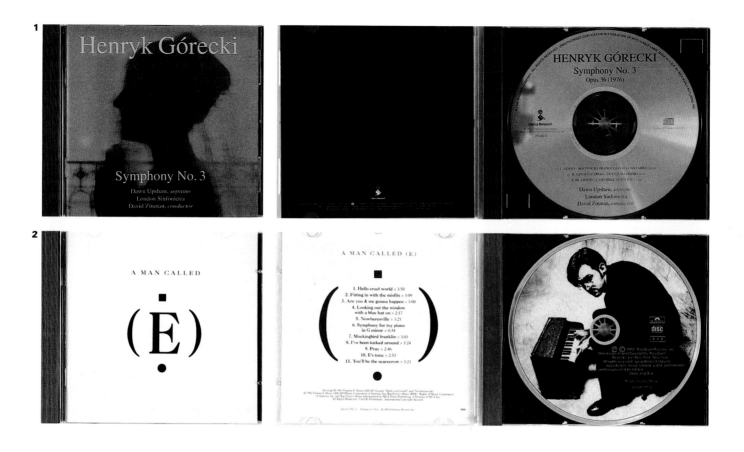

1
Music Packaging Henryk Gorecki "Symphony No. 3"
Art Director John Heiden
Photographer Gertrude Kasebier
Client/Publisher Elektra Entertainment

2
Music Packaging "A Man Called E"
Art Director David Lau
Design Firm Polygram Records, New York, NY
Client A Man Called "E"
Publisher Polygram Records
Printer Shorewood

3
Brochure Dalton Little Theatre 38
Art Directors Russ Ramage, Bill Grant
Designers Sheryl Fendley, Russ Ramage
Photograpgher/Typographer In-house
Design Firm DESIGN!, Dalton, GA
Client/Publisher Dalton Little Theatre
Printer Lee Printing
Paper Manufacturer Neenah Paper

4

Charge by phone: 527-5151 Group discount information: 525-5601 **25ᵗʰ SEASON**

Hartford Stage.

5

NEW YORK
CITY OPERA
CHRISTOPHER KEENE, GENERAL DIRECTOR

4

Poster "Serenading Louie"
Art Director William Wondriska
Designer/Illustrator Christopher Passehl
Design Firm Wondriska Associates Inc., Farmington, CT
Client Hartford Stage Company
Typographer Eastern Typesetting
Printer The Graphic Center

5

Poster La Traviata
Art Director Alane Gemagen
Designer/Illustrator Rafal Olbinski
Design Firm/Agency Ziff Marketing, New York, NY
Client New York City Opera

6

TV Program Title "Northern Exposure"
Art Director Kathie Broyles
Designer Peter Robbins
Design Firm Broyles & Associates, Los Angeles, CA

6

NORTHERN EXPOSURE

SYNERGY
SEMI-CONDUCTOR

1

2

3

4

BRIDGET SULLIVAN

SALES & MERCHANDISING
MANHATTAN RECORDS

1370 Avenue of the Americas, New York, New York 10019 (212) 541-6401

1

Music Packaging Manhattan Records
Art Director Paula Scher
Design Firm Pentagram Design, New York, NY
Typographer CBS Records

2

Record Album Cover Synergy "Semi-Conductor"
Art Director Murray Brenman
Photographer Miguel Pagliere
Design Firm Passport Records
Client Passport Records
Typographer Paintom Studios/Typehaus
Printer Shorewood Packaging (Canada)

3

Logo Manhattan Records
Art Director/Designer Paula Scher
Design Firm Pentagram Design, New York, NY
Client Manhattan Records
Typographer Paula Scher

4

Identity Program Manhattan Records
Art Director/Designer Paula Scher
Design Firm Pentagram Design, New York, NY
Client Manhattan Records
Typographer Paula Scher

5

Environmental Signage Walter Reade Theater
Design Director Ivan Chermayeff
Design Firm Chermayeff & Geismar Inc., New York, NY
Client Film Society of Lincoln Center
Production Company 10/11A

6

Promotional Button Set Talking Heads "Speaking in Tongues"
Art Director Jim Wagner
Design Firm Warner Bros. Records, Burbank, CA
Client Warner Bros. Records

1
Environmental Graphics/Set Design
"Where in the World is Carmen San Diego?"
Art Director Laura Brock
Production Designer James Fenhagen
Executive Producers Kate Taylor, Jay Rayvi

2
Invitation Holiday Greetings
Art Director/Designer Stacy Drummond
Design Firm Sony Music, New York, NY
Client CBS Records

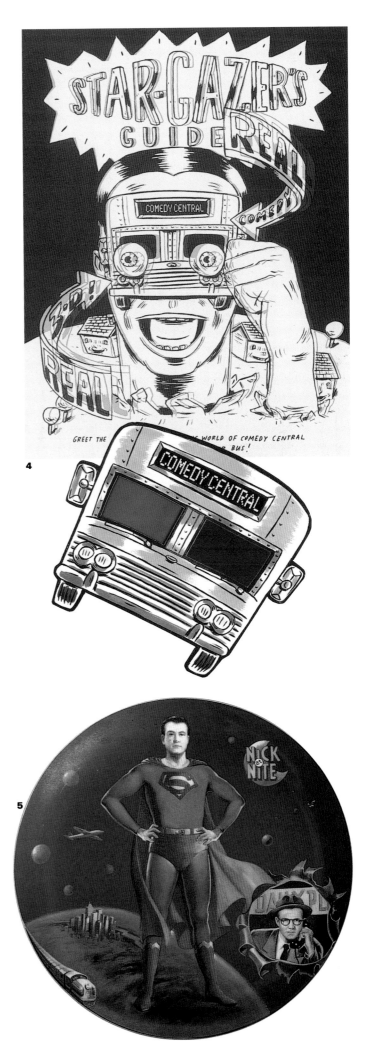

3

Marketing Brochure I Love Your Big Strong Comedy
Art Director Scott Wadler
Illustrator Mark Marek
Design Firm MTV Networks Creative Services, New York, NY
Client Comedy Central
Typographer Characters
Printer Atwater

4

Promotional Folder Star-Gazer's Guide
Art Director Scot Wadler
Illustrator Steven A. Wacksman
Design Firm MTV Networks Creative Services, New York, NY
Client Comedy Central
Typographer Steven A. Wacksman
Printer Atwater/Theatric Support

5

Souvenir Plate Nick-at-Nite "Superman"
Art Director Laurie Keiliher
Illustrators Da-Zhou Wang, Shengyuan Lan
Design Firm MTV Networks Creative Services, New York, NY

1
Movie Poster "Let's Get Lost"
Art Director Sam Shahid
Photographer William Claxton
Client/Publisher Zeitgeist Films Ltd.

2
Souvenir/Press Kit The Pennsylvania Road Show
Art Director Corey Glickman
Illustrator Susan McConnell
Design Firm WQED, Pittsburgh, PA
Client WQED 13
Typographer Don Antal
Printer Mercury Printing
Paper Manufacturer Mohawk

1

2

rific. More of them than you can imagine - so many that the ducks
do walk on the fishes' backs hoping to catch some of that bread.
ngry carp have been attracting tourists since the spillway was
1930s.

to York, visit the "shoe house." First built in 1948 as an
ick, newlyweds were invited to spend their honey-
ng the 50s. Now you can have a guided tour of this
come-to-life...including the living room (in the toe) and
(in the heel).

iles down the road, you may be surprised to spot a giant
lifter spinning atop a building. It's designed to bring you in to
he Weightlifting Hall of Fame. You don't have to be in prime
nysical condition to go into the place, but you might leave inspired to
do something about that spare tire.

Since 1953, many a traveler has stopped in Shartlesville at the world-
famous Roadside America. This masterpiece of folk art, nicknamed

3

Editorial 1992 Yearbook
Art Director Fred Woodward
Director of Photography Laurie Kratochvil
Photographer Geof Kern
Client Rolling Stone Magazine
Publisher Straight Arrow Publishers

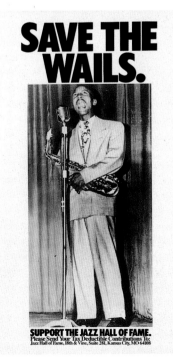

4
Poster Jazz '91
Art Directors Sylvain Beauregard, Yves Archambault
Designer Yves Archambault
Illustrator Luc Robitaille
Design Firm/Client Festival International de Jazz de Montreal, Montreal, CAN
Printer Acme Litho. Montreal

5
Poster Save the Wails
Art Director/Designer John Muller
Photographer Stock
Design Firm Muller & Company, Kansas City, MO
Client KC Jazz Commission

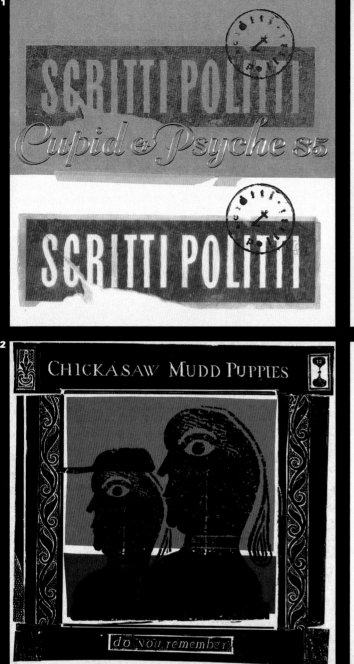

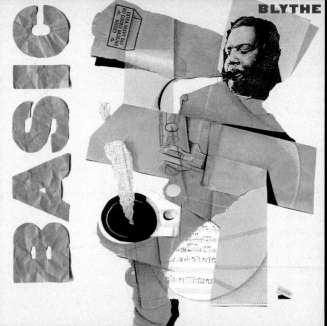

1
Record Album Cover Scritti Politti "Cupid & Psyche 85"
Art Directors Keith Breeden, Green
Screen Process Printing Art-O-Matic
Back Cover Photography Rob Brimson
Inner Sleeve Photography Andy Earl
Client Warner Bros. Records
Typographer The Printed Word
Printer Queens

2
Record Album Cover Chickasaw Mudd Puppies "Do You Remember"
Art Director Michael Bays
Illustrator Mike Klotz
Design Firm Polygram Records, New York, NY
Client Polygram Records

3
Record Album Cover "Basic Blythe"
Art Director/Designer Gary Drummond
Illustrator Peter Kuper
Photographer Nancy Levine
Design Firm CBS Records, New York, NY
Client/Publisher Columbia Records
Typographer Haber

4
Music Packaging Paul Simon "Graceland"
Art Directors Jeffrey Kent Ayeroff, Jeri Heiden
Designer Kim Champagne, Icon Courtesy of Langmuir Collection,
Peabody Museum of Salem; photographed by Mark Sexton
Back Cover Photograph Gary Heery
Design Firm Warner Bros. Records, Burbank, CA
Client Warner Bros. Records
Typographer Aldus Type Studio, LA
Printer Ivy Hill

5

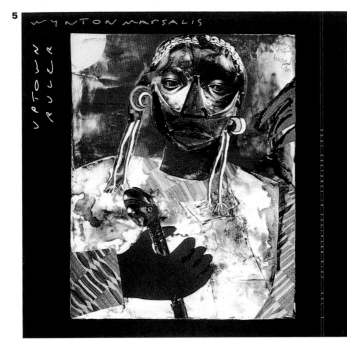

7

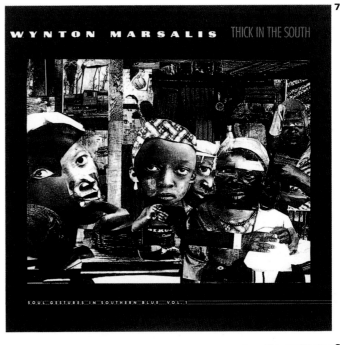

6

8

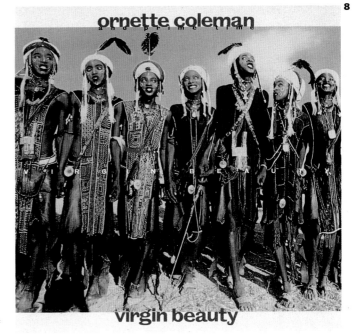

5
Record Album Cover Wynton Marsalis "Uptown Ruler"
Art Director Josephine DiDonato
Cover Paining Romare Bearden
Design Firm/Client Sony Music, New York, NY

6
Record Album Cover Wynton Marsalis "Levee Low Moan"
Art Director Josephine DiDonato
Painter Romare Bearden
Design Firm/Client Sony Music, New York, NY

7
Record Album Cover Wynton Marsalis "Thick in the South"
Art Director Josephine DiDonato
Cover Painting Romare Bearden
Design Firm/Client Sony Music, New York, NY

8
Record Album Cover Ornette Coleman "Virgin Beauty"
Art Director Christopher Austopchuk
Photographer Angela Fisher
Design Firm Sony Music, New York, NY

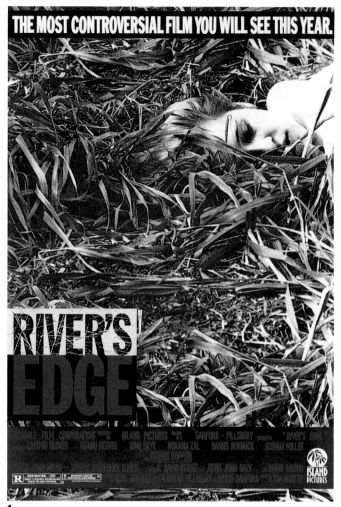

THE MOST CONTROVERSIAL FILM YOU WILL SEE THIS YEAR.

RIVER'S EDGE

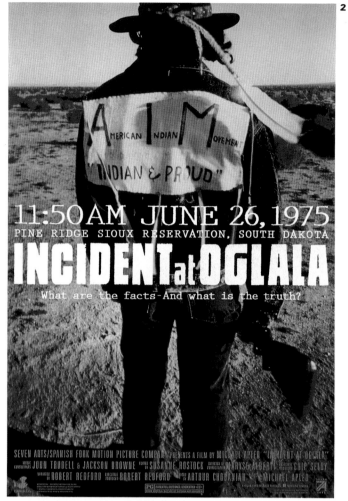

11:50AM JUNE 26, 1975
PINE RIDGE SIOUX RESERVATION, SOUTH DAKOTA
INCIDENT at OGLALA
What are the facts-And what is the truth?

2

1

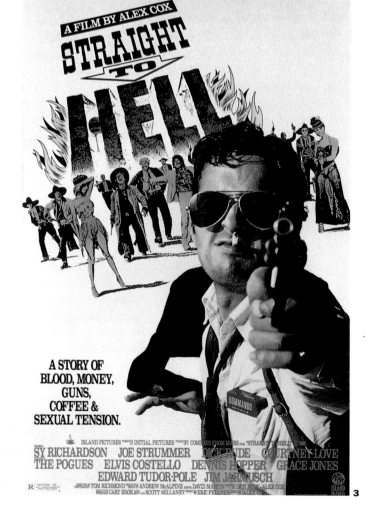

A FILM BY ALEX COX
STRAIGHT TO HELL

A STORY OF
BLOOD, MONEY,
GUNS,
COFFEE &
SEXUAL TENSION.

3

1
Movie Poster "Incident at Oglala"
Art Directors Lucinda Cowell, Ron Michaelson
Designers Ron Michaelson, Michele Lott
Photographers Ron Michaelson, Greg Chapell
Design Firm Concept Arts, Hollywood, CA
Client Seven Arts

2
Movie Poster "River's Edge"
Art Directors Lucinda Cowell, Ron Michaelson
Design Firm Concept Arts, Hollywood, CA
Client Island Pictures
Typographer Ron Michaelson

3
Movie Poster "Straight to Hell"
Art Directors Lucinda Cowell, Ron Michaelson
Illustrator Lucinda Cowell
Design Firm Concept Arts, Hollywood, CA
Client Island Pictures

4

Movie Poster "High Heels"
Art Director James Verdesoto
Designer Juan Gatti
Photographic Illustration Juan Gatti
Design Firm/Client Miramax Films, New York, NY
Typographer In-house
Printer B & B Graphics

5

Movie Poster "Kafka"
Art Director James Verdesoto
Designers Tod Tarhan, Stacy Nimmo
Design Firm Miramax Films, New York, NY
Client/Publisher Miramax Films
Printer B & B Graphics

6

Movie Poster "Black Lizard"
Art Director/Designer Margaret Bodde
Design Firm Margaret Bodde Productions, New York, NY
Client/Production Company Cinevista

7

Movie Poster "The Kill-Off"
Art Directors Thomas Starr, Jennifer Schumacher
Designer Jennifer Washburn
Photographers Thomas Starr, H. Armstrong Roberts
Design Firm Thomas Starr & Associates
Client Cabriolet Films, Inc
Typographer Black Ink
Printer Continental Lithographers

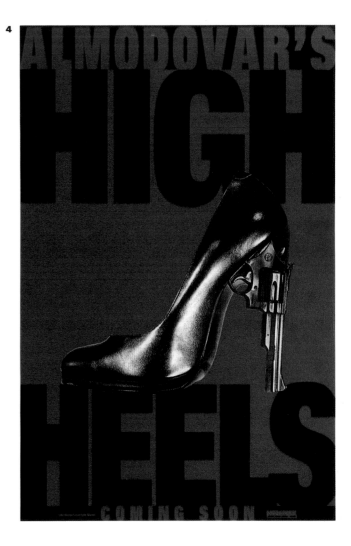

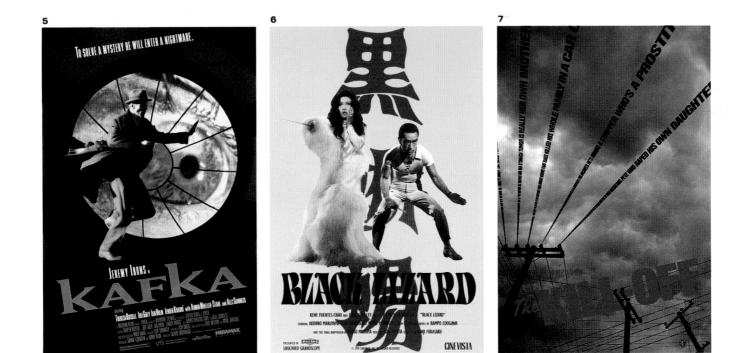

1

Music Packaging and Promotions Sonic Youth "Disappear"
Art Director/Designer Kevin Reagan
Illustrator Raymond Pettibon
Design Firm DGC Records, Los Angeles, CA
Client/Publisher Geffen Records

2

Calendar/Newsletter RockCandy 11/92
Art Director Hank Trotter
Illustrator Jamila Saaed
Design Firm Twodot Design, Seattle, WA
Client RockCandy
Typography Twodot Design

1

2

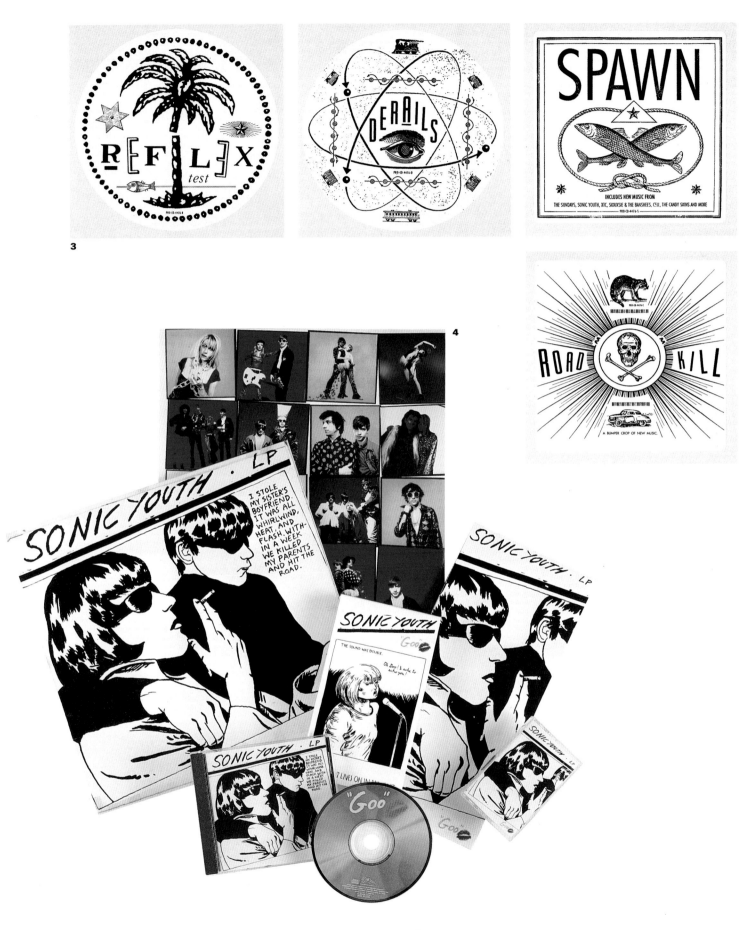

3
Music Packaging GEF/DGC Alternative Music Sampler —
"Derails, Spawn, Reflex, Road Kill"
Art Director/Designer Kevin Reagan
Design Firm Geffen/DGC Records, Los Angeles, CA
Client/Publisher Geffen Records

4
Music Packaging Sonic Youth "Goo"
Art Director/Designer Kevin Reagan
Illustrator Raymond Pettibon
Sleeve Photographer Michael Lavine
Design Firm DGC Records, Los Angeles, CA
Client/Publisher Geffen Records

1

Editorial "Jane's Addiction"
Art Director Gary Koepke
Photographer Chris Cuffaro
Design Firm Koepke Design Group, Magnolia, MA
Client/Publisher Creem Magazine
Printer American Signature

2

Editorial "The Pet Shop Boys"
Art Director Gary Koepke
Photographers The Douglas Brothers
Design Firm Koepke Design Group, Magnolia, MA
Client/Publisher Creem Magazine
Printer American Signature

3

Music Packaging The Replacements "All Shook Down"
Art Directors Kim Champagne, Michael Rey
Designer Rey International/mr/gl
Photographer Michael Wilson
Design Firm Warner Bros. Records, Burbank, CA
Client Sire Records
Printer Ivy Hill

4

Music Packaging Devo "Hardcore, Vol. 2, 1974-1977"
Art Director Lisa Laarman
Photographer Moshe Braka
Design Firm Rykodisc
Printer Litho Specialities

THE ACT WE ACT
A GOOD IDEA
CHANGES
HELPLESS
HOOVER DAM
THE SLIM
IF I CAN'T CHANGE YOUR MIND
FORTUNE TELLER
SLICK
MAN ON THE MOON

PRODUCED BY BOB MOULD AND LOU GIORDANO

RYKO

5

Music Packaging Pixies "Doolittle"

Art Director Vaughan Oliver/v23

Photographer Simon Larbalestier

Client/Publisher Elektra Entertainment

Printer Ivy Hill

6

Music Packaging Sugar "Copper Blue Ltd. Ed."

Art Director Bob Mould

Designer Conrad Warre

Photographers Mark C., Kevin O'Neil

Design Firm Rykodisc, Salem, MA

Printer Litho Specialties

7

Editorial "After Midnight"

Art Director Gary Koepke

Photographer Christopher Kehoe

Design Firm Koepke Design Group, Magnolia, MA

Client/Publisher Creem

Printer American Signature

8

Editorial Public Enemy "Night Before Last"

Art Director David Carson

Photographer Steve Sherman

Design Firm David Carson Design, Del Mar, CA

Client/Publisher Ray Gun Magazine

Typographer David Carson

Elektra Entertainment

1

Music Packaging "Hammer"
Art Directors Tommy Steele, Stephen Walker
Designer Stephen Walker
Photographer Annie Leibovitz
Design Firm Capital Records, Hollywood, CA
Production Wendy Dougan

2

Logo Elektra Entertainment
Art Directors Susan Hochbaum, Peter Harrison
Designer Susan Hochbaum
Design Firm Pentagram Design, New York, NY
Client Elektra Entertainment

3

Print Ad "Body Count"
Art Director John Bade
Copywriter Thane Tierney
Photographer Victor Bracke
Band Photograph Erik Hamilton/Herald
Design Firm Warner Bros. Records In-house
Client Warner Bros./Sire Records, Burbank, CA
Typographer Aldus Type Studio, L.A.

VIBE

preview issue

is treach naughty by nature or nurture?

ll cool j bares his soul, not his chest

bobby brown: call it a comeback

white people who think they're black

FALL 1992 $2.50

naomi campbell sings the blues

4

Editorial Cover "Vibe"
Art Director Gary Koepke
Photographer Albert Watson
Design Firm Koepke Design Group, Magnolia, MA
Client Vibe Magazine
Publisher Vibe/Time Inc.
Printer World Color Press

5

Music Packaging KWS
Art Director Jenniene Le Cleves
Designer Jeff Faville
Illustrator Sergio Baradat
Client Next Plateau Records

6

Editorial "Marked For Life"
Art Director Gary Koepke
Photographer Albert Watson
Design Firm Koepke Design Group, Magnolia, MA
Client Vibe Magazine
Publisher Vibe/Time Inc.
Printer World Color Press

5

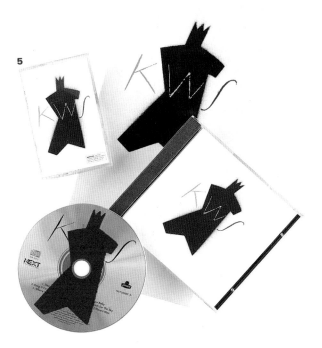

6

marked for life

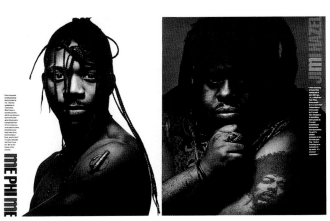

1

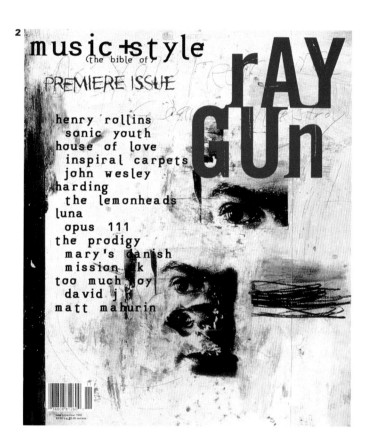

1

Press Kit Ray Gun
Art Director David Carson
Design Firm David Carson Design, Del Mar, CA
Client Ray Gun Magazine

2

Editorial Cover Ray Gun
Art Director David Carson
Illustrator Larry Carroll
Design Firm David Carson Design, Del Mar, CA
Client/Publisher Ray Gun Magazine

3

Editorial "Sex Pistols"
Art Director Scott Menchin
Designer Scott Menchin
Client/Publisher Creem Magazine

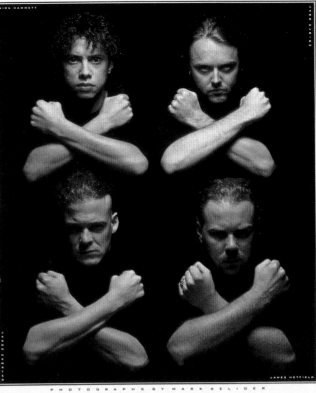

PHOTOGRAPHS BY MARK SELIGER

4

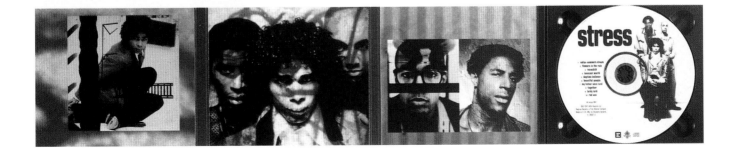

4

Editorial "Metallica"
Art Director Fred Woodward
Designer Angela Skouras
Director of Photography Laurie Kratochvil
Writer David Fricke
Photographer Mark Seliger
Client Rolling Stone Magazine
Publisher Straight Arrow Publishers

5

Music Packaging Stress "Stress"
Art Director Jeff Gold
Designer Greg Ross
Photographers Enrique Badulescu, Eddie Monsoon
Design Firm Warner Bros. Records, Burbank, CA
Client Reprise Records
Printer AGI

5

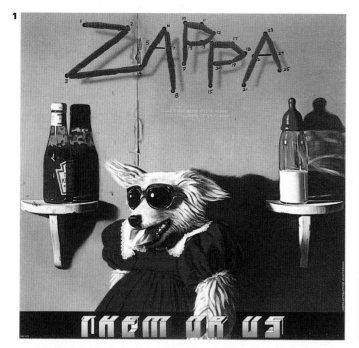

1

Record Album Cover Frank Zappa "Them or Us"
Art Director/Logo Designer Gabrielle Raumberger
Illustrator Donald Roller Wilson
Photographer Steve Shapiro
Design Firm New Age Art, Los Angeles, CA
Client/Publisher Barking Pumpkin Records
Printer AGI

2

Record Album Cover Mick Jagger "Primitive Cool"
Art Director Christopher Austopchuk
Illustrator Francesco Clemente
Design Firm/Publisher Sony Music, New York, NY

3

Record Album Cover Stephen Jesse Bernstein "Prison"
Art Director/Designer Art Chantry
Photographers Arthur S. Aubry, Gary Bedell
Design Firm Art Chantry Design, Seattle, WA
Client Sub Pop
Typographer Grant Alden

4

Record Album Cover The Call "Reconciled"
Art Director Carol Friedman
Designer Janet Perr
Photographs Western History Collections, University of Oaklahoma Library
Client Elektra Records

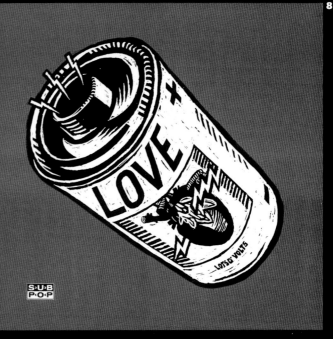

5
Record Album Cover "54 • 40"
Art Director Laura Li-Puma-Nash
Designer Laura Li-Puma
Photographer Willie Osterman
Design Firm/Client Warner Bros. Records, Nashville, TN

6
Record Album Cover Urgent "Thinking Out Loud"
Art Director/Designer Paula Scher
Photographer Buddy Andresa
Design Firm Pentagram Design, New York, NY
Client Manhattan Records
Typographer In-house

7
Record Album Cover Gear Daddies "She's Happy"
Art Director Chris Thompson
Designer/Illustrator David Lau
Design Firm Polygram Records, New York, NY
Client/Publisher Polygram Records
Printer Shorewood

8
Record Album Cover Love Battery "Dayglo"
Art Director/Designer Art Chantry
Illustrator Ed Fotheringham
Design Firm Art Chantry Design, Seattle, WA
Client Sub Pop
Typographer Grant Alden

2

3
Banners/Environmental Graphics Los Angeles Festival
Art Director John Coy
Designer Sean Alatorre
Design Firm Coy, Los Angeles, CA
Client Los Angeles Festival
Typographer Trump Bold Stretched
Production Company AAA Flag & Banner Mfg. Co.

4
Booklet More Protein
Art Director/Designer Carol Bobolts
Design Firm Red Herring Design, New York, NY
Client Charisma Records
Typographer JCH
Printer Red Ink Productions

3

4

"At this point in my career,

nothing matters more than music."

Will anyone really believe those words are from
the mouth of media maven George O'Dowd? It really doesn't
matter—especially to the man people have grown fond of
calling "boy."

"There was a point in my life when other people's opin-
ions, chart figures, and the more superficial things in life
carried a lot of weight with me," the former frontman for
Culture Club says. "But life teaches you priorities. And one of
mine is music and More Protein."

More Protein is the hip and independent dance music label
that George founded two years ago. Up until recently, US
club DJs had to rise at dawn and clamor through import bins
for its highly coveted releases.

Now that Charisma Records has snapped up More Protein
for exclusive distribution in the US, DJs throughout the coun-
try can catch up on their sleep and still lay their hands on
some of the most innovative club music to hit these shores in
years. The label's first release here, "Closet Classics Vol. I," is

Illustration by Matt Mahurin

1

2

1
Editorial "Who Killed Peewee?"
Art Director/Designer Fred Woodward
Director of Photography Laurie Kratochvil
Writer Peter Wilkinson
Illustrator Matt Mahurin
Client Rolling Stone Magazine
Publisher Straight Arrow Publishers

3

2
Logo The Meanies
Art Director/Illustrator Karen Koziatek
Design Firm KMKdesign, Chicago, Il
Client The Meanies

3
Record Album Cover Aural Fixation
Art Director Michael A. Klotz
Design Firm Polygram Creative Services
Client Polygram Records, Inc.

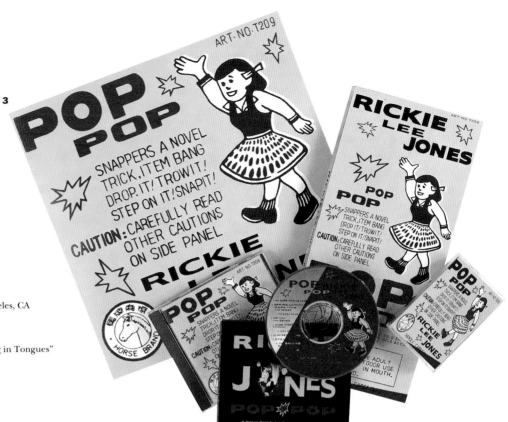

3

Music Packaging Ricki Lee Jones "Pop Pop"
Art Director/Designer Kevin Reagan
Photographer Annalisa
Design Firm/Client Geffen Records, Los Angeles, CA

4

Music Packaging Talking In Heads "Speaking in Tongues"
Art Director David Byrne
Designers M&Co., Adelle Lutz, David Byrne
Cover Painting David Byrne
Design Firm M&Co., New York, NY
Client Sire Records

5

Music Packaging Talking Heads "Little Creatures"
Art Director M&Co., New York
Cover Painting Rev. Howard Finster, Summerville, GA.,
courtesy of Phyllis Kind Gallery, New York, NY
Back Cover Photograph Neil Selkirk
Design Firm M&Co., New York, NY
Client Sire Records
Printer Queens

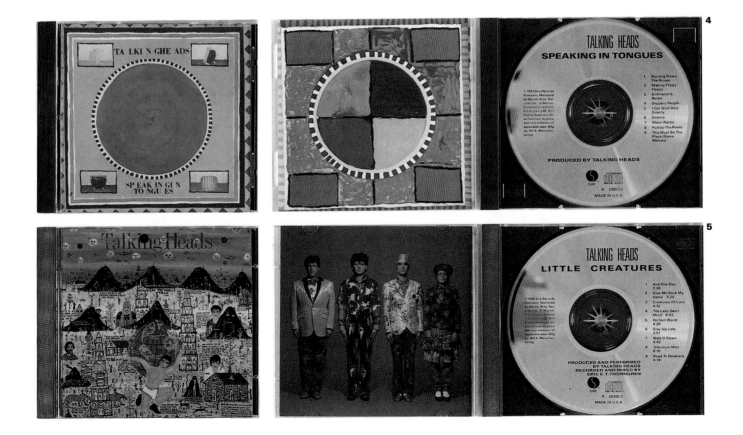

1

Robbins Music Therapy in June. All are currently working in the Clinic, three full-time, and three part-time. Their work is creative and musically resourceful, and it is due to their dedicated commitment that the Clinic has grown so rapidly and successfully. Four additional therapists have begun the training program.

The Clinic's Director of Research is working closely with the staff in studying the processes of music therapy, and the preparation and dissemination of theoretical and prac- tical materials is already helping music therapists in other locations bring therapy to handi- capped children. The compilation of the important Archive and Instructional Libraries has continued throughout the year.

Increasingly, the Clinic serves as an information center for the media, other workers in the health care professions, and the general public. The visibility the music industry has given the Clinic through television and the press is spread- ing across the field of music therapy, and so is raising awareness—worldwide—of the unique benefits music therapy holds for the disabled and disadvantaged.

On behalf of our staff, children, and parents, we wish to express deep appreciation for your continuing support.

Brochure "Thank You" (Nordoff Robbins Campaign)
Art Director/Designer/Illustrator Cheri Dorr
Design Firm MTV Networks Creative Services, New York, NY
Typographer The Graphic Word
Printer Dejay Litho, Genetra, Atwater Press
Paper Manufacturer Kraft Paper/Chipboard

2

Media Kit Comedy Central presents Upfront at a Distance
Art Director Scott Wadler
Designer/Illustrator Laurie Rosenwold
Design Firm MTV Networks Creative Services, New York, NY
Client Comedy Central
Typographer Laurie Rosenwold

3

Music Packaging Peter Case "Six-Pack of Love"
Art Director Kevin Reagan
Designer Janet Wolsborn
Illustrator Jeffrey Vallance
Photographer Dennis Keeley
Design Firm/Client Geffen Records, Los Angeles, CA

3

Movie Poster "Pepi, Luci, Bom"
Art Director Margot Perman
Designer/Illustrator Ceesepe
Design Firm Real Design, New York, NY
Client Cinevista
Typographer Ron Leighton
Printer Register Litho

4

Editorial Cover "Michael Jackson in Fantasyland"
Art Director Fred Woodward
Designer Fred Woodward
Illustrator Anita Kunz
Client Rolling Stone Magazine
Publisher Straight Arrow Publishing

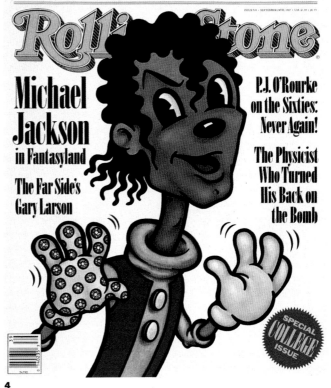

4

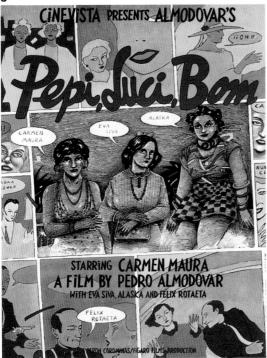

5

Audio/Book Packaging "The True Story Of The 3 Little Pigs!"
Art Director/Designer Molly Leach
Illustrator Lane Smith
Design Firm Molly Leach Design, New York, NY
Client/Publisher Viking Children's Books
Typographer Molly Leach
Printer Barry Fiala, Inc.
Paper Manufacturer Sternberger & Fiala

5

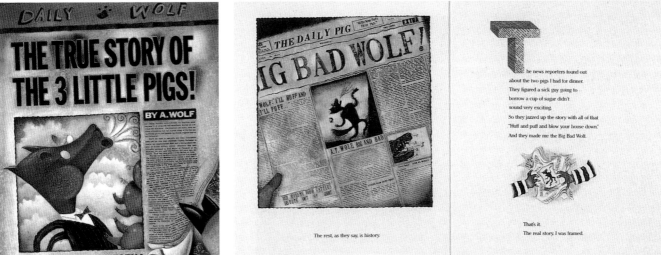

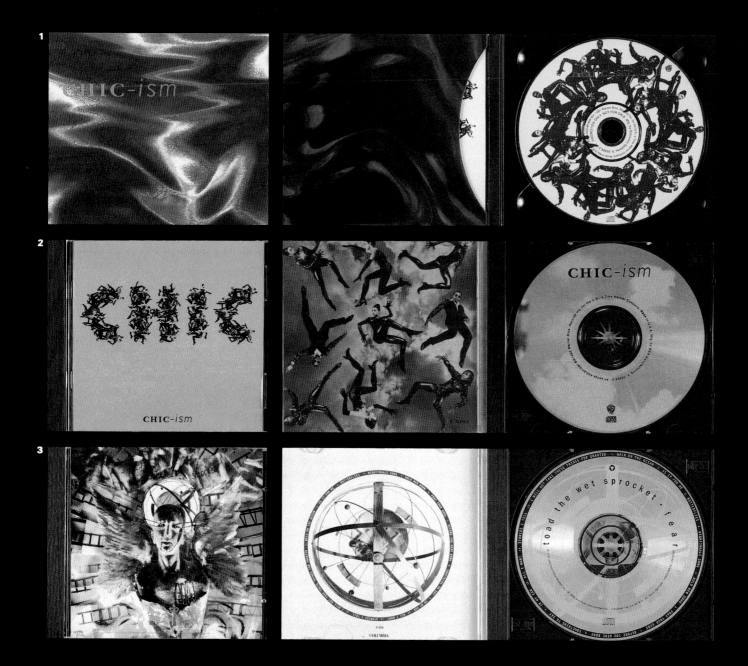

1
Music Packaging Chic "Chicism" (Digipak)
Art Directors Robin Lynch, Jeff Gold
Designer Robin Lynch
Photographer Stephane Sednaoui
Design Firm Warner Bros. Records, Burbank, CA
Client Warner Bros. Records
Printer Westland Graphics

2
Music Packaging Chic "Chicism"
Art Directors Robin Lynch, Jeff Gold
Designer Robin Lynch
Photographer Stephane Sednaoui
Design Firm Warner Bros. Records, Burbank, CA
Client Warner Bros. Records
Printer Ivy Hill

3
Music Packaging Toad The Wet Sprocket "Fear"
Art Director Mary Maurer
Photographer Hans Neleman
Design Firm Sony Music, Santa Monica, CA
Client/Publisher Columbia Records

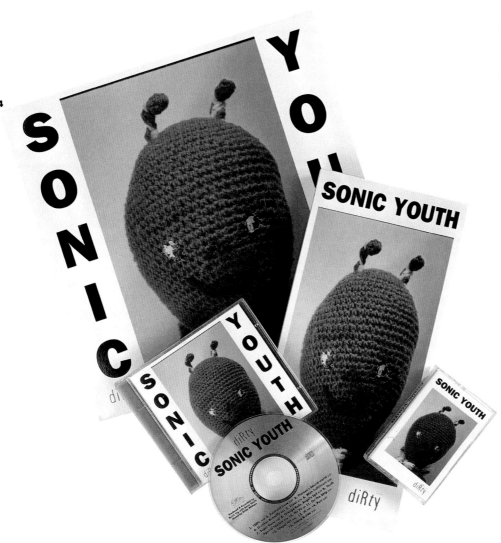

4

Music Packaging Sonic Youth "Dirty"
Art Directors Kevin Reagan, Sonic Youth
Designer Kevin Reagan
Photographer/Artist Mike Kelley
Design Firm DGC Records, Los Angeles, CA
Client/Publisher Geffen Records

5

Poster Sonic Youth "Dirty"
Art Director Kevin Reagan
Photographer/Artist Mike Kelley
Design Firm Geffen Records, Los Angeles, CA
Client/Publisher Geffen Records

6

Poster Toad the Wet Sprocket "Fear"
Art Director Mary Maurer
Photographer Hans Neleman
Design Firm Sony Music, Santa Monica, CA
Client/Publisher Columbia Records

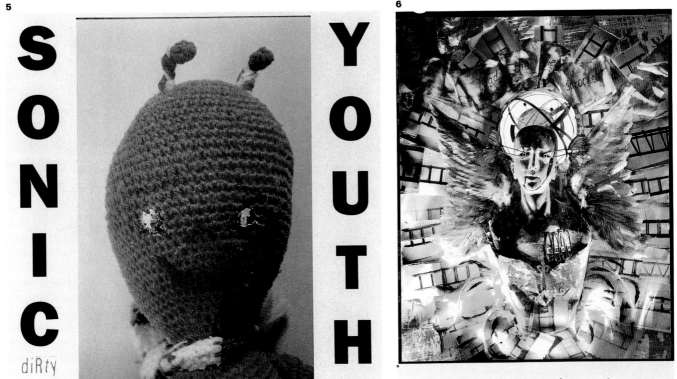

1

Poster Bodeans "Black and White"
Art Director/Designer Kim Champagne
Photographer Michael Wilson
Copywriter Jane Bogart
Design Firm Warner Bros. Records, Burbank, CA
Client Reprise/Slash Records
Printer Ivy Hill

2

Music Packaging R.E.M. "Automatic For The People"
Art Directors Tom Recchion, Michael Stipe
Designers Tom Recchion, Michael Stipe
Back Cover Photographs Fredrik Nilsen
Computer Imaging Cecil Juanarena/Insight Communications
Photographer Anton Corbijn
Design Firm Warner Bros. Records, Burbank, CA
Client R.E.M./Athens, Ltd., Warner Bros. Records
Typographer Tom Recchion
Printer Ivy Hill

3

Music Packaging Bodeans "Black and White"
Art Director Kim Champagne
Photographer Stuart Watson
Band Photograph Michael Wilson
Design Firm Warner Bros. Records, Burbank, CA
Client Reprise/Slash Records
Printer Ivy Hill

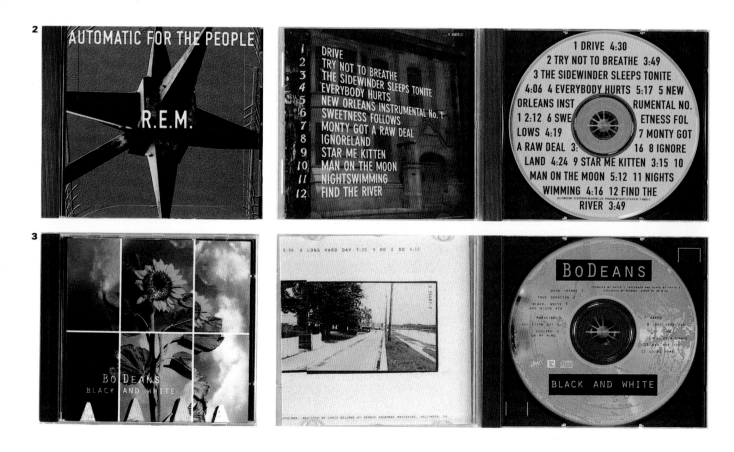

4
Music Promotion R.E.M. "Green" (Meadow In A Can)
Art Director Tom Recchion
Design Firm Warner Bros. Records, Burbank, CA
Client Warner Bros. Records
Printer Sun Unlimited

5
Specialty Music Packaging R.E.M. "Automatic For The People"
Art Directors Tom Recchion, Michael Stipe, Jeff Gold, Jim Ladwig
Designers Tom Recchion, Michael Stipe
Photographer Anton Corbijn
Design Firm Warner Bros. Records, Burbank, CA
Client R.E.M./Athens Ltd., Warner Bros. Records
Printer A.G.I., Westland Graphics

6
Promotional Postcards Bodeans "Black and White"
Art Directors Kim Champagne, Liz Silverman
Designer Kim Champagne
Photographer Michael Wilson
Design Firm Warner Bros. Records, Burbank, CA
Client Reprise/Slash Records
Printer Westland Graphics

1

1
Poster Miles Davis "Tutu"
Art Director Eiko Ishioka
Designer Susan Welt
Photographer Irving Penn
Client Warner Bros. Records, Burbank, CA
Printer Westland Graphics

2
Poster Miles at the Spectrum
Designer Yves Archambault
Design Firm/Client Festival International
de Jazz de Montreal, Montreal, CAN
Printer MP Photo

3
Music Packaging Miles Davis "Tutu"
Art Director Eiko Ishioka
Designer Susan Welt
Photographer Irving Penn
Client Warner Bros. Records, Burbank, CA
Printer PG/Ivy Hill

2

3

4
Record Album Cover Miles Davis "The Columbia Years 1955-1985"
Art Director/Designer Gary Drummond
Photographer Gilles Larrain
Design Firm CBS Records, New York, NY
Client/Publisher Columbia Records

5
Record Album Cover Miles Davis "Aura"
Art Director Stacy Drummond
Photographer Gilles Larrain
Designer Stacy Drummond
Design Firm Sony Music
Client Columbia Records

6
Music Packaging Ray Charles "The Birth of Soul"
Art Directors Bob Defrin and Carol Bobolts
Designer Carol Bobolts
Photographers William Claxton, Bob Parent, Lee Friedlander
Design Firm Red Herring Design, New York, NY
Client Atlantic Records
Typographer Expertype, The Graphic Word
Printer Ivy Hill

The Columbia Years 1955-1985

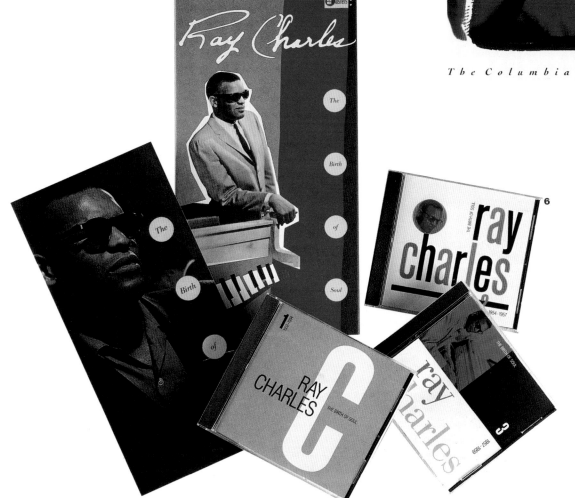

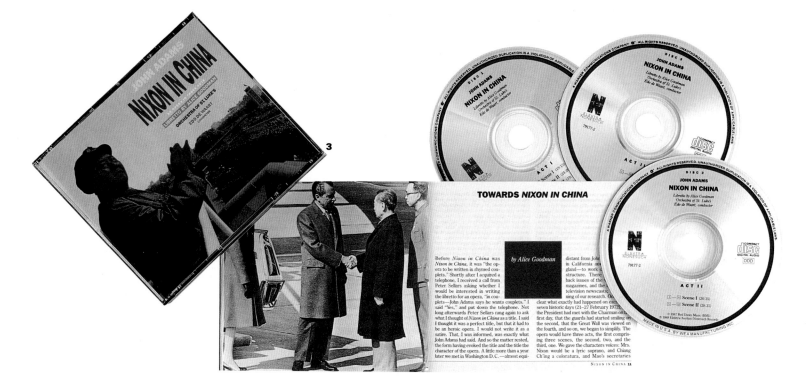

1

2

3

TOWARDS *NIXON IN CHINA*

by Alice Goodman

Before *Nixon in China* was *Nixon in China*, it was "the opera to be written in rhymed couplets." Shortly after I acquired a telephone, I received a call from Peter Sellars asking whether I would be interested in writing the libretto for an opera, "in couplets—John Adams says he wants couplets." I said "Yes," and put down the telephone. Not long afterwards Peter Sellars rang again to ask what I thought of *Nixon in China* as a title. I said I thought it was a perfect title, but that it had to be an heroic opera. I would not write it as a satire. That, I was informed, was exactly what John Adams had said. And so the matter rested, the form having evoked the title and the title the character of the opera. A little more than a year later we met in Washington D.C.—almost equi-distant from John in California and gland—to work structure. There back issues of the magazines, and the television newscasts ning of our research. Or clear what exactly had happened on each seven historic days (21–27 February 1972) the President had met with the Chairman on the first day, that the guards had started smiling on the second, that the Great Wall was viewed on the fourth, and so on, we began to simplify. The opera would have three acts, the first comprising three scenes, the second, two, and the third, one. We gave the characters voices: Mrs. Nixon would be a lyric soprano, and Chiang Ch'ing a coloratura, and Mao's secretaries

NIXON IN CHINA **11**

1

Movie Poster "Tonko"
Art Directors Saul Bass, Art Goodman
Design Firm Bass/Yager and Associates, Los Angeles, CA
Client Creative Enterprises/Toho Film

2

Movie Poster "Tonko"
Art Directors Saul Bass, Art Goodman
Design Firm Bass/Yager and Associates, Los Angeles, CA
Client Creative Enterprises/Toho Film

3

Music Packaging "Nixon in China"
Art Director Stephen Doyle
Designer Stephen Doyle
Design Firm Drenttel Doyle Partners, New York, NY

4

Poster "Vietnam: A Television History"
Art Director Chris Pullman
Designer Dennis O'Rielly
Photographers Roger Viollet, Larry Burrows
Design Firm WGBH Design, Boston, MA
Client WGBH, Boston

5

Music Packaging Elektra Nonesuch Explorer Series
Art Director John Costa
Client/Publisher Elektra Entertainment
Printer Ivy Hill

4

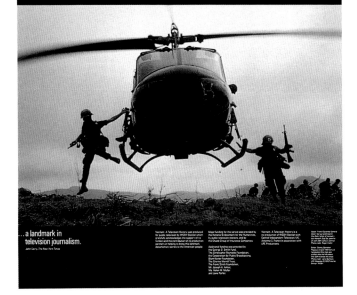

Vietnam: A Television History

…a landmark in television journalism.

5

1

Editorial "State of Luxe"
Art Director Fred Woodward
Designer Angela Skouras
Director of Photography Laurie Kratochvil
Photographer Kurt Markus
Client Rolling Stone Magazine
Publisher Straight Arrow Publishers

2

Editorial "Soul Sister Number One"
Art Director Gary Koepke
Photographer Len Prince
Design Firm Koepke Design Group, Magnolia, MA
Client Vibe Magazine
Publisher Vibe/Time Inc.
Printer World Color Press

3

Book and Music Packaging "LISTEN UP! The Lives of Quincy Jones"
Art Directors Kent Hunter, Danny Abelson
Designers Riki Sethiadi, Johan Vipper, Thomas Bricker
Photographer Patrick Demarchelier
Design Firm Frankfurt Gips Balkind, New York, NY
Client/Publisher Warner Books, Warner Bros. Records
Typographer Frankfurt Gips Balkind
Printer Heritage Press

1

2

3

4

Poster HMV Super Music Stores (Art Blakely)
Art Directors Kent Hunter, Aubrey Balkind
Designer Johan Vipper
Photographer Herman Leonard
Design Firm Frankfurt Gips Balkind, New York, NY
Client HMV Music Stores
Typographer Frankfurt Gips Balkind

5

Poster HMV Super Music Stores (Ballerina)
Art Directors Kent Hunter, Aubrey Balkind
Designer Johan Vipper
Photographer Frederick Lewis
Design Firm Frankfurt Gips Balkind, New York, NY
Client HMV Music Stores
Typographer Frankfurt Gips Balkind

6

Poster HMV Super Music Stores (Oscar Pettiford)
Art Directors Kent Hunter, Danny Abelson
Designer Johan Vipper
Photographer Herman Leonard
Design Firm Frankfurt Gips Balkind, New York, NY
Client HMV Music Stores
Typographer Frankfurt Gips Balkind

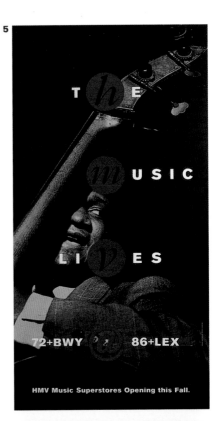

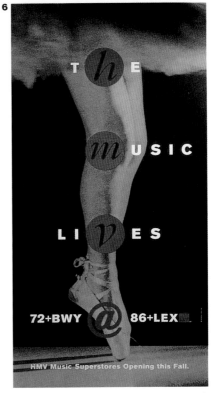

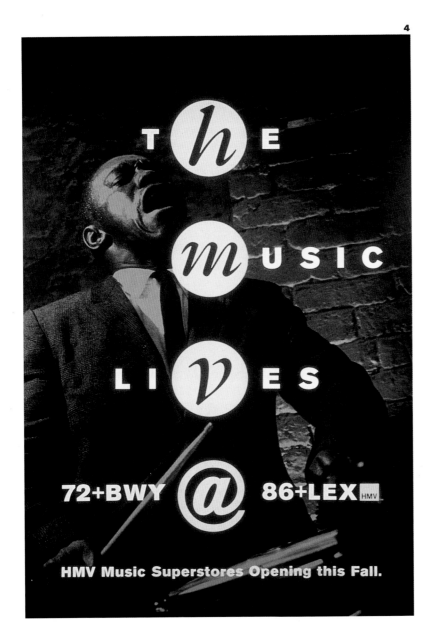

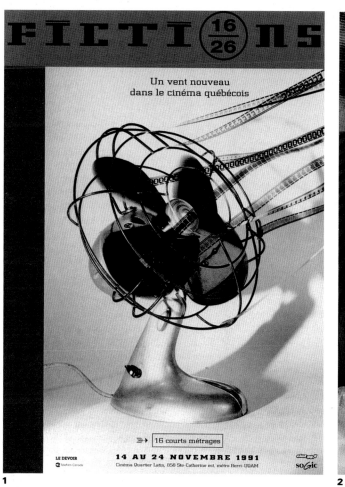

1

Un vent nouveau
dans le cinéma québécois

16 courts métrages

LE DEVOIR

14 AU 24 NOVEMBRE 1991
Cinéma Quartier Latin, 858 Ste-Catherine est, métro Berri-UQAM

soGic

2

Poison

A FILM BY TODD HAYNES

A BRONZE EYE PRODUCTION • A ZEITGEIST FILMS RELEASE

1
Poster Fictions 16/26
Art Director/Designer Lumbago
Photographer Michel Dubreuil
Design Firm Lumbago, Montreal, CAN
Client La Licorne
Typographer Zibra
Printer Bowne de Montreal
Paper Manufacturer Lauzier Little

2
Movie Poster "Poison"
Art Director Bekka Lindstrom
Designer Todd Haynes
Client/Publisher Zeitgeist Films Ltd.

3
Invitation An Invitation for Celebration
Art Director/Designer Nicky Lindman
Design Firm Sony Music, New York, NY
Client CBS Records

Poster Slow Fire-The Gardening of Thomas D.

Art Director Brian Boram

Illustrators/Photographers Marion Gray, Thomi Wroblewski, Steve Ginsburg

Design Firm Boram Design, Seattle, WA

Client Paul Dresher Ensemble

Paper Manufacturer Simpson

Poster "The Performance Place: Uncensored, Uncut, Unexpected"

Art Directors Paul Montie, Carolyn Montie

Designer Paul Montie, Carolyn Montie

Design Firm Fahrenheit, Boston, MA

Client The Performance Place

Printer Capitol Offset

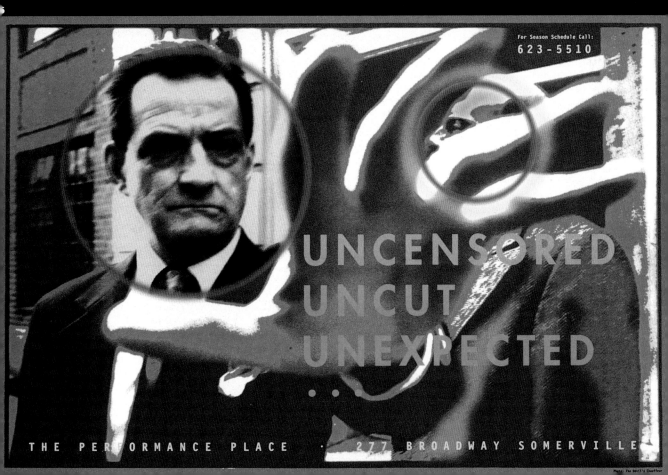

2

3

4

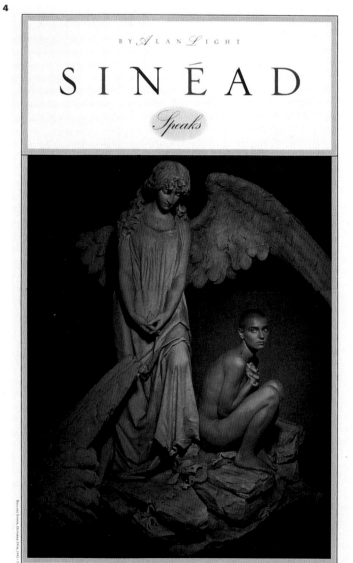

1

5

Movie Poster "Ju-Dou"
Art Director James Verdesoto
Illustrator Graphic Systems
Design Firm James Verdesoto Advertising, New York, NY
Client Miramax Films
Printer B & B Graphics

6

Book Jacket Matter of Life and Sex
Art Director Neil Stuart
Designer Michael Ian Kaye
Photographer Amy Guip
Client/Publisher Dutton Books

7

Book Jacket Flesh and the Word
Art Director Neil Stuart
Designer Michael Ian Kaye
Photographer Amy Guip
Design Firm Penguin USA, New York, NY
Client/Publisher Penguin USA
Typographer Dutton

5

ACADEMY AWARD NOMINEE·BEST FOREIGN LANGUAGE FILM

"A SEXY, SOPHISTICATED FILM."

JU DOU IS VISUALLY SPECTACULAR AND DRAMATICALLY BEGUILING." IT'S A
LOVE TRIANGLE IN THE CLASSIC TRADITION OF THE POSTMAN ALWAYS
RINGS TWICE." AN INTELLECTUALLY AND ARTISTICALLY BRAVE FILM."

JU·DOU

AN EROTIC
TALE
OF
FORBIDDEN
PASSION

WINNER
GOLDEN HUGO-BEST PICTURE
26TH CHICAGO INTERNATIONAL
FILM FESTIVAL

6

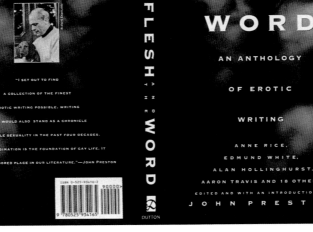

7

1

Poster "Hedda Gabler"
Art Director William Wondriska
Designer Christopher Passehl
Photographer Coon & Garrison
Design Firm Wondriska Associates Inc., Farmington, CT
Client Hartford Stage Company
Typographer The Graphic Center
Printer The Graphic Center

2

Music Packaging "UpClose" Series, Volumes 9
Art Director Bruce Crocker
Designers Bruce Crocker, Martin Sorger
Photographer Hornick/Rivlin Studio
Design Firm Crocker Inc., Brookline, MA
Client Boston Acoustics
Typographer Lee Busch

3

Music Packaging "UpClose" Series, Volumes 11
Art Director Bruce Crocker
Designers Bruce Crocker, Martin Sorger
Photographer Hornick/Rivlin Studio
Design Firm Crocker Inc., Brookline, MA
Client Boston Acoustics
Typographer Lee Busch

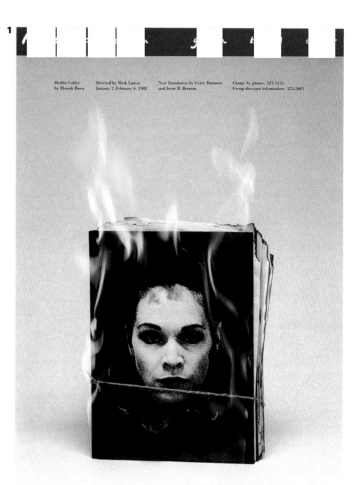

4

Music Packaging "UpClose" Series, Volumes 10
Art Director Bruce Crocker
Designers Bruce Crocker, Martin Sorger
Photographer Hornick/Rivlin Studio
Design Firm Crocker Inc., Brookline, MA
Client Boston Acoustics
Typographer Lee Busch

5

Music Packaging "UpClose" Series, Volumes 12
Art Director Bruce Crocker
Designers Bruce Crocker, Martin Sorger
Photographer Hornick/Rivlin Studio
Design Firm Crocker Inc., Brookline, MA
Client Boston Acoustics
Typographer Lee Busch

6

Newsletter Series Wexner Newsletter
Designer Gary Sankey
Design Firm Wexner Center Design Department,
Columbus, OH
Client/Publisher Wexner Center for the Arts
Typographer Harlan Type
Printer Fineline Graphics
Paper Manufacturer Hammermill

1

Poster 30th New York Film Festival
Art Director Ron Schick
Photographer William Wegman
Color Separation Lumicolor
Publisher Fotofolio
Printer Rapoport Printing
Client Film Society of Lincoln Center

2

Poster "One Night Stand — Keyboard Event"
Art Director Allen Weinberg
Illustrator David Wilcox
Design Firm Sony Music, New York, NY
Typographer Type Shop

3

Logo Red Sky Films
Art Director Steve Zeifman
Designer/Illustrator Michael Schwab
Design Firm Michael Schwab Design, Sausalito, CA
Client Red Sky Film
Printer Jolie Holcomb Printer

4

Folder Hear Today, Hear Tomorrow
Art Director Janet Wolsborn
Design Firm/Client Geffen Records, Los Angeles, CA

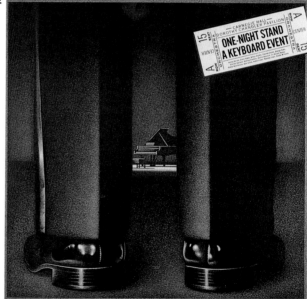

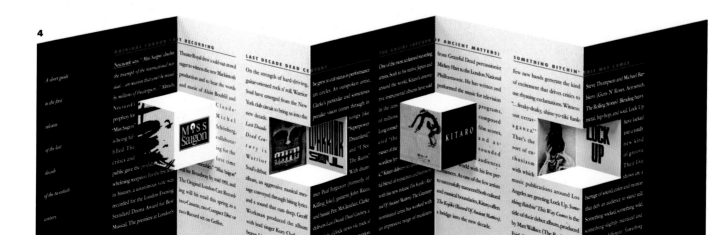

5
Poster "The Substance of Fire"
Art Director Doug Hughes
Designer Robynne Raye
Design Firm Modern Dog, Seattle, WA
Client Seattle Repertory Theatre
Typographer Robynne Raye
Printer The Copy Company
Paper Manufacturer Simpson

6
Poster "Any Natural Disaster"
Art Director/Illustrator Gil Shuler
Design Firm Gil Shuler Graphic Design, Inc., Charleston, SC
Client/Publisher Artists United

7
Poster/Flyer "Come Back to the Five and Dime, Jimmy Dean, Jimmy Dean"
Art Director/Illustrator Jeff Jackson
Design Firm Reactor Art & Design, Toronto, CAN
Client The Factory Theatre
Printer Lunar Caustic Press

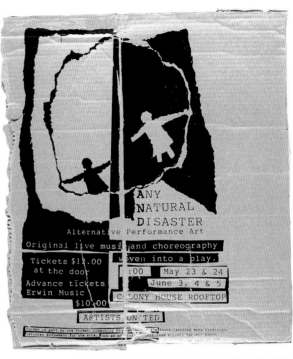

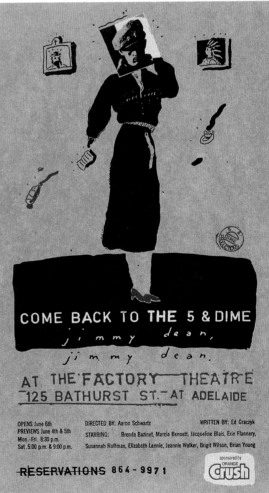

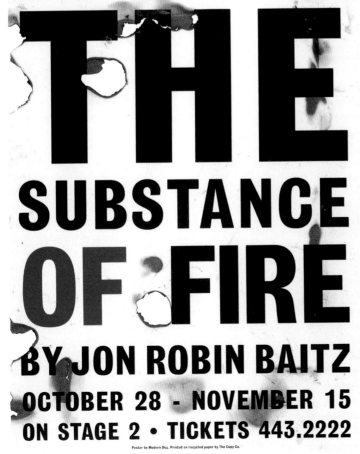

Art is the food for madness.

THE BELLY OF AN
ARCHITECT

HEMDALE PRESENTS IN ASSOCIATION WITH FILM FOUR INTERNATIONAL SACIS AND BRITISH SCREEN
A COLIN CALLENDER PRODUCTION OF A FILM BY PETER GREENAWAY ◆ BRIAN DENNEHY
◆ CHLOE WEBB ◆ LAMBERT WILSON ◆ THE BELLY OF AN ARCHITECT ◆
DIRECTOR OF PHOTOGRAPHY SACHA VIERNY MUSIC WIM MERTENS ADDITIONAL MUSIC GLENN BRANCA
PRODUCED BY COLIN CALLENDER AND WALTER DONOHUE WRITTEN AND DIRECTED BY PETER GREENAWAY
R HEMDALE

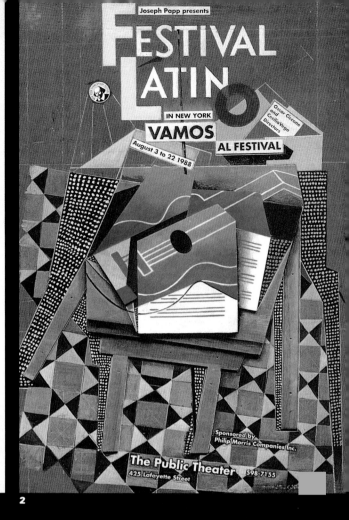

Joseph Papp presents

FESTIVAL
LATINO
IN NEW YORK
VAMOS
August 3 to 22 1988
AL FESTIVAL
Oscar Ciccone and Cecilia Vega Directors

Sponsored by
Philip Morris Companies Inc.

The Public Theater 598-7155
425 Lafayette Street

2

Movie Poster "The Belly of an Architect"
Art Director/Designer Steve Werndorf
Copywriter Amanda Raymond
Design Firm Werndorf Associates, Hollywood, CA
Client Helmdale Film Corp.

Poster Festival Latino 1988
Art Director/Illustrator Paul Davis
Design Firm Paul Davis Studio, New York, NY
Client New York Shakespeare Festival
Printer Stevens Press

Logo Lucas Arts
Art Directors Craig Frazier, Grant Peterson
Designer/Illustrator Craig Frazier
Design Firm Frazier Design, San Francisco, CA
Client Lucas Arts Entertainment Company
Typographer Display Lettering & Copy

3
Poster Juilliard
Art Director Jessica Weber
Illustrator Milton Glaser
Design Firm Jessica Weber Design, Inc., New York, NY
Client The Julliard School

4
Movie Poster "Imagine"
Art Directors Vahe Fattal, Bill Brown, Fred Tio
Designers Bill Brown, Vahe Fattal, Fred Tio
Illustrator John Lennon
Design Firm Fattal & Collins, Santa Monica, CA
Client/Publisher Warner Brothers

5
Poster San Francisco Contemporary Music Players 1986-87
Designer/Illustrator Ward Schumaker
Design Firm Ward Schumaker, San Francisco, CA
Client San Francisco Contemporary Music Players

4

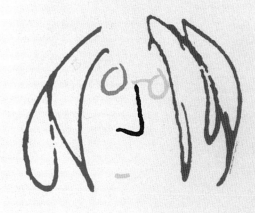

Discover John...the angry youth, the musician, the radical, the husband, the father, the lover, the idealist...through his own words and personal collection of film and music.

IMAGINE
John Lennon

3

JUILLIARD

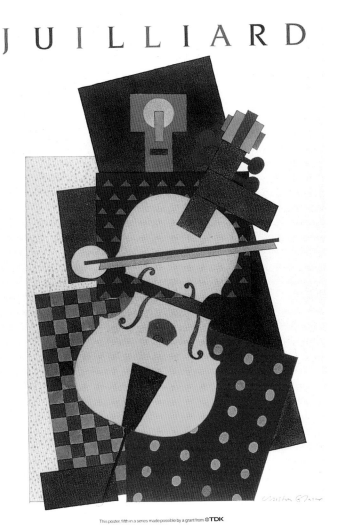

This poster, fifth in a series made possible by a grant from TDK.

5

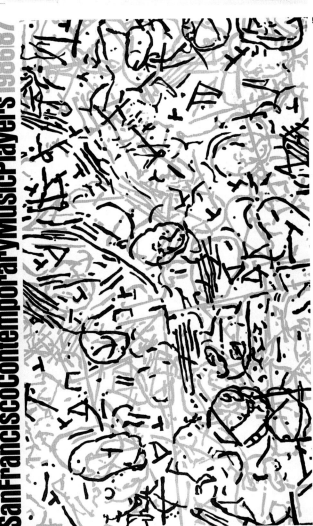

1

Poster Marie & Bruce

Art Director/Designer/Illustrator Michael Bierut

Design Firm Pentagram Design, New York, NY

Client Parallax Theater Company

Typographer Michael Bierut

Printer Ambassador Arts

2

Poster Fool for Love

Art Director/Designer Michael Bierut

Illustrator Michael Bierut

Design Firm Pentagram Design, New York, NY

Client Parallax Theater Company

Typographer Michael Bierut

Printer Ambassador Arts

3

Poster "Hamlet"

Art Director William Wondriska

Designer Susan Fasnick-Jones

Illustrator Perry House

Design Firm Wondriska Associates Inc., Farmington, CT

Client Hartford Stage Company

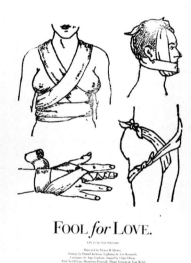

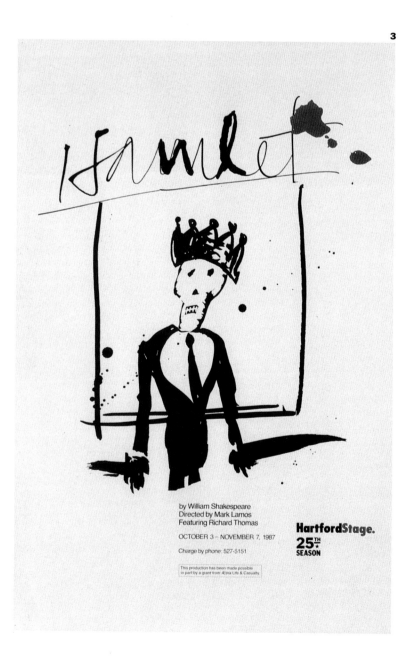

5

Record Album Cover "Oliver Lake"
Design Director/Illustrator Ivan Chermayeff
Designers Ivan Chermayeff, Audrey Krauss,
Cathy Schaefer, Michael Cervantes
Design Firm Chermayeff & Geismar Inc., New York, NY
Client Gramavision
Typographer Typogram
Printer Ivy Hill

6

Logo Native American Film and Media Celebration
Art Director/Designer Craig Bernhardt
Design Firm Bernhardt Budyma Design Group, New York, NY
Client Native American Film and Media Celebration

7

Brochure/Poem "Wind and Glacier Voices"
Art Directors Iris A. Brown, Craig Bernhardt
Designer Iris A. Brown
Design Firm Bernhardt Fudyma Design Group, New York, NY
Client Association on Native
Typographer Iris Brown, MacIntosh/Quark XPress
Printer Atwater Press
Paper Manufacturers Cross Pointe, Champion

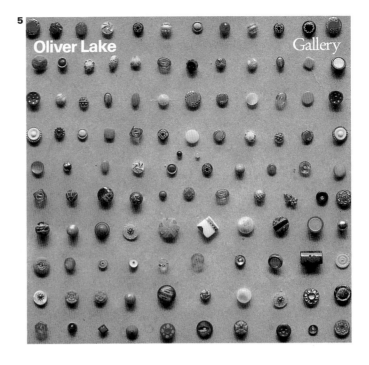

1

Souvenir T-Shirt Joffrey 35
Designer Herbert Migdoll
Client Joffrey Ballet Company
Printer/Production Dewynters Licensing and Distribution

2

Poster Alley Theatre's 1991 Gala
Art Director/Designer Lana Rigsby
Photographer Gary Faye
Design Firm Rigsby Design, Houston, TX
Client Alley Theatre
Typographer Characters
Printer International Printing

3

Program & Invitation 1989 Beaux Arts Ball
Art Director Kit Hinrichs
Designer Susan Tsuchiya
Masks Pentagram Design
Design Firm Pentagram Design, New York, NY
Client American Institute of Architects, San Francisco;
San Francisco Museum of Modern Art
Typographer Eurotype
Printer ColorGraphics

1

Alley Theatre 23rd Annual Gala 2

3

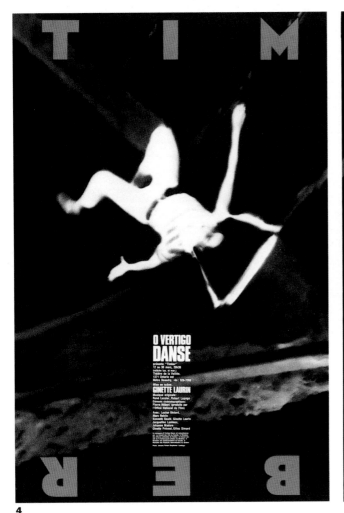

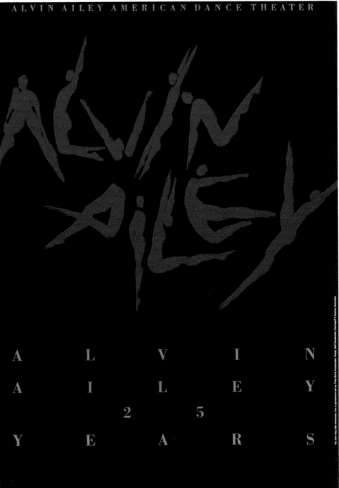

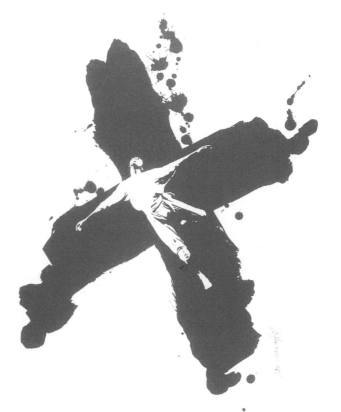

4

Poster Timber

Art Director/Designer Lumbago

Photographer Jacques Perron

Design Firm Lumbago, Montreal, CAN

Client O vertigo danse

Typographer Zibra

Printer Imprimerie PL

Paper Manufacturer Lauzier Little

5

Poster Alvin Ailey

Design Director/Illustrator Steff Geissbuhler

Design Firm Chermayeff & Geismar Inc., New York, NY

Client Alvin Ailey Dance Company

Typographer Print & Design

Printer Steven/Bandes Printing

6

Poster Jacob's Pillow

Design Director Ivan Chermayeff

Illustrator Ivan Chermayeff

Design Firm Chermayeff & Geismar Inc., New York, NY

Client Jacob's Pillow

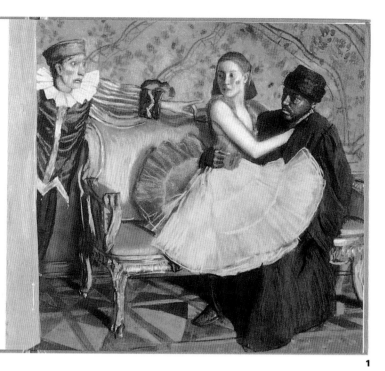

In his dark, cramped cell, far from the richly decorated quarters of the Moor, poor Petrouchka sensed that the Ballerina was in danger. Hurrying to the hole he had punched in the wall earlier, he stuck his head out again. It was dark as midnight, and terrifying to the puppet. But his love was so great that he didn't hesitate at all.

With a mighty effort Petrouchka squeezed through the jagged hole. He felt his way carefully along a passage. When he tripped in the darkness and fell, he picked himself up and went on. At last, at the end of the passage, he came to an opening. He saw a door over to one side. Petrouchka put his shoulder against it, giving a mighty shove. The door opened only slightly, just enough for him to see the two puppets on the couch.

Petrouchka was furious at the sight, and his fury gave him strength. Putting his shoulder to the door again, he gave it another push. This time the door flew open. As it did, the Moor and the Ballerina sprang apart.

By now, Petrouchka was consumed by jealousy. He shook his fist at the Moor and railed at his rival, raging and ranting and fuming.

The Moor was astonished. Was this really Petrouchka, the pathetic little clown? While the puppet raged, the Moor stood with his arms crossed over his brawny chest. He smiled down at Petrouchka, first in amusement, then in scorn. But at last the Moor flew into a rage himself. Drawing his huge scimitar from its place at his side, he lunged at the clown.

Petrouchka tried to run away, but the Moor came after him, chasing him around and around the cell. The Ballerina watched in terror, then let out a bloodcurdling scream. Petrouchka didn't even hear it. He reached the door and squeezed through it, just ahead of the Moor and his terrible sword. He ran right into the square.

24

1

1
Book "Petrouchka"
Designer Alex Jay, Studio J
Illustrator John Collier
Design Firm Studio J, New York, NY
Client/Publisher Viking Children's Books
Typographer Trufont
Printer Tien Wah Press
Paper Manufacturer Stora (Sweden)

2
Poster WNCN Statue of Liberty
Art Director/Illustrator Paul Davis
Design Firm Paul Davis Studio, New York, NY
Client WNCN

2

Poster "Nureyev at Lehman Center"
Designer/Illustrator Ward Schumaker
Agency Grey Entertainment Graphics
Client Lehman Center

4

Souvenir Brochure The Benedum Center 5th Anniversary Book
Art Director/Designer Rick Landesberg
Photographers Lynn Johnson, Clyde Hare
Design Firm Landesberg Design Associates, Pittsburgh, PA
Client/Publisher The Pittsburgh Cultural Trust
Typographer Landesberg Desing Associates
Printer Hoechstetter Printing Co., Inc.
Paper Manufacturers Potlatch, Strathmore

4

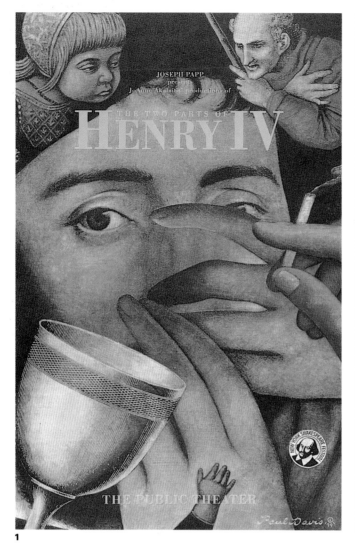

1

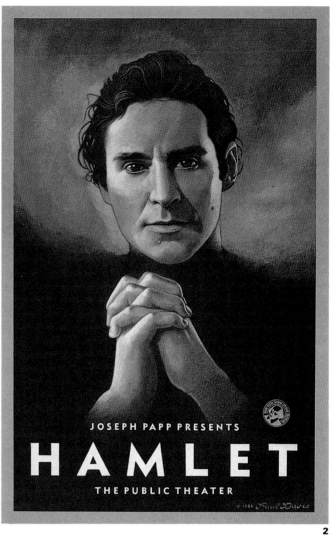

2

1
Poster "Henry IV"
Art Director/Illustrator Paul Davis
Design Firm Paul Davis Studio
Client New York Shakespeare Festival
Typographer Paul Davis Studio, New York, NY
Printer Stevens Press

2
Poster "Hamlet"
Art Director/Illustrator Paul Davis
Design Firm Paul Davis Studio, New York, NY
Client Paul Davis Studio
Printer Stevens Press

3

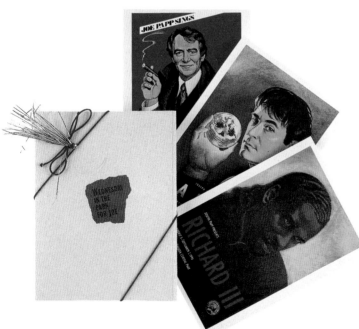

3
Program & Invitation "Wednesday in the Park for Joe"
Art Director/Illustrator Paul Davis
Design Firm Paul Davis Studio, New York, NY
Client New York Shakespeare Festival
Typographer Paul Davis Studio

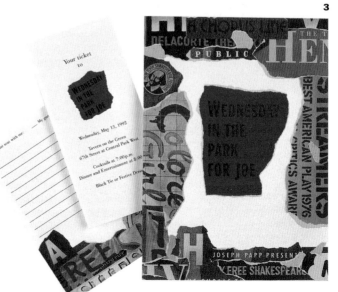

4

Music Packaging Elmore James "The King of the Slide Guitar"
Art Director/Package Design Kim Champagne
Booklet Designers Kim Champagne, Michael Diehl
Guitar Norman's Rare Guitars
Elmore James Photographs George Adins, courtesy of Robert Sacre
Illustrator Josh Gosfield
Design Firm Warner Bros. Records, Burbank, CA
Client Capricorn Records
Printer Ivy Hill

5

Poster "Macbeth"
Art Director/Illustrator Paul Davis
Design Firm Paul Davis Studio, New York, NY
Client New York Shakespeare Festival
Printer Stevens Press

6

Promotional T-Shirt Hamlet Contemplating a 7-10 Split
Art Director/Designer/Illustrator Michael Bierut
Design Firm Pentagram Design, New York, NY
Client Second Stage Theater Company
Typographer Michael Bierut

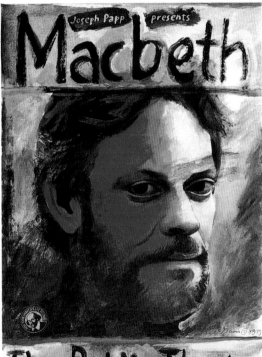

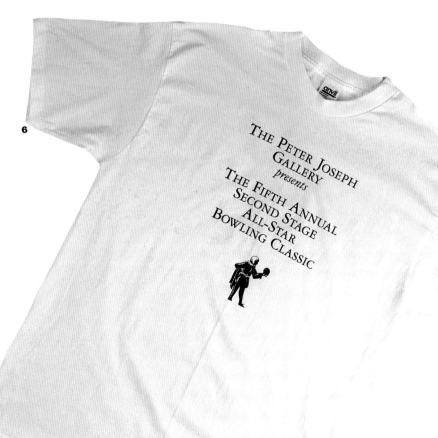

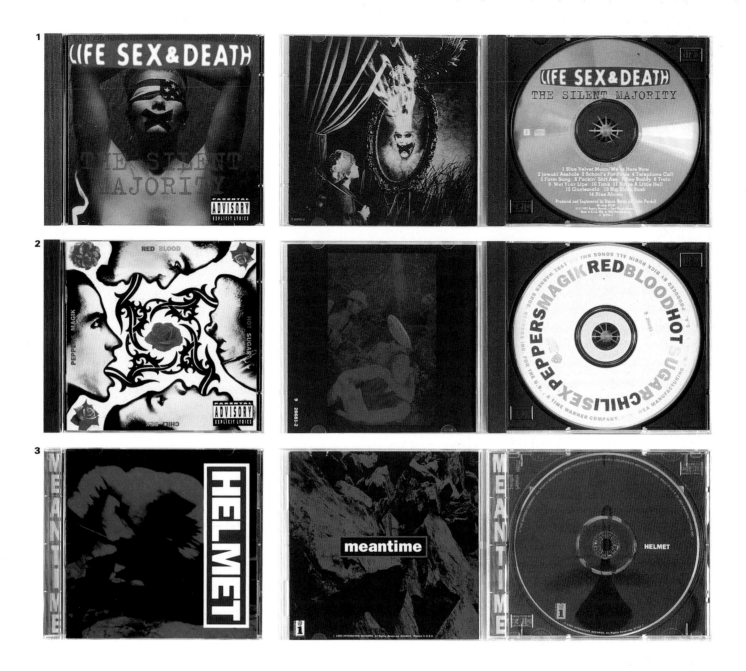

1

Music Packaging Life Sex & Death (L.S.D.)
"The Silent Majority"
Art Directors Deborah Norcross, L.S.D.
Designers Deborah Norcross,
P. Scott Makela, L.S.D.
Logotype P. Scott Makela
Photographer Amy Guip
Design Firm Warner Bros. Records, Burbank, CA
Client Reprise Records
Printer Ivy Hill

2

Music Packaging Red Hot Chili Peppers
"Blood Sugar Sex Magik"
Art Director Kim Champagne
Tongue Illustration Henk Schiftmaker
Photographer Gus Van Zant
Design Firm Warner Bros. Records, Burbank, CA
Client Warner Bros. Records
Printer Ivy Hill

3

Music Packaging Helmet "Meantime"
Art Director Roger Gorman
Designer Rick Patrick
Photographer David Plowden
Design Firm Reiner Design Consultants, Inc.,
New York, NY
Client Interscope Records
Typographer Leah Sherman, Betty Type

5

6

4

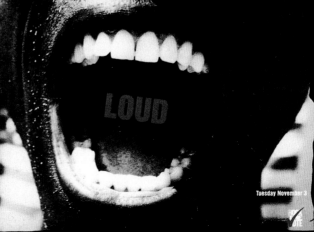

1

For-Sale Promotion ICON (Madonna/Show Girl)
Art Director Ron Meckler
Photographer Steven Meisel
Design Firm Re: Design, New York, NY
Client ICONS

2

For-Sale Promotion ICON (Madonna/All Access)
Art Director Ron Meckler
Photographer Steven Meisel
Design Firm Re: Design, New York, NY
Client ICONS

3

Poster "Madonna With Sunglasses"
Art Director Sandra Horvat Vallely
Photographer Steven Meisel
Design Firm Winterland Productions, San Francisco, CA
Client Madonna
Printer O.S.P. Publishing

4

Movie Poster "In Bed With Madonna"
Art Director Mitch Strausberg
Photographer Steven Meisel
Agency B.D. Fox & Friends, Inc. Advertising
Client Dino De Laurentis Communications, Josh Kramer
Typographer Mitch Strausberg

The Madonna Mystique

With a new movie, another hit record and a world tour, she's bigger than ever. But does anybody really know the person behind the celebrity?

IT IS A SEVERE, WIND-SWEPT SATURDAY NIGHT IN THE teeming city of Tokyo, and Madonna – the most notorious living blonde in the modern world – sits tucked into the corner of a crowded limousine, glaring at the rain that is lashing steadily against the windows. "We never had to cancel a show before," she says in a low, doleful voice. "Never, never, never." With her upswept hairdo, her cardinal-red lips and her pearly skin, she looks picture perfect lovely – and also utterly glum.

Madonna has come to Japan to launch the biggest pop shebang of the summer, the worldwide Who's That Girl Tour, and since arriving at Narita Airport several days ago, she's been causing an enormous commotion. By all accounts, the twenty-eight-year-old singer, dancer, film star and lollipaloora has been fawned over, feted, followed and photographed more than any visiting pop sensation since the Beatles way back in 1966. All this hubbub is nothing new. In America, Madonna has attracted intense scrutiny throughout her career: from fans, inspired by her alluring manner; from critics, incensed by what they perceive as her vapid tawdriness; and from snoopers of all sorts, curious about the state of her marriage to the gifted and often combative actor Sean Penn. But in Japan – where she enjoys a popularity that has lately eclipsed even that of Michael Jackson and Bruce Springsteen – Madonna is something a bit better than another hot or controversial celebrity: she is an icon of Western fixations.

Tonight, though, Madonna's popularity in the Far

BY MIKAL GILMORE

5

5
Editorial "The Madonna Mystique"
Art Director/Designer Fred Woodward
Director of Photography Laurie Kratochvil
Writer Mikal Gilmore
Photographer Herb Ritts
Client Rolling Stone Magazine
Publisher Straight Arrow Publishers

6
Invitation Madonna: Invitation to Sex
Art Director Carol Bobolts
Illustrator T. Perez
Design Firm Red Herring Design, New York, NY
Client Warner Bros. Records
Typographer JCH
Printer Red Ink Productions

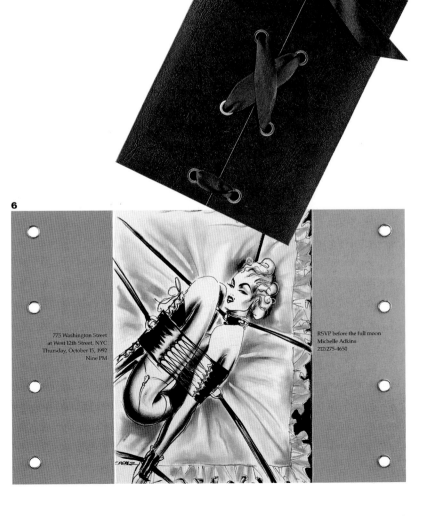

6

775 Washington Street
at West 12th Street, NYC
Thursday, October 15, 1992
Nine PM

RSVP before the full moon
Michelle Adkins
212/275-4650

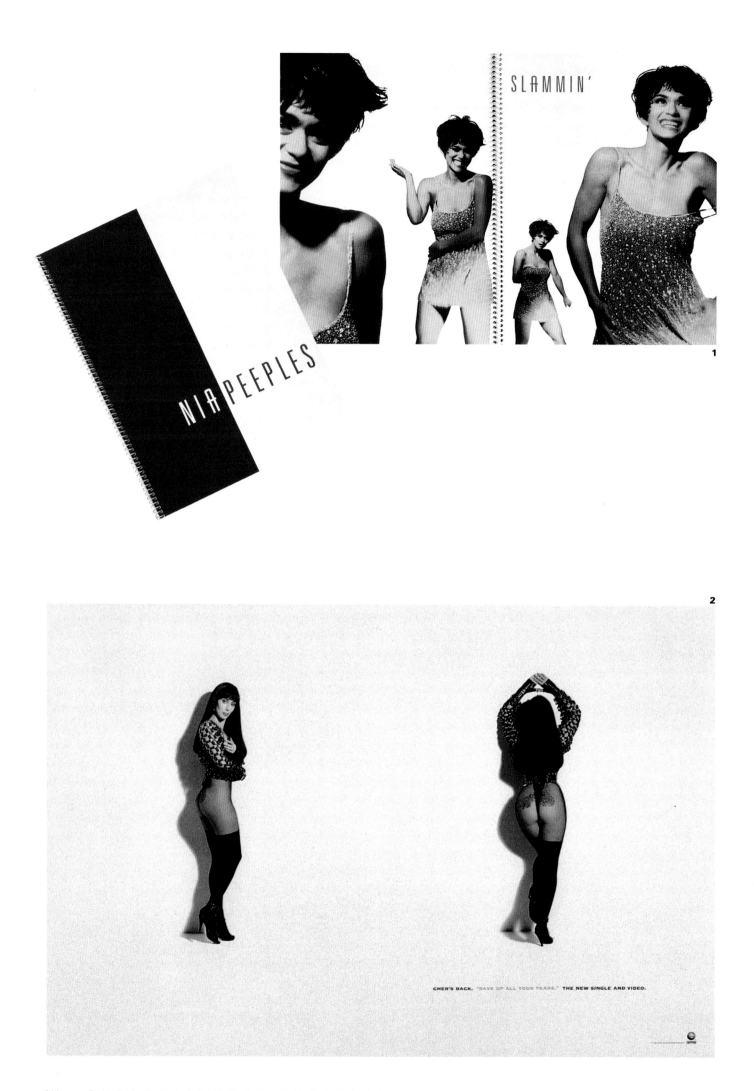

SLAMMIN'

NIA PEEPLES

1

2

CHER'S BACK. "SAVE UP ALL YOUR TEARS." THE NEW SINGLE AND VIDEO.

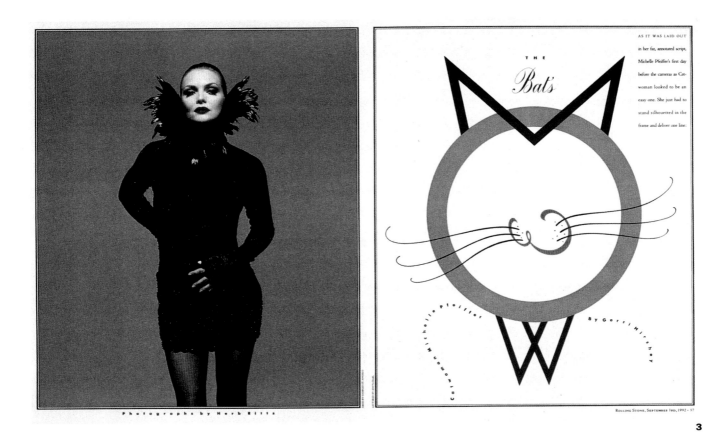

Photographs by Herb Ritts

THE Bat's

AS IT WAS LAID OUT in her fat, annotated script, Michelle Pfeiffer's first day before the cameras as Cat-woman looked to be an easy one. She just had to stand silhouetted in the frame and deliver one line:

Cartoon Michelle Pfeiffer By Gerri Hirshey

ROLLING STONE, SEPTEMBER 3RD, 1992 · 37

3

1

Bio/Press Kit Nia Peeples
Art Director Carol Bobolts
Designer Carol Bobolts and Ph.D.
Photographer Guzman
Design Firm Red Herring Design, New York, NY
Client Charisma Records
Typographer Expertype, The Graphic Word
Printer Red Ink Productions

2

Print Ad Cher Announcement
Art Director/Designer Kevin Reagan
Photographer Herb Ritts
Design Firm/Client Geffen Records, Los Angeles, CA

3

Editorial "The Bat's Meow"
Art Director/Designer Fred Woodward
Director of Photography Laurie Kratochvil
Photographer Herb Ritts
Client Rolling Stone Magazine
Publisher Straight Arrow Publishers

4

Print Ad Columbia Hard Rock & Metal
Art Director Mark Burdett
Design Firm Sony Music, New York, NY
Client Columbia Records

4

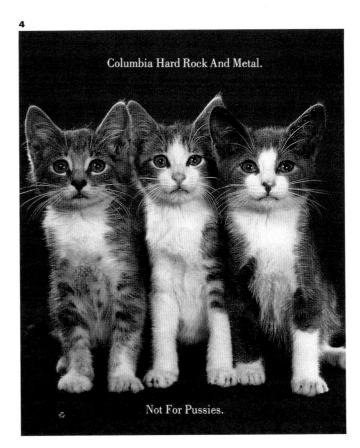

Columbia Hard Rock And Metal.

Not For Pussies.

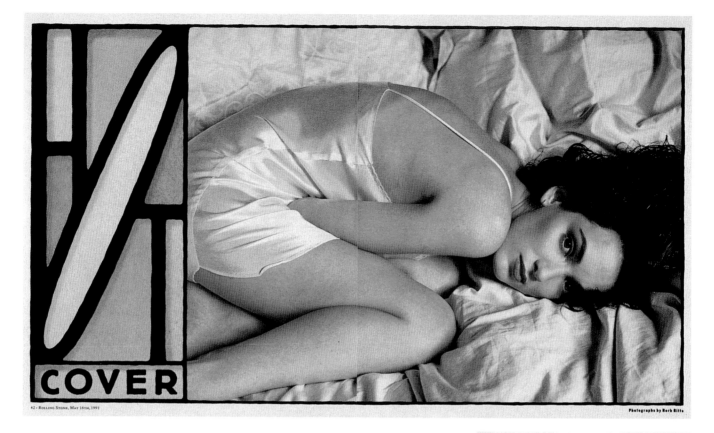

Photographs by Herb Ritts

1

Editorial "Hot Cover — Winona Ryder"
Art Director Fred Woodward
Designer Gail Anderson
Director of Photography Laurie Kratochvil
Client Rolling Stone Magazine
Publisher Straight Arrow Publishers

2

Book "Those Lips, Those Eyes"
Art Director/Designer Paula Scher
Photographers Various
Design Firm Pentagram Design, New York, NY
Client Carol Publishing
Typographer Paula Scher
Printer Typogram

1

2

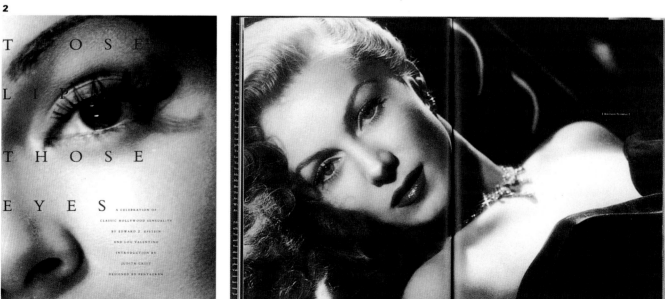

You grew up. With **music**. Became an **adult**. Got an **education**. Got a **job**. Got a **house**. Got **kids**. Got it **all**. Got **busy**. Still. **Gotta have your music.**

Tune in and Turn on the greatest hits.

Need+Want=Demand.

The rock & roll grown-up **needs VH-1.**
The direct tune-in to what's going on.
The rock & roll grown-up **wants VH-1.**
The grown-up style mix of music & Tv.
This person has a life.
Wants to be involved in what's on the screen.
Past. Present. And Future.
You can trust people over 30.

3

The Greatest Hits of Music Video

4

destiny

good news people
find one. help one. be one.

The world can change for the better. One action
by one action. One person by one person.
VH-1 announces a new affiliate campaign.
Specifically designed to make it easy for
you to take that action. To be that catalyst.

Mail back the attached form.
We'll send you the **VH-1** Good News People 1993 kit.
Fun! Easy! Pro-social!

then what?

If your system participates.
you earn good will in
your community + a great way to further your current
pro-social causes +
national exposure on VH-1.

action

i want
to know more about the
good news

change

Send me your **Good News People** 1993 kit containing
more galore; info, entry form, plus everything my
cable system needs to make good news, for a change.

VH-1
Good News People
1515 Broadway
New York, NY 10036

3

Marketing Kit The Greats Hits of Music Video VH-1
Art Director Cheri Dorr
Designers Parham-Santana, Okey Westor
Design Firm Parham-Santana, New York, NY
Client VH-1
Publisher S.D. Scott/Bradford Graphics

4

Promotional Announcement Good News People Teaser
Art Director Cheri Dorr
Design Firm IT Design, New York, NY
Printer Gotham City

do
you
believe
in

1

Editorial "JIMI: The Man and His Music"
Art Director Fred Woodward
Designer Catherine Gilmore-Barnes
Photographer Jered Mankowitz
Lettered by Dennis Ortiz-Lopez
Client Rolling Stone Magazine
Publisher Straight Arrow Publishing

2

For-Sale Apparel "Hendrix Lyrics"
Art Director Sandra Horvat Vallely
Designer Roger Labon Jackson
Design Firm Winterland Productions, San Francisco, CA
Client Are You Experienced, LTD.
Printer Winterland Productions

3

Music Packaging "The Complete Billie Holiday on Verve"
Art Director/Designer David Lau
Design Firm Polygram Records, New York, NY
Client/Publisher Verve

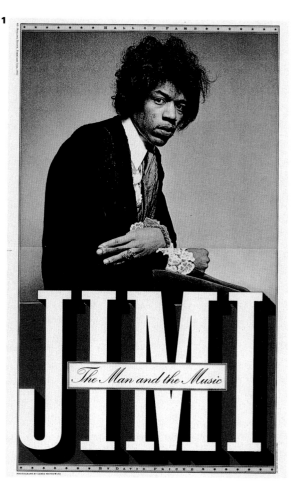

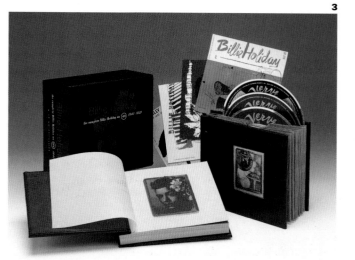

4

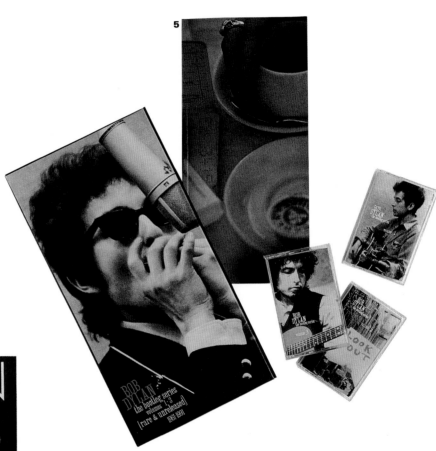

5

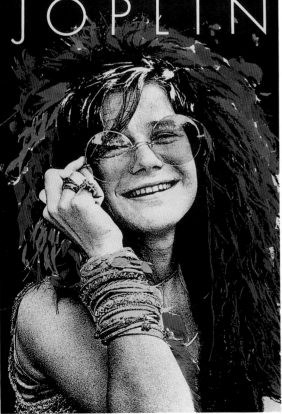

6

4

Music Packaging Rolling Stones "Flashpoint & Collectibles"
Art Director Carol Chen
Designers Gary Mouvat, David Crow
Design Firm Sony Music Entertainment, New York, NY
Client/Publisher The Rolling Stones

5

Music Packaging Bob Dylan "The Bootleg Series"
Art Directors Chris Austopchuk, Nicky Lindeman
Designer Nicky Lindeman
Client/Publisher Columbia Records, Sony Music

6

Poster "Joplin"
Art Director Josephine DiDonato
Design Firm/Publisher Sony Music, New York, NY

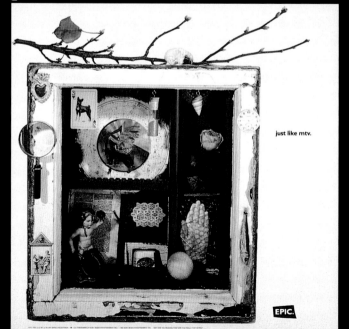

best international videos

Where there is no vision, the people perish.

just like mtv.

EPIC.

1
Souvenir Program 1991 Video Music Awards Book —
"Where There is No Vision, the People Perish"
Art Director Jeffrey Kenton
Designers Stacy Drummond, Steve Byram
Design Firm MTV Network Creative Services, New York, NY
Client MTV
Typographer The Graphic Word
Printer Waldman Graphics

2
Print Ad Just Like MTV
Art Director Mark Burdett
Photographer Mark Burdett
Design Firm Sony Music, New York, NY

3

Souvenir Program 1992 Video Music Awards Book
Art Directors Stacy Drummond, Steve Byram
Designers Stacy Drummond, Steve Byram
Photographer Robert Lewis
Design Firm MTV & MTV Networks Creative Services, New York, NY
Client MTV
Typographer JCH/The Graphic Word Division
Printer Waldman Graphics

4

Marketing/Media Kit MTV 1992
Art Director Kent Hunter
Designers Andreas Combuchen, Johan Vipper
Copywriter Danny Abelson
Photographers Andreas Combuchen, Johan Vipper
Design Firm Frankfurt Gips Balkind, New York, NY
Client MTV
Typographer Frankfurt Gips Balkind
Printer Tanagraphics

3

How do you convince voters that you are telling the truth? George Bush: Voters are intelligent. They'll decide the kind of leader they want based on who has the character, the experience, the compassion and the toughness to make the important decisions. These principles are important to Americans — principles that have guided my life as a public servant. I am absolutely convinced that as voters sort out where the candidates stand on many complex issues, as they assess the fact that we are at peace and are no longer haunted by the specter of nuclear war, and as they look at my agenda for increasing economic growth and expanding opportunity, they will know that the values I hold dear — faith, family and freedom — are genuine. Decency, honor, hard work, caring — that's the America I know. These same principles have always guided my decisions — and they always will. Bill Clinton: There is no one word, no one truth that will convince voters a candidate is telling the truth. Every voter measures by his own yardstick. But I'll tell you one thing: In 1964, I was 18, and most people wanted to ignore the younger generation. They didn't trust our energy, our imagination. They were afraid of all the crazy, heart-stopping ideas we couldn't keep below the surface. Young people today put their ideas into music, dance, into every conceivable thing except voting. But voting is the most precious thing. It's the trade you make, it's the trust you invest in a president. It's when you say, "If you want my vote, you have to listen to my ideas. Every last one of them." If you knew how few people trusted us in 1964, you'd be amazed. And you'd vote. Ross Perot: By telling it.

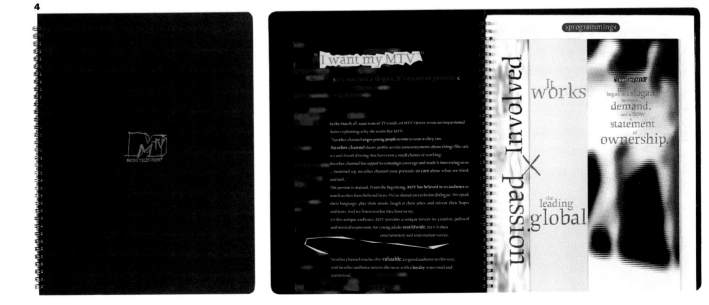

1

3

1
Poster "Nicholas Nickleby"
Art Director/Designer/Illustrator Seymour Chwast
Design Firm The Pushpin Group, New York, NY
Client Fran Michelman, Mobil Corp.

2
Poster "Scoop"
Art Director/Designer/Illustrator Seymour Chwast
Design Firm The Pushpin Group, New York, NY
Client Fran Michelman, Mobil Corp.

3
Audio/Visual Book Packaging "We All Have Tales"
Art Director Peter Millen
Designer David Cagle
Design Firm Corey/Edmonds/Millen, New York, NY
Client Rabbit Ears/Paul Elliott

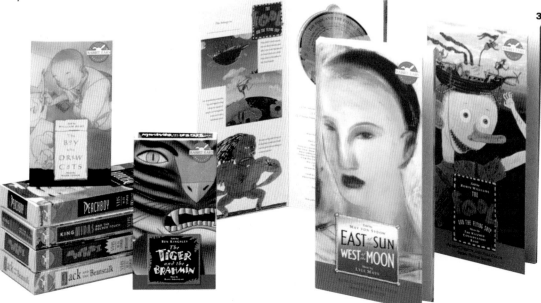

4
Souvenir and Sale Promotion Cartoon Network Dog Watch
Art Director Tom Corey
Designers Tom Corey, Christie Swanson
Design Firm Corey, McPherson, Nash, Watertown, MA
Client Cartoon Network

5
Book "Max in Hollywood, Baby"
Art Director Tibor Kalman
Designer Emily Oberman
Illustrator Maira Kalman
Design Firm M&Co., New York, NY
Client/Publisher Viking Children's Books
Typographer Diddo Ramm
Printer Ringier America

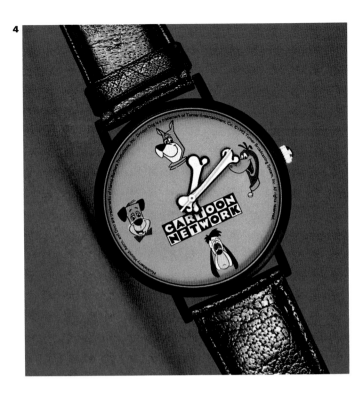

4

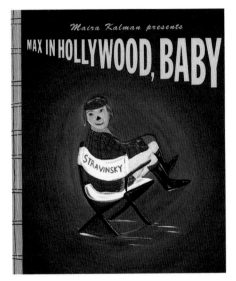

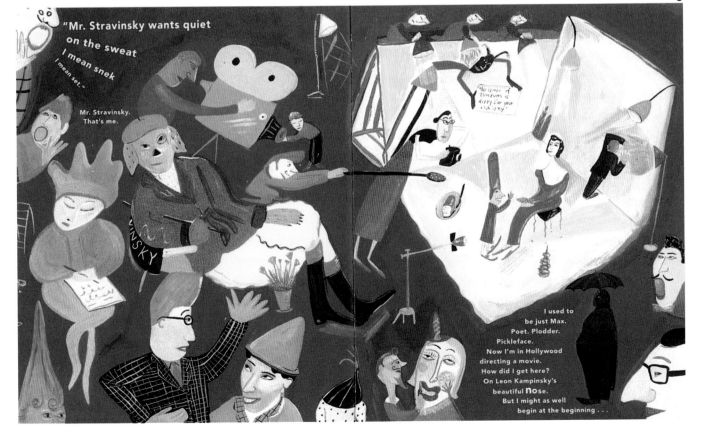

5

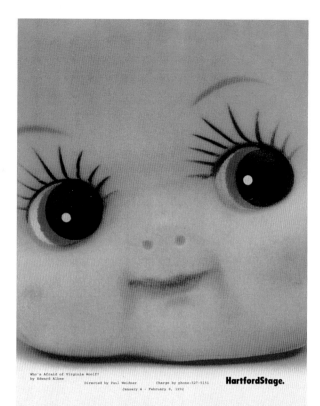

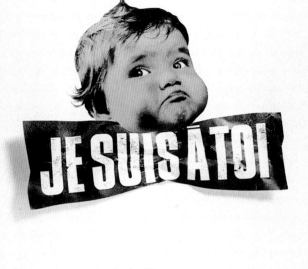

1

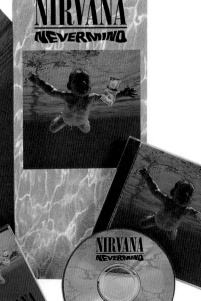

1

Poster "Who's Afraid of Virginia Wolf"
Art Director William Wondriska
Designer Christopher Passehl
Photographer Jim Coon
Design Firm Wondriska Associates Inc., Farmington, CT
Client Hartford Stage Company
Typographer Eastern Typesetting
Printer Lithographics

2

Poster "Je suis a toi"
Art Director/Designer Lumbago
Photographer Michel Dubreuil
Design Firm Lumbago, Montreal, CAN
Client La Licorne
Typographer Zibra
Printer Bowne de Montreal
Paper Manufacturer Lauzier Little

3

Music Packaging Nirvana "Nevermind"
Art Director/Designer Robert Fisher
Band Photographer Michael Lavine
Cover Photographer Kirk Weddle
Design Firm DGC Records, Los Angeles, CA
Client/Publisher Geffen Records

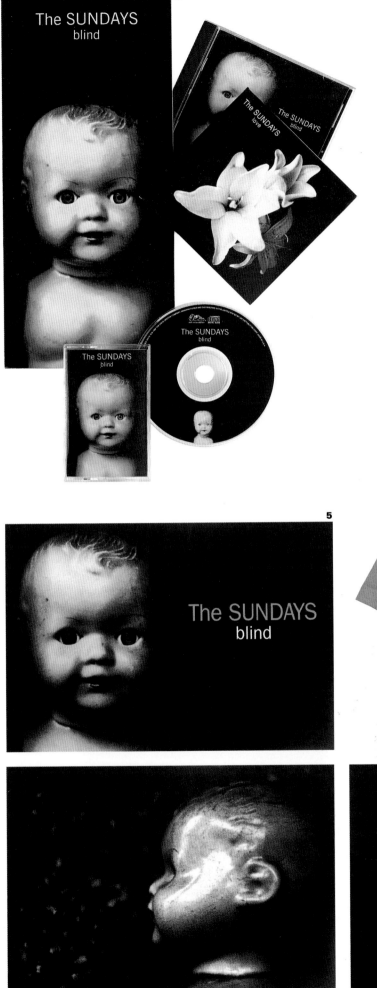

4

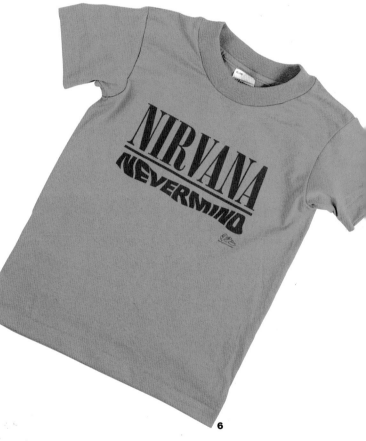

Music Packaging The Sundays "blind"
Art Director Janet Wolsborn
Photographer Gavurin/Wheeler
Client/Publisher Geffen Records

5

Promotional Postcards The Sundays "blind"
Art Director Janet Wolsborn
Photographer Gavurin/Wheeler
Client/Publisher Geffen Records

6

Promotional T-Shirt Nirvana "Nevermind"
Art Director Robert Fisher
Client/Publisher Geffen Records

5

6

Laughter is chemical, physical, biological. Two objects meet and an explosion occurs.

The universe is rent asunder by side-splitting guffaws.

THE MUSEUM IS A FERTILE GROUND WHERE HUMOUR CAN TAKE ROOT AND GROW.

After all, humour is constantly being reborn, reinvented. That is why this museum is necessarily a space for creativity. Its exhibitions are total, multi-media productions, exploiting the myriad talents standing behind every comedian: set designers, directors, writers, actors, educators, historians and bald guys with big shoes.

Beyond its role as a staging ground for exhibitions, however, the museum is vibrant and alive – at once cabaret, school and meeting place. At its heart, a two-storey courtyard *cum*-forum dedicated to daily interaction with the public.

This museum is in fact an institution that is open and accessible to the community's needs. It is an integral part of the city, where a company of artists and their audience intersect and learn from each other.

Politics,

love,

beliefs

nothing is sacred

before this laughing demigod.

This answer to the everyday

antidote to the ordinary.

So by all means, laugh at life!

Otherwise life laughs at you.

1

1

Booklet Un Nouveau Museé . . . Pour Rire

Art Director Danielle Roy

Designer Paulo Correia

Photographers Normand Gregoire, Mikael Floman

Client/Publisher Groupe Juste Pour Rire, Montreal, CAN

Typographer Typographie M & H Ltee

Printer Hit Graphiques

Paper Manufacturer Cougar

2

Promotional T-Shirt "Depth, Muscle, Razzle Dazzle (Channel 2 & 44)"

Art Director Chris Pullman

Photographer Disfarmer

Design Firm WGBH Design, Boston, MA

Client WGBH, Boston

2

3
Specialty Promotion Michelle Shocked "Arkansas Traveler"
Art Director Michael Bays
Designer Ben Argueta
Illustrator Phil Yarnell
Photographer Frank Ockenfel
Design Firm Polygram Records, New York, NY
Client Mercury Records

4
Video Packaging "TVVC's Christmas"
Art Director Paula Scher
Designers Paula Scher, Ron Louie
Design Firm Pentagram Design, New York, NY
Client CBS Fox Video
Typography In-house

5
Music Packaging "Michelle Shocked"
Art Director Sheryl Lutz Brown
Designer Sheryl Lutz Brown
Design Firm Polygram Records, New York, NY
Client Polygram Records

1

Movie Poster "My Own Private Idaho"
Art Directors Steve Werndorf, Rigel Morrison
Designers Steve Werndorf, Rigel Morrison
Copywriter Amanda Raymond
Design Firm Werndorf Associates, Hollywood, CA
Client Fineline Features

2

Movie Poster "Jungle Fever"
Art Director Tom Martin
Designer Barbara Kolo
Photographer Todd Grey
Design Firm/Client MCA/Universal Pictures, Universal City, CA
Typographer Art Sims

3

Movie Poster "The Hot Spot"
Art Directors Steve Werndorf, Mark Shoolery
Designers Steve Werndorf, Mark Shoolery
Copywriters Amanda Raymond, Dennis Hopper
Design Firm Werndorf Associates, Hollywood, CA
Client Orion Pictures

4

Movie Poster "Dead Men Don't Wear Plaid"
Art Director Mitch Strausberg
Photographer Steven Meisel
Agency B.D. Fox & Friends, Inc. Advertising
Client Dino De Laurentis Communications, Josh Kramer
Typographer Mitch Strausberg

5

Movie Poster "True Stories"
Art Directors Lucinda Cowell, Ron Michaelson
Photographer Annie Leibovitz
Design Firm Concept Arts, Hollywoood, CA
Client Warner Bros.

6

Movie Poster "Swimming to Cambodia"
Art Director Bud Lavery
Photographer Marian Goldman
Design Firm Ross Culbert Lavery & Russman, New York, NY
Client Cinecom

Two Rooms

by Lee Blessing

Presented by

TheaterWorks

with the cooperation of the
Hartford Advocate and WTIC-TV Fox 61

The Bronson & Hutensky Theater
233 Pearl Street · Downtown Hartford

March 13 through April 12, 1992
Wednesdays through Saturdays at 8 p.m.
Sunday matinees at 2:30 p.m.

Tickets: $15
Students & Seniors: $12
(Saturdays: $17 & $15)

For tickets call 527-7838

1

2

1

Poster "Italian American Reconciliation"
Art Director Paul Sahre
Designers Paul Sahre, Chris Panzer
Client Fells Point Corner Theatre
Typographer Paul Sahre
Printer Mumbo-Jumbo

2

Poster "Two Rooms"
Art Director/Designer/Illustrator Peter Good
Photographer Jim Coon
Design Firm Peter Good Graphic Design, Chester, CT
Client TheaterWorks
Typographer Typehouse

3

Music Packaging Pat Metheny "Secret Story"
Art Director/Designer Kevin Reagan
Photographer Richard Litt
Design Firm/Client Geffen Records, Los Angeles, CA

3

4

Music Packaging "Tracy Chapman"
Art Director Carol Bobolts
Photographer Matt Mahurin
Agency/Client Elektra Records, New York, NY
Client Elektra Records
Typographer The Graphic Word

5

Editorial "A Conversation With Van Morrison"
Art Director/Designer Fred Woodward
Director of Photography Laurie Kratochvil
Writer David Wild
Photographer Matt Mahurin
Client Rolling Stone Magazine
Publisher Straight Arrow Publishers

6

Music Packaging Michelle Shocked "Short, Sharp, Shocked"
Art Directors Michael Bays, Michelle Shocked
Design Firm Polygram Records, New York, NY
Client/Publisher Polygram Records

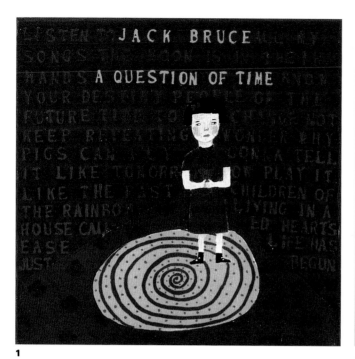

1

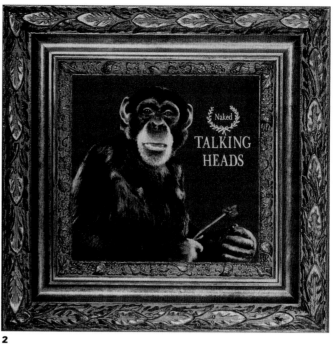

2

1
Record Album Cover Jack Bruce "A Question of Time"
Illustrator Laura Levine
Design Firm Sony Music, New York, NY

2
Record Album Cover Talking Heads "Naked"
Art Director M&Co, New York
Cover Concept David Byrne
Front Cover Painting Paula Wright
Back Cover Photograph Fredric Lewis
Band Photograph Chris Callis
Design Firm M&Co., New York, NY
Client Sire/Fly Records
Printer Queens

3
Poster Talking Heads "Naked"
Designers Tibor Kalman, Douglas Riccardi
Photographer Chris Callis
Illustrator Paula Wright
Design Firm M&Co., New York, NY
Client Talking Heads
Publisher Warner Brothers Records

3

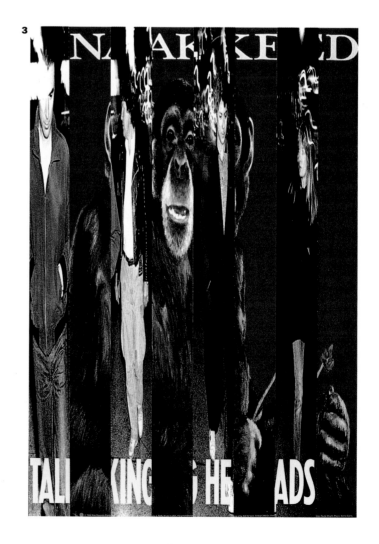

4

Editorial "Rock & Roll Hall of Fame"
Art Director Fred Woodward
Designers Fred Woodward, Gail Anderson
Director of Photography Laurie Kratochvil
Illustrator Josh Gosfield
Client Rolling Stone Magazine
Publisher Straight Arrow Publishers

5

Music Packaging "Sonia Dada"
Art Director Carol Friedman
Designer Janet Perr
Photographer Carol Friedman
Client Chameleon Records

5

TV Broadcast Graphics "Nick-at-Nite Ski TV"
Art Directors Scott Webb, Eleo Hensleigh
Producer Scott Webb
Design Firm Charlex, Pomposello Productions,
New York, NY

TV Broadcast Graphics "My Three Sons Sing Along"
Art Director Scott Webb
Producers Jim Levi/Scott Webb

TV Broadcast Graphics "Nick Promise — Walk the Dog"
Art Directors Steve Thomas, Scott Webb, Eleo Hensleigh
Director of Photography Steve Grieder, Steve Thomas
Writer Steve Thomas

TV Broadcast Graphics
"The Adventures of Pete and Pete Freeze Tag"
Art Directors Scott Webb, Eleo Hensleigh
Producers Chris Viscardi, Katherine Dieckmann
Writer Will McRobb

TV Broadcast Graphics "Nick Studios Video Rap"
Art Directors Scott Webb, Eleo Hensleigh
Producers Scott Webb/Tom Pomposello/Charlex
Design Firm Tom Pomposello/Charlex, New York, NY

TV Broadcast Graphics
"Nick-at-Nite 2-D Movie Week"
Art Director Scott Webb
Writer/Producer Dave Potorti

TV Broadcast Graphics "Inside Out Boy"
Art Director R. Scott Webb
Producer R. Scott Webb
Illustrator Tom Gasek, Elizabeth Buttler

TV Broadcast Graphics "How To Be Swell-Clean Day"
Art Directors Scott Webb, Steve Thomas, Eleo Hensleigh
Producer Steve Grieder
Writer Joe Stillman

TV Broadcast Graphics "Big Beast Quintet ID"
Art Director Scott Webb
Producers Scott Webb/Fred Allan/Colossal Pictures
Design Firm Fred Allan/Colossal Pictures, New York, NY

TV Broadcast Graphics "Twin Peaks"
Creative Director Russell Collins
Designer Brett Darken
Director of Photography Braden Lutz
Producers Richard Goldman, Paul Cross Blanchard
Writer Paul Cross Blanchard
Design Firm Fattal & Collins, Santa Monica, CA
Client KATU TV

TV Broadcast Graphics "Take A Good Look At Yourself"
Creative Directors Paul Cross Blanchard, Eric Hirshberg
Producers Paul Cross Blanchard, Eric Hirshberg
Writer Paul Cross Blanchard
Design Firm Fattal & Collins, Santa Monica, CA
Client Turner Network Television

TV Broadcast Graphics "See Your Nature In Nature"
Creative Directors Paul Cross Blanchard, Russell Collins
Producers Paul Cross Blanchard, Eric Hirshberg
Writer Paul Cross Blanchard
Design Firm Fattal & Collins, Santa Monica, CA
Client Turner Network Television

TV Broadcast Graphics Saturday Special Promo
Art Director Jill Taffet
Designers Andy Hann, Amy Nagasawa
Paintbox Mike Brown-Harry, Lauraine Gibbons
Agency E! Entertainment Television
Production Company Nagasawa & Hann

TV Broadcast Graphics Art of Movies
Art Director Jill Taffet
Designers Andy Hann, Amy Nagasawa
Paintbox Lauraine Gibbons
Editor Mike Davis
Agency E! Entertainment Television
Production Company Nagasawa & Hann

TV Broadcast Graphics On Cable
Art Director Jill Taffet
Designer David Sparrgrove
Paintbox Lauraine Gibbons
Agency E! Entertainment Television

TV Broadcast Graphics Network
Art Director Jill Taffet
Director of Photography Scott McVie
Producers Jill Taffet, Kelly Cole
Writers Jan Fisher, Kelly Cole
Editor Mike Davis
Agency E! Entertainment Television

TV Broadcast Graphics Behind the Scenes
Art Director Jill Taffet
Designer Andy Hann
Illustrators Lauraine Gibbons, Bob Engelsiepen,
Kathy Peasly
Agency E! Entertainment Television
Production Company Andy Hann Design, Inc.

TV Broadcast Graphics Beatnik
Art Director Jill Taffet
Director of Photography Scott McVie
Producers Jill Taffet, Kelly Cole
Writers Jan Fisher, Kelly Cole
Editor Mike Davis
Agency E! Entertainment Television

TV Broadcast Graphics Now Playing
Art Director Jill Taffet
Designer Andy Hann
Director of Photography Scott McVie
Agency E! Entertainment Television
Production Company Andy Hann Design Inc.

TV Broadcast Graphics Univision On-Air ID
Design Director Steff Geissbuhler
Designer Piera Grandesso
Design Firm Chermayeff & Geismar Inc., New York, NY
Client Univision
Printer The DI Group

TV Broadcast Graphics
"Fox Broadcasting Company Numerical Countdown"
Art Director Jennifer Morla
Designers Craig Bailey, Jennifer Morla
Creative Director David Fowler
Photographers Holly Stewart, Craig Bailey
Design Firm Morla Design, San Francisco, CA
Client Fox Broadcasting Company

TV Broadcast Graphics "Mystery!"
Art Directors Chris Pullman, Derek Lamb
Designer Derek Lamb
Illustrator Edward Gorey
Design Firm WGBH Design
Client WGBH, Mystery!
Production Company Derek Lamb

TV Broadcast Graphics "Magritte"
Art Director Isabella Bannerman
Director of Photography Glen Claybrook
Producer David Starr

Film Trailer "Ghostbusters"
Art Director Richard Greenberg
Design Firm R/Greenberg Associates, Inc.
Client Columbia Pictures
Production Company R/Greenberg Associates, Inc.

TV Broadcast Graphics "Dollhouse"
Art Director Harley Jessup
Animators Eric Leighton, Tim Hittle, Anthony Scott
Producer Henry Selick
Creative Directors Judy McGrath, Abby Terkuhle
Production Company Selick Projects

TV Broadcast Graphics "Godzilla-M"
Art Director David Starr
Designer Louis Lino
Director of Photography Glen Claybrook
Producer Kristine Trumbo
Director Phil Trumbo
Creative Directors Judy McGrath, Abby Terkuhle
Production Company Broadcast Arts

TV Broadcast Graphics M-XEROX
Art Director/Designer Henry Selick
Animator/Producer Henry Selick
Creative Directors Judy McGrath, Abby Terkuhle
Production Company Selick Projects

TV Broadcast Graphics "Words"
Art Director Mark Pellington
Creative Directors Judy McGrath, Abby Terkuhle
Producer Mark Pellington
Writer Mark Pellington

TV Broadcast Graphics Elements
Art Directors Drew Takahashi, Tim Boxell
Directors Gary Guttierrez, Tim Boxell, Drew Takahashi
Creative Directors Judy McGrath, Abby Terkuhle
Producer Jane Antee
Production Company Colossal Pictures

TV Broadcast Graphics Art History
Art Director Kirk Henderson
Creative Directors Judy McGrath, Abby Terkuhle
Animation Kirk Henderson
Producer Kirk Henderson
Production Company Colossal Pictures

TV Broadcast Graphics "M-Hood"
Art Director Jerry Musser
Designer Fred Miles
Director Fred Miles
Creative Directors Judy McGrath, Abby Terkuhle
Producer Fred Miles
Production Company Good Design

TV Broadcast Graphics "Club Sandwich"
Art Director Steve Oakes
Director Steve Oakes
Producer Steve Oakes
Creative Directors Judy McGrath, Abby Terkuhle
Production Company Broadcast Arts

TV Broadcast Graphics "Wilding PSA"
Art Director Fred MacDonald
Creative Directors Judy McGrath, Abby Terkuhle
Director of Photography Sean Mathiesen
Producer Matthew Charde
Animator David Chartier

TV Broadcast Graphics
"Man On The Moon Top Of The Hour"
Director/Designer Candy Kugel
Creative Directors Judy McGrath, Abby Terkuhle
Producers Buzz Potamkin, Fred Siebert
Animator Vincent Cafarelli
Editor Neil Lawrence
Production Company Buzzco

TV Broadcast Graphics "Use A Rag"
Art Director Frank Fraser
Director David Wild
Director of Photography Allen Thatcher
Producer Janie Conner
Writer Walter Wanger
Creative Directors Judy McGrath, Abby Terkuhle

TV Broadcast Graphics "MTV 10 Open"
Art Director Pam Thomas
Creative Directors Judy McGrath, Abby Terkuhle
Producer Pam Thomas
Writer Glenn Eichler

TV Broadcast Graphics "M-Mollusk"
Art Director Carl Willat
Director Carl Willat
Creative Directors Judy McGrath, Abby Terkuhle
Animators Carl Willat, Heidi Holman
Production Company Colossal Pictures

TV Broadcast Graphics "Generic M"
Art Director Richard Childs
Director of Photography Richard Childs
Producer Jana Canellos
Creative Directors Judy McGrath, Abby Terkuhle
Animator Richard Childs
Production Company Colossal Pictures

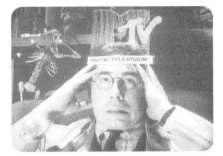

TV Broadcast Graphics "Haircut"
Art Director John Pohl
Animators Eric Leighton, Tim Hittle, Anthony Scott
Producer Henry Selick
Creative Directors Judy McGrath, Abby Terkuhle
Production Company Selick Projects

TV Broadcast Graphics MTV Sound Cue Menus
Art Directors Tom Corey, Scott Nash
Designer Tim Nihoff
Director of Photography Peter Martinez
Producer Patty LaVigne
Design Firm Corey, McPherson, Nash, Watertown, MA
Client MTV

TV Broadcast Graphics WLVI — News at Ten
Art Director Scott Nash
Designers Scott Nash, Tim Nihoff
Writer Bobbi Clark
Illustrator Bobbi Clark
Design Firm Corey, McPherson, Nash, Watertown, MA
Client WLVI-TV 56
Production Company Olive Jar Animation

TV Broadcast Graphics "Once Upon A Time "
Art Director Scott Nash
Designer Big Blue Dot
Producers Lizzie Shaw, Stan Brooks
Design Firm Big Blue Dot, Watertown, MA
Client Once Upon A Time
Production Company Videocraft

TV Broadcast Graphics "Vietnam: A Television History"
Art Director Chris Pullman
Producer Richard Ellison
Design Firm WGBH Design
Client WGBH
Production Company Digital Effects

TV Broadcast Graphics "The Reporters"
Art Director Scott Miller
Designers Scott Miller, Ellen Kahn
Director of Photography James Livingston
Editor Andrew Hanges
Animator Henry Baker
Telecine Joe Bono
Design Firm Scott Miller & Associates, Inc., Los Angeles, CA

TV Broadcast Graphics "Pitchman"
Art Director Gene Mackles
Producer Roger Lyons
Writers Roger Lyons, Gene Mackles
Design Firm WGBH Design
Client WGBH
Production Company WGBH

TV Broadcast Graphics "Madonna Stick Figure Theatre"
Art Director Robin Steele
Creative Directors Judy McGrath,
Abby Terkuhle, Japhet Asher
Editor Diane Caliva
Producer Tammy Haboush
Animation Robin Steele

TV Broadcast Graphics 1980's Decades Spot
Art Director Gene Mackles
Producer Caroline Collins
Writer Mark Halliday
Design Firm WGBH Design
Client WGBH
Production Company WGBH

TV Broadcast Graphics "Anagram"
Art Director Don Smith
Creative Directors Judy McGrath, Abby Terkuhle
Director of Photography Don Smith
Producer Shari Glusker
Animator Stop Motion Angie Glocka
Voice Joi Eiriksson
Production Company Colossal Pictures

TV Broadcast Graphics "VH-1: Ground Zero"
Art Director Myles Tanaka
Designer Jun Miyata
Director of Photography Thomas Tercek
Producer Myles Tanaka
Typographer Jun Miyata

TV Broadcast Graphics "VH-1 Pop Quiz Campaign"
Art Director Bonnie Siegler
Designers Bonnie Siegler, Emily Oberman
Director of Photography Thomas Tercek
Producers Bonnie Siegler, Emily Oberman

TV Broadcast Graphics "VH-1 Runner"
Art Director Thomas Tercek
Producers Howard Greenhalgh, David Ellis
Design Firm Why Not Films, London, ENG

TV Broadcast Graphics "VH-1: More More More"
Art Director Bonnie Siegler
Producer Mark Tiedemann
Director of Photography Thomas Tercek

TV Broadcast Graphics "VH-1: Rock The Vote"
Art Director Bonnie Siegler
Director of Photography Walter McGrady
Producer Bonnie Siegler
Writers Karen Salmansohn, Wendy Bott, Glenn Eichler

TV Broadcast Graphics "VH-1: World Alerts"
Art Director Chris Spencer
Designer Chris Spencer
Producer Chris Spencer
Design Firm Caesar Video Graphics, New York, NY

TV Broadcast Graphics "Flipman (Flix ID)"
Creative Director Karen Olcott
Designers Lambie, Nairn, Pinnacle Effects, EADG
Director of Photography Ink Tank, Kurtz & Friends, Pittard/Sullivan
Design Firms Lambie-Nairn, Pinnacle Effects, EADG
Client Showtime Networks Inc.

TV Broadcast Graphics "Crash" (Flix ID)
Creative Director Karen Olcott
Designers Lambie, Nairn, Pinnacle Effects, EADG
Director of Photography Ink Tank, Kurtz & Friends, Pittard/Sullivan
Design Firms Lambie-Nairn, Pinnacle Effects, EADG
Client Showtime Networks Inc.

TV Broadcast Graphics "Decade Open"
Art Director Angie Li
Creative Directors Judy McGrath, Abby Terkuhle
Producer Angie Li
Writer Susan Flinker

TV Broadcast Graphics "NOVA"
Art Director Richard Greenberg
Director of Photography Paul Johnson
Producer Lisa Fisher
Design Firm R/Greenberg Associates, New York, NY
Client WGBH, NOVA
Production Company R/Greenberg Associates

TV Broadcast Graphics "CBS 1992 Winter Olympics"
Art Director Paul Sidlo
Designer Dale Herigstad
Producers Patricia Moore, Sally Syberg

Logo/Station ID "VH-1, Please Stand By"
Art Director Bonnie Siegler
Designers Bonnie Siegler, Marianne Angelo
Director of Photography Thomas Tercek
Client/Publisher VH-1, MTV Networks
TV Broadcast Graphics "Magritte"
Art Director Isabella Bannerman
Director of Photography Glen Claybrook

TV Broadcast Graphics "Red, Hot & Dance"
Director Mark Pellington
Producers John Woo, Leigh Blake
Production Company Woo Art International

Music Video "Jeremy"/Pearl Jam
Art Director Anna Morgana
Director Mark Pellington
Directors of Photography Tom Richmond, Dennis Crossan
Producers Victoria Strange, Thomas Gorai
Production Company Woo Art, International

Music Video "The Fly"/U2
Director Mark Pellington
Production Company Woo Art International

Music Video "Shut 'Em Down"/Public Enemy
Director Mark Pellington
Production Company Woo Art International

TV Broadcast Graphics "Buzz #1"
Director Mark Pellington
Production Company MTV Networks

TV Broadcast Graphics "Me/We"
Director Mark Pellington
Production Company Woo Art International

Music Video "Television, Drug of a Nation"/Disposable
Heroes of Hiphopcricy
Director Mark Pellington
Production Company Woo Art International

Music Video "One"/U2
Director Mark Pellington
Production Company Woo Art International

TV Broadcast Graphics
"Alive From Off Center"/Sekou Sundiata
Director Mark Pellington
Production Company Woo Art International

TV Broadcast Graphics "Liquid Television Open"
Art Director Mark Malmberg
Creative Directors Judy McGrath,
Abby Terkuhle, Japhet Asher
Special Effects Xaos Inc.
Producer Prudence Fenton
Animation Ken Pierce

Film Title "Cape Fear"
Designers Saul and Elaine Bass
Design Firm Bass/Yager And Assoc.
Client Martin Scorsese

Film Title "Mr. Saturday Night"
Designers Saul and Elaine Bass
Design Firm Bass/Yager And Assoc.
Client Billy Crystal

Film Title "Goodfellas"
Designers Saul and Elaine Bass
Design Firm Bass/Yager And Assoc.
Client Martin Scorsese

Film Trailer "Body Double"
Art Director Richard Greenberg
Producer Brian Williams
Design Firm R/Greenberg Associates, Inc.
Production Company R/Greenberg Associates, Inc.

TV Broadcast Graphics "American Playhouse"
Art Director Richard Greenberg
Design Firm R/Greenberg Associates, Inc., New York, NY
Typographer Richard Greenberg

Film Trailer "Bram Stoker's Dracula"
Art Director Richard Greenberg
Designer Bruce Schluter
Producer Beth Anthony
Design Firm Greenberg & Schluter
Client Columbia Pictures
Printer Greenberg & Schluter: The Chandler Group

Film Title "The World According to Garp"
Art Director Richard Greenberg
Producer Brian Williams
Design Firm R/Greenberg Associates, Inc.
Client Warner Bros.
Typographer Richard Greenberg

Film Trailer "Dirty Dancing"
Art Director Richard Greenberg
Design Firm R/Greenberg Associates, Inc.
Client Vestron Pictures
Typographer Richard Greenberg
Production Company R/Greenberg Associates, Inc.

Film Title "Desert Bloom"
Art Director Richard Greenberg
Designer John Kay
Director of Photography B. David Green
Design Firm R/Greenberg Associates, Inc.
Client Columbia Pictures
Production Company R/Greenberg Associates, Inc.

Film Trailer "Blow Out"
Art Director Richard Greenberg
Design Firm R/Greenberg Associates, Inc.
Production Company R/Greenberg Associates, Inc.

Film Trailer "Bladerunner"
Art Director Richard Greenberg
Producer Brian Williams
Design Firm R/Greenberg Associates, Inc.
Client Warners Bros.
Production Company R/Greenberg Associates, Inc.

Film Title "New York Stories"
Art Director Bruce Schluter
Design Firm R/Greenberg Associates, Inc.
Clients Untitled Productions, Touchstone Pictures
Production Company R/Greenberg Associates, Inc.

Film Trailer "Kafka"
Art Director Thomas Barham
Producer Diane Pearlman
Design Firm R/Greenberg Associates, Inc.
Client Baltimore Productions
Typographer Thomas Barham
Production Company R/Greenberg Associates, Inc.

Film Trailer "Zebrahead"
Art Director Kyle Cooper
Producer Chip Houghton
Design Firm R/Greenberg Associates, Inc.
Client Zebra Head, Inc.
Production Company R/Greenberg Associates, Inc.

Film Title "LISTEN UP! The Lives of Quincy Jones"
Art Directors Kent Hunter, Phil Gips
Designers Kent Hunter, Jeff Hixon, Gina Stone
Producer Kent Alterman
Writer Danny Abelson
Design Firm Frankfurt Gips Balkind
Client Warner Bros.
Typographer Frankfurt Gips Balkind
Production Company Cynosure Films

Film Title "City Slickers"
Designer Wayne Fitzgerald
Producer Bob Kurtz
Animation Bob Kurtz and Friends
Editor Sim Sadler
Project Art Director/Creative Director Wayne Fitzgerald
Company Art Director/Project Manager Wayne Fitzgerald
Design Firm Pittard, Sullivan, Fitzgerald
Client A Castle Rock Production
Executive Producer Billy Crystal
Producer Irby Smith
Director Ron Underwood

Film Title "Dick Tracy"
Art Director Wayne Fitzgerald
Designer Wayne Fitzgerald
Illustrator Michael Lloyd
Matte Shots Disney Studios
Project Art Director/Creative Director Wayne Fitzgerald
Company Art Director/Project Manager Wayne Fitzgerald
Design Firm Pittard, Sullivan, Fitzgerald
Client A Mulholland Production
Producer Warren Beatty
Executive Producer Barry Osborne
Director Warren Beatty

TV Broadcast Graphics "Sisters"
Company Art Director/Project Manager Billy Pittard
Project Art Director/Creative Director Judy Korin
Designers Judy Korin, Francis Schifrin
Producer Dale Everett
Associate Producer Jessie Ward
Paintbox Artist Judy Korin
Director Judy Korin
Production Coordinator Julie Heal
Production Assistant Casey Dake
Design Firm Pittard, Sullivan, Fitzgerald
Client Lorimar Television
Executive Producers Ron Cowen, Daniel Lipman,
Michael Filerman, Kevin Inch

TV Broadcast Graphics
MTV "Liquid Television Open"
Art Directors Mark Malmberg, Japhet Asher
Producers Prudence Fenton,
Japhet Asher (Colossal Pictures)
Animators Ken Pearce, Tony Lupidi,
Henry Preston, Mark Malmberg
Design Firm (MTV), Abby Terkuhle,
John Payson, New York, NY
Production Company Colossal Pictures/Big Pictures

TV Broadcast Graphics "The Tracey Ullman Show"
Project Art Director/Creative Director Ed Sullivan
Company Art Director/Project Manager Billy Pittard
Designer Jeff Boortz
Paintbox Artist Jeff Boortz
Harry Artist Jeff Boortz
Executive Producer James L. Brooks
Design Firm Pittard, Sullivan, Fitzgerald
Client Gracie Films
Executive Producer James L. Brooks

TV Broadcast Graphics The Box ID Campaign
Art Directors Holly Chasin, Phil Delbourgo
Designers Holly Chasin, Brian Diecks
Director of Photography David Knaus
Producer Phil Delbourgo
Writer Stacy Wall
Client Video Jukebox Network
Typographers Holly Chasin, Brian Diecks
Production Company Big Fat TV Inc.

TV Broadcast Graphics
"Action Adventure/The Movie Channel"
Art Director Jerry Cook, Pinnacle Effects
Designers John & Roger Woo, Woo Art
Directors of Photography Alex Weil/Charlex,
Fred Seibert, Fred Allan
Creative Director Karen Olcott
Design Firm Pinnacle Effects, Woo Art, Charle
Client Showtime Networks Inc.
Typographer Louis Lino

Music Video Michael Jackson "Black or White"
Director John Landis
Effects Supervisor Jamie Dixon
Director of Photography Mac Ahlberg
PDI Producer Julia Gibson
PDI Executive Producer Carl Rosendahl
Animation Company Pacific Data Images
Client MJJ Productions
Production Company Propaganda Films

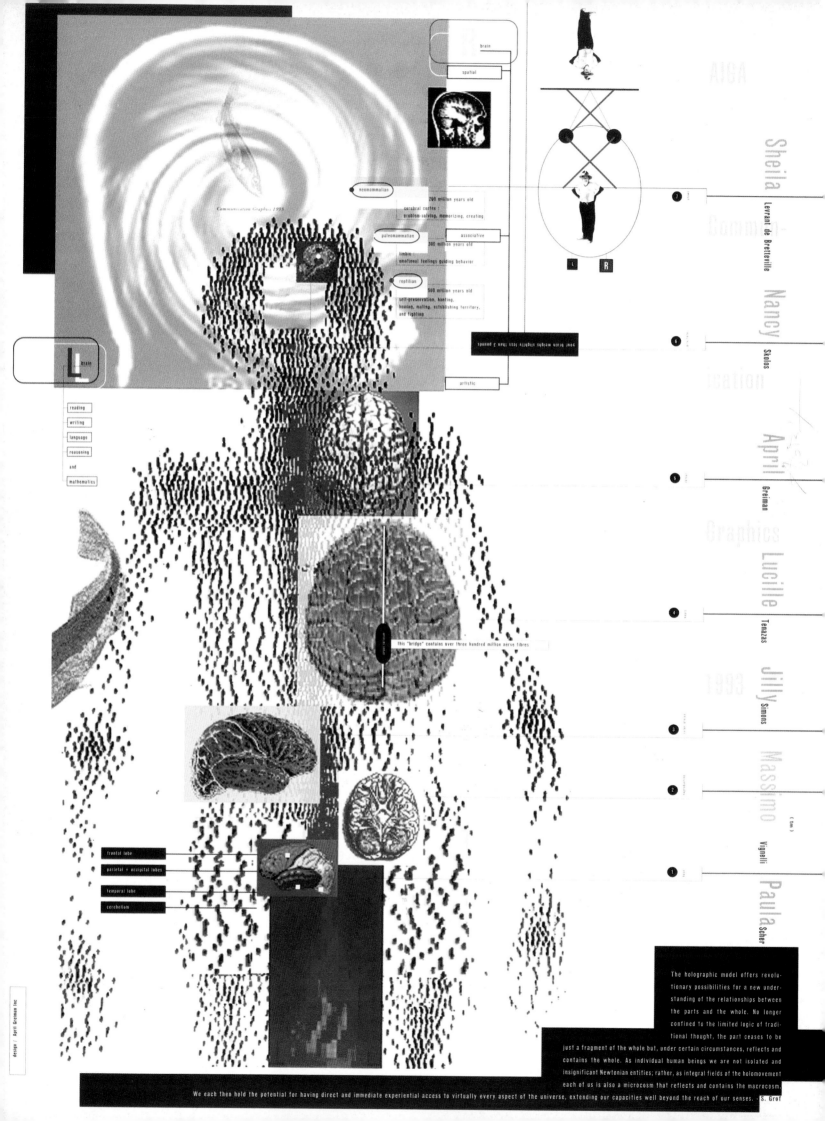

brain

spatial

neomammalian

200 million years old
cerebral cortex :
problem-solving, memorizing, creating

associative

paleomammalian

300 million years old
limbic :
emotional feelings guiding behavior

reptilian

500 million years old
self-preservation, hunting,
homing, mating, establishing territory,
and fighting

your brain weighs slightly less than 3 pounds

artistic

L brain

reading
writing
language
reasoning
and
mathematics

this "bridge" contains over three hundred million nerve fibres

frontal lobe
parietal + occipital lobes
temporal lobe
cerebellum

L R

Communication Graphics 1993

design / April Greiman Inc

AIGA Sheila Levrant de Bretteville Nancy Skolos Communication April Greiman Graphics Lucille Tenazas Jilly Simons 1993 Massimo (tm) Vignelli Paula Scher

The holographic model offers revolutionary possibilities for a new understanding of the relationships between the parts and the whole. No longer confined to the limited logic of traditional thought, the part ceases to be just a fragment of the whole but, under certain circumstances, reflects and contains the whole. As individual human beings we are not isolated and insignificant Newtonian entities; rather, as integral fields of the holomovement each of us is also a microcosm that reflects and contains the macrocosm. We each then hold the potential for having direct and immediate experiential access to virtually every aspect of the universe, extending our capacities well beyond the reach of our senses. - S. Grof

This year's CG Show represents visually the paradigm shift that is occuring not only within our industry, vis-a-vis new technology, but the global picture as well, in terms of the dominant communication media.

Specifically, the real vitality in the entries was in the area of motion graphics. (There was that great half day of judging, when Massimo was swaying to the music, right along with Jilly and Lucille.) And ironically you the "reader" can't begin to experience this, as the format for presenting the winners is still locked in that old paradigm of "print media."

Generally one could see the plurality of styles as the overriding "M.O." One could feel (right around the corner) that the majority of print will be "going digital." And finally, and most important, that the driving force and concern is our awareness of the environment!

The new tools represent a bigger metaphor, that of a new way of creating and communicating via the collective. The old hierarchical "top-down" paradigm is giving way to more democratic, collective processes for creativity and communication.

While we see here some of the forerunners of total integration in all forms of media, the bigger goal is to begin the process of integrating consciousness with every form of art and design. In order to change the external, one must first change the internal.

April Greiman, *Chairman*

Jury

April Greiman (Chair)
Principal
April Greiman, Inc.
Los Angeles, CA

Sheila Levrant de Bretteville
Principal
The Sheila Studio
Hamden, CT

Nancy Skolos
Designer
Boston, MA

Lucille Tenazas
Principal
Tenazas Design
San Francisco, CA

Jilly Simons
Principal
Concrete
Chicago, IL

Massimo Vignelli
Principal
Vignelli Associates
New York, NY

Paul Scher
Partner
Pentagram
New York, NY

Call for Entries

Design April Greiman Inc.
Digital Output RPI
Filmwork Andresen Graphic Services
Printer The Pikes Peak Lithographing Co.
Paper Mohawk Vellum Cool White 60 lb. Text
Special thanks to Print Magazine, and Bryan and Phyllis for the brains

1

uɐᵍɪsǝpivot

3

1
Newsletter CAM (contemporary Arts Museum)
Art Director Herman Dyal
Designers Herman Dyal, Susan McIntyre
Design Firm Fuller Dyal & Stamper, Austin, TX
Client Contemporary Arts Museum, Houston, TX

2
Logo Design Pivot
Art Director/Designer Brock Haldeman
Design Firm Pivot Design, Chicago, IL
Typographer Brock Haldeman

3
Print Advertising "Last Year Readers of US and Rolling Stone Relaxed"
Art Director/Writer Gary Goldsmith
Design Firm Goldsmith/Jeffrey, New York, NY
Client US Magazine

4
Print Advertising "Last Year Readers of US and Rolling Stone Plugged In"
Art Director Gary Goldsmith
Writer Ty Montague
Design Firm US Magazine

domus

MONTHLY REVIEW OF ARCHITECTURE INTERIORS DESIGN ART

NUMERO 712 — APRILE 1992

Editoriale: Progetto e durata □ John Hejduk, due monumenti a Praga □ Michael Hopkins, edificio per uffici a Londra □ Enric Miralles, cimitero a Barcellona □ Mario Botta, studio a Lugano □ Tre interni: a Londra, New York e Parigi □ Mobili: l'arredo svizzero 1925-1950 □ Saggio sul concetto di qualità □ Frank Lloyd Wright: la tecnica del *textile block* e itinerario in California.

5

5
Magazine Cover "Domus"
Art Director/Illustrator Henry Wolf
Design Firm Henry Wolf Productions, Inc., New York, NY
Publisher Domus
Typography Characters

6
Annual Report On Herman Miller, 1992
Art Director Stephen Frykholm
Designers Stephen Frykholm, Yang Kim
Writer Clark Malcolm
Illustration Guy Billout
Client Herman Miller, Inc.
Typographer Rita Endres/Herman Miller, Inc.
Printer Etheridge Company
Paper Manufacturer Champion

6

On Herman Miller

and 1992 Financial Statements of Herman Miller, Inc., and Subsidiaries

On past leaders at Herman Miller

There have been four CEOs at Herman Miller. Did I not truly admire and respect them—D.J., Hugh, and Max DePree, and Dick Ruch —I would not be writing this report. I cannot copy their success. I have come to Herman Miller at a unique point in this company's history, and I feel fortunate to be here now.

When I leave, I hope that I will have been good for the company and its people. I will try hard to earn, as past CEOs here have, the trust and fellowship of Herman Miller's people.

33

1

Trade Advertising "The Standard"
Art Director/Designer Earl Gee
Writer Morgan Thomas
Photographer Geoffrey Nelson
Design Firm Earl Gee Design, San Francisco, CA
Client Greenleaf Medical
Typographer Earl Gee
Printer AR Lithographers
Paper Manufacturer Simpson Paper Company

2

Trade Advertising "Precision System"
Art Director/Designer Earl Gee
Writer Morgan Thomas
Photographer Geoffrey Nelson
Design Firm Earl Gee Design, San Francisco, CA
Client Greenleaf Medical
Typographer Earl Gee
Printer AR Lithographers
Paper Manufacturer Simpson Paper Company

3

Promotion Cal Arts Program Key
Art Director/Designer/Illustrator P. Lyn Middleton
Client Cal Arts Admissions, Ken Young
Printer Mitchell Graphics

4
Magazine Advertising Photonica
Art Director John C. Jay
Writer Brian Leitch
Photography Photonica Stock Photography
Design Firm John Jay Design, New York, NY
Client Photonica

5
Print Matter SCI-Arc Director's Circle
Art Director April Greiman
Designers Sean Adams, April Greiman
Illustrators Various
Design Firm April Greiman Inc., Los Angeles, CA
Client Southern California Institute of Architecture
Typography Icon West
Printer Monarch Litho
Paper Manufacturer Various

6
Brochure Connecting a Continent
Art Director Tim Thompson
Designer Joe Parisi
Photography Ed Whitman, Stock
Design Firm Graffito, Inc., Baltimore, MD
Client American Mobile Satellite Corporation
Typography Graffito, Inc.
Printer French Bray, Inc.
Paper Manufacturer Domtar Fine Papers

1

Corporate Newsletters If:
Art Director Bruce Crocker
Designers Bruce Crocker, Martin Sorger
Illustrator Mark Fisher
Design Firm Crocker, Inc., Brookline, MA
Client IdeaScope Associates
Typographer Lee Busch
Printer Fine Art Press
Paper Manufacturer Westvaco

2

Brochure DanceAspen
Art Director Jamie Koval
Designer Curt Schreiber
Design Firm VSA Partners, Inc., Chicago, IL
Client DanceAspen
Typography VSA Partners, Inc.
Printer Banta

3

Catalog Art Center College of Design Catalog 1993-94
Art Director Rebeca Méndez
Designers Rebeca Méndez, Darren Namaye, Darren Beaman
Photographer Steven A. Heller
Design Firm/Client Art Center College of Design, Pasadena, CA
Typography Macintosh II
Printer Typecraft, Inc.
Paper Manufacturer Potlatch

4

Booklet A Look at Art Center College of Design
Art Director Rebeca Méndez
Designers Darren Namaye, Rebeca Méndez
Principal Photographer Steven A. Heller
Design Firm/Client Art Center College of Design, Pasadena, CA
Paper Manufacturer Potlatch

5

Stationery Program Werner design Werks Inc.
Art Director Sharon Werner
Illustrators Sharon Werner, Lynn Schulte
Design Firm Werner design Werks Inc., Minneapolis, MN
Typography Great Faces
Printer Print Craft

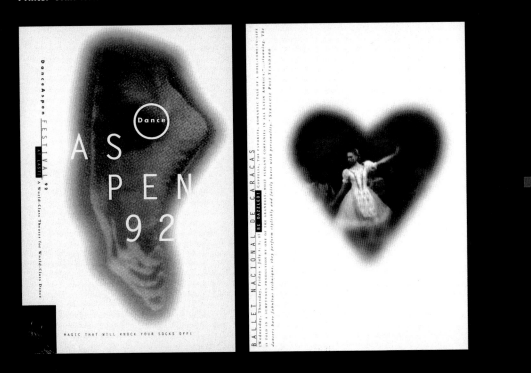

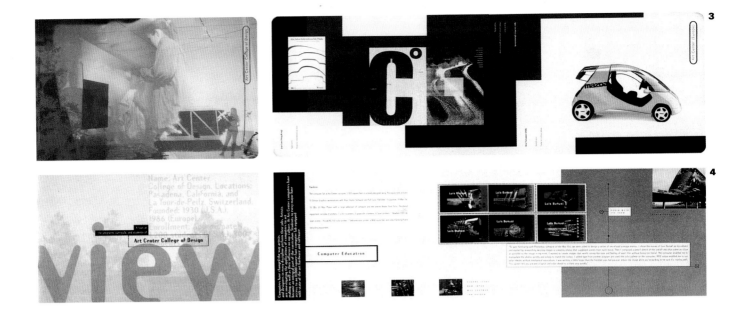

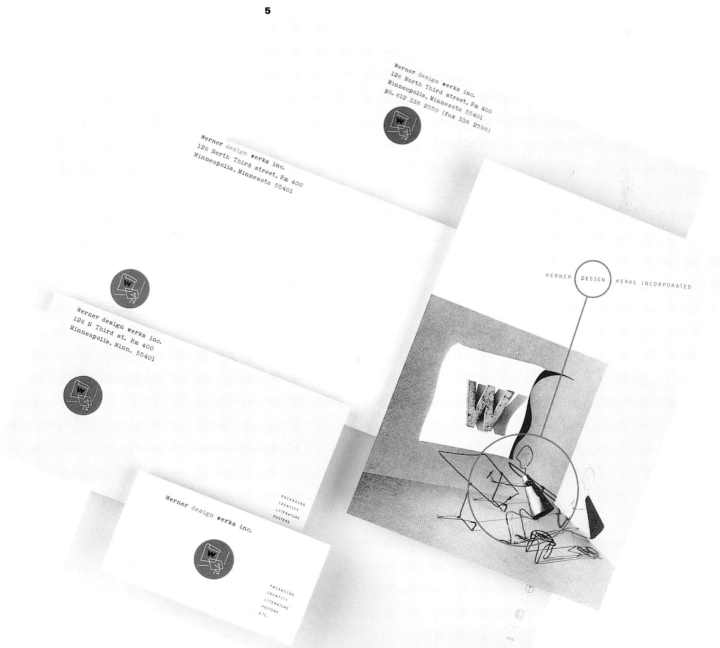

1

Brochures The Lynnfield Series 300L/500L
Art Director Bruce Crocker
Designers Bruce Crocker, Martin Sorger
Photographers Gallen Mei, Bill Gallery, John Shotwell
Illustration Microcolor
Design Firm Crocker, Inc., Brookline, MA
Client Boston Acoustics
Typographer Lee Busch
Printer Nimrod Press
Paper Manufacturer Potlatch

2

Print Matter Louis Dreyfus Energy
Art Director/Designer Tom Wood
Writer Mary Anne Costello
Photographer Jeff Corwin
Design Firm Wood Design, New York, NY
Client Louis Dreyfus Energy
Printer Hennegan
Paper Manufacturers Potlatch, Simpson

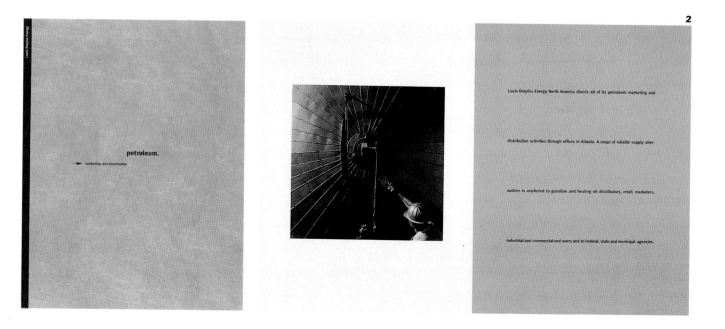

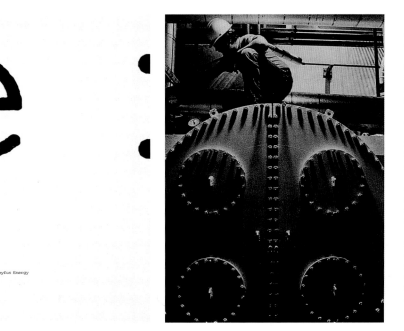

e

Louis Dreyfus Energy

independent power producer. Louis Dreyfus Energy fills that niche by combining its traditional marketing experience with new opportunities in an evolving deregulated market.

To meet the increasing demand for electric power, Louis Dreyfus is committed to providing fuel to cogeneration facilities at fixed prices for a set term. This commitment is possible through (1) the ownership and operation of gas reserve properties; (2) effective management of production and transportation costs during the contract period; and (3) global experience in merchandising and hedging activities which take advantage of volatile conditions in the marketplace.

In addition to serving the independent power market in North America, Louis Dreyfus is well positioned in the global energy market to participate in development and equity opportunities.

Louis Dreyfus Energy is a wholly owned subsidiary of the Louis Dreyfus Group, a worldwide organization of diversified companies headquartered in Paris, France. In addition to its principal operational headquarters in Paris, New York and Wilton, Connecticut, there are major offices in Zurich, Madrid, London, São Paulo, Buenos Aires, Melbourne and Tokyo with representative offices in 16 other countries.

Founded in 1851, principal activities of the parent company include the international merchandising and exporting of various commodities, ownership and management of ocean vessels, manufacturing operations and real estate development, management and ownership. In addition to petroleum and petroleum products, the Louis Dreyfus Group, through a number of subsidiaries, also merchandises all agricultural commodities, industrial alcohol, fibers and financial instruments. Annual global trading volume is approximately $25 billion.

The shipping fleet consists of 19 vessels including Lakers, Panamaxes, Cape-size dry bulk carriers, seismic research vessels and LNG carriers. Louis Dreyfus owns and operates orange juice processing plants in Brazil as well as rice milling and oilseed crushing facilities in the United States, Europe and South America. The Group's other industrial operations are located in Argentina and Brazil and involve the manufacture of particleboard wood products, modular furniture and plastic laminates. Real estate activities are conducted through Louis Dreyfus Property Group, which develops, owns and manages real properties in North America and Europe. The Property Group owns over three million square feet of premier office space as well as hotels and retail properties.

3

3
Print Matter e: Louis Dreyfus Energy
Art Director/Designer Tom Wood
Writer Mary Anne Costello
Photographer Jeff Corwin
Design Firm Wood Design, New York, NY
Client Louis Dreyfus Energy
Paper Manufacturer Zanders

4
Series Campaign Proposal/Qualifications Program/Serv-Tech, Inc.
Art Director Lana Rigsby
Designers Lana Rigsby, Troy Ford
Writer JoAnn Stone
Illustrator Troy Ford
Photographers Chris Shinn, Jim Simms, Joe Baraban
Design Firm Rigsby Design, Inc., Houston, TX
Typography Characters, One Works
Printer Emmott-Walker Printing, Inc

5
Corporate Identity Continental Airlines
Art Director Constance Birdsall
Designer Richelle Huff
Photographer Susan Wides
Design Firm Lippincott & Margulies, Inc., New York, NY
Client Continental Airlines

5

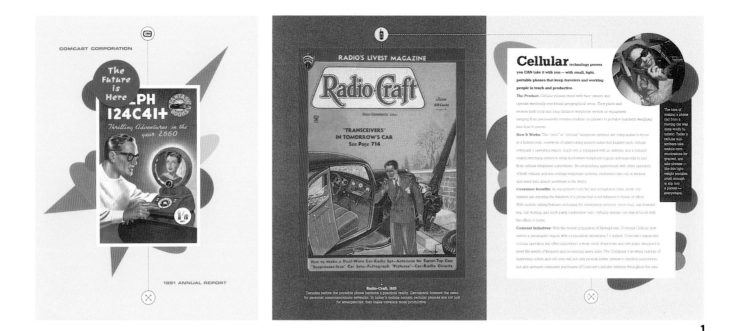

1

Annual Report Comcast Corporation: The Future is Here 1991
Art Directors Danny Abelson, Kent Hunter, Aubrey Balkind
Designer Riki Sethiadi
Photographers Chip Simons, Mark Jenkinson
Design Firm Frankfurt Gips Balkind, New York, NY
Client Comcast Corporation
Typography Frankfurt Gips Balkind
Printer Lebanon Valley Offset
Paper Manufacturer Simpson

2

Packaging Condom Matchbooks
Art Director J. Christopher Edwards
Designers Tina Shaw, J. Christopher Edwards
Design Firm Mission Design, Winston-Salem, NC
Client Safeway Marketing
Typography AdType
Printer Hutchinson-Allgood

3

Booklet Try Eze-Stik
Designer David Williams
Writing Lausen Williams + Co.
Design Firm/Typography Lausen Williams + Co., Chicago, IL
Client/Paper Manufacturer Fitzburgh CPI
Printers Elmcor, Solo Printing

4
Shopping Bag Bloomingdale's Holiday '92
Art Director/Designer Todd Waterbury
Creative Director Helane Blumfield
Copy Supervisor Susan Cooper
Foreign Language Copy Steve Hogan
Illustrator/Typographer Todd Waterbury
Design Firm/Client Bloomingdale's, New York, NY
Printer Duro

5
Print Advertising Lighter Fluid
Art Director Gary Goldsmith
Writer Dean Hacohen
Design Firm Goldsmith/Jeffrey, New York, NY
Client Berdorf Goodman, New York

6
Print Advertising "It's Not How Many Closets You Have"
Art Director Gary Goldsmith
Writer Dean Hacohen
Design Firm Goldsmith/Jeffrey, New York, NY
Client Bergdorf Goodman, New York

7
Print Advertising "Your Magazine Has Never Given Much Thought to…"
Art Director Gary Goldsmith
Writer Dean Hacohen
Design Firm Goldsmith/Jeffrey, New York, NY
Client Bergdorf Goodman, New York

1

The ability

to produce protein

drugs intracellularly makes possible

entirely new strategies for managing life-threatening diseases.

Vimpex, Inc.

2

Wellness Center

Ask someone to

Texas Children's Hospital

It's more than
a crutch to lean on

Rehabilitation

3

1

Brochure Viagene
Art Director Diana DeLucia
Designer Patricia Kovic
Photographers Earl Ripling, Bard Martin
Illustrators Gilbert Cruz, Martin Hagland/Microcolor, Inc.
Design Firm Diana DeLucia Design, New York, NY
Agency Noonan/Russo Communications, Inc.
Client Viagene
Typography In-house
Printer Diversified Graphics, Inc

2

Brochure Texas Children's Hospital Wellness Center
Designer Mark Geer
Photographer Beryl Striewski
Illustrators Mark Geer, Morgan Bomar
Design Firm/Typography Geer Design, Inc., Houston, TX
Client Texas Children's Hospital
Printer Houston Grover Litho
Paper Manufacturer Simpson

3

Annual Report CornerHouse 1991: Committed to the Safety of Children
Art Director Kevin Kuester
Designers Kevin Kuester, Tim Sauer
Illustrators Landon Kuester, Lauren Kuester, Martine Lizama,
Mike Lizama, Tim Sauer
Writer Andy Blankenburg
Client CornerHouse
Typography May Typography
Printer Watt/Peterson, Inc.
Paper Manufacturers Potlatch, Gilbert

4

5

4
Catalog Problems and Solutions: Surveying the Work of Jon Tower
Designers James Sholly, Laura Lacy-Sholly
Design Firm Antenna, Indianapolis, IN
Client Herron Gallery
Printer Design Printing Co

5
Annual Report COR Therapeutics 1991
Art Director Bill Cahan
Designer Jean Orlebeke
Photographers Jock McDonald, R.J. Muna, Michele Clement,
Dr. Michael Stern
Design Firm Cahan & Associates, San Francisco, CA
Client COR Therapeutics, Inc.
Typography Andresen Typography

Poster "The Substance of Fire"
Art Director Doug Hughes
Designer Robynne Raye
Design Firm Modern Dog, Seattle, WA
Client Seattle Repertory Theatre
Typographer Robynne Raye
Printer The Copy Company
Paper Manufacturer Simpson

2

Journal Design Penn State Journal of Contemporary Criticism
Creative Director Lanny Sommese
Art Directors/Designers George Migash, Colleen Stokes
Editor John Kissick
Client Penn State Journal of Contemporary Criticism
Typographers George Migash, Colleen Stokes
Printer Nittany Valley Offset

SEATTLE REPERTORY THEATRE PRESENTS

THE SUBSTANCE OF FIRE

BY JON ROBIN BAITZ

OCTOBER 28 - NOVEMBER 15
ON STAGE 2 • TICKETS 443.2222

Printed on recycled paper by The Copy Co.

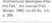

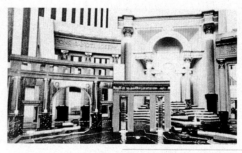

Figure 1.1
Charles Moore,
Piazza d'Italia, 1976.

centric culture and the International Style. Politically, these dominant traditions can be understood as residual forms of colonialism and imperialism. Artistically and architecturally the International Style was simply less interesting in its visual vocabulary, tied up with authoritarian aesthetics that needed to be tested or teased into change. Less is not more. In Post Modernist language, less is less and more is indeed more.

Post-Modernism adopts strategies from literary theory and linguistics in order to buttress its ideology, the main issue of which is a kind of illustration of critical theory rather than the development of new architectural concepts. Its premises parallel those of the Symbolist movement of the 19th century, which rejected the retinal formalism of the Impressionists and exalted symbolic consciousness and literary ideas. Ironically, Post-Modernism has proven instrumental in the re-evaluation of early Modernism. It made possible various stylistic tendencies from Punk typography and design (a gloss on early Dada) to the application of collage (initially developed in Cubism) in video and computer graphics. In adapting the visual strategies of artists such as Picasso and Braque through the use of collage and the introduction of the vernacular into "high art," Post-Modernism anticipates the current critical revisioning of early Modernism. It has introduced a renewed appreciation of the radical visual play of early Modernism that previously was discarded by the deliberate purism of late Modernist ideology, typified by formalist critics such as Clement Greenberg. This revival of

5 Richard Pommer, "Some Architectural Ideologies After the Fall," *Art Journal* (Fall/Winter, 1980) Vol.40 No. 1/2), p. 368.

Figure 1
Charles Moore, *Piazza d'Italia* 1976. (Photograph courtesy of Norman McGrath)

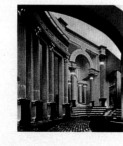

the earlier style suggests that Post-Modernism is not so much a self-directed style as a reaction; against a Bauhaus backdrop, it sasses modernist purity with as much architectural lip as it can muster.

The collage principle of early Modern art is employed by Post-Modernism to provoke the audience with startling juxtapositions of architectural forms, as in the layered facades of the Piazza d'Italia by Charles Moore[5] (Figure 1). But there is a difference in the way in which collage is understood in each style; in architecture, forms already found in the vocabulary are reintroduced in new orders, whereas in Cubism, collage was built of refuse, of scraps of everyday life. In Picasso's *The Card Player* of 1913-1914, the

artist introduces an element of everyday life with the addition of the ordinary playing card (Figure 2). And in other Cubist collages the shred of newspaper or the wine label evoke a sympathetic recognition of their mundane origin. Collage derives its very vitality from this interpenetration of art and life. In Post-Modern Classicism, disparate elements are collaged together with the intention of provoking a similar response in the viewer, as in the juxtapositions of the Piazza d'Italia. The "2-4-6-8 House" by Morphosis Architects also uses elements of collage. Where the early modern collage broke the fixed frame of reference of Renaissance art, in the "2-4-6-8 House" the window breaks out of its customary frame becoming an unfixed idea in the construction of the house (Figure 3). This is closer in spirit to Cubist collages such as Picasso's *Man with a Hat*, in which forms are detached from their outlines and repetition, doubling, and surprise are essential (Figure 4).

But elements from other periods and styles of art are already removed from direct experience. By comparison, the overlay of architectural orders employed by much of Post-Modernism has not at all the same effect as the Cubist collages from which it claims derivation, for these early collages employ scraps of the immediate environment in a new and meaningful unity. To mimic the principle of collage but not its intuitive logic is to give way to artifice and arbitrariness that is but a footnote of a footnote in the movement's spiraling eclecticism.

16 17

3

Annual Report Signs of the Times/Greater Minneapolis
American Red Cross 1991-1992
Designers/Directors of Photography Donna Daubendiek and Timorse
Writers Wilhide & Company
Photographers Brady Willette, Marty Berglin, David Ellis
Design Firm Coloured Blind
Client American Red Cross
Printer Wallace Carlson Company
Paper Manufacturer Jaguar

4

Bus Shelter Poster "I Believe in Safe Sex Until the Third Drink"
Art Director/Designer Cecilia Brunazzi
Photographer Lorie Eanes
Agency Public Media Center, San Francisco, CA
Client Stop AIDS Project
Typography Rapid Type
Printer JOMAC

3

4

5

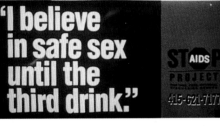

5

T-Shirt Capp Street
Art Director Jennifer Morla
Designer Sharrie Brooks
Photographer Holly Stewart
Design Firm Morla Design, San Francisco, CA
Client Capp Street Project
Printer Stinkfish Actionwear

1

Brochure Discover
Art Director/Designer Joel Katz
Illustration Seymour Mednick
Design Firm Katz Design Group
Client Monadnock Paper Mills
Typography Katz Design Group
Printer Strine Printing Co., Inc

2

Stationery Linda Chryle
Art Director Mark Oldach
Designers Mark Oldach, Mark Meyer
Design Firm Mark Oldach Design, Chicago, IL
Client Linda Chryle, Writer
Typography Infocomm
Paper Manufacturer Simpson

3

Catalog World Holiday and Time Guide

Art Director Emily Singer

Photographer William Whitehurst

Design Firm/Typography J.P. Morgan Corporate Communication

Client J.P. Morgan & Co. Incorporated

Printer Veitch Printing

Paper Manufacturers Acosta, Lustro

4

Corporate Identity Stanley Kaplan SAT Campaign

Art Directors Rick Stermole, Robert Greenberg

Writers Diana Amsterdam

Photographers Nick Basilion, Miranda Turin

Design Firm Parham-Santana, Inc., New York, NY

Client Stanley Kaplan

Typography Macintosh

4

5

Corporate Newsletter Digital News #2

Art Director Mark Koudys

Photographer Ron Baxter Smith

Design Firm Atlanta Art and Design, Toronto, CAN

Client Digital Equipment of Canada

Printer Matthews, Ingham and Lake

5

1

Poster Aalto
Art Director Jeffrey Morris
Designers Jeffrey Morris, Patricia Kovic
Design Firm Studio Morris, New York, NY

2

Promotion Kit Knoll Visitation Program
Design Director Thomas Geismar
Designer Weston Bingham
Design Firm Chermayeff & Geismar, Inc., New York, NY
Client The Knoll Group
Printer Etheridge

3

Catalog Frank Gehry: New Bentwood Furniture Designs
Art Director Bruce Mau
Designers Bruce Mau, Alison Hahn, Nigel Smith
Photographers Joshua White, Jay Ahrend
Design Firm Bruce Mau Design, Inc., Toronto, CAN
Client The Montreal Museum of Decorative Arts
Typography Archetype in Alpha
Printer Stinehour Press
Paper Manufacturer Cross Pointe

3

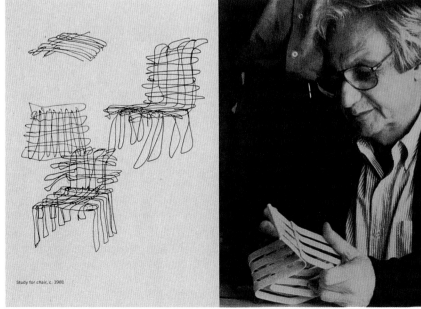

Study for chair, c. 1981

4

4

Exhibition Poster AIGA Book Show Unfolds . . . Book Your Seat
Designers Sam Silvio, Jeff Stasik, Susan Johnson Clifton
Design Firm Silvio Design, Chicago, IL
Photographer Alan Shortall
Client AIGA/Chicago
Typography Paul Baker Typography, Inc.
Printer Rohner Printing

5

6

5

Newsletter Abridged IV/"Hot Seats"
Art Director Rebeca Méndez
Designer Darren Namaye
Design Firm/Client Art Center College of Design, Pasadena, CA
Typography Macintosh II
Printer Sinclair Printing Company
Paper Manufacturer Simpson

6

Print Matter Knoll Price Lists
Design Director Thomas Geismar
Designer Cathy Schaefer
Design Firm Chermayeff & Geismar Inc./Knoll Graphics, New York, NY
Client The Knoll Group
Typography Macintosh
Printers Etheridge, Burch Printing, Westinghouse Printing
Paper Manufacturer Simpson

1

Type Specimen Booklet Poetica
Art Director Laurie Szujewska
Designer James Young
Design Firm/Client Adobe Systems, Inc., Mountain View, CA
Typographers Laurie Szujewska, James Young
Printer West Coast Litho
Paper Manufacturer Mohawk Superfine

2

Type Specimen Booklet Myriad/Two-Axis Typeface
Art Director Laurie Szujewska
Designers/Typographers Margery Cantor, James Young
Design Firm/Client Adobe Systems, Inc., Mountain View, CA
Printer West Coast Litho
Paper Manufacturer Mohawk Superfine

3

Type Specimen Booklet Minion/Three-Axis Typeface
Designers/Typographers Margery Cantor, Laurie Szujewska, James Young
Design Firm/Client Adobe Systems, Inc., Mountain View, CA
Printer West Coast Litho
Paper Manufacturer Mohawk Superfine

4

Self Promotion Ugly Promotion
Art Director/Designer Jilly Simons
Photography Francois Robert
Design Firm Concrete, Chicago, IL
Client Mohawk Paper Mills, Inc.
Printer Active Graphics, Inc.
Paper Manufacturer Mohawk

You've found yourself face to face with something basic, something familiar. A bridge, perhaps. What does it look like? Wait! Before you describe it, ask: What time of day is it? Am I in love? Is it raining? How well do I swim? Does this bridge remind me of Venice? Do I like surprises? Would other people call ugly the things I'd defend as beautiful? What happened at work today? What is a bridge, anyway? An extension of the road, or an end in itself? Because it's you, looking at the world through your eyes, from your unique point of view, no bridge is familiar. There's no such thing as just your basic bridge. Now it's time to put pen to paper and show the world what the bridge looks like to you. If you're of a classical temperament, you'll search for papers that are frightfully elegant. If you're a romantic, only appallingly lovely paper will do. And if you're practical (who isn't?), you'll want paper that's hardworking and accessible as well as terribly extraordinary. Your search for petulantly unique paper begins in your eyes, at your unique point of view. Your search ends at Mohawk.

Come quickly, I am tasting the stars!
DOM PERIGNON

"Paige" mother-of-suede pump, $190,
and matching clutch bag
with shoulder strap, $285. 585-0995
BALLY OF SWITZERLAND

Art strives for form and hopes for beauty.
GEORGE BELLOWS

Sterling and vermeil cufflinks by
Donald Friedlich, $95. Handblown one-of-a-kind
glass bowl by Jesse Reece, $1470. 233-0128
DIANA BURKE GALLERY

5

5

Catalog The World Financial Center Holiday Collection 1992
Art Director Rose Marie Turk
Creative Director Stephen Doyle
Photographer William Abranowicz
Design Firm Drenttel Doyle Partners, New York, NY
Client Olympia & York (USA)
Printer Queens Group
Paper Manufacturer Champion International

6

Book Packaging Time Exposed: Hiroshi Sugimoto
Art Directors Takaaki Matsumoto, Michael McGinn
Photography Hiroshi Sugimoto
Design Firm/Typography M Plus M Incorporated, New York, NY
Publisher Kyoto Shoin Publishing Company

Was he
a scoundrel...
or a saint?

James Michael Curley began life in the slums of Boston. Smart and ambitious, he charmed his way to four terms as mayor, four as congressman and one as governor of Massachusetts. To the city's Irish immigrants, he was a saint. To others he was a scoundrel who used political influence for his own gain. He was regularly investigated for corruption, and ran one campaign for mayor from jail. He won. Fifty years later he interrupted a mayoral term to do time in a federal penitentiary. And still the people thought of him as their champion. At his funeral, thousands turned out to salute a great charmer – and, many say, an incorrigible crook.

Watch *Scandalous Mayor* on
The American Experience,
hosted by David McCullough.

The American Experience

Monday, October 28 at 9 p.m. (ET)
in most cities, on public television.

Made possible by Aetna.

1

Now picture them in
three-piece suits.

These Indians are on their way to becoming the white men's idea of gentlemen. They have been enrolled in a special school where they will have their hair cut short, will be allowed to speak only English, will be denied visits home for five years. The idea is, they will stay in school until they are "civilized." An honorable notion, maybe, in the 1890s when the Carlisle School for Indians was established. But by the 1930s, after the Carlisle model had been copied at many reservation boarding schools, it was clear that "killing the Indian and saving the man" was not doing the tribes any good. The noble experiment was abandoned. Native Americans who lived through it help tell the story.

Watch *In the White Man's Image* on
The American Experience,
hosted by David McCullough.

The American Experience

Monday, February 17 at 9 p.m. (ET)
in most cities, on public television.

Made possible by Aetna.

2

3

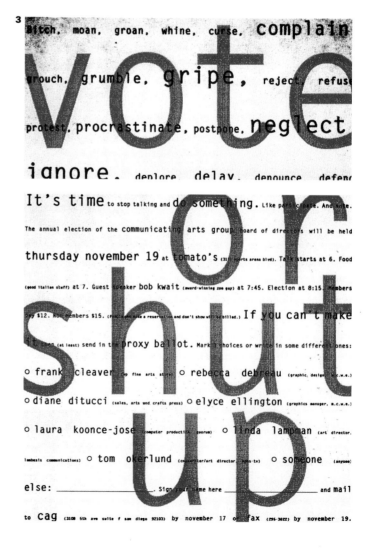

1

Magazine Advertising The American Experience:
"Scandalous Mayor"
Art Director/Designer Susan Fasick-Jones
Design Firm Peter Good Graphic Design, Chester, CT
Client Aetna
Typography Typehouse

2

Magazine Advertising The American Experience:
"In the White Man's Image"
Art Director/Designer Susan Fasick-Jones
Design Firm Peter Good Graphic Design, Chester, CT
Typography Typehouse

3

Announcement Communication Arts Group Election
Art Director/Designer John Ball
Design Firm Mires Design, Inc., San Diego, CA
Client Communications Arts Group

4

Flyer Choose or Lose
Art Director/Designer Jeffrey Keyton
Writing Doublespace
Photographer Herman Costa
Design Firm MTV Networks, New York, NY

5

Catalog MLK Commemorative Exhibit
Art Director Franc Nunoo-Quarcoo
Designers Franc Nunoo-Quarcoo, Garland Kirkpatrick
Editors James S. Jackson, Maria Phillips
Photographer Rodney A. Roberts
Design Firm Nunoo-Quarcoo Design, Ann Arbor, MI
Printer The Inland Press
Paper Manufacturer Monadnock Paper Mills, Inc

6

Poster Beware of God
Art Director/Designer Mark Fox
Design Firm/Client BlackDog, San Rafael, CA
Printer Wasserman Silkscreen (Sheet Metal)

4

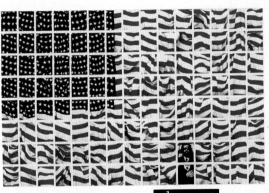

5

6

1

Photography An Annual Meeting of Epic Proportion
Art Director Gail Wiggin
Designers Robert Innis, Lauren Barr
Writer Alec Wiggin
Photographer Amos Chan
Design Firm Wiggin Design Inc., Darien, CT
Client MasterCard International Inc.
Typographer Gail Wiggin
Printer Diversified Minneapolis
Paper Manufacturer Strathmore

2

Annual Report Chicago Board of Trade 1991
Art Director Dana Arnett
Designers Dana Arnett, Curt Schreiber
Writer Michael Oakes
Illustration Francois Robert, Wayne Cable
Design Firm VSA Partners, Inc., Chicago, IL
Client Chicago Board of Trade
Printer Hennegan Printing
Paper Manufacturers Potlatch, Gilbert

1

2

C B O T

3

3

Publication Design Atheneum

Art Director/Designer Peter Good

Illustrators Edward Kim, Peter Good

Design Firm Peter Good Graphic Design, Chester, CT

Client Wadsworth Atheneum Museum

Typography Typehouse

Printer Cromwell Printing Company

Paper Mountie Matte

4

Stationery Grafik Communications, Ltd.

Design Team David Collins, Judy F. Kirpich, Jim Jackson

Illustrator David Collins

Design Firm Grafik Communications, Ltd., Alexandria, VA

Printer Huffman Press

Paper Manufacturer James River Corporation

4

1

Catalog In Good Conscience/Alan E. Cober

Art Director Daphne Geismar

Design Firm Context, Inc., South Norwalk, CT

Client Katonah Museum of Art

Printer Penmar Lithographers

Paper Manufacturers Mohawk, Simpson

2

Brochure World Design '92

Designer Michael Mabry

Design Firm Michael Mabry Design, San Francisco, CA

Client Industrial Designers Society of America

Printer Howard Quinn Company

CHRISTOPHER LE BRUN

KROMEKOTE

ONE · SUBJECTIVE REASONING

THE END

OF COMMUNISM
IS A MESSAGE TO THE
HUMAN RACE.

EXCERPTED FROM AN ADDRESS BY
VACLAV HAVEL
PRESIDENT OF THE CZECH AND SLOVAK FEDERAL REPUBLIC
AT THE WORLD ECONOMIC FORUM
FEBRUARY 4, 1992

It is a message we have not yet fully deciphered and comprehended. In its deepest sense, the end of Communism has brought a major era in human history to an end. It has brought an end not just to the 19th and 20th centuries, but to the modern age as a whole.

The modern era has been dominated by the culminating belief, expressed in different forms, that the world—and Being as such—is a wholly knowable system governed by a finite number of universal laws that man can grasp and rationally direct for his own benefit. This era, beginning in the Renaissance and developing from the Enlightenment to socialism, from positivism to scientism, from the Industrial Revolution to the information revolution, was characterized by rapid advances in rational, cognitive thinking.

This, in turn, gave rise to the proud belief that man, as the pinnacle of everything that exists, was capable of objectively describing, explaining and controlling everything that exists, and of possessing the one and only truth about the world. It was an era in which there was a cult of depersonalized objectivity, an era in which objective knowledge was amassed and technologically exploited, an era of belief in automatic progress brokered by the scientific method. It was an era of systems, institutions, mechanisms and statistical averages. It was an era of ideologies, doctrines, interpretations of reality, an era in which the goal was to find a universal theory of the world, and thus a universal

3
Catalog Christopher Le Brun
Art Director/Designer Rebeca Méndez
Illustrator Christopher Le Brun
Design Firm/Client Art Center College of Design, Pasadena, CA
Typography Macintosh
Printer Typecraft, Inc.
Paper Manufacturer Potlatch

4
Promotion Subjective Reasoning Campaign: The End
Art Directors Paula Scher, Bill Drenttel
Design Firm Pentagram, New York, NY
Client/Paper Manufacturer Champion International

5
Poster Culture Clash Lecture Series
Art Directors Margaret Youngblood, Doug Becker
Photographer Kevin Ng
Production Artist Bruce McGovert
Design Firm Landor Associates, San Francisco, CA
Client San Francisco Museum of Modern Art

Poster Pike's Peak Litho
Art Director/Designer April Greiman
Producer Sean Adams
Design Firm April Greiman Inc., Los Angeles, CA
Client/Printer Pike's Peak Lithographing Co.
Typography RPI

2

Brochure Drexel University, College of Information Studies
Art Directors Paul Sahre, Anthony Rutka
Designer Paul Sahre
Photographers Hugh Kretschmer, Edward Matalon
Ilustrator Lonnie Sue Johnson
Design Firm Rutka Weadock Design, Baltimore, MD
Client Drexel University
Printer Westland Printers
Paper Manufacturer Consolidated

3

Annual Report The Illinois Facilities Fund
Art Director Michael Glass
Designers Michael Glass, Adam Kallish
Client The Illinois Facilities Fund
Design Firm Michael Glass Design, Chicago, IL
Typography Paul Baker Typography, Inc.
Printer Rohner Printing Co.
Paper Manufacturer Mohawk

4

Annual Report The Progressive Corporation 1991
Art Directors Mark Schwartz, Joyce Nesnadny
Designer Joyce Nesnadny
Photography Nesnadny & Schwartz, Cleveland, OH
Client The Progressive Corporation
Typography Typsetting Service Inc.
Printer Fortran Printing, Inc.
Paper Manufacturer Millcraft

5

Publication Fighting HIV
Designer Mark Nelson
Design Firm Studio G.A., Decatur, GA
Client Patrick Scully
Publisher Walker Art Center Bookshop, Minneapolis, MN

5

1

1
Promotion Subjective Reasoning Campaign: The View From the Mirror
Art Directors Paula Scher, Bill Drenttel
Design Firm Pentagram, New York, NY
Client/Paper Manufacturer Champion International

2

3

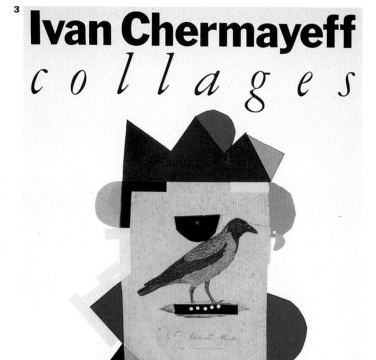

2
Poster AIGA/Los Angeles
Art Director Charles S. Anderson
Designers Charles S. Anderson, Todd Hauswirth
Writer Lisa Pemrick
Design Firm Charles S. Anderson Design Company, Minneapolis, MN
Client AIGA/Los Angeles
Typographers Todd Hauswirth, Charles S. Anderson
Printer Print Craft, Inc.
Paper Manufacturer French Paper Company

3
Poster Ivan Chermayeff Collages
Design Director/Illustrator Ivan Chermayeff
Design Firm Chermayeff & Geismar, Inc., New York, NY
Client Ginza Graphic Gallery
Printer Dai Nippon Printing Co

Certificate Design Barcelona Olympics Employee Recognition Award
Art Director Irene Gunter
Illustrator Janet Travis
Design Firm EDS Corporate Communications
Calligrapher Janet Travis
Paper Manufacturer Potlatch

5

5

Brochure The Getty Center Object
Art Director/Designer Anita Meyer
Design Firm plus design, inc., Santa Monica, CA
Client The Getty Center for the History of Art and the Humanities
Project Director Julia Bloomfield
Project Coordinator Stacy Miyagawa
Sewing Elissa Della-Piania
Collage Anita Meyer, Nicole Juen, Carolina Senior
Printer Aldus Press
Paper Manufacturers Curtis, Getty Center

6

Promotional Brochure Signatures of the Body
Art Director/Designer Susan Hochbaum
Cover Illustrator Steven Guarnaccia
Design Firm Pentagram, New York, NY
Client/Paper Manufacturer Mead Paper
Printers D.L. Terwilliger, Sterling-Roman

1

2

3

1
Program Book Video Music Awards 1992
Art Directors Stacy Drummond, Steve Byram
Designer Jeffrey Keyton
Writers Sharon Glassman, Cheryl Family
Photographer Robert Lewis
Design Firm MTV Networks Creative Services, New York, NY

2
Editorial Inserts Video Music Awards 1992
Art Directors Stacy Drummond, Steve Byram
Designer Jeffrey Keyton
Writers Sharon Glassman, Cheryl Family
Design Firm MTV Networks, New York, NY

3
Self Promotion ReThinking Design
Art Director/Designer Michael Bierut
Design Assistant Lisa Cervany
Client/Publisher Mohawk Paper Mills, Inc.
Printer Arthurs-Jones
Paper Manufacturer Mohawk

4
Print Promotion Designer's Saturday
Art Director Michael Donovan
Designer Tracey Cameron
Design Firm Donovan and Green, New York, NY
Client Designer's Saturday
Production Editor Brian Stanlake/Donovan and Green

5
Invitation/Call-for-Entries AIGA Baltimore
First Regional Design Show
Art Directors/Designers Tim Thompson,
Morton Jackson, Dave Plunkert
Photographers Morton Jackson, E. Brady Robinson
Design Firm Graffito, Inc., Baltimore, MD
Client AIGA/Baltimore
Printer French Bray, Inc.
Paper Manufacturer Domtar Specialty Papers

1
Cover Illustration ECO Magazine
Art Directors Jeff Darnall, David Carson
Illustrator Gerald Bustamante
Design Firm Studio Bustamante, San Diego, CA
Client ECO Magazine

2
Stationery Moose's Restaurant
Designer/Illustrator Ward Schumaker
Design Firm Schumaker, San Francisco, CA
Client Moose's Restaurant
Typography Display Lettering
Calligrapher Ward Schumaker
Printer Vision Printing
Paper Manufacturer Strathmore Paper

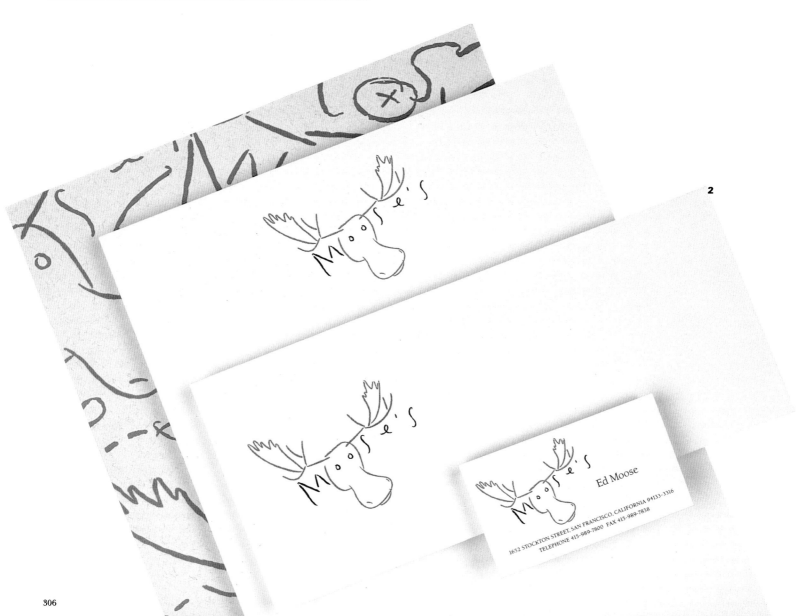

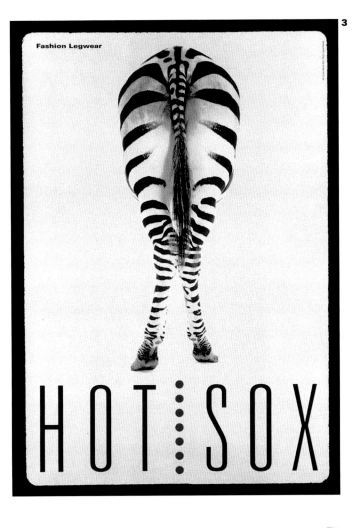

3

Bus Shelter Poster Hot Sox
Art Director Jeffrey Morris
Photographer Lizzie Himmel
Design Firm Studio Morris, New York, NY

4

Packaging Trail Mark
Art Director Joe Duffy
Designers Joe Duffy, Jeff Johnson
Design Firm Joe Duffy Design, Inc., Minneapolis, MN
Client Mark III

5

Press Kit Target Holiday
Art Director Nancy Gardner
Designer Brian Collins
Design Firm Gardner Design, Minneapolis, MN
Client Tunheim Santrizos
Printer Park Press

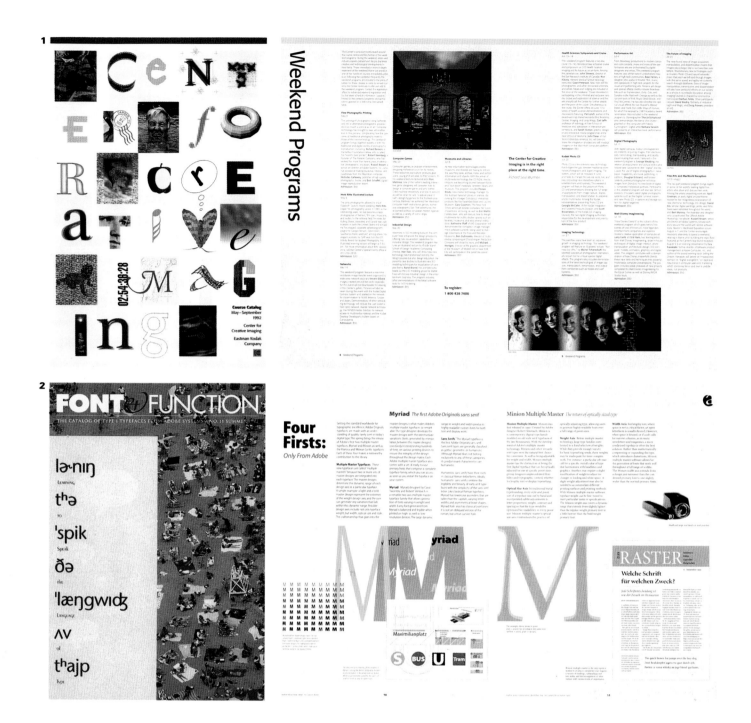

1

Catalog Center for Creative Imaging Courses Summer 1992
Art Director Brian Wu
Designers Brian Wu, Jessica Simmons
Design Firm Brian Wu, New York, NY
Client Center for Creative Imaging
Typographer Brian Wu

2

Catalog Font&Function Summer 1992
Art Director Gail Blumberg
Designers Susan Verba, Ewa Gavrielov, Min Wang, Keala Hagmann
Design Firm/Client Adobe Systems Marcom Dept., Mountain View, CA
Typography Adobe Systems, Z Pre-Press
Printer S. Rosenthal & Co.
Paper Manufacturer Westvaco

3

Announcement/Self-Promotion The Pentagram Press
1991/2 New Year's Card
Art Directors Merce Dostale, Michael Tarachow
Designer Michael Tarachow
Design Firm Pentagram Press, Minneapolis, MN
Typographer/Printer Pentagram Press
Paper Manufacturer Rising Mill

4

Promotion Campaign Newton Intro
Art Directors Keith Yamashita, Andy Dreyfus, Tim Brennan
Designers Andy Dreyfus, Robert Stone, Patty Richmond
Production Managers Jeanne Stewart, Gret Mikkelson
Writer Keith Yamashita
Photographers/Illustrators David Martinez, John Greenliegh
Design Firm Apple Creative Services, Cupertino, CA
Client The Apple Newton Group
Printer Various
Paper Manufacturer Various

5

Logo Design Ready Set Go
Art Director William Wondriska
Designer Christopher Passehl
Illustrator Bill Semerau
Design Firm Wondriska Associates, Inc., Farmington, CT
Client Manhattan Graphics
Typography Macintosh

4

Some of the thinking behind Newton technology.

Technology is not supposed to be hard.

It's supposed to improve your life, not complicate it.

But you wouldn't guess that based on all the difficult products you encounter during the course of a typical day.

Companies everywhere seem to have gotten the proposition wrong: In the name of progress, they're churning out products that offer more and more features—but are so complicated that most people can't use them.

At Apple, we've always strived to make our products understandable and friendly. Newton technology takes that ideal to a new level.

Newton technology is about inventing products that are significantly more intelligent, more intuitive, and by design, extraordinarily useful.

5

1

Brochure Star Gazers Guide
Art Director Scott Wadler
Illustrator Steven A. Wacksman
3-D: Gerald Marks
Design Firm MTV Networks Creative Services, New York, NY
Client Comedy Central

2

Promotional Brochure Useless Information
Art Director Paula Scher
Designers Paula Scher, Ron Louie
Producer Melissa Hoffman
Writers Tony Hendra, Paula Scher
Illustrator Paula Scher
Client Champion International
Typography Typogram
Printer Lebanon Valley Offset
Paper Manufacturer Champion International

1

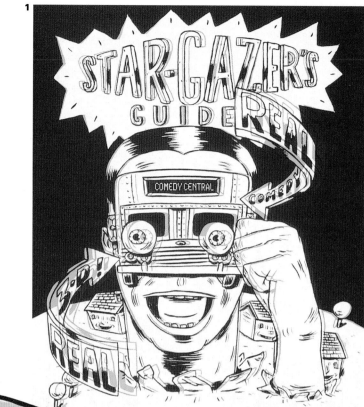

GREET THE STARS AS YOU TRAVEL THE WORLD OF COMEDY CENTRAL IN YOUR VERY OWN TOUR BUS!

2

3

Invitation AIGA/NY 1992-93 Season Opening Party
Art Director Robert Valentine
Designers Robert Valentine, Dina Dell'Arciprete
Illustrator Jean-Michel Basquiat
Design Firm Robert Valentine Incorporated, New York, NY
Client AIGA/NY
Typographer Robert Valentine
Printer Diversified Graphics
Paper Manufacturer Gilbert Paper

4

Magazine Illustration The 1992 Spy 100
Art Director Christiaan Kuypers
Illustrator Ron Meckler
Design Firm RE:Design, New York, NY
Client Spy Magazine

5

Self Promotion Modern Dog
Art Director Michael Strassburger
Designers Michael Strassburger, Robynne Raye, Vittorio Costarella
Writers Anna McAllister, Michael Strassburger
Photographer Rex Rystedt
Design Firm/Client Modern Dog, Seattle, WA

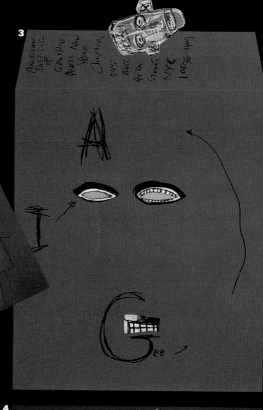

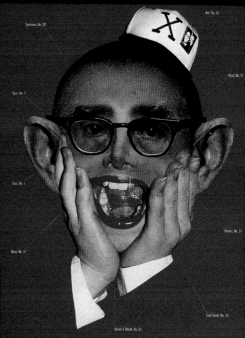

1

Catalog Side 1 Products
Art Director Valerie Taylor Smith
Photographer Barbara Penoyer
Design Firm Nike Design, Beaverton, OR
Client Side 1
Printer Irwin Hodsen

2

Catalog Live and Uncut
Art Director Bruce Crocker
Designers Bruce Crocker, Martin Sorger
Photographer Bill Gallery
Design Firm Crocker, Inc., Brookline, MA
Client Fat City Cycles
Typographer Lee Busch
Printer Winthrop Press
Paper Manufacturer Westvaco

3

Catalog Whatever Drives You
Art Director Bruce Crocker
Designers Bruce Crocker, Martin Sorger
Design Firm Crocker, Inc., Brookline, MA
Client Boston Acoustics
Typographer Lee Busch
Printer Nimrod Press
Paper Manufacturer Westvaco

4

Gift Book Nike Town
Art Director Michele Melandri
Copywriter Bob Lambie
Photographers Michael Jones, Barbara Karant, Elliot Schwartz
Design Firm/Client Nike Design, Beaverton, OR
Typography V.I.P. Typographers
Printer Diversified Graphics
Paper Manufacturers French Paper Company, Neenah

5

Packaging Design Vistalite VL 400 Series
Art Directors Cathy Choi, Robert Choi
Designer Cathy Choi
Illustrator Stephanie Molanko
Design Firm/Client Vistalite Inc., Lancaster, PA
Printers Strine Printing, Accurate Box
Paper Manufacturers Accurate Box

6

Stationery Firewheel Automotive
Art Director Timothy O'Donnell
Design Firm David Morris Design Associates, Jersey City, NJ
Printer Franklin's Printing
Paper Manufacturer Hammermill

NIKE TOWN

4

5

6

FIREWHEEL
AUTOMOTIVE
63 S. DEAN ST
ENGLEWOOD NJ
07631
TELEPHONE
201 728 8665

FIREWHEEL
AUTOMOTIVE
63 S. DEAN ST
ENGLEWOOD
NJ 07631
TELEPHONE
201 728 8665
Joseph A. Agresta, Jr.
Vice President

1

2

3

4

5

1

Banner New York City Opera
Art Director Alane Gahagan
Designer Lori Littlehales
Illustrator Rafal Olbinski
Agency Ziff Marketing, New York, NY
Client New York City Opera
Typographer Brandon Ashcraft
Printer Metromedia

2

Self Promotion Res Ipsa Loquitur
Art Director Sam Smidt
Design Firm Sam Smidt, Inc., Palo Alto, CA
Printer Oceanic Graphic Printing

3

Promotional Publication Dimensions: The Other Museums
Art Director Richard Poulin
Designers Richard Poulin, Rosemary Simpkins
Design Firm Richard Poulin Design Group, Inc., New York, NY
Client/Paper Manufacturer Simpson Paper Company
Printer L.P. Thebault

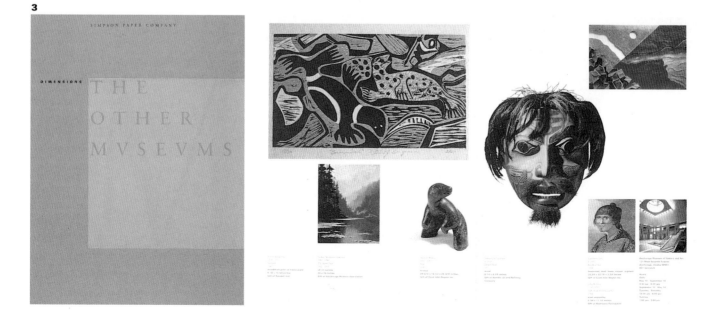

4

5

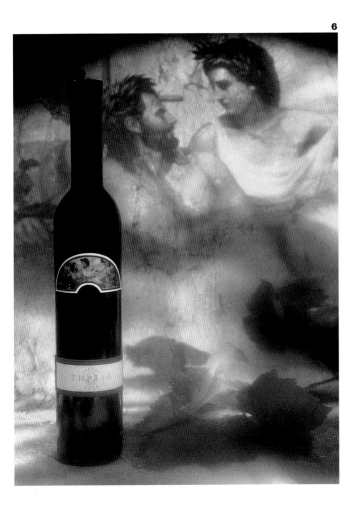

6

4
Brochure Passport
Art Directors/Designers Mark Oldach, Don Emery
Design Firm Mark Oldach Design, Chicago, IL
Client Closer Look Entertainment
Typographer Mastertype
Printer Active Graphics
Paper Manufacturer Consolidated

5
CD Packaging/Box Set "B.B. King of the Blues"
Art Director Vartan
Designer John O'Brien
Design Firm Cimarron/Bacon/O'Brien, Hollywood, CA
Client MCA Records
Typographer Jeff Smith
Printer Queens Printing

6
Wine Label Design Thalia
Art Director Patti Britton
Photographer Thea Schrack
Illustration Evans and Brown Co.
Design Firm Britton Design, San Francisco, CA
Client Viansa Winery
Typography Petrographics
Printer Bolling and Finke
Paper Manufacturer Mactac Starliner

NOTTAGE AND WARD

Nottage and Ward
concentrates in negotiation and litigation
related to matrimonial and family law
divorce proceedings
post-decree matters
custody disputes
prenuptial and lifestyle contracts

Lori S. Loeb
Victoria Munizzo
associates of the Law Firm of
Nottage and Ward

LET GENTLE PEACE ASSERT HER POWER.
Charles Sprague

1

1
Self Promotion Nottage and Ward — Gentle Peace
Designers Jilly Simons, David Robson
Writer Deborah Barron
Illustrator Francois Robert
Design Firm Concrete, Chicago, IL
Client Nottage and Ward
Typography Concrete
Printer Active Graphics, Inc.
Paper Manufacturer Mohawk Paper Mills, Inc.

2
Stationery Mundo Trade Company
Designer Susan Cummings
Design Firm The Leonhardt Group, Seattle, WA
Client Mundo Trade Company
Printer Evergreen Printing

2

THE MUNDO TRADE COMPANY

ANTIQUES RESOURCE

219 FIRST AVENUE NORTH, No. 376
SEATTLE, WASHINGTON 98109 U.S.A
PHONE 206·283·1277
FAX 206·286·8238

To:

3
Print Publications Image Value
Designers Jeff and Adrienne Pollard
Agency Williams & House
Client Engraved Stationery Manufacturers Association
Printers ESMA Members
Paper Manufacturers Strathmore, Crane, Gilbert, Fox River, Simpson

4
Brochure The Strathmore Letterhead Guide
Art Director Michael Scricco
Designers Adrienne and Jeff Pollard
Illustrator Jeff Pollard
Design Firm Keiler Design Group
Client Strathmore Paper
Printer Allied Printing
Paper Manufacturer Strathmore

As long as mankind has searched for adventure and knowledge, there has been the guide. Trusted companion, fearless pursuer, leader into unknown territories. Native Americans led our pioneers through the West, Sherpas scale the Himalayas, and Maine guides still direct clientele through the Great North Woods in search of fish, game and a chance to "experience wildness," as Thoreau described it. Over 100 years ago, Strathmore Paper began its role as a guide for people seeking to achieve the best results when printing on fine papers. This Strathmore Letterhead Guide was designed to help you create distinctive, elegant business letterheads on fine cotton fiber papers. When you realize how far and wide the average business letter travels each year on behalf of a company, you get an idea of how much impact it can have on the company's image. In this Guide, you'll discover a series of printing techniques that can open up new possibilities for producing the kind of letterhead that's destined to leave its mark on the world.

1
Poster Wear A Condom!
Designer/Illustrator Mark Fox
Design Firm BlackDog, San Rafael, CA
Client ACT UP!/New York
Printer Wasserman Silkscreen

2
Calendar Bunny 1993
Art Director/Photographer Brian Hagiwara
Designer Betty Chow
Design Firm/Client The Buddy Co., New York, NY
Printer Rapoport Metropolitan Printing Corp

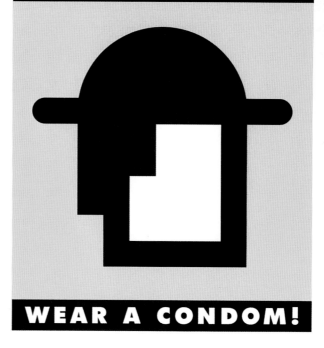

3
Promotion Comedy Central Presents "Up Front at a Distance"
Art Directors Scott Wadler, Sharon Glassman
Designer/Illustrator Laurie Rosenwold
Design Firm MTV Networks Creative Services,
Studio: Laurie Rosenwold, New York, NY
Client Comedy Centra

4

4
Calendar "Simpson Heroes" 1993
Art Director/Designer Kenny Garrison
Writer Mary Langridge
Illustrators Daniel and Mitchell Acevedo, Pat Binder,
Gerald Bustamante, Jack Unruh
Photographers Robb Debenport, Neal Farris, Jim Olvera, Tom Ryan
Illustrators Daniel Acevedo, Mitchell Acevedo, Pat Binder,
Gerald Bustamante, Jack Unruh
Design Firm/Agency RBMM/The Richards Group, Dallas, TX
Client Simpson Paper Company
Printer Williamson Printing Company
Paper Manufacturer Simpson Paper Company

5

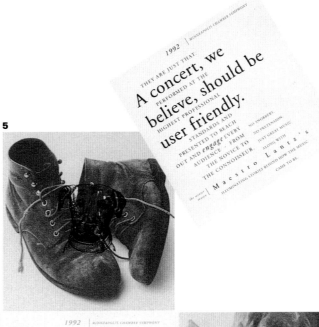

5
Invitation Engage/Minneapolis Chamber Symphony
Art Director Bill Thorburn
Design Firm/Agency Dayton's Hudson's Marshall Field's,
Minneapolis, MN
Client Minneapolis Chamber Symphony
Typography In-house
Printer Diversified Graphics

1

2

3

San Francisco International Airport introduced service abroad with the first West Coast flight to Asia. The *1992 Annual Report* is presented during a period of continued rapid growth in international service. Two hundred twenty-four flights weekly provide convenient non-stop service to twenty destinations worldwide.

4

1
Annual Report Airborne Express
Art Director Julia LaPine
Designers John Hornall/Heidi Hatlestad
Photographers Jeff Zaruba, Tom Collicott
Design Firm Hornall Anderson Design Works, Seattle, WA
Printer Graphic Arts Center
Paper Manufacturer Potlatch

2
Promotion The Power of Maps Education Guide
Art Director Peter Harrison
Designer Christina Treyss
Design Firm Pentagram, New York, NY
Client Cooper-Hewitt Museum
Typography Pentagram
Printer S.D. Scott/Tanagraphics
Paper Manufacturer Cougar

3
Annual Report Expeditors International 1991
Art Director/Designer Kerry Leimer
Writer Jeff Corwin
Illustrator Carla Siboldi
Design Firm Leimer Cross Design, Seattle, WA
Printer H. MacDonald Printing
Paper Manufacturers Tumba, Potlatch

4
Annual Report San Francisco International Airport 1992
Art Director Jennifer Morla
Designers Jennifer Morla, Sharrie Brooks
Illustration Art Lab
Design Firm Morla Design, San Francisco, CA
Client San Francisco International Airport
Typography Pacific Demand
Printer James H. Barry
Paper Manufacturers Simpson, Kimberly-Clark

5
Recruiting Brochure Gemini
Design Director Thomas Geismar
Designer Cathy Schaefer
Photographers Michael Kutch, Chuck Gathard
Design Firm Chermayeff & Geismar, Inc., New York, NY
Client Gemini Consulting
Typography In-house
Printer Milocraft
Paper Manufacturer Potlatch

5

1
Brochure Yunker Designs, Spring-Summer '93
Art Director Del Terrelonge
Writer Kanae Kinoshita
Illustrator Shin Sugino
Design Firm/Client Yunker Design, Inc., Toronto, CAN

2
Packaging Applied Chemistry
Art Directors Byron Glaser, Sandra Higashi
Writers Byron Glaser, Sandra Higashi, Amy Grgich
Design Firm Higashi Glaser Design, Fredericksburg, VA
Client Zolo, Inc.
Typography Trufont
Printer Cardinal Press, Inc

1

ONE

2

3
Magazine Design W, 9 Lives
Creative Director Dennis Freedman
Art Directors Owen Hartley, Dennis Freedman, Jean Griffin, Edward Leida, Kirby Rodriquez
Designers Rosalba Sierra, Myra Carver
Photographer Michel Compte
Design Firm W Magazine, New York, NY
Publisher Fairchild Publications

3

Ralph Lauren

4

4
Brochure Zapata
Art Directors John Pylypczak, Diti Katona
Designer Diti Katona
Photographer Deborah Samuel
Design Firm Concrete Design Communications, Inc., Toronto, CAN
Printer Baker Gurney McLaren
Paper Manufacturer Mohawk Paper Mills, Inc

5
Stationery Program Bill Phelps
Art Director/Designer Haley Johnson
Design Firm Charles S. Anderson Design Company, Minneapolis, MN
Client Bill Phelps
Typographer Haley Johnson
Printer Litho, Inc.
Paper Manufacturer French Paper Company

5

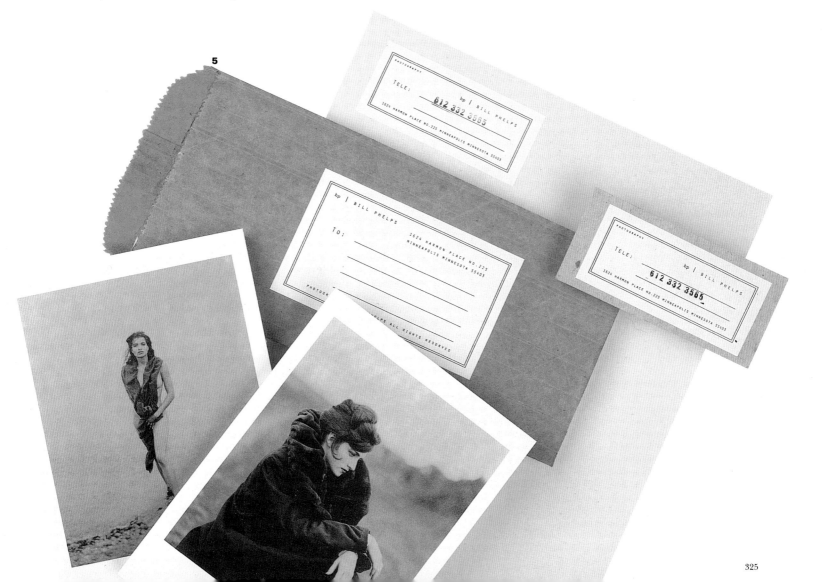

Television Broadcast Graphics
Numerical Countdown Video: "Melrose Place"
Art Director Jennifer Morla
Designers Jennifer Morla, Craig Bailey
Creative Director David Fowler
Photographers Holly Stewart, Craig Bailey
Design Firm Morla Design, San Francisco, CA
Client Fox Broadcasting Company

Television Broadcast Graphics
R.E.M. "Earth Summit"
Art Director/Producer Pam Thomas
Director of Photography Declan Quinn
Writer David Felton
Creative Directors Judith McGrath,
Abby Terkuhle

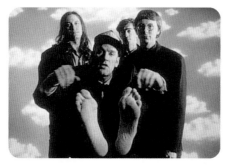

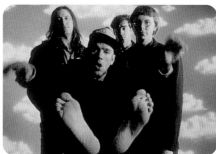

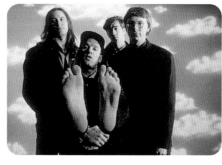

Television Broadcast Graphics
E! 5 Show Promo
Art Director/Designer Jill Taffet
Producers Jill Taffet, Kelly Cole
Writer Kelly Cole
Design Firm/Client E! Entertainment Television,
Los Angeles, CA

Video Levi's Concept Merchandising
Fall '93 Video
Art Directors Dennis Crowe, Neal Zimmermann
Directors of Photography Dennis Crowe,
Jeffrey Newbury
Dennis Crowe, Jeffrey Newbury (Modern Cowboy)
Producer Tammy Smith-White
Design Firm Zimmermann Crowe Design,
San Francisco, CA
Client Levi Strauss & Co.
Editor Bob Spector/Good Pictures!

Video Levi's Sweats Intro Video
Art Directors Dennis Crowe, Neal Zimmermann
Directors of Photography Dennis Crowe,
David Peterson
Producers Tammy Smith-White
Design Firm Zimmermann Crowe Design,
San Francisco, CA
Client Levis Strauss & Co.
Editor Bob Frisk, Phoenix Editorial

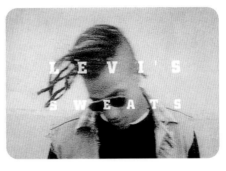

Television Broadcast Graphics
E! On Cable Open
Art Director Jill Taffet
Designer David Sparrgrove
Design Firm/Client E! Entertainment
Television, Los Angeles, CA

Television Broadcast Graphics
"Family Values"
**Art Director/Producer/Director
of Photography** Bill Kent
Writer David Felton
Design Firm MTV Networks Creative
Services, New York, NY

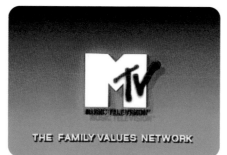

Television Broadcast Graphics
No You Don't Promo
Art Director/Designer Jill Taffet
Producers Jill Taffet, Kelly Cole
Writers Robert Bell, Kelly Cole
Design Firm/Client E! Entertainment
Television, Los Angeles, CA

Video Adobe Acrobat Presentation:
"The Computer and Me"
Art Directors Hank Perlman, Frank Todaro,
Bryan Buckley, Robert Wong
Designers Robert Wong, Frank Todaro
Director of Photography Laura Belsey
Producer Valerie Edwards
Writers Hank Perlman, Frank Todaro,
Bryan Buckley, Robert Wong
Design Firm/Agency Frankfurt Gips Balkind,
New York, NY
Client Adobe Systems, Inc.
Production Company First Light

Video Title Sequence
Medicine at the Crossroads
Art Director/Designer David Chomowicz
Producers Stephan Moore, Kerri Iterman
Design Firm WNET/Thirteen Design,
New York, NY
Typography Macintosh
Printer National Video

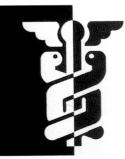

Television Broadcast Graphics
"Kids Pick the President"
Art Directors Scott Webb, Eleo Hensleigh
Producers Steve Grider, Liza Klein
Writer Steve Grider
Illustrator Mathew Dunteman

Film Title "Cape Fear"
Designers Saul and Elaine Bass
Design Firm Bass/Yager And Assoc.
Client Martin Scorsese

Film Title "Mr. Saturday Night"
Designers Saul and Elaine Bass
Design Firm Bass/Yager And Assoc.
Client Billy Crystal

A show about design and production excellence that tries to embrace the diversity of the American book publishing industry is perhaps inherently unfair. It is unfortunate, for instance, to see so many examples of fine, restrained typography, particularly in the general trade category, that emerge from their high-speed presswork looking gray or spidery, though still heavy enough to show through the cheap paper they're printed on.

We looked at a lot of good books, generally well designed and made. A number that were greatly admired were ultimately eliminated, for a variety of reasons; some with beautifully executed elements lacking a unifying concept or vision — front matter unrelated to chapter openings or other interior design, for example. Others came up short in details that were distracting or that brought no clarity in the interest of the reader. Still others failed to create — through design, typography, layout — a tone in harmony with subject, text, or illustration, or an understanding response to them.

Are these the 50 *best* books of 1992? Some were included over the fairly strenuous objections of at least one juror, in the interest of creating a more representative selection. Few of them are flawless. But in the end, of some 540 entries submitted, these are the 50 we felt best about including.

Jim Wageman, *Jury Chairman*

For nearly 70 years under the aegis of the AIGA examples of the best bookmaking in the United States have been recognized and honored. Prior to 1976 the selection was a Fifty Books show which later expanded to embrace the burgeoning number of titles being published. Aware that quality in design and manufacture was not increasing correspondingly, I have been campaigning for a smaller, prestigious exhibition. This year we have it. The new inclusion of books produced for special audiences or not published for the public has enriched the Fifty Books of 1992.

All too often one is dismayed to find books in the stores which, had they been submitted, might have been selected. This year, in contrast, you will encounter books hard to find elsewhere. Gone are the large design staffs who created beautiful books for the large publishers. Design departments have been pared down, even eliminated, letting independent designers and book packagers add diversity to the design process. The composition of the jury reflects this trend: it represents differing, even opposing approaches to book creation.

These jurors met and exceeded their charge; they identified many books of uncommon substance, where design has furthered the content. For their insights and perserverance we owe them thanks. I am particularly grateful to Jim Wageman for acting as chairman of this jury.

Congratulations to the makers of the Fifty Books of 1992. The level of design attests to a continuing search for quality, even in a beleaguered industry.

Samuel N. Antupit, *Chairman*

Jury

Sam Antupit (Chair)
Art Director
Harry N. Abrams Publishers
New York, NY

Michael Carabetta
Design Director
Chronicle Books
San Francisco, CA

Michael Hentges
Director of Graphics
The Museum of Modern Art
New York, NY

Amy Janello
Partner
Jones and Janello
New York, NY

Claire Van Vliet
Book Artist
Burke, VT

Jim Wageman
Director of Art and Design
Stewart Tabori & Chang
New York, NY

Call for Entries

Design Samuel N. Antupit
Photographs John Parnell
Cartoon Erica T. Moran
Book Symbol Ayn Svoboda
Photoshop Christine Edwards
Keyboarding Penelope Hardy
Postscript Output Sarabande Press
Printer Fleetwood Fine Arts
Binding and Finishing Intergraphic
Cover Paper Ward Brite-Hue, 65 lb. Sea Blue Cover
Text Paper Strathmore Renewal, 80 lb. Text, Spice

Title Sabine's Notebook

Author Nick Bantock

Art Director/Illustrator Nick Bantock

Designer Julie Noyes Long

Letterer Nick Bantock

Publisher Chronicle Books, San Francisco, CA

Typography Petro Graphics

Printer/Bindery Interprint

Production Managers Nancy Reid,
Lindsay Anderson

Paper Manufacturer Japan Art Paper

Paper 157 gsm Matte

Trim Size 7 1/2 x 7 1/2

Typefaces Augustea, Palatino

Jacket Designer Julie Noyes Long

Jacket Illustrator/Letterer Nick Bantock

Title Four Friends

Art Direction Jones Medinger Kindschi
Bushko, Inc.

Designer Karen Lukas-Hardy

Cover Photographer Ralph Gibson

Publisher The Aldrich Museum of
Contemporary Art

Printer Tucker Printers

Paper Manufacturers Champion, Potlatch

Paper Benefit Natural, uncoated 70 lb. (Text),
Quintessence Remarque Velvet, 100 lb. (Text)

Trim Size 5 3/4 x 8 1/4

Typeface Garamond #3

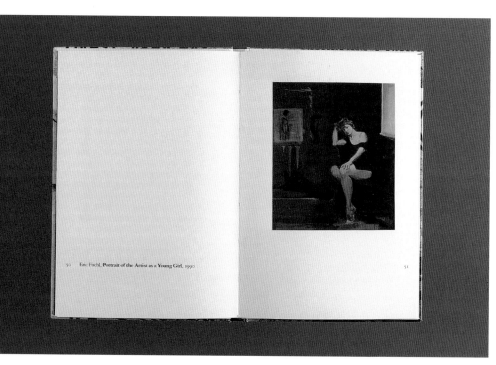

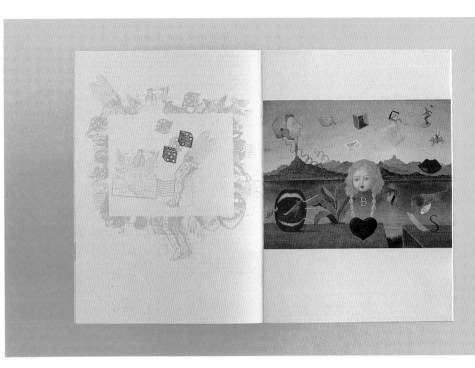

Title 1985 The Twelve Months
Author Walter Hamady
Illustrator John Wilde
Publisher The Perishable Press Ltd.
Typographer Lester Doré
Printer Litho Productions
Production Manager Walter Hamady
Paper Manufacturers Karma, Simpson, French
Trim Size 11 1/4 x 7 7/8
Bindery Booklab
Jacket Designer Walter Hamady

Title Where You Form the Letter "L"
Author Denise Liddell Lawson
Art Director Mark Fox/BlackDog, San Rafael, CA
Designers Mark Fox,
Denise Liddell Lawson/BlackDog
Publisher San Francisco State University
Typographer Mark Fox
Printers Logos Graphics (Cover), American
Business Communications (Text)
Paper Manufacturers Potlatch, Mohawk
Paper Potlatch Vintage Velvet (Cover),
Mohawk Superfine (Text)
Trim Size 7 x 9
Typefaces Centaur, Bank Gothic
Bindery American Business Communications
Jacket Designers Mark Fox,
Denise Liddell Lawson/BlackDog
Jacket Photographers David Peterson,
Will Mosgrove

Title Ferrington Guitars
Author Danny Ferrington
Art Directors/Designers Nancy Skolos,
Tom Wedell
Photographer Tom Wedell
Publisher HarperCollins/Callaway Editions,
New York, NY
Typographer Nancy Skolos
Printer Graphic Arts Center
Production Manager True Sims
Paper Manufacturers Northwest, Potlatch
Paper Vintage Gloss, 100 lb.
Trim Size 8 1/8 x 13 1/2 x 9 3/4
Typeface Adobe Garamond
Bindery Rand McNally Media Services
Jacket Designers/Photographers
Nancy Skolos, Tom Wedell

Title Frank Gehry: New Bentwood
Furniture Designs
Art Director Alison Choate
Designers Bruce Mau with Alison Hahn
and Nigel Smith
Photographers Joshua White, Jay Ahrend
Publisher The Montreal Museum
of Decorative Arts
Typography Archetype
Printer The Stinehour Press
Production Manager Paul Hoffmann
Paper Manufacturers S.D. Warren,
Cross Pointe Paper Company
Paper Warren Lustro Dull White, 80 lb. Text,
Cross Pointe Sycamore Gray, 80 lb. Text
Trim Size 5 3/4 x 8
Typefaces Alpha Gothic, Franklin Gothic
Bindery Mueller Trade Bindery

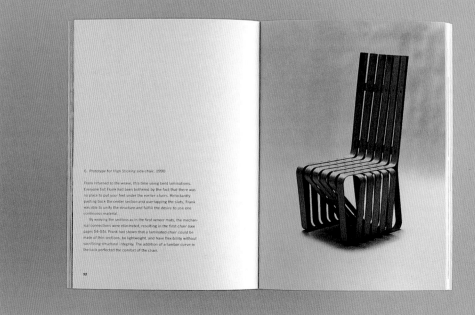

Title Modernities and Other Writings

Author Blaise Cendrars

Art Director/Designer Richard Eckersley

Publisher University of Nebraska Press

Typography Keystone Typesetting, Inc.

Printer/Bindery Edwards Brothers, Inc.

Production Manager Debra K. Turner

Paper Manufacturer Glatfelter Paper Co.

Paper Glatfelter 55 lb. Natural

Trim Size 5 1/2 x 9

Typefaces Adobe Garamond,
Futura Bold Condensed

Jacket Designer Richard Eckersley

Title Fabulous Fabrics of the 50s

Authors Gideon Bosker, Michele Mancini,
John Gramstad

Art Director Michael Carabetta

Designer Michele Wetherbee

Photographer Gideon Bosker, Bruce Beaton

Publisher Chronicle Books, San Francisco, CA

Typographer City Type

Printer Dai Nippon, Hong Kong

Production Manager Nancy Reid,
Lindsay Anderson

Paper Manufacturer Japan Art Paper

Trim Size 10 x 9 5/8

Typeface Bodoni

Bindery Dai Nippon, Hong Kong

Jacket Designer Michele Wetherbee

Looking for a City in America: Down These Mean Streets a Man Must Go... An Essay by André Corboz Photographs by Dennis Keeley

Occasional Papers from Los Angeles

Title Looking for a City in America:
Down These Mean Streets a Man Must Go . . .
Author Andre Corboz
Art Director/Designer Bruce Mau
Photographer Dennis Keeley
Publisher The Getty Center for the History
of Art and the Humanities
Typography Archetype
Printer/Bindery The Stinehour Press
Production Manager Rick J. Stinehour
Paper Manufacturers Mohawk,
Manadnock, S.D. Warren
Papers Mohawk Vellum Warm White, 70 lb.
(Text), Monadnock Caress Colonial White, 80 lb.
(Cover), Warren Lustro Dull White, 100 lb.
Trim Size 6 1/2 x 8 3/4
Typefaces Futura Text, Baskerville

Title The New York School:
Photographs 1936-1963
Author Jane Livingston
Designer Alex Castro
Photographers Various
Publisher Stewart, Tabori & Chang
Typography STC In-house
Production Manager Kathy Rosenblum
Papers OK Dune Art Dull 157 gsm,
U-Lite Matte, 157 gsm New Age Matte,
126.5 gsm Gagakoshi Woodfree
Trim Size 10 x 12
Typeface Bauer Bodoni
Jacket Designer Alex Castro

THE NEW YORK SCHOOL
PHOTOGRAPHS 1936–1963

JANE LIVINGSTON

Title MOJO: Photographs by Keith Carter
Author Rosellen Brown
Art Director D.J. Stout
Designers D.J. Stout, Nancy McMillen
Photographer Keith Carter
Publisher Rice University Press
Printer Dai Nippon Printing Co.
Trim Size 11 x 11
Typeface Garamond #3 Italic and Roman
Jacket Designer D.J. Stout
Jacket Photographer Keith Carter

Title A Photographic Journey: Explorations
Author Ray McSavaney
Art Directors Patrick Dooley, Ray McSavaney
Designer Patrick Dooley
Photographer Ray McSavaney
Publisher Findlay & Sampson
Printer Gardner Lithograph
Paper Centura Gloss, 100 lb. Book
Trim Size 12 1/2 x 12
Typeface Adobe Garamond
Bindery Roswell Bookbinding
Jacket Photographer Ray McSavaney

Title Froggy Went-A-Courtin'
Art Director Jim Wageman
Designer Julie Rauer
Illustrator Kevin O'Malley
Publisher Stewart, Tabori & Chang
Typography STC In-house
Printer/Bindery Tien Wah Press
Production Manager Dierdre Duggan Ventry
Paper Mitsubishi Matte 157 gsm
Trim Size 8 1/2 x 11
Typefaces Della Robbia, Kaufmann Script
Jacket Designer Julie Rauer
Jacket Illustrator/Letterer Kevin O'Malley

Title The House That Crack Built
Author Clark Taylor
Art Director Julie Noyes Long
Designer Lael Robertson
Illustrator Jan Thompson Dicks
Publisher Chronicle Books, San Francisco, CA
Printer South Seas International Press, Ltd.
Production Managers Nancy Reid,
Lindsay Anderson
Paper 128 gsm matte
Trim Size 7 3/4 x 7 3/4
Typeface Bernhard
Bindery South Seas International Press, Ltd.
Jacket Designer Lael Robertson
Jacket Illustrator Jan Thompson Dicks

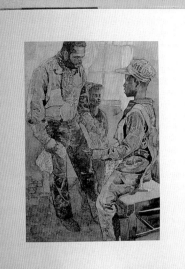

VIRGINIA HAMILTON
DRYLONGSO

ILLUSTRATED BY
Jerry Pinkney

Title Dry Long So
Author Virginia Hamilton
Art Director Michael Farmer
Designer Trina Stahl
Illustrator Jerry Pinkey
Publisher Harcourt Brace & Company
Typography Thompson Type
Printer/Bindery Tien Wah Press
Production Managers
Warren Wallerstein, Ginger Boyer
Trim Size 8 x 10
Typefaces Centaur, Berling
Jacket Designer Trina Stahl
Jacket Illustrator Jerry Pinkney

Title Fanny at Chez Panisse
Authors Alice Waters, Patricia Curtan, Bob Carrau
Art Director Joseph Montebello
Designer Patricia Curtan
Illustrator Ann Arnold
Letterer Georgianna Greenwood
Publisher HarperCollins Publishers
Typographer Patricia Curtan
Printer/Bindery R.R. Donnelley
Production Manager Lisa Feuer
Paper Manufacturer Westvaco
Paper Sterling Web Matte, 80 lb.
Trim Size 7 1/2 x 11
Typfaces Minion
Jacket Designer Patricia Curtan
Jacket Illustrator Ann Arnold
Jacket Letterer Georgianna Greenwood

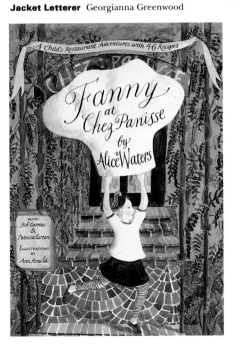

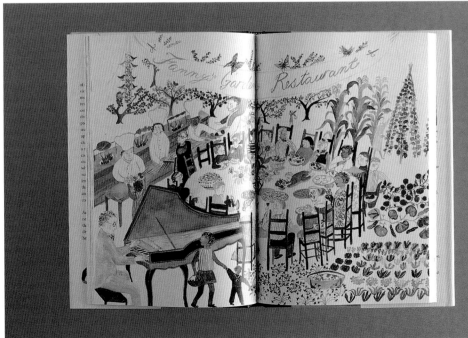

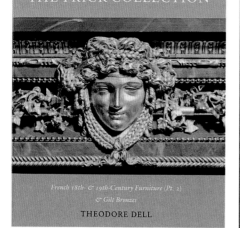

Title Furniture in the Frick Collection, Volume VI
Author Theodore Dell
Designer Mark Argetsinger
Photographer Richard di Liberto
Publisher The Frick Collection
Typography The Stinehour Press
Printer The Stinehour Press
Production Manager David Lorczak
Paper Manufacturer Mohawk Paper Mills, Inc.
Paper Mohawk Superfine Smooth, 90 lb. Text
Trim Size 7 3/4 x 10 1/4
Typefaces Sabon, Galliard Italic
Bindery Acme Bookbinding Company

Title Beyond Representation:
Chinese Painting and Calligraphy, 8th-14th Century
Author Wen C. Fong
Designer Bruce Campbell
Map Illustrator Wilhelmina Reyinga-Amrhein
Photographer Malcolm Varon
Publisher The Metropolitan Museum
of Art/Yale University Press
Typographer U.S. Lithograph
Printer Jean Genoud, SA; Offset-litho
Production Managers Susan Chun,
Gwen Roginsky
Paper Manufacturer Biberist
Paper Biberist Demi-matte, 150 gsm
Trim Size 9 x 12
Typefaces Adobe Garamond (Text),
Bembo (Display)
Bindery Mayer et Soutter, SA
Jacket Designer Bruce Campbell
Jacket Photographer Malcolm Varon

Title Agnes Martin
Author Barbara Haskell
Art Director Katy Homans
Designers Katy Homans, Sayre Coombs
Photographers Jerry Thompson, Various
Publishers Whitney Museum,
Harry N. Abrams, New York
Typographers Katy Homans, Sayre Coombs
Printers Nissha Printing (Color), Meridian
Printing (Black-and-white)
Production Manager Doris Palca
Paper Manufacturers Kanzaki, Mohawk
Papers Satin Kinfuji (Color), Mohawk Vellum,
Mohawk PC 100
Trim Size 8 1/2 x 11 3/4 Vertical
Typefaces Adobe Garamond, Gill Sans
Bindery Acme Bookbinding
Jacket Designers Katy Homans, Sayre Coombs
Jacket Illustration Agnes Martin
Jacket Photographer Jerry Thompson

Title Centuries of Books and Manuscripts
Designer Roderick D. Stinehour
Photographer Rick Stafford
Publisher The Harvard College Library
Typography The Stinehour Press
Printer/Bindery The Stinehour Press
Production Manager Sandra Klimt
Paper Manufacturers James River/
Curtis, Mohawk
Papers Curtis Flannel Gray, 80 lb. Cover,
Mohawk Superfine White Smooth, 80 lb. Text
Trim Size 9 x 12 upright
Typefaces Adobe Lithos, Minion

Title Pacific: An Undersea Journey
Author David Doubilet
Designer Susan Marsh
Photographer David Doubilet
Publisher Bulfinch Press/
Little, Brown and Company
Typography Monotype Composition Co.
Printer/Bindery Dai Nippon Printing Co.
Production Manager Amanda W. Freyman
Paper Art Gloss, 86 lb.
Trim Size 11 x 11
Typeface Gill Sans
Jacket Designer Susan Marsh
Jacket Photographer David Doubilet

Title Flair: Fashion Collected by Tina Chow
Author Richard Martin, Harold Koda
Art Director/Designer Kiyoshi Kanai
Illustrator Frank Young
Photographers Nana Watanabe, Various
Editor Robert Janjigian
Publisher Rizzoli International
Typographer Kiyoshi Kanai, Inc.
Printer/Bindery Dai Nippon Printing Co., Tokyo
Production Manager Junichi Iwama
Paper Manufacturer Nihon Seishi
Paper U-Lite, 86 lb.
Trim Size 9 x 12
Typefaces Futura, Garamond Italic
Jacket Designer Kiyoshi Kanai
Jacket Photographers David Seidner
(Front cover), Sheila Metzner (Back cover)
Jacket Letterer Kiyoshi Kanai

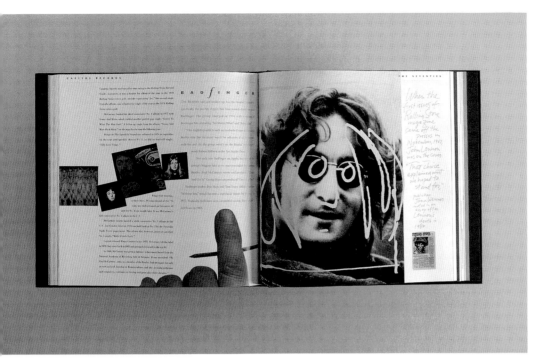

Title Capitol Records 50th Anniversary, 1942-1992

Authors Paul Grein, Various

Art Director Tommy Steele

Designer Andy Engel

Photographer Brad Benedict,
Capitol Records Archives

Publisher Capitol Records, Inc., Los Angeles, CA

Typographer Kim Saunders/Andy Engel Design

Printer Anderson Printing

Production Richard Mark Herzog

Paper Manufacturer Potlatch

Paper Karma, 100 lb. Text, White

Trim Size 11 x 11 1/4

Bindery Area Trade

Jacket Designer Andy Engel

Jacket Photographer Ron Slenzak

Title The Color of Fashion

Editors Lona Benney, Fran Black, Marisa Bulzone

Art Director/Designer Jim Wageman

Photographers Various

Publisher Stewart, Tabori & Chang

Typography Graphic Arts Composition,
STC In-house

Printer/Bindery Toppan Printing Co.

Production Manager Kathy Rosenbloom

Paper Manufacturer Oji Paper Mill
Manufacturing Co.

Paper OK Coat 157 gsm

Trim Size 10 x 13

Typefaces Berthold Bodoni Antiqua, Univers 93

Jacket Designer Jim Wageman

Jacket Photographer David Jensen

Title Roofed Theaters of Classical Antiquity
Author George C. Izenour
Art Director Sylvia Stiener
Designer James J. Johnson
Illustrator George C. Izenour
Publisher Yale University Press
Typography Keystone Typesetting, Inc.
Printer Arcata Graphics
Production Manager Cele Syrotiak
Paper Manufacturer Glatfelter Paper Co.
Paper Glatco Matte Smooth,
High Bright White, C16, 80 lb.
Trim Size 11 3/8 x 12
Typefaces Linotron 202 Walbaum, Torino Roman
Bindery Horowitz-Rae
Jacket Designer James J. Johnson
Jacket Illustrator George C. Izenour

Title Franklin D. Israel: Buildings and Projects
Writers Frank Gehry, Thomas Hines
Designer Tracy Shiffman
Publisher Rizzoli International Publications
Printer Dai Nippon Printing Co.
Production Manager Elizabeth White
Paper U-Lite
Trim Size 8 1/2 x 11
Typeface Univers

Title Land Spirit Power: First Nations at the
National Gallery of Canada
Authors Diana Nemiroff, Robert Houle,
Charlotte Townsend-Gault
Designer Turquoise Design Inc.
Publisher National Gallery of Canada
Printer/Bindery M.O.M. Printing
Production Manager Jean-Guy Bergeron
Paper Manufacturer Neenah
Papers Classic Crest, Zanders Ikonofix Matte,
Zanders Elephanthide
Trim Size 9 x 11 3/4
Typefaces Adobe Garamond,
Expert, Trade Gothic
Films Chromascan

Title Technics and Architecture
Author Cecil D. Elliott
Designer Jean Wilcox
Illustration/Photography Various artists
Publisher M.I.T. Press
Typography DEKR Corporation
Printer/Bindery Halliday
Production Manager Terry Lamoureaux
Paper Manufacturer S.D. Warren
Paper Patina Matte, 70 lb.
Trim Size 8 x 11
Typefaces Helvetica, Janson
Jacket Designer Jean Wilcox

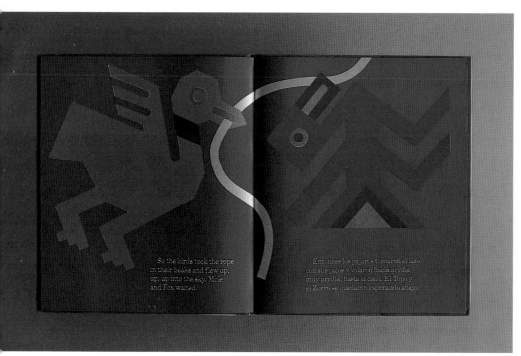

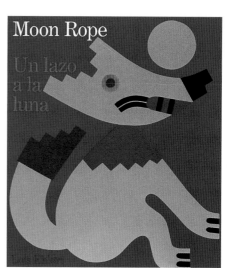

Title Moon Rope
Author Lois Ehlert
Art Director Michael Farmer
Designers Lois Ehlert, Lydia D'moch
Illustrator Lois Ehlert
Publisher Harcourt Brace & Company
Typography Thompson Type
Printer/Bindery Tien Wah Press
Production Manager Fran Wager
Paper Manufacturer Tien Wah Press
Paper 130 gsm Matte art paper
Trim Size 10 x 12
Typeface Century Expanded
Jacket Designers Lois Ehlert, Lydia D'moch
Jacket Illustrator Lois Ehlert

Title I Hate to Read
Author Rita Marshall
Art Director/Designer Rita Marshall
Illustrator Etienne Delessert
Publisher Creative Education
Typography Dix Type
Printer Corporate Graphics
Production Manager Tom Peterson
Paper Manufacturer Potlatch
Paper Koma 100 lb.
Trim Size 8 1/2 x 12
Typefaces Simocini, Garamond
Bindery Horowitz-Rae
Jacket Designer Rita Marshall
Jacket Illustrator Etienne Delessert

Title I Saw Esau: The Schoolchild's Pocket Book
Authors Iona Opie, Peter Opie
Art Director Amelia Edwards; Helen Read,
Dierdre McDermott (Assistants)
Illustrator Maurice Sendak
Publisher Candlewick Press (U.S)/
Walker Books (U.K.)
Typographers Amelia Edwards;
David Small, John Peacock (Assistants)
Printer Printers SRL, Italy
Production Managers Judith Burdsall,
Linda Morgan
Paper Manufacturer St. Regis Paper Co./
McNaughton Publishing Papers, Ltd.
Paper Esau Cartridge, 150 gsm
Trim Size 185mm x 130mm
Typefaces Garamond/ITC, Garamond Monotype
Bindery LEGO, Italy
Jacket Designer Elizabeth Wood
Jacket Illustrator Maurice Sendak

Title Alpha Beta Chowder
Author Jeanne Steig
Art Director Michael di Capua
Designer Atha Tehon
Illustrator/Letterer William Steig
Publisher Michael di Capua Books/
HarperCollins Publishers
Typographer CT Photegenic Graphics, Inc.
Printer/Bindery Berryville Graphics
Production Managers
Danielle Valentino, John Vitale
Paper Manufacturer Consolidated Papers, Inc.
Paper Paloma Matte, 80 lb.
Trim Size 7 1/2 x 9 3/4
Jacket Designer Atha Tehon
Jacket Illustrator/Letterer William Steig

Title St. Francis Preaches to the Birds
Author Peter Schumann
Art Director Julie Noyes Long
Designer Claire Van Vliet
Illustrators Peter Schumann,
Solveig Schumann, Kaja McGowan
Publisher Chronicle Books, San Francisco, CA
Printer/Bindery
South Seas International Press, Ltd.
Production Managers Nancy Reid,
Lindsay Anderson
Paper Manufacturer Japan Art Paper
Trim Size 6 x 7
Typeface Neuland
Jacket Designer Julie Noyes Long
Jacket Illustrator Peter Schumann, Solveig
Schumann, Kaja McGowan

Title Still Such
Author James Salter
Designer Stephen Doyle
Photographer Duane Michals
Publisher William Drenttel New York
Printer The Stinehour Press
Production Manager Jerry Kelly
Paper Manufacturer Mohawk
Paper Mohawk Vellum
Trim Size 6 x 9
Typeface Sabon

Some died while I was too young to have any memories. I have impressions of who they were, distilled from anecdotes passed down by family.

Title Past Presences

Author Kirsten S. Johnson

Art Director/Designer Kirsten S. Johnson

Illustrator Kirsten S. Johnson

Publisher Kida Press

Typographer/Printer/Binder Kirsten S. Johnson

Paper Rives

Trim Size 5 3/4 x 6 1/2

Typeface Garamond, Garamond Italic

Jacket Designer/Illustrator Kirsten S. Johnson

Title Tallos de Luna/Moon Shoots

Author Elba Rosario Sanchez

Designer Felicia Rice

Drybrush Ink Drawings Robert Chiarito

Publisher Moving Parts Press

Typographer Felicia Rice

Printer Felicia Rice

Papers Rives BFK, Starwhite Vicksburg

Trim Size 11 1/2 x 12; 8 x 9 (trade)

Typeface Spectrum

Bindery Booklab, Inc.

Title Notorious
Author Herb Ritts
Designer Tibor Kalman, M&Co.,
A Design Group, Inc.
Photographer Herb Ritts
Publisher Bulfinch Press/
Little, Brown and Company
Typography M&Co., A Design Group, Inc.
Printer The Stinehour Press
Production Manager Consolidated Papers, Inc.
Paper Frostbite, coated matte, 65 lb. Cover
Trim Size 11 3/4 x 15 upright
Bindery Acme Bookbinding
Jacket Designer Tibor Kalman, M&Co.,
A Design Group, Inc.
Jacket Photographer Herb Ritts

Title Here and There
Author/Photographer Joyce Ravid
Art Director Carol Devine Carson
Designer Iris Weinstein
Publisher Alfred A. Knopf, New York, NY
Typography In-house
Printer Everbest Printing Co.,
Hong Kong/Four Colour Imports
Production Manager Ellen McNeilly
Paper Manufacturer
Everbest Printing Co., Hong Kong
Paper New Age Matte
Trim Size 9 1/2 x 9 1/2
Typeface Perpetua
Bindery Everbest Printing Co.,
Hong Kong/Four Colour Imports
Jacker Designer Carol Devine Carson
Jacket Photographer Joyce Ravid

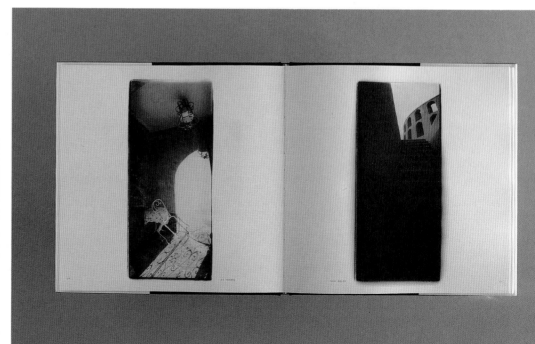

Title Life-Size
Author Jenefer Shute
Designer Anne Chalmers
Publisher Houghton Mifflin Company
Typography ComCon
Printer/Bindery The Book Press, Inc.
Production Manager S.D. Warren
Paper Sebago Antique Cream White, 55 lb.
Trim Size 5 x 8
Typefaces Sabon, Huxley Vertical
Jacket Art Director Michael Sullivan
Jacket Designer Louise Fili
Jacket Photographer Betsy Lerner

Title Breaking Bounds
Author William A. Ewing
Art Direction Thames and Hudson
Designer William A. Ewing
Photographer Lois Greenfield
Publisher Chronicle Books, San Francisco, CA
Typography Eurotype
Production Managers Nancy Reid,
Lindsay Anderson
Trim Size 10 1/2 x 10 1/2
Typeface Bodoni
Jacket Designer Karen Smidth
Jacket Photographer Lois Greenfield
Art Director Michael Carabetta (Cover)

MAX BECKMANN
THE SELF-PORTRAITS

BY PETER SELZ

Title Max Beckmann: The Self-Portraits
Author Peter Selz
Art Director Tony Morgan
Designers Tony Morgan, Lisa Yee
Publishers Gagosian Gallery, Rizzoli New York
Typographers Tony Morgan, Lisa Yee
Printer La Cromolito, Milan
Production Manager Lisa Yee
Paper Manufacturer Garda Patt
Paper 150 gsm Text
Trim Size 12 x 9 1/2
Typefaces Weiss, Cochin

Title Jackson Pollack: "Psychoanalytic" Drawings
Author Claude Cernushi
Designers Molly Renda, Nancy Sears
Illustrations Jackson Pollack
Publishers Duke University Press in association
with Duke University Museum of Art
Typography Marathon Typography Service
Printer Harperprints, Inc.
Production Managers Molly Renda, Nancy Sears
Paper Manufacturer Monadnock
Paper Astrolite, Bright White, 80 lb.
Trim Size 9 x 12 upright
Typefaces Sabon, Gill Sans Bold
Bindery Bridgeport Bindery
Jacket Designers Molly Renda, Nancy Sears
Jacket Illustration Jackson Pollack

Brice Marden Paintings and Drawings

Title Brice Marden: Paintings and Drawings
Author Klaus Kertess
Art Director Samuel N. Antupit
Designer Elissa Ichiyasu
Publisher Harry N. Abrams, New York, NY
Typography The Sarabande Press
Printer/Bindery Nissha Printing Co., Ltd.
Paper 157 gsm top-coated
Trim Size 12 x 11 1/4 oblong
Typeface Perpetua
Jacket Designer Elissah Ichiyasu

Title American Folk Art Canes
Author George Meyer
Art Director/Designer Ed Marquand
Photographer Charles B. Nairn
Publisher University of Washington Press/
Sandringham Press
Typography Type Gallery, Solo Type
Printer/Bindery C&C Offset Printing Co., Ltd.
Trim Size 10 1/2 x 9 Vertical
Typefaces Post Monotone, Joanna
Jacket Designer Ed Marquant
Jacket Photographer Charles B. Nairn

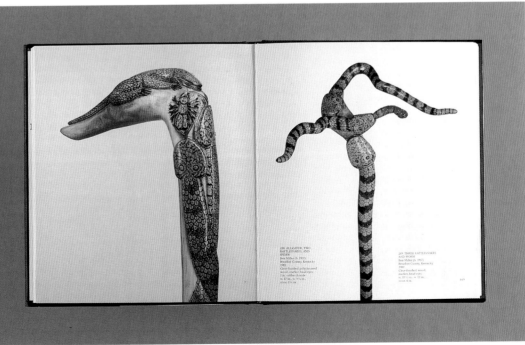

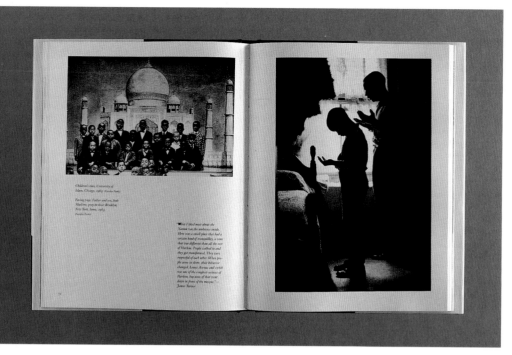

Title Malcolm X: The Great Photographs

Author Thulani Davis

Art Director/Designer Jim Wageman

Photographers Various

Publisher Stewart, Tabori & Chang

Typography STC In-house

Printer/Bindery Toppan Printing Co.

Production Manager Hope Koturo

Paper Manufacturer
Oji Paper Mill Manufacturing Co.

Paper OK Coat 157 gsm

Trim Size 8 1/2 x 11

Typefaces Janson, Gill Sans

Jacket Designer Jim Wageman

Jacket Photographers Eve Arnold, Gordon Parks

Title Liberators: Fighting on Two Fronts
in World War II

Author Lou Potter, with William Myles
and Nina Rosenblum

Art Director Vaughn Andrews

Designer Lydia D'Moch

Publisher Harcourt Brace & Company

Typography Thompson Type

Printer R.R. Donnelley

Production Manager Fran Wager

Typfaces Trump Medieval (Text),
Albertus Regular (Captions)

Jacket Designer Vaughn Andrews

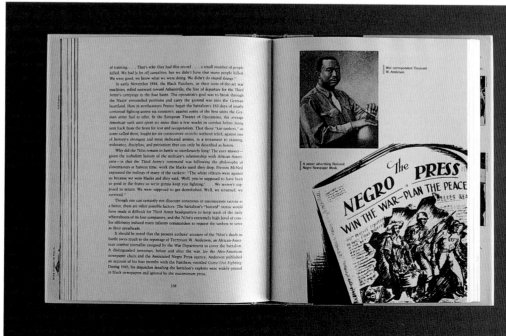

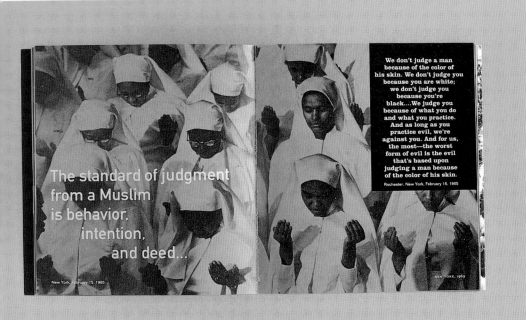

Title Malcolm X Speaks Out
Art Director Roger Gorman
Designer Rick Patrick
Photographers Various
Publisher Andrews & McMeel/Callaway Editions
Typographer Betty Type/Leah Sherman
Printer/Bindery Graphic Arts Center
Production Manager True Sims
Paper Manufacturer Newton Falls
Paper St. Lawrence Matte, 80 lb.
Trim Size 5 3/16 x 5 3/4 (Vertical)
Typefaces Clarendon, Folio, Din Mittelschrift, Helvetica, Minion, Walbaum
Jacket Designer Roger Gorman
Jacket Photography UPI/Bettman Archive

Title Crack Wars
Author Avital Ronell
Art Director/Designer Richard Eckersley
Publisher University of Nebraska Press
Typographer G&S Typesetters, Inc.
Printer/Bindery Edwards Brothers, Inc.
Production Manager Debra K. Turner
Paper Manufacturer Glatfelter Paper Co.
Paper Glatfelter 55 lb. Natural
Trim Size 6 1/8 x 9 1/4
Typefaces Galliard, Sabon Old Style
Jacket Designer Richard Eckersley

Title Barn

Authors Elric Endersby,
Alexander Greenwood, David Larkin

Art Director/Designer David Larkin

Principal Photographer Paul Rocheleau

Publisher Houghton Mifflin Company

Typography United Lithograph

Printer/Bindery Dai Nippon, Tokyo

Production Manager Terry McAweeney

Paper 157 gsm U-lite Matte

Trim Size 9 x 12 (upright)

Typeface Baskerville

Jacket Designer David Larkin

Title Parallel Visions: Modern Artists
and Outsider Art

Authors Maurice Tuchman, Carol Eliel,
Barbara Freeman

Designer Jim Drobka

Cover Illustrator Jim Drobka

Photography Supervision Steve Oliver

Publishers Los Angeles County Museum of Art,
Princeton University Press

Typography Andresen Graphic Services

Printer/Bindery Nissha Printing Co., Ltd., Tokyo

Production Manager Carol Pelosi

Paper Espel 128 gsm

Trim Size 9 x 12

Typefaces Fournier, Times Roman, Courier